The Yeats Circle, Verbal and Visual Relations in Ireland, 1880–1939

Karen E. Brown

First published 2011 by Ashgate Publishing

Published 2016 by Routledge
2 Park Square, Milton Park, Abingdon, Oxon OX14 4RN
711 Third Avenue, New York, NY 10017, USA

Routledge is an imprint of the Taylor & Francis Group, an informa business

Copyright © Karen E. Brown 2011

All rights reserved. No part of this book may be reprinted or reproduced or utilised in any form or by any electronic, mechanical, or other means, now known or hereafter invented, including photocopying and recording, or in any information storage or retrieval system, without permission in writing from the publishers.

Notice:
Product or corporate names may be trademarks or registered trademarks, and are used only for identification and explanation without intent to infringe.

Karen E. Brown has asserted her right under the Copyright, Designs and Patents Act, 1988, to be identified as the author of this work.

British Library Cataloguing in Publication Data
Brown, Karen E.
 The Yeats circle, verbal and visual relations in Ireland, 1880-1939.
 1. Yeats, W.B. (William Butler), 1865-1939--Knowledge--Art. 2. Art and literature--Ireland. 3. Yeats, W.B. (William Butler), 1865-1939--Friends and associates. 4. Art, Irish--19th century. 5. Art, Irish--20th century. 6. English literature--Irish authors--History and criticism. 7. English literature--20th century--History and criticism.
 I. Title
 709.4'15'09034-dc22

Library of Congress Cataloging-in-Publication Data
Brown, Karen E., 1972-
 The Yeats Circle, Verbal and Visual Relations in Ireland, 1880-1939 / Karen E. Brown.
 pages cm
 Includes bibliographical references and index.
 ISBN 978-0-7546-6644-8 (hardcover : alk. paper)
 1. Arts, Irish--19th century. 2. Arts, Irish--20th century. 3. Yeats, W.B. (William Butler), 1865-1939--Friends and associates. 4. Art and literature--Ireland--History--19th century. 5. Art and literature--Ireland--History--20th century. I. Title.

NX546.A1B76 2011
700.9415'09034--dc22

2010044970

ISBN 9780754666448 (hbk)

THE YEATS CIRCLE, VERBAL AND VISUAL RELATIONS IN IRELAND, 1880–1939

Focusing on W.B. Yeats's ideal of mutual support between the arts, Karen Brown sheds new light on how collaborations and differences between members of the Yeats family circle contributed to the metamorphosis of the Irish Cultural Revival into Irish Modernism.

Making use of primary materials and fresh archival evidence, Brown delves into a variety of media including embroidery, print, illustration, theatre, costume design, poetry, and painting.

Tracing the artistic relationships and outcome of W.B. Yeats's vision through five case studies, Brown explores the poet's early engagement with artistic tradition, contributions to the Dun Emer and Cuala Industries, collaboration between W.B. Yeats and Norah McGuinness, analysis of Thomas MacGreevy's pictorial poetry, and a study of literary influence and debt between Jack Yeats and Samuel Beckett. Having undertaken extensive archival research relating to word and image studies, Brown considers her findings in historical context, with particular emphasis on questions of art and gender and art and national identity.

Interdisciplinary, this volume is one of the first full-length studies of the *fraternité des arts* surrounding W.B. Yeats. It represents an important contribution to word and image studies and to debates surrounding Irish Cultural Revival and the formation of Irish Modernism.

Karen E. Brown is an art historian and curator specializing in interdisciplinarity and visual culture. She has produced a number of publications on twentieth-century Irish art and literature, and is editor of Women's Contributions to Visual Culture, 1918–1939 *(Ashgate, 2008). She is currently an AHRI Visiting Research Fellow at the University of Dundee, Scotland.*

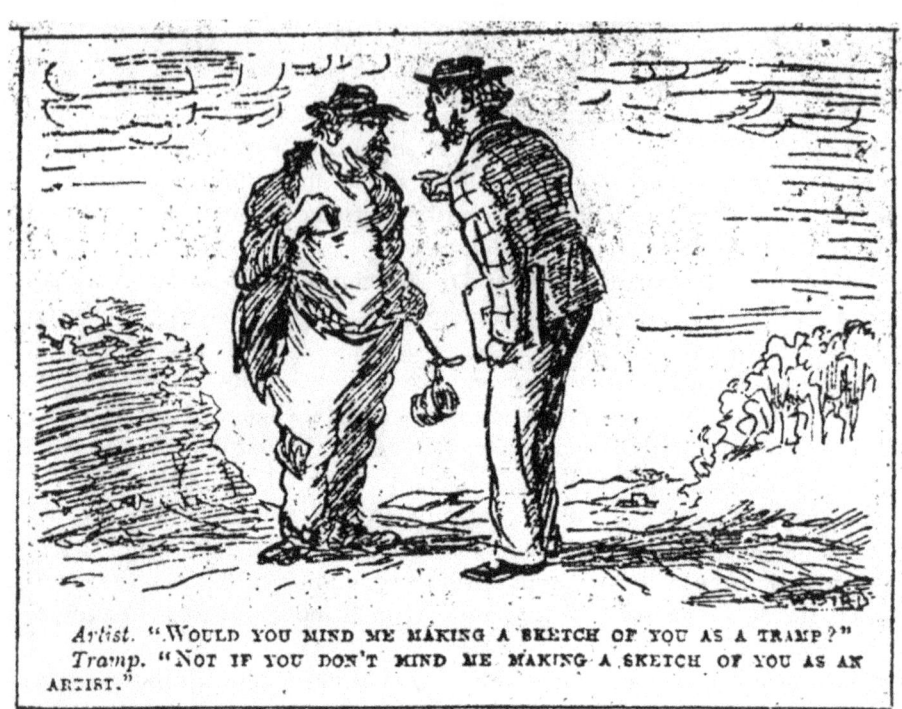

Frontispiece Jack B. Yeats, Cartoon in *Punch* (1926).

Contents

List of Plates and Figures *vii*
Acknowledgements *xi*
List of Abbreviations *xiii*

Introduction 1

1 W.B. Yeats and the *Fraternité des Arts* Tradition 9

2 The Dun Emer and Cuala Industries During the Irish Cultural Revival 29
 Evelyn Gleeson's Contribution to the Decorative Arts in Ireland 30
 Word, Image and Ideology in Dun Emer and Cuala Publications 41

3 W.B. Yeats, Norah McGuinness and Irish Modernism 63
 Writer and Illustrator: The Stories of Red Hanrahan and the Secret Rose 65
 The Gender of Irish Modernism in Painting 77

4 The Pictorialist Poetics of Thomas MacGreevy 89
 Thomas MacGreevy's Poems after Jack Yeats 92
 Verbal and Visual Ties: Thomas MacGreevy, Samuel Beckett and Jack Yeats 116

5 Word and Image Relations in the Later Career of Jack Yeats 129
 Sligo *and* The Aramanthers: *Jack Yeats Experimenting with the Novel* 135
 'The Two Travellers' in the Work of Jack Yeats, W.B. Yeats, J.M. Synge and Samuel Beckett 147

Bibliography 169
Index 181

List of Plates and Figures

All measurements are given in centimetres.

Cover Jack Butler Yeats (1871–1957), *The Two Travellers* (1942), oil on wood, 91.4 × 121.9; support, 92.1 × 122.6. Coll. Tate, London. © The estate of Jack Butler Yeats/Tate London 2009. All rights reserved, DACS 2010.

Frontispiece Jack B. Yeats, Cartoon in *Punch* (8 September 1926): 264. © Estate of Jack B. Yeats. All rights reserved, DACS 2010.

Colour Plates

1 Jack Yeats, *Draughts* (1922), oil on canvas, 22.9 × 35.5. Coll. National Gallery of Ireland. Photo © National Gallery of Ireland. © Estate of Jack B. Yeats. All rights reserved, DACS 2010.

2 Jack Yeats, *Low Tide* (1935), oil on canvas, 6.1 × 91.5. Coll. Dublin City Gallery, The Hugh Lane. Photo © Dublin City Gallery, The Hugh Lane. © Estate of Jack B. Yeats. All rights reserved, DACS 2010.

3 Jack Yeats, *Storm/Gaillshion* (1936), oil on canvas, 46 × 61. Private Collection. Photo courtesy of Waddington Galleries, London. © Estate of Jack B. Yeats. All rights reserved, DACS 2010.

4 Jack Yeats, *A Morning* (1936), oil on canvas, 22.9 × 35.5. Coll. National Gallery of Ireland. Photo © National Gallery of Ireland. © Estate of Jack B. Yeats. All rights reserved, DACS 2010.

Black and White Figures

1 W.B. Yeats and the *Fraternité des Arts* Tradition

1.1 John Butler Yeats (1839–1922), *Pippa Passes* (1870–72), gouache on paper, 48 × 34. Coll. National Gallery of Ireland. Photo © National Gallery of Ireland.

1.2 *The Works of Geoffrey Chaucer* (London: Kelmscott Press, 1896), title page and frontispiece by Sir Edward Burne-Jones (1833–98), woodcut and black type on paper, 29.5 × 42.5. Coll. Fitzwilliam Museum, Cambridge. Photo © Fitzwilliam Museum, Cambridge.

1.3 Althea Gyles (1868–1949), book cover and spine, W.B. Yeats, *The Secret Rose* (New York: Dodd, Mead & Co.; London: Lawrence & Bullen Ltd., 1897). Book cover, 19.7 × 13.2. Image

reproduced from the copy held in University College Dublin Library Special Collections.

1.4 John Butler Yeats (1839–1922), frontispiece and title page, W.B. Yeats, *The Secret Rose* (New York: Dodd, Mead & Co.; London: Lawrence & Bullen Ltd., 1897), 23.7 × 18.8. Image reproduced from the copy held in University College Dublin Library Special Collections.

2 The Dun Emer and Cuala Industries During the Irish Cultural Revival

2.1 *An Claidheamh Soluis*, 21 Marta [March] 1914. Dun Emer fashion designs. Cutting, 41.5 × 28.2, TCD, MS 10676/9/5, folio 1 (recto). Image produced by kind permission of the Board of Trinity College Dublin.

2.2 The Embroidery Room at Dun Emer, 1905. Photograph 11 × 15.4. Dun Emer Scrapbook. TCD, EPB PRESS ARCH, Box 1A, no. 3, p. 3. Image reproduced by kind permission of Gráinne Yeats and the Board of Trinity College Dublin.

2.3 Embroidered banner by Susan Mary (Lily) Yeats (1866–1948). Photograph in Dun Emer Scrapbook, 1904. Scrapbook page 33 × 21; photograph 8.9 × 16, TCD, EPB PRESS A CUALA ARCH, Box 1A, no. 2, p. 3. Image reproduced by kind permission of Gráinne Yeats and the Board of Trinity College Dublin.

2.4 Catía ní Cormac as the 'Youngest Pupil' in W.B. Yeats's *The King's Threshold*. Dun Emer Scrapbook, December 1903, 14.8 × 10.6, TCD, EPB PRESS A CUALA ARCH, Box 1A, no. 1, p. 5. Image reproduced by kind permission of Gráinne Yeats and the Board of Trinity College Dublin.

2.5 'Yeats, Father of Irish Poet, Brings Message to America', *New York American* (n.d.), 30 × 11, TCD, MS 10676/9/1, folio 14 (verso). Image reproduced by kind permission of the Board of Trinity College Dublin.

2.6 'Evelyn Gleeson Aids the Girls of Ireland', *The Boston Herald*, 3 February 1908. Cutting, 30.5 × 19.5; article, 28 × 16.5, TCD, MS 10676/9/1, folio 16 (recto). Image reproduced by kind permission of the Board of Trinity College Dublin.

2.7 Elinor Monsell (1871–1954), 'Lady Emer Pressmark' for the Dun Emer and later Cuala Press, originally carved as a wood engraving, 6 × 3.8, first printed as an electrotype without the border in Katherine Tynan, *Twenty One Poems* (Dublin: Dun Emer Press, 1907). Image reproduced from the copy held in Early Printed Books, Trinity College Dublin, by kind permission of the Board of Trinity College Dublin.

2.8 Cuala Industries Stall. Photograph taken at an Arts and Crafts exhibition in Belfast, 2–7 August 1909, 9.5 × 14.6. Photograph Album, TCD, EPB PRESS A CUALA ARCH xBox 17, no. 44. Image reproduced by kind permission of Gráinne Yeats and the Board of Trinity College Dublin.

2.9 Cuala Press Greetings Card (Dublin: The Cuala Press, n.d.). Poem by Susan L. Mitchell (1866–1926); illustration by Elizabeth Corbet ('Lolly') Yeats (1868–1940). Hand-coloured card, 17.8 × 11.5. Image reproduced by kind permission of Gráinne Yeats from copy held in the National Irish Visual Arts Library, National College of Art and Design, Dublin.

2.10 Jack Yeats, *The Ballad Singer*, hand-coloured process print, 7.6 × 8.9.

Private collection. Reproduced here as an illustration first used in *A Broadside*, no. 9 (February 1910). Image reproduced from the copy held in University College Dublin Library Special Collections.

2.11 Cuala Industries Christmas 'At Home' exhibition, 1938. Photograph, 6 × 8.3. Cuala Scrapbook, TCD, EPB CUALA PRESS A ARCH xBox 17, p. 36. Image reproduced by kind permission of Gráinne Yeats and the Board of Trinity College Dublin.

3 W.B. Yeats, Norah McGuinness and Irish Modernism

3.1 Norah McGuinness (1901–80), book cover embossed with gold leaf. Front cover, 22.8 × 15.2, W.B. Yeats, *The Stories of Red Hanrahan and the Secret Rose* (London: Macmillan & Co., 1927). Reproduced with permission of Palgrave Macmillan. Image reproduced from the copy held in University College Dublin Library Special Collections.

3.2 Norah McGuinness, frontispiece and title page, colour process print (double page) 21.6 × 29.2. Frontispiece illustration, 15.9 × 10.2, in W.B. Yeats, *The Stories of Red Hanrahan and the Secret Rose* (London: Macmillan & Co., 1927). Reproduced with permission of Palgrave Macmillan. Image reproduced from the copy held in University College Dublin Library Special Collections.

3.3 Photograph which belonged to W.B. Yeats, 'Natività di Gesù', vault to the west of the central square in the Church of the Martorana, Palermo, mosaic, c. 1143–51. Photograph, 22.9 × 17.8, W.B. Yeats Library, National Library of Ireland, Collection List 96. Image reproduced by kind permission of A.P. Watt Ltd. on behalf of Gráinne Yeats, and the Board of the National Library of Ireland.

3.4 Norah McGuinness, illustration, 'The Crucifixion of the Outcast', colour process print (double page), 21.6 × 29.2. Illustration, 15.3 × 10.2, in W.B. Yeats, *The Stories of Red Hanrahan and the Secret Rose* (London: Macmillan & Co., 1927), pp. 88–9. Reproduced with permission of Palgrave Macmillan. Image reproduced from the copy held in University College Dublin Library Special Collections.

3.5 John Butler Yeats, illustration, 'The Crucifixion of the Outcast'. Reproduced from an original watercolour painting (double page) 19 × 25.4, in W.B. Yeats, *The Secret Rose* (New York: Dodd, Mead & Co.; London: Lawrence & Bullen Ltd., 1897), facing p. 36. Image reproduced from the copy held in University College Dublin Library Special Collections.

3.6 Mainie Jellett (1897–1944), *Decoration* (1923), tempera on board, 88.9 × 53.3. Coll. National Gallery of Ireland. © Heirs and Successors of Mainie Jellett. Photo © National Gallery of Ireland.

3.7 Jack Yeats, *Communicating With Prisoners* (c. 1924), oil on canvas, 44 × 59. Coll. National Gallery of Ireland. Courtesy of The Model – Home of the Niland Collection. Photo © Ronan McCrea. © Estate of Jack B. Yeats. All rights reserved, DACS 2010.

4 The Pictorialist Poetics of Thomas MacGreevy

4.1 George Rouault (1871–1958), *Christ and the Soldier* (1927), oil on canvas, 63.5 × 48.3. Coll. Dublin City Gallery, The Hugh Lane. © ADAGP, Paris and DACS, London 2010. Photo © Dublin City Gallery, The Hugh Lane.

5 Word and Image Relations in the
Later Career of Jack Yeats

5.1 Jack Yeats, *Tramps*, illustration, 12.8
× 8.3, in *A Broadside*, no. 3 (August 1908).
Curran Collection, Special Collections
Library, University College Dublin.
© Estate of Jack B. Yeats. All rights
reserved, DACS 2010.

Acknowledgements

I am most thankful to the Government of Ireland IRCHSS Fellowship Scheme for enabling me to complete this book, and to University College Dublin for hosting me within the School of Art History and Cultural Policy. Thanks are also due to the University College Dublin SEED funding scheme, the Department of Employment and Learning (Northern Ireland) and the Queen's University Belfast Hellena Wallace Scholarship for their invaluable contributions. I also owe a great deal of gratitude to the people who have supported me along the way. Some have shared my passion for the topic and others have inspired my research. They include Brian Caraher and Edna Longley of Queen's University Belfast, Paula Murphy of University College Dublin, and Barbara Wright, David Scott and Edward McParland of Trinity College Dublin. This book would never have been completed without their friendship and guidance over the years. Thanks also to those who have read and commented on my research, including Cordelia Warr, Fintan Cullen, Siobhán Kilfeather, Averill Buchanan, Amanda Croft and Hilary Pyle.

Carla Briggs, Valerie Brouder and Simon Murphy of the School of Art History and Cultural Policy at University College Dublin were most helpful when I was organizing the rights and reproduction of images, as were the Special Collections Librarians in University College Dublin and the Departments of Early Printed Books and Manuscripts in Trinity College Dublin. I have made every effort to trace copyright holders, and I wish to thank the following people and organizations for their permissions:

Permission to cite the writings and poems of Thomas MacGreevy has been granted by kind permission of Margaret Farrington and Robert Ryan. Excerpts from *Disjecta* by Samuel Beckett, copyright © 1984 by Grove Press, Inc. Used by permission of Grove/Atlantic Inc., Rosica Colin Limited and Faber & Faber Ltd. The Letters of Samuel Beckett © The Estate of Samuel Beckett 2009, published by Cambridge University Press. Permission to cite the writings of Jack B. Yeats has been granted by A.P. Watt Ltd on behalf of Gráinne Yeats.

An excerpt from 'The Municipal Gallery Revisited' by W.B. Yeats has been reprinted with the permission of Schribner, a Division of Simon & Schuster, Inc., from *The Collected Works of W.B. Yeats, Volume I: The Poems, Revised*, edited by Richard J. Finneran. Copyright © 1940 by Georgie Yeats; copyright renewed © 1968 by Bertha Georgie Yeats, Michael Butler Yeats and Anne Yeats. All rights reserved. Extracts reprinted with the permission of Scribner, a Division of Simon & Schuster, Inc., from *Autobiography* by W.B. Yeats, edited by William H. O'Donnell and Douglas N. Archibald. Copyright © 1916, 1936 by Macmillan Publishing Company; copyright renewed 1944; 1964 by Bertha Georgie Yeats. All rights reserved. Extracts from *Essays and Introductions* by W.B. Yeats are reprinted with the permission of Scribner, a Division of Simon & Schuster, Inc. Copyright ©1961 by Mrs W.B. Yeats. All rights reserved. Extracts from the poems 'The Song of the Happy Shepherd', 'The Municipal Gallery Revisited' and 'The Secret Rose' by W.B. Yeats are granted by kind permission of A.P. Watt Ltd on behalf of Gráinne Yeats. Illustrations from *The Stories of Red Hanrahan and the Secret Rose,* published in 1927 by Macmillan, are reproduced with permission of Palgrave Macmillan. Unpublished letters of W.B. Yeats held in the Norah Allison McGuinness archive are reproduced by kind permission of the Board of the National Library of Ireland and by permission of Oxford University Press. Material from the Cuala Press archive, Department of Early Printed Books, Trinity College Dublin is reproduced by kind permission of Gráinne Yeats and the Board of Trinity College Dublin. Material from the Evelyn Gleeson Papers, Department of Manuscripts, Trinity College Dublin is reproduced by kind permission of the Board of Trinity College Dublin. Quotations from the John Quinn papers have been cited by kind permission of the Manuscripts and Archives Division, the New York Public Library, Astor, Lenox and Tilden Foundations, and Gráinne Yeats. For quotations from the William Butler Yeats collection of papers, the Berg collection of English and American Literature, I thank the New York Public Library, Astor, Lenox and Tilden Foundations, and Gráinne Yeats.

Finally, I wish to thank my family and friends whose patience and encouragement has been unwavering over the years – especially my father and mother, John and Connie, Morven, Roísín and Vina, Ingrid and Caroline, the Hammond family, and Meg.

List of Abbreviations

Au	W.B. Yeats, *Autobiographies* (Dublin: Gill and Macmillan, 1955)
Coll.	Collection
E&I	W.B. Yeats, *Essays and Introductions* (New York: The Macmillan Company, 1961)
ECY	Elizabeth Corbet ('Lolly') Yeats (1868–1940)
EPB	Early Printed Books (TCD)
JBY	John Butler Yeats (1839–1922)
LY	Susan Mary ('Lily') Yeats (1866–1949)
NLI	National Library of Ireland, Dublin
NYPL	New York Public Library
Quinn Coll.	John Quinn Memorial Collection, 1920–29 (NYPL)
RHA	Royal Hibernian Academy
TCD	Trinity College Dublin
VP	*The Variorum Edition of the Poems of W.B. Yeats*, eds Peter Allt and Russell K. Alspach (London: Macmillan, [1903] 1989)
WBY	William Butler Yeats (1865–1939)
YLIB	Jack Yeats's Library (Yeats Archive, NGI)
YMUS	Yeats Archive (NGI)

For my parents

Introduction

'Word and image,' ... is not a critical 'term' in art history ... but a pair of terms whose relation opens a space of intellectual struggle, historical investigation, and artistic/critical practice. Our only choice is to explore and inhabit this space.

W.J.T. Mitchell, 'Word and Image' (1996)[1]

The career of W.B. Yeats (1865–1939; hereafter WBY) spans the range of developments that take place in the arts, from the Irish Cultural Revival at the turn of the twentieth century to the emergence of Modernism in Ireland. In recent years, however, canonical histories of the 'Irish Revival' and 'Irish Modernism' have been subject to revision from interdisciplinary perspectives that challenge the 'literary' hegemony of the Irish Cultural Revival, attempt to re-define 'Irish Modernism' and debate issues of continuity.[2] *The Yeats Circle, Verbal and Visual Relations in Ireland, 1880–1939* focuses on interactions between word and image in early twentieth-century Irish literary and visual culture, drawing on the work of WBY, his family and their circle to open up a new space of enquiry between literature and the visual arts.[3]

At present, there are only a few monographs – by Elizabeth Bergmann Loizeaux (on WBY), Lois Oppenheim (on Samuel Beckett) and Christa-Maria Lerm Hayes (on James Joyce) – which deal with this interdisciplinary field in twentieth-century Ireland.[4] *The Yeats Circle* builds on this platform to present a new perspective which takes in the broad range of artistic media that interconnected with the rich intellectual, social and cultural environment of early twentieth-century Ireland. The diversity of art forms practised in the Yeats family circle places lesser-known figures alongside the more illustrious, thus prompting a closer examination of often overlooked members of the circle and of previously neglected archives. The intention is not to canonize artists whose talent has been hidden, but rather to show how intrinsic this nexus of inter-arts relationships was to the conception of cultural change in this period of Irish history.

The study of word and image interrelations has a long history in Western culture, from the Horatian *ut pictura poesis* ('as in painting, so in poetry') ideal and the Renaissance *paragone* ('argument') of the superiority of painting over the other arts, to the eighteenth-century insistence on difference in the arts, expounded in Edmund Burke's *A Philosophical Enquiry into the Origin of our Ideas of the Sublime and the Beautiful* (1757) and Georg Lessing's *Laocoon: An Essay on the Limits of Poetry and Painting* (1766).[5] Since then, boundaries have continued to be challenged, and in the context of European Modernism in particular, the relationship between literature and the visual arts has proved to be a fertile area for discussion by scholars working within disciplines as wide-ranging as history, literary studies, art history, linguistics, philosophy, the study of optics, neurology, anthropology and film studies.[6] Yet this research, while inexorable, remains persistently contentious. Edna Longley has drawn attention to the fact that W.J.T. Mitchell (who is arguably the leading theorist in this field) refutes the idea of a coherent conceptual framework for analysing word and image interactions, yet presents us with a homogenizing title for his book, *Iconology: Image, Text, Ideology*.[7] And in his critique of the word and image theorists Nelson Goodman, Ernst Gombrich, Lessing and Burke, Mitchell insists that socio-political issues have inevitably shaped the 'space' between word and image, which he describes as a shifting, dialectical trope.

I

A useful way of addressing the relationship between the verbal and the visual is to consider them as existing within a 'family of images', a model proffered by Mitchell. In this he joins a line of poets and scholars in the history of word and image studies who have described the two media in terms of kith and kinship – 'friendly neighbours' (Lessing) or 'siblings' (Hagstrum; Wendorf).[8] However, Mitchell expands the concept by describing it in terms of a family tree, with a parent ('image') and five children/siblings (see opposite).[9]

Mitchell points out that *graphic* images, such as pictures and designs, have been the property of art historians, but that *verbal* images, such as metaphors and descriptions, have belonged to literary critics. Further, the branch of *mental* imagery has belonged to psychology and epistemology, *optical* imagery to graphics, and *perceptual* imagery, situated between physical and psychological accounts of imagery, to the disciplines of physiology, neurology, history of art, the study of optics, philosophy and literary criticism.

By definition, academic disciplines create boundaries, structures, conventions and terminology; therefore studies of Irish artists and writers have belonged to the traditional disciplines of art history or literary criticism respectively.[10] Interdisciplinary studies, such as those by Loizeaux,

Mitchell's 'family of images' (*Iconology*, p. 10)

Oppenheim, Lerm Hayes and by this author, are inevitably open to scepticism for, as Mitchell states, '[i]f a discipline is a way of ensuring the continuity of a set of collective practices (technical, social, professional, etc.), "indiscipline" is a moment of breakage or rupture, when the continuity is broken and the practice comes into question'.[11] The aim of word and image analysis, however, is not to deconstruct established disciplines in order to parent a new one, but rather to 'understand the text–image relation as a social and historical one, characterized by all the complexities and conflicts that plague the relations of individuals, groups, nations, classes, genders, and cultures'.[12]

Artistic media created in the nineteenth and early twentieth centuries include painting, prose, poetry, art criticism, book illustration and the arts and crafts. If literature is situated on one branch of a family tree and visual art on another, as Mitchell suggests, then it is possible that some media (most obviously art criticism, poetry and book illustration) are situated in a middle ground, shuttling between graphic and verbal imagery. This raises the issue – are these art forms the 'property' of literary critics or of art historians? Such polarization has proved unfruitful for word and image analysts, because verbal and pictorial forms inevitably feed off each other, in subtle and unacknowledged ways, to appropriate, cultivate, disseminate and, at times, manipulate cultural heritages.

In this book, the artistic activities of members of the Yeats family and their wider circle are examined for textual and visual evidence of the conception and reception of works in both media in order to open up Mitchell's aesthetic and ideological 'space between' word and image.[13] Archival evidence, including much previously unpublished material, is used to expose the ways in which artists, writers and critics in Ireland were often working within complex social, cultural, political and gendered environments. *The*

Yeats Circle adds to our knowledge of Irish literature and the visual arts, and contributes meaningfully to current international debates in word and image studies pertaining to visual cultures outside of, but related to, Ireland. Indeed, movements such as Romanticism, Symbolism, Modernism, Pre-Raphaelitism and Arts and Crafts all have a significant role to play in consolidating patterns of word and image exchange.

During the Irish Cultural Revival, the reclamation of Irish literature, folklore and the Irish Language movement were key concerns for WBY, Lady Augusta Gregory (1852–1932), George Russell (AE) (1867–1935) and others. However, in comparison with the creative transitions in Irish literature in the early twentieth century, the first Irish 'Modernist' style of painting, Cubism, was promoted much later – in the 1920s. It is perhaps for this reason that Irish cultural studies of the nineteenth and twentieth centuries have sidelined the visual arts – as Brian O'Doherty (Patrick Ireland) put it in 1971: 'Irish artists occupy the gate lodge to the literary Big House, listening to the heavy traffic up and down the driveway.'[14] By investigating what Longley calls the familial 'relationship-in-difference' between literature and a wider range of visual arts within the Yeats family circle, developments in Irish culture can be considered through the careers of both writers and visual artists.[15] Word and image research explores moments in history when the two art forms either created fusions or resisted collaboration, at times working together towards a common goal and at others, stipulating a specific media as the most appropriate. These semiotic and ideological struggles are explored in this book by tracing new passages from the Irish Cultural Revival to Irish Modernism during the lifetime of WBY.

II

Each of the following chapters tells a distinct story of word and image interaction to develop the theme of 'relationship-in-difference' against a historical and family background. Chapter 1 describes how the ideal of mutual support between the arts, embodied in Romanticism, Symbolism, Pre-Raphaelitism and the Arts and Crafts movement, was mediated to the young Yeats family through their painter-father John B. Yeats (1839–1922) and his contemporaries. By establishing the artistic gifts of each sibling, it becomes clear why, when they returned permanently to Ireland in the early twentieth century, interdisciplinarity was at the heart of Yeats family enterprises. Drawing on Mitchell's theory, it is possible to identify the tensions apparent between the arts in this socio-historic climate, and this first chapter discusses how discord played an important part in WBY's early creative activities. I contend that even though the young poet argued for the superiority of the verbal over the visual arts, his admiration for and

research into the visual arts had considerable resonance, not least through his involvement in the burgeoning Irish Cultural Revival.

The career of the Revivalist, socialist, feminist secretary of the Irish Literary Society in London, Evelyn Gleeson (1855–1944) is the subject of Chapter 2. Her contribution to Irish visual culture informs emerging scholarship on the visual arts in the Irish Cultural Revival, and of women producers within it. New evidence drawn from her archive concerning the creation and management of the Dun Emer Industries advances our understanding of the *fraternité des arts* tradition in the Yeats family circle, and reclaims her as a remarkable entrepreneur. The chapter begins with an introduction to the ways in which the ideals and aesthetics of the English Arts and Crafts movement affected the aims and objectives of the Gaelic League and other Revivalist initiatives through Dun Emer cultural production. Gleeson's papers provide fresh evidence of how she located other examples of Arts and Crafts industries across Europe which were fostering national identity through the decorative arts, and reveal explanations for the managerial split between her and the Yeats sisters in 1908. Investigating the conception and reception of goods printed at the new Cuala Industries demonstrates compatibility and conflict both amongst Yeats family members, and between text and illustration on the printed page. These dialectical tensions reflect Mitchell's theory of word and image as a space of both ideological and artistic/critical struggle, and draw attention to the different attitudes of Yeats family members and their associates to word and image juxtapositions.

As editor of the Cuala Press, WBY resisted excessive book illustration, but when he was publishing elsewhere he had less control. Drawing on unpublished letters recently made available in the National Library of Ireland, Chapter 3 discusses his collaboration with the illustrator Norah McGuinness (1901–80) in 1927 for Macmillan & Co. They worked together on several projects, yet McGuinness is best remembered as one of several Irish women artists who painted in a late Cubist idiom, a style at odds with WBY's resistance to Modernist developments in literary culture of the 1920s. This paradoxical partnership prompts a considered analysis of their collaboration, and the results consolidate McGuinness's contribution to Modern Irish visual culture. Her unusual Byzantine-style illustrations for WBY's *The Stories of Red Hanrahan and the Secret Rose* (1927) are analysed in the light of their contemporary critical reception, and the implications of this reception for the poet's career are also considered. I argue that the decorative arts were as much a force as the fine arts in the naturalization of Modernism in Irish visual culture, and conclude by questioning how we define Irish Modernism in relation to dialogues between word and image.

One of the curious things about the breakthrough of European Modernist painting in Ireland is that women were its chief pioneers. Artists and arts administrators Mainie Jellett (1897–1944) and Norah McGuinness are key

examples, while the critic Thomas MacGreevy (1893–1967) also championed women artists at that time. His writings, both published and unpublished, challenge the conservativism and patriarchy of the Royal Hibernian Academy during this period, and lead to a discussion of his pictorialist poetics – the subject of Chapter 4. Herein, the potential contradiction between 'national' and 'Modern' Irish painting and poetry in the 1920s and 1930s is resolved, for original interpretations of his poetry, written in response to paintings and in relation to his art criticism, break through accepted readings of him as a minor, *soi-disant* Modernist poet of the 1930s. In his pictorialist poems, his dual preoccupations with dissonant Modernist poetics and Irish patriotism come to the fore, and this is particularly interesting when his poetry is read in context with Samuel Beckett's provocative essay 'Recent Irish Poetry' (1934). The discussion closes with an inevitable confrontation between the views of MacGreevy, Beckett and Jack Yeats (1871–1957), and assesses where Jack Yeats situated himself between nationalism and Modernism, an opposition established by his friends.

The concluding chapter debates the role of the 'relationship-in-difference' between literature and the visual arts in Jack Yeats's interdisciplinary career. He held strong views on artistic hierarchies, and consistently advocated painting as superior, 'direct communication' over writing. Yet in the 1930s, before his last 'triumphant' phase of painting, he published a series of novels and plays which, he claimed, were written to 'jettison memories'. My strong conviction, a rebuttal of established art-historical theories, is that this unpopular literary work is a key to his subsequent success as a painter. Investigating not only the content of these books, but also his relationships with his literary peers, Chapter 5 uncovers the extent to which Jack Yeats was familiar with developments in Modern literature by T.S. Eliot, Joyce, MacGreevy, Beckett and others. Only Beckett praised his friend's book, *The Aramanthers* (1936), for its Modernism, internationalism and disregard for parochial 'Irishness', and he presents a perceptive theory of 'stages of an image' to explain it.[16] Testing Beckett's theory leads to a discussion of the similarities in Jack Yeats's work in both word and image, and I take the motif of 'two travellers', which he employs throughout his *oeuvre*, as an example. Two travellers are of course also prevalent in the work of WBY, J.M. Synge (1871–1909) and Beckett, which in turn prompts a comparative analysis and opens up the possibility that Beckett owes a literary debt to Jack Yeats. Breaking down boundaries between word and image, Jack Yeats's 'painterly writing' can be understood as an artistic hybrid, thus exemplifying Mitchell's thesis of 'word and image' as a shifting, dialectical trope, and demonstrating how it engenders transitions in Modern Irish visual culture.

The following case studies are amongst the first to identify the integral role that word and image interactions played in the development of Modern Irish visual culture. From artistic and literary movements in late nineteenth-century

London to the burgeoning Cultural Revival in Ireland, and ultimately to the breakthrough of Irish Modernism in the 1920s and 1930s, these case studies demonstrate WBY's ideal of mutual support between the arts. It will be seen that during the poet's lifetime, verbal and visual relations engendered both collaboration and contestation. These 'relationships-in-difference' provoked creative synergies between media and were an important driving force in early twentieth-century Ireland.

Notes

1. W.J.T. Mitchell, 'Word and Image', in Robert S. Nelson and Richard Shiff (eds), *Critical Terms for Art History* (Chicago and London, 1996), p. 56.

2. The Irish Revivalists movement is variously referred to as the 'Literary Renaissance', the 'Literary Revival' and the 'Irish Cultural Revival', but for a discussion of Irish arts and crafts production at this time, the latter term offers the best conceptual framework. On the Irish Cultural Revival, see, for example, P.J. Mathews, *Revival: The Abbey Theatre, Sinn Féin, the Gaelic League and the Co-operative Movement* (Cork, 2003); Betsey Taylor FitzSimon and James H. Murphy (eds), *The Irish Revival Reappraised* (Dublin, 2004); and Sinéad Garrigan Mattar, *Primitivism, Science and the Irish Revival* (Oxford, 2004). For a review of this 'new academic vogue' and its implications for historical and literary studies of the Irish Revival, see Edna Longley, 'Not Guilty?', *The Dublin Review*, 16 (Autumn 2004): 17–31. On literary continuities, see, for example, John Wilson Foster, *Colonial Consequences: Essays in Irish Literature and Culture* (Dublin, 1991), pp. 44–59; Edna Longley, *Poetry and Posterity* (Northumberland, 2000); P.J. Mathews, 'The Irish Revival: A Re-Appraisal', in Mathews (ed.), *New Voices in Irish Criticism* (Dublin, 2000), pp. 12–19. In relation to Irish Modernism, see Edwina Keown and Carol Taaffe (eds), *Irish Modernism: Origins, Contexts, Publics* (Bern and New York, 2009), and Alan Gillis, *Irish Poetry of the 1930s* (Oxford, 2005). In relation to the visual arts, see, for example, Anne Crookshank, *Irish Art from 1600 to the Present Day* (Dublin, 1979); Françoise Henry, *Art Irlandais* (Dublin, c. 1962); Julian Campbell, *The Irish Impressionists: Irish Artists in France and Belgium, 1850–1914* (Dublin and Belfast, 1985); Brian Kennedy, *Irish Art and Modernism 1880–1950* (Belfast, 1991); Bruce Arnold, *Mainie Jellett and the Modern Movement in Ireland* (New Haven and London, 1991); Fintan Cullen, 'Painting the Modern', in his *Visual Politics: The Representation of Ireland, 1750–1930* (Cork, 1997), pp. 160–74; James Christian Steward (ed.), *When Time Began to Rant and Rage: Figurative Painting from Twentieth-Century Ireland* (London, 1999). Gesa Elsbeth Thiessen's *Theology and Modern Irish Art* (Dublin, 1999) is a fine example of the potential for an interdisciplinary approach to Modern Irish art.

3. The Yeats family includes: John Butler Yeats (1839–1922; hereafter JBY), his wife Susan Mary Yeats (née Pollexfen; 1841–1900), and their children William Butler Yeats (1865–1939), Susan Mary ('Lily') Yeats (1866–1949), Elizabeth Corbet ('Lolly') Yeats (1868–1940) and Jack Butler Yeats (1871–1957). There were two other children who died young, Robert Corbet Yeats (1870–73) and Jane Grace Yeats (1875–76).

4. Elizabeth Bergmann Loizeaux, *Yeats and the Visual Arts* (New Brunswick and London, 1986); Lois Oppenheim, *The Painted Word: Samuel Beckett's Dialogue with Art* (Ann Arbor, 2000); Christa-Maria Lerm Hayes, *Joyce in Art: Visual Art Inspired by James Joyce* (Dublin, 2004). Other texts focusing on Beckett's dialogue with the visual arts include John Pilling, *Samuel Beckett* (London and Boston, 1976), pp. 13–24, and Breon Mitchell and Lois More Overbeck (eds), *Word and Image: Samuel Beckett and the Visual Text [Mot et Image: Samuel Beckett et le Texte Visuel]* (Atlanta, 1999). The National Gallery of Ireland's 2008 exhibition 'Samuel Beckett: A Passion for Painting' showed a number of paintings of significance for the writer. Nicola Gordon Bowe, *Harry Clarke: His Life and His Work* (Dublin, 1989) considers interactions between word and image in Clarke's career.

5. See, for example, C.O. Brink, *Horace on Poetry: The 'Ars Poetica'* (Cambridge, 1971); Leonardo da Vinci, 'Paragone: Of Poetry and Painting', in his *Treatise On Painting: [Codex urbinas latinus 1270]*, trans. and annotated by A. Philip McMahon (Princeton, NJ, 1956); Edmund Burke, *A Philosophical Enquiry into the Origin of our Ideas of the Sublime and Beautiful*, ed. James T. Boulton (Notre Dame, 1958); Gotthold Ephraim Lessing, *Laocoon*, trans. with preface and notes by Sir Robert Phillimore (London, 1874, repr. 1905). The theories of Horace, Leonardo and Lessing are regularly cited as staging posts in the historical relationship between literature and the visual arts in important texts such as John Dixon Hunt, *Self-Portrait in a Convex Mirror on Poems on Paintings* (Somerset,

1980); W.J.T. Mitchell, *Iconology: Image, Text, Ideology* (Chicago and London, 1986); and David Scott, *Pictorialist Poetics: Poetry and the Visual Arts in Nineteenth-Century France* (Cambridge, 1988).

6. See, for example, E.H. Gombrich, 'Image and Word in Twentieth-Century Art', *Word & Image*, 1/3 (July–September 1985): 213–41; Charlotte Schoell-Glass, 'Introduction', in Claus Clüver, Véronique Plesch and Leo Hoek (eds), *Orientations: Space/Time/Image/Word* (Amsterdam and New York, 2005), pp. xi–xvi; Brian Caraher's 'hieroglyphic' reading of Paul Klee's work in his introduction to *Intimate Conflict: Contradiction in Literary and Philosophical Discourse* (Albany, 1992), pp. 1–33; and David Peters Corbett, 'Visuality and Unmediation in Burne-Jones's *Laus Veneris*', *Art History*, 24/1 (February 2001): 83–102.

7. Edna Longley, *The Living Stream: Literature and Revisionism in Ireland* (Newcastle Upon Tyne, 1994), p. 229.

8. Lessing, *Laocoon*, p. 145; Jean Hagstrum, *The Sister Arts: The Tradition of Literary Pictorialism and English Poetry from Dryden to Gray* (Chicago, 1958); Richard Wendorf (ed.), *Articulate Images: The Sister Arts from Hogarth to Tennyson* (Minnesota, 1983).

9. Mitchell, *Iconology*, pp. 9–14.

10. See Charles A. Hill and Marguerite Helmers (eds), *Defining Visual Rhetorics* (Mahwah, NJ and London, 2004). The boundaries of art history regularly undergo intense scrutiny, the panel at the 32nd Association of Art Historians' Conference, 'Contents, Discontents, Malcontents', University of Leeds, 5–7 April 2006 being just one example.

11. W.J.T. Mitchell, *Art Bulletin*, 77/4 (1995): 540–44. For an exposition of these questions, see also Hill and Helmers (eds), *Defining Visual Rhetorics*, p. 18.

12. Mitchell, *Iconology*, p. 157.

13. 'Conception: Reception' was the theme of the 31st Association of Art Historians' Conference held at the University of Bristol, 31 March–2 April, 2005.

14. Brian O'Doherty, 'The Literary Tradition and the Visual Response', in *The Irish Imagination 1959–1971* (Dublin, 1971), p. 24. More recently, Fintan Cullen and John Morrison have commented: 'In Ireland the visual arts have too often been seen as a poor relation to the literary tradition', in Cullen and Morrison (eds), *A Shared Legacy: Essays on Irish and Scottish Art and Visual Culture* (Aldershot, 2005), p. 5.

15. Longley, *The Living Stream*, p. 229.

16. Jack B. Yeats, *The Aramanthers* (London and Toronto, 1936). Samuel Beckett, 'An Imaginative Work! *The Aramanthers*. By Jack B. Yeats', *Dublin Magazine*, 11/3, July–September 1936, p. 81. Reprinted in Beckett, *Disjecta*, p. 90.

1

W.B. Yeats and the *Fraternité des Arts* Tradition

> Two days ago I was at the Tate Gallery to see the early Millais's, and before his Ophelia, as before the Mary Magdalene and Mary of Galilee of Rossetti that hung near, I recovered an old emotion. I saw these pictures as I had seen pictures in my childhood. ... I had learned to think in the midst of the last phase of Pre-Raphaelitism and now I had come to Pre-Raphaelitism again and re-discovered my earliest thought.
>
> <div align="right">W.B. Yeats, 'Art and Ideas' (1913)[1]</div>

W.B. Yeats's emotional attachment to Pre-Raphaelitism began at the age of 18 when the Yeats family moved to London in 1887. In that year his father, John B. Yeats (JBY), gave up a career in law to enrol at Heatherley's School of Art, where he met John T. Nettleship (a friend of Dante Gabriel Rossetti) and Edwin John Ellis, and together they formed the 'brotherhood' (later with George J. Wilson), which carried Pre-Raphaelite ideas forward.[2] Reacting against Victorian painting and materialism, the movement was inspired by the arts of the Middle Ages and early Italian Renaissance. The three paintings referred to by WBY in 'Art and Ideas' – Millais's *Ophelia* (1851–52), and Rossetti's *Mary Magdalene* (1877) and *Mary of Galilee* (1857) – depict classic Pre-Raphaelite women set against backgrounds which are elaborate in their portrayal of nature, like the tapestries of the Arts and Crafts movement. In essence, they seek to convey spiritual and emotional realities, and all of them illustrate the written word, for the Pre-Raphaelites encouraged mutual support between the arts, painting pictures inspired by poems, writing poetry about pictures, and producing finely illustrated books. Rossetti's *fraternité des arts* practice became especially inspirational for WBY, and he too transposed painting into poetry, creating an imaginative embodiment of the artwork through tone, mood or idea.[3]

In the nineteenth century, translations of painting into poetry took many shapes. Rossetti often transposed his pictures into highly structured sonnets, the favoured poetic form amongst earlier French Romantic and Symbolist

painters.⁴ David Scott has described how, in France, a turn towards what we now call 'Romantic' painting triggered contemporary Parnassian and Symbolist poets to experiment with rhyme, which they perceived as colour in verse.⁵ This was a view shared by Charles Baudelaire:

> Je crois sincèrement que la meilleure critique est celle qui est amusante et poétique; ... Ainsi le meilleur compte rendu d'un tableau pourra être un sonnet ou une élégie [I believe sincerely that the best critic is the amusing and poetic one; ... Thus the best translation of a painting could be a sonnet or an elegy].⁶

Scott has also pointed out that since the Romantic era and the publication of Baudelaire's work, it has been possible for pictorialist poets to understand the term 'image' as applicable both to painting and poetry.⁷ This idea is in keeping with Mitchell's 'family of images' concept, and is consonant with WBY's move from painting images to creating them in the mind's eye through literature (a ploy which he would later foster in drama). In addition, Mitchell contends that word and image analysis 'opens up a space of intellectual struggle, historical investigation, and artistic/critical practice',⁸ and this prompts an analysis of the politics behind a poet's 'borrowing' from a painting. When pictorialist poems are scrutinized, it becomes clear that poets such as Baudelaire, Rossetti and WBY were indeed appropriating elements of pictorial form into their work. As Scott concludes, their definition of an inter-arts 'synaesthetic' was therefore less of a neighbourly exchange than a familial struggle for supremacy:

> If *ut pictura poesis* was to have meaning in the context of nineteenth-century French poetry it was, thus, not simply as a reference to poetry's tendency to imitate painting rather than Nature, but as a confirmation of its ability to create a richer synthesis of pictorial, musical and semantic elements than any other art form.⁹

The legacy of this search for synthesis is evident not only in the work of WBY, but also in that of his painter-father, JBY. *Pippa Passes* (1870–72) (Figure 1.1) is a good example of this artist's late Pre-Raphaelitism, and illustrates the *fraternité des arts* at work.¹⁰ In keeping with the movement's tradition of painting pictures after poems, John Todhunter commissioned JBY around 1870 to illustrate Pippa from Robert Browning's narrative poem of 1841.¹¹ He portrays the young girl as she passes through the woods, her head tilted slightly back, and her neck and facial features thrown into relief by light. Her dark auburn hair flows behind her, adding to the sense of sweeping movement, and her mouth suggests that she is singing, thus portraying, as do many Pre-Raphaelite paintings such as Millais's *Ophelia*, a blend of innocence and ecstasy.¹²

JBY's interest in fusing the arts was encouraged by his 'brotherhood' and surrounding *milieu*. In the spring of 1879, the Yeats family moved to 8 Woodstock Road, Bedford Park, London, at a time when the neighbourhood had grown into 'a resort of painters, players, poets, journalists, schoolmasters,

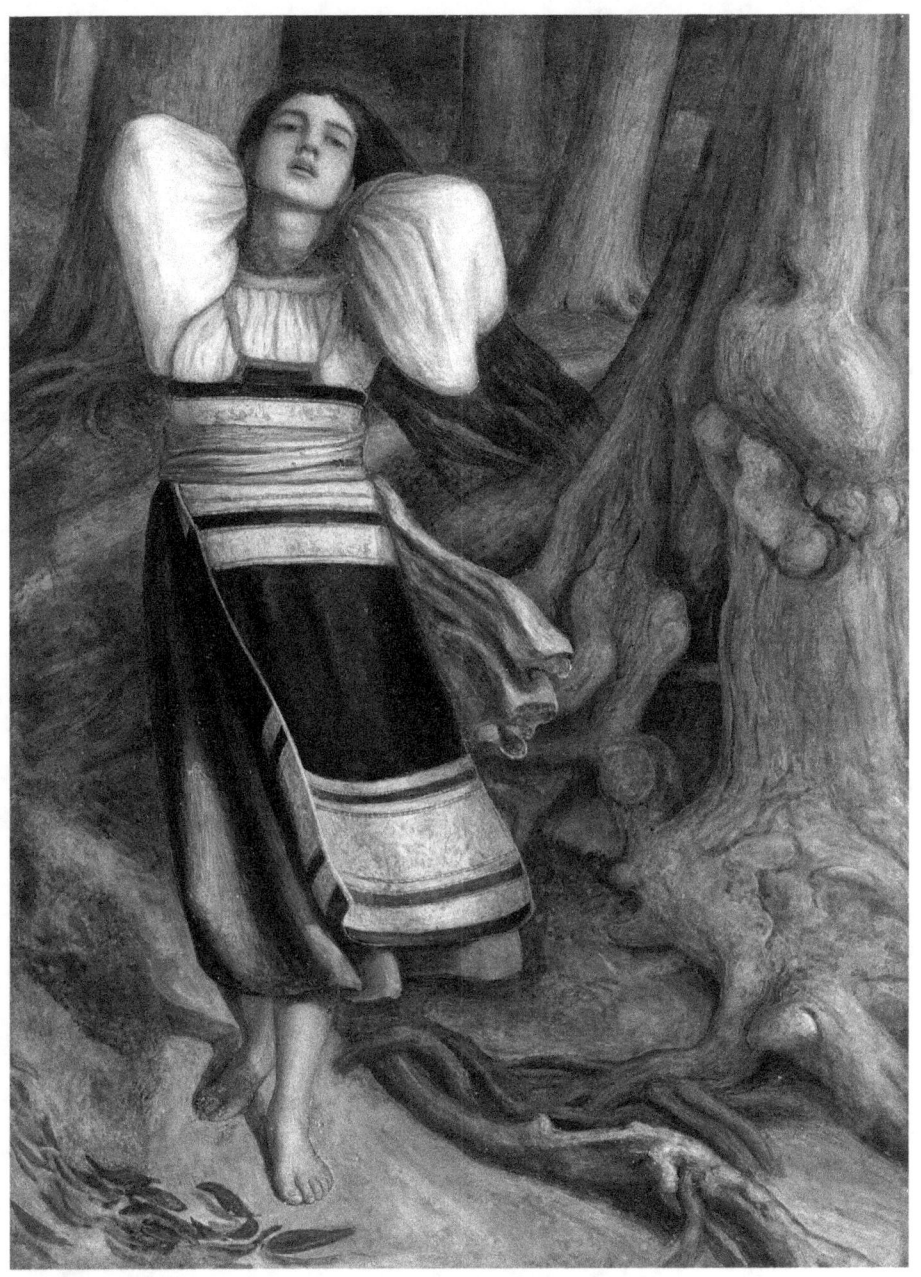

1.1 John Butler Yeats (1839–1922), *Pippa Passes* (1870–72), National Gallery of Ireland, Dublin

exiles, Bohemians, mostly innocent, "nephews of Rameau," stray city men and bourgeois'.[13] But by living in this locality, the painter found it difficult to provide a secure income for his family, and so frequently moved them between London, Dublin and Howth (Co. Dublin) as some income was to be gained through portrait commissions. During this time, the Yeats children often stayed with their grandparents, William and Elizabeth Pollexfen, in Sligo, and from 1879 to 1887, Jack Yeats attended school there. Between 1881 and 1883, WBY lived with his father in Howth, attended school in Dublin, and subsequently followed in his father's footsteps by studying art at both the Metropolitan School of Art and the Royal Hibernian Academy (RHA). However, the young art student found his father overbearing and the academic training tiresome. 'For words alone are certain good', he wrote in his 1885 poem 'The Song of the Happy Shepherd'. He left his studies in 1886, declaring: 'I was bored to death by that routine, and in consequence I have left Art, and have taken to Literature.'[14]

By 1886, WBY had already published poems in *The Dublin Magazine* and was an active member of the Dublin Hermetic Society. The impact of his early training as a painter, together with the artistic *milieu* in which he lived and worked in both Dublin and London, should not be overlooked, however, when considering his relationship with the *fraternité des arts* tradition. 'Crossways', the name given to the group of poems which begin *The Collected Poems of W.B. Yeats* (1933), opens with 'The Song of the Happy Shepherd'.[15] The poems are dedicated to 'AE' (George Russell) whom he befriended at the Metropolitan School, and the epigraph reads: '"The stars are threshed and the souls are threshed from their husks." – WILLIAM BLAKE', WBY drawing our attention to two well-known painter-writers whom he admired.[16] After that, WBY increasingly turned to visual traditions for inspiration, which ranged widely from Michelangelo's sculptures (*A Vision* [1925]) to Byzantine mosaics ('Sailing to Byzantium') and eighteenth-century Chinese carvings ('Lapis Lazuli').[17]

Several critics, including T.R. Henn, Frank Kermode, Giorgio Melchiori, Elizabeth Bergmann Loizeaux and Edna Longley, have drawn attention to WBY's vision for unity in the arts.[18] In her insightful book, *Yeats and the Visual Arts* (1980), Loizeaux rightly takes the poet's Pre-Raphaelitism as a starting point for her discussion, but admits that she has 'not tried to offer a theory of those [inter-art] relationships'.[19] By keeping Mitchell's analysis of 'iconology' in mind, the scope of her discussion can be expanded by examining aspects of WBY's version of the tradition wherein contradictions emerge, and by speculating about how characteristic they are of inter-arts relationships at large. Patterns of word and image exchange can thereby be seen to emerge in early twentieth-century Irish visual culture.

From the spring of 1888, the new Yeats family residence was 3 Blenheim Road, also in Bedford Park, London. In his essay 'Four Years 1887–1891', WBY recounts his experiences of living there, and stresses the importance of

Pre-Raphaelitism to his artistic development.[20] In order to earn an income, he wrote and continued to work in journalism. Driven by the same motive, his sisters and brother were also developing their talents. His eldest sister, Elizabeth, studied painting and attained a certificate from the Froebel Institute in the use of a 'brushwork' method for teaching art to children.[21] And from 1886 to 1894, his other sister, Lily, worked as a professional embroiderer under William Morris's younger daughter, May Morris (1862–1938). On his return to London in 1888, WBY's brother, Jack, also attended classes at a series of art schools, including the Westminster School, and began to work as an illustrator for magazines such as *The Vegetarian* and *Ariel, or the London Puck*.[22] There were early collaborations between the Yeats brothers when WBY published the poem 'A Legend' in *The Vegetarian* (1888), hand-lettered and illustrated by his brother, and WBY's *Irish Fairy Tales* (1892), which was illustrated with two drawings by Jack, 'The Young Piper' and 'The Fairy Greyhound'.[23] This period of time in Bedford Park foreshadowed the family's collaborative work in the Dun Emer Industries some ten years later in Ireland.

In Blenheim Road, JBY and his literary and artistic friends gathered for 'At Homes', and one of the most important houses frequented by the young family was that of the writer, designer, craftsman and socialist, William Morris (1834–96), Kelmscott House. Here, WBY and his sisters were tutored in French and allowed to join the 'Sunday evenings', meeting George Bernard Shaw, Ernest Rhys, Walter Crane and Emery Walker amongst others. The house was richly decorated with paintings by Rossetti, and this decorative aspect of Pre-Raphaelite painting extended to draperies, wallpaper and upholstery.[24]

Carrying forward the legacies of Pre-Raphaelitism and of the writer and social critic John Ruskin, Morris's Arts and Crafts movement was a reaction against the mass-production of goods during the Industrial Revolution, when quality, craftsmanship and community work ethic had been all but lost. Envisaging an idealized medieval world, Morris began to gather more and more artists together to bring fine design back into society, and to give greater importance to the decorative arts.[25] He used his home as a gathering place for fellow artists, writers, craft workers and socialists, and, with his daughter May, friends and staff, he effectively carried forward Pre-Raphaelite ideals relating to the *fraternité des arts* tradition. Tapestry was considered by Morris to be, at its best, associated with 'painting pictures with coloured wools on a warp', and often his designs incorporated scrolls bearing lines of poetry.[26] A most impressive example of this practice is 'The Morris Bed', comprising an embroidered bedcover and hangings.[27] An elaborate and time-consuming piece of work, it was produced in May's embroidery workshop, which she initially ran from Kelmscott House (from 1885 to c. 1906). Lily Yeats, along with May and Ellen Wright, was employed to work the cover and hangings, and, through this and other commissions, Lily provided the Yeats family with a necessary regular income for some six years.

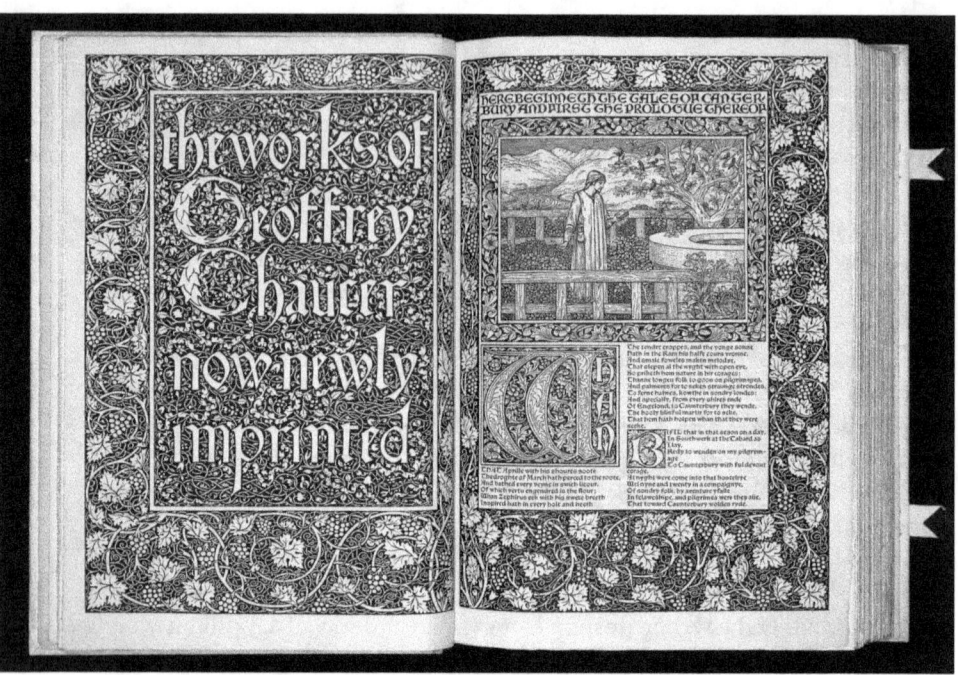

1.2 *The Works of Geoffrey Chaucer* (London, 1896), title page and frontispiece by Sir Edward Burne-Jones (1833–98), Fitzwilliam Museum, Cambridge

Another important strand of Kelmscott production was fine printing. In the mid-nineteenth century, machine-made goods contained mediocre typography and poor-quality illustration. But Morris and other enthusiasts set up private printing presses to maintain Pre-Raphaelite standards.[28] The Kelmscott Press folio edition of *The Works of Geoffrey Chaucer* (1896), illustrated by Sir Edward Burne-Jones (Figure 1.2), is a fine example of this quality craftsmanship.[29] A very large and expensive volume, it is bound in stiffened cloth on paper boards with decoration and type embossed in gold leaf.

WBY's book covers emphasize the legacy of the Arts and Crafts and Pre-Raphaelite movements in his career, and they were clearly significant to the poet beyond their materiality:

It is a pleasure to me to think that many young men here and elsewhere will never know my work except in this form. My own memory proves to me that at 17 there is an identity between an author's imagination and paper and book-cover one does not find in later life. I still do not quite separate Shelley from the green covers, or Blake from the blue covers and brown reproductions of pictures, of the books in which I first read them. I do not separate Rossetti at all from his covers.[30]

Both movements obviously appealed to the young WBY because they were associated with literature and because both of them, as Loizeaux has pointed out, were linked in his mind with the Romantic imagination.[31] A selection of illustrations and covers for WBY's books will be discussed later, but it is worth noting here that this aspect of his cultural production extends also to more transient media, such as magazines and journals.

French Symbolism was very much in vogue in certain literary and artistic circles in late Victorian London, and D.J. Gordon, Ian Fletcher and John Dixon Hunt, amongst others, have discussed how, together with Pre-Raphaelitism, this movement was interwoven into WBY's *fin de siècle* aesthetics. Illustrated books and the range of articles published in English periodicals of the time such as *The Pageant*, *The Dome – A Quarterly Containing Examples of All the Arts*, and *The Savoy: An Illustrated Quarterly* demonstrate this fusion.[32] In 1895 WBY moved out of the family home to Temple, where his association with late Victorian *décadent* writers and artists, including Arthur Symons (1865–1945), editor of *The Savoy*, and Aubrey Beardsley (1872–98), its chief illustrator, deepened.[33] WBY provided two love poems – 'The Shadowy Horses' (later known as 'He bids his Beloved be at Peace') and 'The Travail of Passion' – and the short story 'The Binding of the Hair' for the first number of *The Savoy*, and submitted the short story 'Rosa Alchemica' for the second number.[34] *The Savoy* was intended to rival *The Yellow Book* and was 'Pre-Raphaelite rather than Decadent' in content.[35] It was through these publications in *The Savoy* that the poet put 'the finishing touches to the collection which would appear the next year as *The Secret Rose*'.[36]

WBY's friendship with Symons at this time is important, as it inspired a deepening interest in French Symbolism. Hunt has discussed how both men embraced the Symbolist movement as a reaction against nineteenth-century materialism because 'it required the artist to see past the mere phenomena of life to a world of the subconscious, of magic, of suggestion, and of invisible essences', and concludes that 'Yeats was the first to appreciate how much the actual practice of the Pre-Raphaelite arts endorsed the more vocal and formulated programme of French symbolism'.[37] Hunt's analysis is in sympathy with my own understanding of WBY's relationship with the *fraternité des arts* tradition because it consolidates the roles of Pre-Raphaelitism and Symbolism in his early career. Moreover, WBY's Pre-Raphaelite affiliations suggest that he may have been aiming towards a Romantic *fusion des arts* rather than *fin de siècle* 'collaborative resistance'.[38]

One example of the 1890s 'collaborative resistance' can be seen in the work of Oscar Wilde, who had many books illustrated by contemporary artists, including Charles Ricketts, Charles Shannon and Aubrey Beardsley. Wilde, however, asserted the inferiority of pictorial art to writing, telling

'Michael Field' that 'it should be our faith that everything in this world could be expressed in words'.[39] David Peters Corbett discusses Wilde's attitude in relation to *The Sphinx* (1894), published by Elkin Mathews and John Lane in London. He scrutinizes Wilde's letters and writings, Ricketts's journals, letters, essays on art and his diary, secondary texts, and *The Sphinx* itself. Together, they provide evidence about the men's convictions concerning art, and about the conception of their collaboration. In *The Sphinx*, Ricketts's designs appear autonomous (thus seemingly confirming Wilde's beliefs about artistic boundaries), but they also demonstrate fidelity to the text (carrying them beyond Wilde's request for merely 'evocative' illustration). This contradiction, concludes Peters Corbett, is indicative of the commodified art market of 1890s London, which places the illustrator in a position of paradox. Similar conflicts are evident in the careers of those in the Yeats circle, not least in WBY's illustrated books. The important thing to note is that the poet advocated unity, even though at times he paradoxically demonstrated resistance to collaboration.

By the turn of the twentieth century, therefore, WBY was striving for synthesis between the arts rather than renouncing 'Art', and was arguing strongly for the merits of mutual support between them. At the end of 'Art and Ideas' (1913), he proffers Pre-Raphaelite equivalency between the arts as the richest means of artistic expression, and uses the quaint simile of little children playing about a chimney to conclude his argument:

We are becoming interested in expression in its first phase of energy, when all the arts play like children about the one chimney ... Shall we be rid of the pride of intellect, of sedentary meditation, of emotion that leaves us when the book is closed or the picture seen no more; and live amid the thoughts that can go with us by steamboat and railway as once upon horseback, or camel-back, rediscovering, by our reintegration of the mind, our more profound Pre-Raphaelitism, the old abounding, nonchalant reverie?[40]

This desire for unity in the arts can clearly be discerned in his early writings, and was to have far-reaching consequences when the Irish *émigrés* shifted their focus at the turn of the twentieth century back to Ireland.

In summary, by the late 1890s, WBY had been living and working under the influence of four main artistic movements – Romanticism, Pre-Raphaelitism, the Arts and Crafts movement and Symbolism – in which the relationship between the arts was always his central preoccupation. Coupled with his studies in the occult and in Celtic Irish literature, the result was complex. As well as much theorizing about relationships between the arts in essays, WBY also applied his theories in both poetry and drama by integrating aspects of the visual arts into his writing. He formalized his ideas about Symbolism in the essays 'Symbolism in Painting' (1898) and 'The Symbolism of Poetry' (1900), in which, as Edna Longley has so succinctly noted, an appreciation

of the sister-arts' aesthetic of sound, colours and forms (WBY's *'rhythmic symbolism'*) is crucial for understanding the origin of inter-arts relationships in Irish poetry from his time to the present day.[41] In 'Symbolism in Painting', WBY separates symbol from allegory, and describes how symbol 'entangles, in complex colours and forms, a part of the Divine Essence', listing the visual artists, writers and musicians (English, French and Irish) with whom he associates this symbolic art.[42] In 'The Symbolism of Poetry', he argues that an intrinsic 'arrangement of colours and sounds and forms' creates symbolic writing:

All sounds, all colours, all forms, either because of their preordained energies or because of long association, evoke indefinable and yet precise emotions, or, as I prefer to think, call down among us certain disembodied powers, whose footsteps over our hearts we call emotions; and when sound, and colour, and form are in a musical relation, a beautiful relation to one another, they become, as it were, one sound, one colour, one form, and evoke an emotion that is made out of their distinct evocations and yet is one emotion.[43]

In her discussion of his early poetry, Loizeaux has drawn attention to WBY's desire for poems that would be 'regions' in which the reader could wander (in a way comparable to Rossetti's 'embodiments' of poetry).[44] The pattern, heightened colour and flatness of Pre-Raphaelite and Arts and Crafts designs (tapestry in particular) renounce Renaissance perspective. In the eyes of the young poet, these arts therefore strove towards the same revelation of symbolic vision that he sought to re-create in his poems.[45] But the craving for synthesis apparent in his essay of 1900 requires more than the two-dimensionality of painting or tapestry, for the poet is calling for a multi-sensory approach to the 'Symbolism of Poetry' wherein 'sound', 'colour' and 'form' are in beautiful, musical relation to one another, not only in space, but also in time, and reminding us distinctly of Scott's analysis of the Romantic poet's search for synthesis in nineteenth-century France.[46]

WBY's publication *The Secret Rose* (1897) (Figure 1.3) demonstrates the practical application of these ideas in book form, introducing the potential for analysing word and image interactions in the context of the Irish Cultural Revival. *The Secret Rose* is a compilation of stories pursuing 'but one subject, the war of the spiritual with the natural order'.[47]

Roy Foster has traced various elements of the poet's alter ego in the characters of Michael Robartes, Owen Aherne and Red Hanrahan, and tracked literary debts as wide-ranging as Irish folklore, Rosicrucianism (WBY joined the Order of the Golden Dawn in London), Stéphane Mallarmé (the trembling of the veil of the temple), Joris-Karl Huysmans (whom he encountered through Symons), Ernest Renan (whose work he had read concerning connections between Celticism and the New Age) and William Blake (WBY had published articles concerning Blake's illustrations to Dante

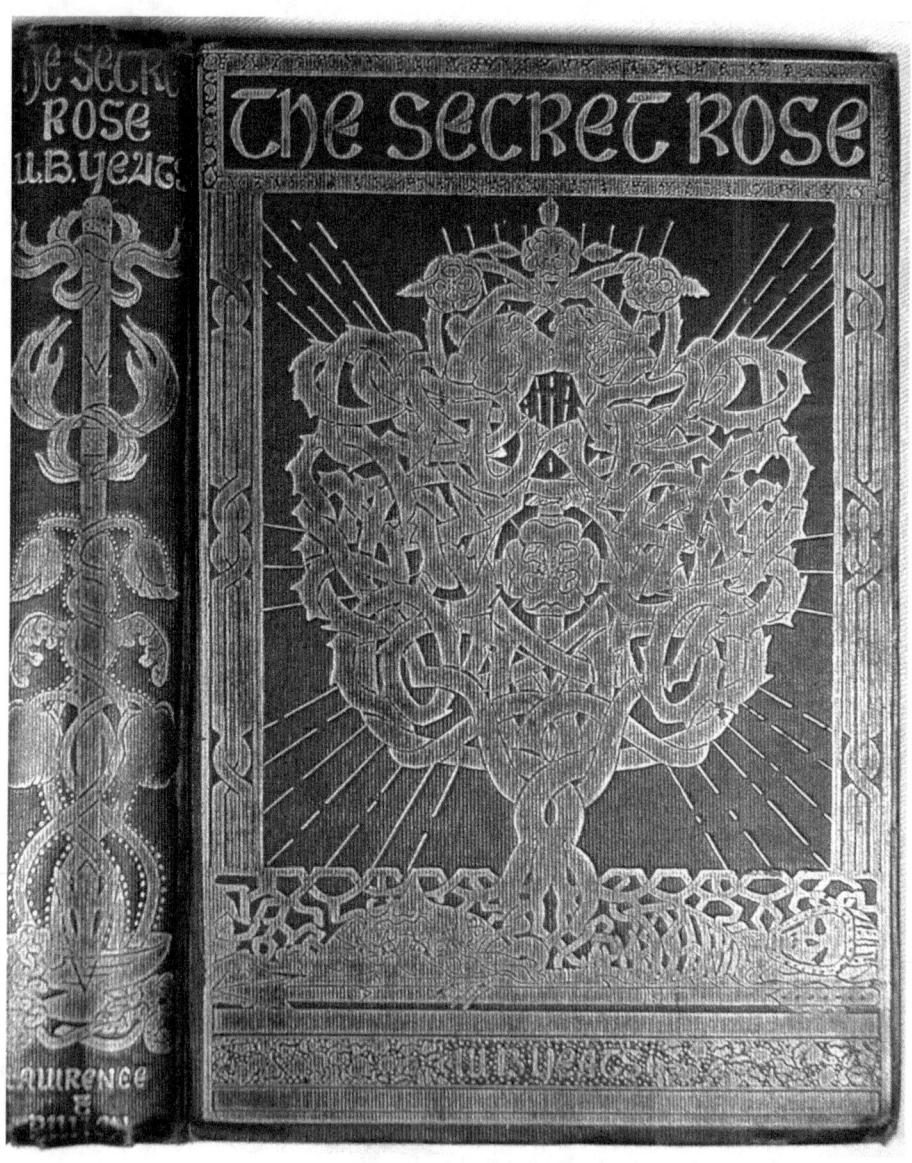

1.3 Althea Gyles (1868–1949), book cover and spine, W.B. Yeats, *The Secret Rose* (New York and London, 1897)

through his theory of symbol). In short, Foster concludes, '[t]he stories in *The Secret Rose* grew out of the underworld of *The Savoy* as well as the disciplines of supernatural study'.[48]

WBY dedicates his book once again to 'AE', and states that by 'looking into that little, infinite, faltering, eternal flame that one calls one's self', he has created poetry and romance suitable to Celtic Ireland, for 'when one looks into the darkness there is always something there'.[49] This early form of the poet's 'proper dark' ('The Statues' [1938], line 31), signals his recourse not only to indigenous creativity, but also to the darker side of the unconscious that his occult activities will increasingly unleash.[50] When we look beyond the individual stories contained in *The Secret Rose* to its verbal and visual make-up, it becomes apparent that Pre-Raphaelite and Symbolist aesthetics overshadow the Celtic element.

The first publication of *The Secret Rose* was richly illustrated. Althea Gyles's (1868–1949) impressive book cover (Figure 1.3) sets the mood and heralds the legacy of the poet's affiliations: the quality of production and craftsmanship in the blue cloth binding with gold embossing stems from Pre-Raphaelitism, Ricketts and the Arts and Crafts movement; the Kabbalistic symbolism encapsulates the occult practice of meditating on symbols; and the allusion to life and love (the kissing tree figures) growing out of death (the skeleton in the sarcophagus) signals French Symbolism. In WBY's writing, pattern, rhythm and symbol play key roles in conveying the 'Divine Essence' to the reader, just as they do in Gyles's impressive book cover.

Her artistic style descends from the Pre-Raphaelite movement. Gyles was a member of the Order of the Golden Dawn in the mid-1890s, although she and WBY first met in the late 1880s through the Dublin Theosophists.[51] In December 1898, he wrote an article in praise of her work entitled 'A Symbolic Artist and the Coming of Symbolic Art' for *The Dome*. He discussed her 'passion for symbol', and maintained that he saw in her work the beginning of a new manner in the arts:

> Pattern and rhythm are the road to open symbolism, and the arts have already become full of pattern and rhythm. ... pictures with patterns and rhythms of colour, like Mr. Whistler's, and drawings with patterns and rhythms of line, like Mr. Beardsley's in his middle period, interest us extremely.[52]

He also stated that, like several writers, Gyles had been 'touched by a visionary energy' that affected her work in the visual arts. 'Certain French writers, like Villiers de l'Isle Adam, have it,' he continued, 'and I cannot separate art and literature in this, for they have gone through the same change, though in different forms.'[53] Gyles also provided covers for WBY's *The Wind Among the Reeds* (1899) and *Poems* (1901), but after a breakdown in her health in 1901, their collaboration ended.[54]

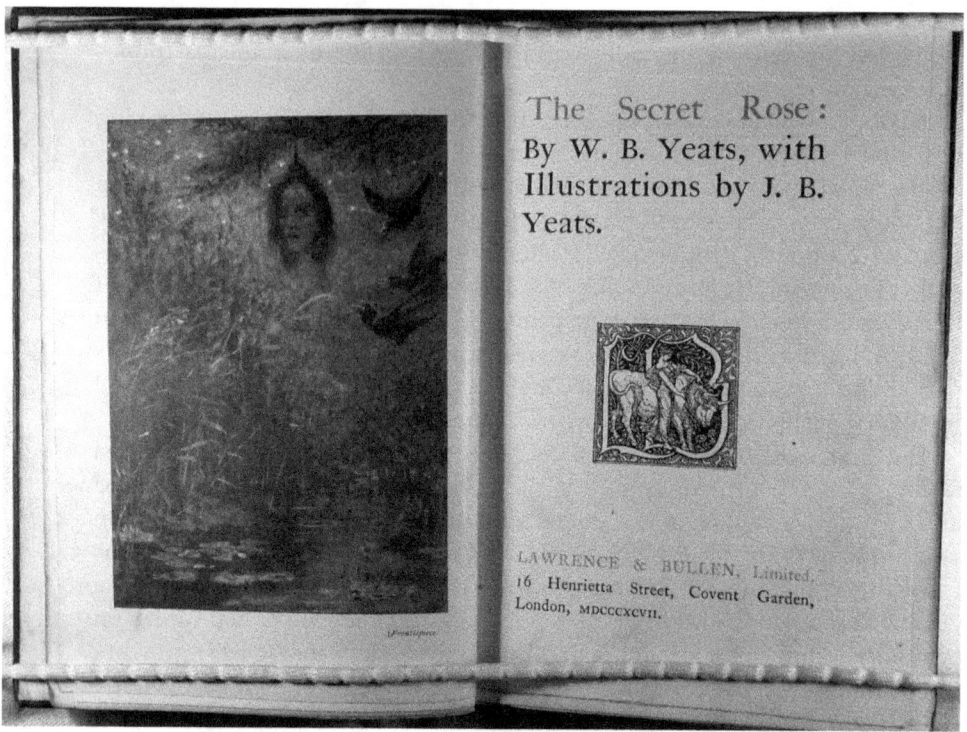

1.4 John Butler Yeats (1839–1922), frontispiece and title page, W.B. Yeats, *The Secret Rose* (New York and London, 1897)

In *The Secret Rose*, John Butler Yeats provides a frontispiece of a severed head suspended above a pool of water, and opposite, on the title page, a medieval-style vignette of a classical female figure with a bull (a juxtaposition of two iconic motifs of French Symbolism and Morris-inspired medievalism) (Figure 1.4).[55] The book's six other monochrome wash illustrations, also by JBY, are more naturalistic than Symbolist, striving to elucidate the narrative and carry the story forward.[56]

In the book, WBY's inter-arts aesthetics also become appropriately consolidated through fusions of word and image, extending beyond immediate visual appeal into a growing speciality of poetic rhythm. Following his dedication to 'AE', he presents his poem 'To the Secret Rose', thus introducing the rose symbol (deriving from Pre-Raphaelitism), which will be a constant presence in his work throughout his lifetime. Then his passions for poetry and Symbolism unfold in prose. For example, the opening section, 'The Binding of the Hair', is set in a druidic Celtic Irish landscape. Queen Dectira is pictured with Aodh as a languorous woman with 'brightness' in her eyes and 'glimmering' on her chest: 'Sighing a long, inexplicable sigh, she bound

the tress about her head and fastened it with a golden pin.'⁵⁷ She is the object of Aodh's gaze, who, 'the fierce light fading in his eyes, ... began to murmur something over to himself, and presently, taking the five-stringed cruit from the ground, half knelt before her, and softly touched the strings'.⁵⁸ But Aodh is abruptly called to battle. The (Celtic Pre-Raphaelite) beauty, Queen Dectira, walks through the forest with an old man to find him, when:

Of a sudden, a sweet, tremulous song came from a bush near them. They hurried towards the spot, and saw a head hanging from the bush by its dark hair; and the head was singing, and this was the song it sung;

Fasten your hair with a golden pin,
 And bind up every wandering tress;
 I bade my heart build these poor rhymes:
It worked at them, day out, day in,
 Building a sorrowful loveliness
 Out of the battles of old times.

You need but lift a pearl-pale hand,
 And bind up your long hair and sigh;
 And all men's hearts must burn and beat;
And candle-like foam on the dim sand,
 And stars climbing the dew-dropping sky,
 Live but to light your passing feet.⁵⁹

This moment of passionate experience (first published in *The Savoy*), exemplifies what WBY so admired in the Symbolist and Pre-Raphaelite temperament in the 1890s.

In the first stanza, the reader (hearer) senses a pattern being threaded through song, principally by rhythm, rhyme and repetition. In the second stanza, pattern becomes consolidated through the repetition of 'And' at the beginning of lines two to five, which draws the reader's eye vertically from 'You' (beginning of line one) to 'Live' (beginning of line six). And the regular a b c, a b c rhyme pattern in both stanzas knits it all together. The poem therefore has an incantatory quality, employing rhythm and refrain to create a trance-like, contemplative moment. The imagery in the poem is Pre-Raphaelite and Symbolist: the allusion to long, wandering tresses of hair evokes a quintessentially Pre-Raphaelite woman, and this is given further authenticity by the 'sorrowful loneliness' experienced in the heart of the poet (an introspection characteristic of the Romantic and Pre-Raphaelite imagination).⁶⁰ However, the colours and hues evoked in the verse are not the rich, warm colours associated with Pre-Raphaelitism, but rather are cold, dim, flickering crepuscular ones such as 'a pearl-pale hand', 'And candle-like foam on the dim sand, / And stars climbing the dew-dropping sky'. This imagery is more often associated with Symbolism and is typical of WBY's 'Celtic Twilight' literature.

Symbolist elements enter the imagination of the reader in a deeper way when he/she recalls the frontispiece by JBY with its transposition from word to image: the open-mouthed, singing head, the stars painted in the (dew-dropping) night sky, and its overall ephemerality. This book, like the 'Kelmscott Chaucer' and those created by the Pre-Raphaelites, strives to become a total artwork. *The Secret Rose* demonstrates, therefore, that in the 1890s WBY endeavoured to synthesize and unify the arts, carrying on French Romantic and Symbolist, and English Pre-Raphaelite and Arts and Crafts ideals. It was not until later, when he became actively involved in his sister's printing press, that 'collaborative resistance' began to play a role in his career.

In 1897, WBY spent the summer at Coole Park, Co. Galway with Lady Gregory and associates, including George Russell (AE), Sir Horace Plunkett and Douglas Hyde. There they conceived the Irish Literary Theatre (not announced until December 1898), which was heralded with a production of WBY's heavily 'Celtic' drama, *The Shadowy Waters*.[61] WBY had now turned towards drama as the art form *par excellence* to achieve his goals. In public debates he praised Wagner's musical drama and the French *avant-garde* (including Mallarmé). He wrote to the Scottish poet William Sharp [Fiona MacLeod]: 'My own theory of poetical or legendary drama is that it should have no realistic, or elaborate, but only a symbolic and decorative setting. A forest, for instance, should be represented by a forest pattern and not by a forest painting.'[62] Later, in 1899, his *The Countess Cathleen* (rather than *The Shadowy Waters*) and Edward Martyn's *The Heather Field* were launched in a new Dublin theatre that was to become the Abbey Theatre Company. The intention was to produce 'poetic drama', for which the actors needed to learn to rhapsodize using the rhythm of the verse, thus departing from realist drama where words, rather than actions, were important.[63] Through WBY and his associates, the cultural agenda of the Irish Revival was now largely channelled through the theatre, thus relegating any use of the visual arts to symbolic and decorative theatre design, such as backdrops and costumes. The lessons he had learned from the visual arts were unified in his drama, as well as in his prose and poetry, although his approach to theatre and costume design was to change over the years.[64]

Fintan Cullen and Roy Foster have observed that 'Irish talent was exported to London in the nineteenth century; by the turn of the twentieth, it was being imported back, with interest, to an Ireland undergoing political radicalization and cultural renaissance'.[65] The artistic experiences of the London *émigrés* were to have a profound impact on the arts in Ireland when they returned. Many scholars have discussed WBY's literary achievements, and writers such as Loizeaux have rightly emphasized the legacy of his London experiences. Yet surprisingly few have dwelt on inter-arts relationships in

his wider artistic circle, and their impact on the emergence of Modernism in Ireland.

At the turn of the century several important events motivated the Yeats family to focus on Ireland and the arts. In 1901, challenging the hegemony of 'academic' art promoted by the RHA, Sarah Purser set about organizing the famous exhibition of paintings by Nathaniel Hone (1831–1917) and JBY, which effectively launched the latter's career as a portraitist at the age of 62.[66] News of the exhibition's success travelled as far as America, and caught the imagination of the successful American lawyer John Quinn (1870–1924). After travelling to Dublin in 1902, Quinn accelerated the impetus and offered financial help to the Yeats sisters and their father. In particular, he helped to fund an exhibition of JBY's portraits, and set up an annual grant for the Irish National Dramatic Society.[67] In August that year, he also attended Jack Yeats's solo exhibition, 'Sketches of Life in the West of Ireland', held at the Well's Central Hall, Westmoreland Street, Dublin, and purchased nine pictures. In 1903, he was instrumental in WBY's lecture tour of America, and in 1904 secured for Jack Yeats exhibition space at Clausen's Gallery, Fifth Avenue, New York, which showed 70 works drawn in Ireland and England – Jack's largest hang to date. For the next 40 years, Quinn made regular visits to the Yeats family, and at different times each member travelled to see him in New York (JBY lived there from 1907 onwards). What is more, Quinn maintained regular correspondence with each of them, which provides valuable information about family relationships and financial matters.[68] But the strongest driving force behind the literati's renewed focus on Ireland was the burgeoning Cultural Revival, including the birth of the Dun Emer, and later Cuala, Industries. WBY, his sisters and Jack were at the centre of this landmark in Irish history, and the different roles played by each member of the family clearly reveal their independent attitudes towards the ideologies of word and image in Irish culture.

However, if we are to take seriously W.J.T. Mitchell's contention, cited in my introduction, that the text–image relation is 'a social and historical one, characterized by all the complexities and conflicts that plague the relations of individuals, groups, nations, classes, genders, and cultures',[69] then it is prudent to look closely at the instigator of the Dun Emer Industries, Evelyn Gleeson, before analysing the contributions of the Yeats family. An English-born woman of Irish descent, her writings generally, both private and public, reveal areas of conflict that are hidden in most histories of the businesses. They also provide insight into the important role of the decorative arts and crafts in the Irish Cultural Revival, and the emerging role of women therein.[70] Her essays, letters and scrapbooks reveal not only a hidden history of a remarkable entrepreneur, but also the complicity between her vision for an Irish Arts and Crafts revival and WBY's vision for a *fraternité des arts* tradition.

Notes

1. W.B. Yeats, 'Art and Ideas', in *E&I*, p. 346.

2. John Everett Millais, Dante Gabriel Rossetti and William Holman Hunt founded the Pre-Raphaelite Brotherhood in 1848. Ellis, poet and illustrator, became a frequent visitor to the Yeats household and was to have a great influence on WBY, particularly through their mutual appreciation of William Blake. Together they produced a three-volume edition, *The Works of William Blake, Poetic, Symbolic, and Critical* (London, 1893). JBY studied at Heatherley's, the Slade and the Royal Academy Schools (Thomas Bodkin, 'John Butler Yeats', in *The Dublin Magazine* [January 1924]: 481).

3. Elizabeth K. Helsinger has argued that the repetition of linear design in Rossetti's pictures, his use of elaborate frames and his attendance to the larger scheme of a patron's room or collection, also work towards this 'embodiment' ('Rossetti and the Art of the Book', in Catherine J. Golden [ed.], *Book Illustrated: Text, Image, and Culture 1770–1930* [Delaware, 2000], pp. 147–93).

4. A comparison of the aims of the interrelated movements of Romanticism, Symbolism and Pre-Raphaelitism adds historical credence to WBY's *fraternité des arts* tradition, and confirms the importance of the Symbolist movement during the poet's early career.

5. David Scott, 'Pictorialist Poetics: The Nineteenth-century French Re-reading of "ut pictura poesis"', *Word & Image*, 4/1 (January–March 1988): 364–71, esp. 368–70. See also Scott's 'The Problem of Illustratability: The Case of *Sonnets et eaux-fortes*', *Word & Image*, 6/3 (July–September 1990): 241–5.

6. Charles Baudelaire, 'Salon de 1846', *Oeuvres Complètes ii.* (Paris, 1976), p. 418.

7. Scott, 'Pictorialist Poetics', p. 364.

8. W.J.T. Mitchell, 'Word and Image', in Robert S. Nelson and Richard Shiff (eds), *Critical Terms for Art History* (Chicago and London, 1996), p. 56.

9. Scott, 'Pictorialist Poetics', p. 370.

10. John B. Yeats, *Pippa Passes* (1870–72), gouache on paper, 48 × 34cm. Coll. NGI.

11. Robert Browning, *Pippa Passes* (1841), in Robert Browning, *Pippa Passes, King Victor and King Charles, The Return of the Druses, A Soul's Tragedy* (London, 1889), pp. 1–79.

12. For a feminist reading of Pre-Raphaelite paintings of women, see Lynne Pearce, *Woman/Image/Text: Readings in Pre-Raphaelite Art and Literature* (Hemel Hempstead, 1991), pp. 1–30.

13. William M. Murphy, *Prodigal Father: The Life of John Butler Yeats (1839–1922)* (Ithaca and London, 1978), p. 154. For other accounts of JBY's life and work, see Fintan Cullen and William M. Murphy, *The Drawings of John Butler Yeats (1839–1922)* (Albany, NY, 1987), and Janis Londraville (ed.), *Prodigal Father Revisited: Artists and Writers in the World of John Butler Yeats* (Cornwall, 2003).

14. W.B. Yeats, 'The Song of the Happy Shepherd', in *VP*, p. 64, line 43. R.F. Foster, *W.B. Yeats: A Life, Vol. I: The Apprentice Mage, 1865–1914* (Oxford, 1997), p. 36. It is possible that JBY's painting style and tutelage also influenced WBY's move away from fine art. 'I had come to think the philosophy of his fellow-artists and himself a misunderstanding created by Victorian science,' wrote WBY, '… In my heart I thought that only beautiful things should be painted, and that only ancient things and the stuff of dreams were beautiful. … I did not care for mere reality and believed that creation should be deliberate, and yet I could only imitate my father. I could not compose anything but a portrait and even to-day I constantly see people as a portrait-painter, posing them in the mind's eye before such-and-such a background' (*Au*, pp. 82–3).

15. W.B. Yeats, *The Collected Poems of W.B. Yeats* (New York, 1933).

16. As early as c. 1881, JBY gave Gilchrist's *Life of Blake* to WBY (Donald James Gordon [ed.], *W.B. Yeats: Images of a Poet* [Westport, CT, 1979], p. 92).

17. W.B. Yeats, *A Vision* (London, 1925); 'Sailing to Byzantium', *VP*, pp. 407–8; 'Lapis Lazuli', *VP*, p. 565.

18. T.R. Henn, *The Lonely Tower: Studies in the Poetry of W.B. Yeats* (London, 1965), pp. 238–71; Frank Kermode, *Romantic Image* (London, 2002); Giorgio Melchiori, *The Whole Mystery of Art: Pattern into Poetry in the Work of W.B. Yeats* (London, 1960); Elizabeth Bergmann Loizeaux, *Yeats and the Visual Arts* (New Brunswick and London, 1986); Edna Longley, *The Living Stream: Literature and Revisionism in Ireland* (Newcastle Upon Tyne, 1994), pp. 227–51.

19. Loizeaux, *Yeats and the Visual Arts*, p. 2.
20. *Au*, pp. 113–95.
21. In 1895, Elizabeth Yeats published *Brushwork*, the first of four books demonstrating this painting technique (Hilary Pyle, *Yeats: Portrait of an Artistic Family* [Dublin and London, 1997], pp. 36–7).
22. For a full appraisal of Jack Yeats's work as a black-and-white artist at this time, see Hilary Pyle, *The Different Worlds of Jack B. Yeats: His Cartoons and Illustrations* (Dublin, 1994), pp. 57–129. Bruce Arnold records that (like his brother William), Jack Yeats did not value his formal art education, and was relieved when he moved from the South Kensington School of Art to the local Chiswick School of Art in 1888 (*Jack Yeats* [New Haven and London, 1998], p. 36).
23. 'A Legend', *The Vegetarian* (22 December 1888); W.B. Yeats, *Irish Fairy Tales* (London, 1892). For analysis, see Pyle, *Different Worlds*, pp. 60–61, p. 179, and Hilary Pyle, '"Men of Destiny" – Jack B. and W.B. Yeats: The Background and the Symbols', *Studies* (Summer/Autumn 1977): 188–213.
24. WBY to Katherine Tynan, 25 June 1887, in W.B. Yeats, *The Collected Letters of W.B. Yeats*, gen. ed. John Kelly, 4 volumes (Oxford, 1986–2005), vol. 1, p. 23. See also *Au*, pp. 139–40.
25. In the 1840s and 1850s, John Ruskin sought to bring nobility to both handcrafts and their producers. For a summary of both Ruskin's and Morris's influences on Irish handcrafts, see Paul Larmour, *The Arts and Crafts Movement in Ireland* (Belfast, 1992), pp. 1–9.
26. Quoted in Loizeaux, *Yeats and the Visual Arts*, p. 58.
27. For a full colour illustration, see Linda Parry, *Textiles of the Arts and Crafts Movement* (London, 2005), Plate 81.
28. Kelmscott Press was established in 1890, Charles Ricketts's Vale Press in 1896, Thomas Cobden-Sanderson's Doves Press in 1900 and Elizabeth Yeats's Dun Emer Press in 1902 (renamed Cuala Press in 1908).
29. For a discussion, see Edward Hodnett, 'The Kelmscott Burne-Jones', in *Image and Text: Studies in the Illustration of English Literature* (London, 1982), pp. 197–218. In 1905, WBY was presented with a copy of the 'Kelmscott Chaucer' by his friends for his 40th birthday.
30. WBY to Charles Ricketts, 5 November [1922], *The Letters of W.B. Yeats*, ed. Allan Wade (London, 1954), p. 691. See Joan Coldwell, '"Images That Yet Fresh Images Beget": A Note on Book Covers', in Robin Skelton and Ann Saddlemyer (eds), *The World of W.B. Yeats: Essays in Perspective* (Dublin, 1965), pp. 152–7. In 2006, an exhibition opened at the National Library of Ireland on 'The Life and Works of W.B. Yeats' which demonstrated the richness of these productions.
31. See Loizeaux, *Yeats and the Visual Arts*, p. 24.
32. In the 1896 volume of *The Pageant*, for example, Verlaine published a poem after Rossetti's *Monna Rosa* (1867), Collection: Ashmolean Museum, Oxford. The inter-arts magazine, *The Dome*, was published by the Unicorn Press in London. WBY was a frequent contributor from 1897 to 1900. Eight numbers of *The Savoy* were published, all in 1896. For a discussion of *The Dome*, the 'Little Magazine' and other periodicals, see Joan Coldwell, '"The Art of Happy Desire": Yeats and the Little Magazine', in Skelton and Saddlemyer (eds), *The World of W.B. Yeats*, pp. 40–53.
33. Associations grew through his membership of the Rhymers' Club, which WBY set up with Ernest Rhys. They met in a London pub called The Cheshire Cheese, and other members included Lionel Johnson, Ernest Dowson, Arthur Symons and John Davidson. Symons was author of *The Symbolist Movement in Literature* (London, 1899).
34. *The Savoy*, 1 (January 1896): 83, 135–8; *The Savoy*, 2 (April 1896): 56–94.
35. Foster, *Yeats, Vol. I*, p. 157. *The Yellow Book* magazine was published from April 1894 to May 1897. It was an *avant-garde* venture promoting art and literature in equal measure.
36. Foster, *Yeats, Vol. I*, p. 159.
37. John Dixon Hunt, *The Pre-Raphaelite Imagination, 1848–1900* (London, 1968), p. 128. See also Kermode, 'Arthur Symons', in *Romantic Image*, pp. 128–40.
38. The phrase 'collaborative resistance' has been used by David Peters Corbett to discuss the conflicting roles and agendas of author, illustrator and publisher in the production of an illustrated book. In his discussion of Charles Ricketts's illustrations for Oscar Wilde, Peters Corbett has noted how in late nineteenth-century London, market or ethical demands on writers, painters

and illustrators encouraged unity of (Pre-Raphaelite and Arts and Crafts) aesthetics, but that over time, artists were forced to assert their individuality and artistic uniqueness in order to succeed ('"Collaborative Resistance": Charles Ricketts as Illustrator of Oscar Wilde', *Word & Image*, 10/1 [January–March 1994]: 22–37).

39. [Michael Field], *Works and Days: From the Journal of Michael Field*, eds T. and D.C. Sturge Moore (London, 1933), p. 135. 'Michael Field' was the pseudonym used by Katherine Bradley and Edith Cooper. The comment was made in a discussion about the richness of French words in comparison to English words.

40. *E&I*, p. 355.

41. *E&I*, pp. 146–52; pp. 153–64. Edna Longley, 'No More Poems About Painting?', in her *The Living Stream* (Newcastle Upon Tyne, 1994), pp. 227–51.

42. 'Wagner's dramas, Keats' odes, Blake's pictures and poems, Calvert's pictures, Rossetti's pictures, Villiers de l'Isle-Adam's plays, and the black-and-white art of Mr. Beardsley and Mr. Ricketts, and the lithographs of Mr. Shannon, and the pictures of Mr. Whistler, and the plays of M. Maeterlinck, and the poetry of Verlaine, in our own day' (*E&I*, p. 149).

43. *E&I*, p. 157.

44. Loizeaux discusses WBY's 'The Island of Statues' (1885) in comparison to Turner's *The Golden Bough* (1834) (Collection: Tate Britain), WBY's 'The Wanderings of Oisin' (1889) in relation to William Morris's tapestries, and exemplifies WBY's use of symbolic detail in *The Wind Among the Reeds* (1899) (*Yeats and the Visual Arts*, pp. 53–68).

45. Loizeaux, *Yeats and the Visual Arts*, p. 63.

46. These ideas lead us back to the space/time dichotomy of Gotthold Ephraim Lessing's *Laocoon* (1766). Lessing famously expressed his reservations about the Horatian *ut pictura poesis* ideal based on the premise that poetry is an art of time, and painting is an art of space. Scott elucidates how the Romantic's emphasis on the imagination bridges Lessing's space/time division (*Pictorialist Poetics: Poetry and the Visual Arts in Nineteenth-Century France* [Cambridge, 1988], p. 11). For W.J.T. Mitchell's critique of Lessing, see his *Iconology: Image, Text, Ideology* (Chicago and London, 1986), pp. 95–115.

47. W.B. Yeats, 'Dedication to AE', *The Secret Rose. With Illustrations by J.B. Yeats* (New York and London, 1897), p. vii.

48. Foster, *Yeats, Vol. I*, p. 178. WBY published 'William Blake and his Illustrations to the *Divine Comedy* I. His Opinions Upon Art' in *The Savoy* (July 1896): 41–57, and 'William Blake and his Illustrations to the *Divine Comedy* II. His Opinions on Dante' in *The Savoy* (August 1896): 25–41.

49. W.B. Yeats, *The Secret Rose*, p. vii.

50. Sinéad Garrigan Mattar, *Primitivism, Science and the Irish Revival* (Oxford, 2004), has discussed this aspect of WBY's career in relation to 'The Statues' and in terms of the importance of comparative literature to the poet.

51. See Gordon (ed.), *W.B. Yeats: Images of a Poet*, pp. 98–101. Gyles's papers are held in the University of Reading.

52. W.B. Yeats, 'A Symbolic Artist and the Coming of Symbolic Art', *The Dome*, 1/3 (December 1898): 233–4.

53. W.B. Yeats, 'A Symbolic Artist and the Coming of Symbolic Art': 234.

54. W.B. Yeats, *Poems* (London, 1901). An earlier book cover for his *Poems* was produced by the artist H.G. Fell; W.B. Yeats, *Poems* (London, 1895). W.B. Yeats, *The Wind Among the Reeds* (London, 1899).

55. The severed head encompasses at once Christian iconography and mythological history painting. It underwent a metamorphosis into a new, mysterious icon in Symbolist works such as paintings of Orpheus by Gustave Moreau and Odilon Redon, and in Beardsley's illustration of John the Baptist's severed head for Oscar Wilde's *Salomé* (1894).

56. JBY's other illustrations for *The Secret Rose* comprise 'Crucifixion of the Outcast', 'Out of the Rose', 'The Curse of the Fires and of the Shadows', 'The Heart of the Spring', 'The Twisting of the Rope and Hanrahan the Red', and 'The Rose of the Shadow'. Hilary Pyle suggests that Jack Yeats's monochrome watercolour wash, *Red Hanrahan's Vision* (c. 1896–97) may have been intended as an illustration for the book (Pyle, *Different Worlds*, pp. 179–80).

57. W.B. Yeats, *The Secret Rose*, p. 4.
58. W.B. Yeats, *The Secret Rose*, p. 4.
59. W.B. Yeats, *The Secret Rose*, p. 9.
60. WBY cites Villiers de l'Isle-Adam at the opening of his book: 'As for living, our servants will do that for us.'
61. WBY's aims for Irish literature were later codified in his essay 'The Celtic Element in Literature' (1902): 'The reaction against the rationalism of the eighteenth century has mingled with a reaction against the materialism of the nineteenth century, and the symbolical movement, which has come to perfection in Germany, in England in the Pre-Raphaelites, in France in Villiers de l'Isle-Adam, and Mallarmé, and in Belgium in Maeterlinck, and has stirred the imagination of Ibsen and D'Annunzio, is certainly the only movement that is saying new things' (*E&I*, p. 187).
62. WBY to Fiona MacLeod [early January 1897?], in Wade (ed.), *The Letters of W.B. Yeats*, p. 280.
63. Nevertheless, as Foster has pointed out, 'his message was the old one: local inspiration and national culture produced pure art' (*Yeats, Vol. I*, p. 208; p. 199).
64. Loizeaux has persuasively argued that later in WBY's career, when he was inspired by Noh drama, his idea of 'drama as picture' evolved into a 'drama of sculpture' (*Yeats and the Visual Arts*, pp. 88–116).
65. Fintan Cullen and R.F. Foster, *Conquering England: Ireland in Victorian England* (London, 2005), p. 10. In the late nineteenth century, the Yeats family formed part of a group of very gifted Irish literary and artistic *émigrés* in London. One such group was the Irish Literary Society, formed by WBY, D.J. O'Donoghue, T.W. Rolleston and John Todhunter in 1891. Cullen and Foster's exhibition called into question narratives in Irish history and literature pertaining to colonial and post-colonial Ireland, Cullen and Foster pointing out that '[t]he two countries were engaged in a relationship that was quarrelsome, contentious, and in many ways inter-dependent. Exploitative as the connection between the countries often was, it also provided a wider arena for certain ambitions, in literature, politics and the arts' (p. 10).
66. In his essay, 'Fifty Years of Irish Painting, 1900–1950', Thomas MacGreevy wrote that the exhibition was 'the inevitable point of departure of the modern Irish school of painting' (*Capuchin Annual* [Dublin, 1949]: 497). Brian Kennedy claims that this exhibition was 'a seminal event in the advance of Modernism in Ireland' because it inspired Hugh Lane's commitment to Irish art (*Irish Art and Modernism* [Belfast, 1991], pp. 6–7).
67. Foster, *Yeats, Vol. I*, p. 273.
68. NYPL, John Quinn Memorial Collection, 1900–1924; NYPL, Jeanne R. Foster–William M. Murphy Collection.
69. Mitchell, *Iconology*, p. 157.
70. Evelyn Gleeson Papers (TCD, MS 10676).

The Dun Emer and Cuala Industries During the Irish Cultural Revival

> I was at that time very intimate with the Yeats family and full of sympathy with the girls, they were very anxious to go back to Ireland but could not, because of giving up their London employment and seeing nothing in prospect over here. We talked about Irish arts and crafts in which we were all interested – I had to go and leave my friends because London air was killing me. I thought how delightful to start a group of workers in the arts and keep my friends with me.
>
> Evelyn Gleeson, 1924[1]

The Irish Literary Society in London, of which Gleeson was a member, was a melting pot for literature, politics and the decorative arts, including embroidery, tapestry, fine printing and theatre design, which, Nicola Gordon Bowe has argued, functioned as powerfully as literature in moving towards the aims of the Irish Cultural Revival.[2] Gleeson's achievements in this field are only one example. Between 1890 and 1892 she studied first at the Atelier Ludovici, and later at South Kensington under Alexander Miller. She also became a member of the Gaelic League in London, and was a suffragette, affiliations which demonstrate her commitment to the role of the decorative arts in both cultural nationalism and the emancipation of women.[3] After the turn of the century, when Dublin had 'become the focus for Irish cultural energy',[4] Gleeson collaborated with the Yeats sisters to found the Dun Emer Industries, an Irish craft centre situated in Dundrum, Co. Dublin. In 1903, she noted: 'coming back to Ireland after some years one returns with a fresh eye to which everything appears with startling clearness', and she praised the work of the Gaelic League, observing that 'wherever a branch is established the young men are no longer listless and intemperate, the young women do not go to America'.[5]

Fuelled by a passion to create employment for young Irish girls, and to revive and disseminate native Irish goods, the Industries demonstrated that the Irish Arts and Crafts movement was 'a distinct visual counterpart to

the better known literary Celtic Revival'.[6] In the context of word and image interactions, Gleeson's textiles, stemming from Pre-Raphaelitism and the Arts and Crafts movement, are traditionally categorized as 'visual'. However, they also appropriate aspects of contemporary literary arts by aspiring towards the same goals in that they move beyond their function of adorning a home to become subtle missionaries of the deeper ideologies of Pre-Raphaelitism and the Arts and Crafts socialist ideals.

In existing histories of the Dun Emer and Cuala Industries, the heritage of the English Arts and Crafts movement is widely acknowledged, and much attention is paid to the roles played by the Yeats sisters to the exclusion of Gleeson,[7] probably because WBY acted as editor and, at times, provided financial security for the Industries.[8] This 'sin of omission' has overshadowed Gleeson's important feminist and nationalist influences, and as a result, questions of both gender and inter-arts relationships have not been fully addressed.[9] In all likelihood, the omission is also related directly to the friction between the women and the eventual separation of Gleeson's business interests from those of the Yeats family.[10] Indeed, hints were made as early as 1909 that the truth had been suppressed when one of the workers in Dun Emer, Nora Fitzpatrick, wrote to the *Daily Sketch*: 'Miss Gleeson has given her time, money, and great artistic abilities to this work and we – the Misses Yeatses, myself, and others who have worked for her – would like those who happen to be interested in this undertaking to understand the truth about it.'[11]

Evelyn Gleeson's Contribution to the Decorative Arts in Ireland

When Gleeson and the Yeats sisters were making plans to return to Ireland, Dr Augustine Henry offered financial backing, and Gleeson conceived a business enterprise that would suit all their needs admirably. In 1902 she found premises in Dundrum on the outskirts of Dublin, and there 'Dun Emer Industries' was born. The name of the building was changed from 'Runnymede' to 'Dun Emer', named after the legendary Lady Emer, wife of Cúchulainn, who was famed for her skill in needlework. The Industries encompassed weaving, embroidery and, later, printing. All employees were local girls, and arrangements were soon made for the Yeats sisters to return from London to assist. Lily supervised the production of embroidery, and on the advice of Emery Walker, Elizabeth undertook a course at the Women's Printing Association in London in 1903 in order to set up a printing press on her return. Unfortunately, however, the financial and working relationships within the Industries were far from amiable, and the women's collaboration lasted only until 1908. Gleeson continued weaving independently under the name 'The Dun Emer Guild', and the Yeats sisters created 'The Cuala Industries' in Churchtown, Co. Dublin.

From the beginning, the Dun Emer and Cuala enterprises represented an interesting conflation of the ideals and aesthetics of the English Arts and Crafts movement with those of the Irish Cultural Revival. The first Dun Emer Industries prospectus (1903–1904) names William Morris twice in relation to embroidery and tapestry, and Gleeson also pays tribute to his influence:

I grew up in an atmosphere charged with interest in industrial effort for
the benefit of Ireland. I went to London to study art and among my friends
there, met some who had been disciples of William Morris in the Arts and
Crafts movement, which was a reaction from the worship of machinery of the
preceding generation and a revolt against the bad taste that went with it.[12]

Gleeson's mission statement for the Dun Emer Industries was also in harmony with the aims of the Gaelic League and the Co-operative movement (both established in 1893), and was aligned with other contemporary 'Revivalist' initiatives, including the National Literary Society and the Abbey Theatre. In a lengthy dissertation entitled 'Fragment of an Essay for the Irish Literary Society, probably 1907', she situates Ireland within a wider European framework, and consolidates her sympathy with Irish Revivalism:

The truth is that Ireland is behind-hand in the matter of artistic industry. Every
other European nation is now engaged in developing its distinctive types – even
the Swiss. But is there any distinctive school of [Irish] art? If so where can one
find it? What are the best books dealing with it and what are its chefs-d'oeuvres?
... By Irish art I mean Gaelic art, – it must either be Gaelic or nothing. All else
is imitation: though we might take suggestions from other lands, especially
perhaps from the old Byzantine style with its Greek and Eastern influences. For
from it, I believe, we originally drew our methods of expression in the days of
the missionary church twelve hundred years ago. I have here some photographs
of Ravenna in which more than one detail is very suggestive of Celtic feeling.
Here then we stand on the verge of an immense question, – the problem whether
it is possible to revive Gaelic ideas in our material surroundings, – our tables,
our chairs, our silver, our inkstand, our various kinds of stuff. Something has
been done in this direction, chiefly owing to the Language Movement. But
infinitely more could be done. And, of those who are Gaelic Leaguers I would
ask, – Cannot one nationalise through the eyes as well as through the ears?[13]

When this essay was written, literature was the principal medium of the Irish Cultural Revival, but Gleeson's question 'Cannot one nationalise through the eyes as well as through the ears?' opens up debates about artistic superiority, and forces the reader/listener to consider the power of the visual in the creation of Irish cultural heritages.[14] Interestingly, she also creates a link between Gaelic art and Byzantine art that would become of increasing importance to WBY in the 1920s. In the Byzantine era, as in certain of WBY's works and in some of the industries carried out at Dun Emer and Cuala, direct links between text and image can be observed. Illustration and the decorative binding of books are obvious examples, while other activities, including the dying and

weaving of tapestry and creative embroidery, can be categorized as 'visual' signifiers of Irish identity, alongside literature and fine art when considered in a socio-historical context.

WBY was active from the 1890s, with Lady Augusta Gregory and Douglas Hyde, in assembling old Irish folk tales, songs and customs, and recording them for posterity. At the same time, the Irish Language movement was recording regional dialects and promoting the use of Irish language in schools. These activities can be compared with the means by which the visual arts and the Irish Arts and Crafts movement sought artistic motifs from Early Christian art, such as the spiral, the pelta and the triscale, to weave and embroider into their wares. Alice Hart's 'Kells Embroidery' began the trend to produce goods inspired by Celtic design in the 1880s, and the Dun Emer and Cuala Industries built upon this idea.[15] Their designs were derived from tangible sources, such as objects seen in the National Museum in Dublin, as well as intangible ones, such as ancient sagas and poems. To illustrate how suggestions for clothing design could be taken from women's adornments in the ancient Celtic world, Gleeson quotes from an old Irish text:

She had a bright comb of silver and gold, and she was washing in a silver basin having four birds on it, and little bright purple stones set in the rim of the basin. A beautiful purple cloak she had, and silver fringes to it and a gold brooch; and she had on her dress of green silk with a long hood, embroidered with red gold, and wonderful clasps of gold and silver on her breasts and on her shoulders.[16]

It is interesting to note that this is an influence in keeping with WBY's literary portrayal of Queen Dectira in *The Secret Rose*, and Gleeson's text clearly suggests that her crafts were consciously modelled on the ancient. But one of the most interesting things about her research is that she consolidates and legitimizes her ideas by gathering evidence that other countries across Europe were also reviving their inherited arts and crafts.[17] This fact adds texture to a discussion of her 'Celticism' beyond Irish borders.[18] In the same essay, Gleeson uses evidence from Italy to explore the potential of using national emblems, stating that in Italy some of these had been taken 'from the quilts on the peasant's bed, some from scenery from nature itself, – ... from libraries ... museums, ... books ... heraldic devices on the banners of ancient families; ... laces and dresses ... the architecture of the churches, – every source is tried'.[19] This suggests that she may have helped conceive many of the Irish emblems with which we are most familiar today.

The Irish Cultural Revival encouraged strategies for recording 'the regional', the Irish Language movement, by maintaining and encouraging local dialects, and Gleeson's Arts and Crafts industries, by gathering local information about methods and natural pigments for dyeing fabric.[20] Gleeson maintained that women from Donegal produced the best vegetable dyes, mostly from native cultivated and wild plants which were treated with simple chemicals. She

quotes from the notes of Mrs Kennedy, a Donegal woman, but adds her own anecdotal evidence: '[a] rose-red is derived from fuchsia blossoms and from the roots of the briar-rose, as I learned in Kerry, and a rich deep black is found in certain deposits in bog drains'.[21] Because there were no definite tones of red or blue among Irish plants, some foreign plants and simple mordants were used, such as indigo and madder.[22] One of the principal ways in which native Irish design developed, therefore, was through the colours found in the natural Irish habitat (the visual equivalent of dialect). Gleeson's niece, Miss Katherine MacCormack, who carried on Dun Emer after Gleeson's death, claimed that '[s]he also originated what has become known as "Irish" colouring, taking from the fields, the trees and mountains which she saw from the windows of Dun Emer; – the blues, purples and greens so characteristic of the Irish countryside, and using the colours in her designs for rugs and tapestries'.[23]

In 'Fragment of an Essay for the Irish Literary Society', Gleeson also links the ideals of her Industries with Irish patriotism by stating that her girls worked best when contributing to a national cause:

The people themselves must be interested in the work, enthusiastic if possible, otherwise the scheme is a failure, not merely financially but educationally. This enthusiasm is aroused by appealing to local patriotism. ... the only true patriotism, the only natural and unselfish enthusiasm for which men of every class will live and die; the inborn love of a man for the hills and streams among which he spent his childhood, and the longing for the speech of his own people. All else is artificial.[24]

Her words echo WBY's belief in drawing on the Irish passion for 'love of Unseen Life and love of country' for the arts in Ireland,[25] and as Roy Foster has pointed out, '[w]orking at Dun Emer became a way-station, almost a rite of passage, for many young women involved in nationalist cultural enterprises: future writers, painters, Sinn Féin activists and Abbey actresses served their time there'.[26] A nationalist ethos in the Industries was also reflected in their participation in the Irish Language movement: girls were taught the Irish language as part of their training at Dun Emer, and Dun Emer clothing was marketed to an Irish language-speaking clientele through newspapers such as *An Claidheamh Soluis* ('The Sword of Light'), edited by Pádraig Pearse from 1903.[27] Figure 2.1 demonstrates this point, where three elaborate and beautifully crafted dresses are illustrated in the nationalist newspaper.

Typically, these garments incorporate elements of ancient Irish design such as a cloth held in place at the shoulder (lower right-hand image), and the incorporation of embroidered Celtic motifs with their 'flowing curves dear to the Celtic scribes' (upper right-hand image). To produce and exhibit goods so authentically Irish was perfectly in tune with the aims of the Irish Cultural Revival. Douglas Hyde and the Gaelic League, Gleeson's cousin, T.P. Gill, of the Department of Agriculture and Technical Instruction, and Horace Plunkett, all promoted The Dun Emer Guild.[28] Soon members of the Gaelic League,

2.1 *An Claidheamh Soluis*
(21 Marta [March] 1914)

including Lord Ashbourne and the Irish patriot Thomas MacDonagh, became clients and wore Dun Emer kilts, thus 'performing' the ideologies they shared with the Industries.[29]

Despite the highly commendable aims of the Industries and the support they received from eminent Irish people, and despite the fact that Gleeson and the Yeats sisters worked tirelessly with little monetary reward, by 1904 there were many difficulties, both financial and personal, at Dun Emer.[30] Eventually, George Russell (AE), acting as mediator, oversaw the separation of the Industries into the 'Dun Emer Guild' and the 'Dun Emer Industries'. Gleeson records that the Yeats sisters carried over a total of £821–7–0½d. to their new business, consisting of pay from 1902 to 1904 of £523–6–6d., stock amounting to £313–0–6½d., minus a repayment to Dr Henry of £15–6–6d.[31] The Guild, whose members were Gleeson, Katherine MacCormack and five workers, produced tapestries and carpets, while the Industries, managed by a committee of shareholders, encompassed embroidery and printing for which Lily and Elizabeth Yeats were responsible. As president of the Industries, Gleeson was the majority shareholder, holding 150 of 159 shares, and Elizabeth Yeats acted as secretary.[32]

A photograph of the embroidery room at Dun Emer (1905) (Figure 2.2) shows a rather dreamy Lily Yeats with her assistants embroidering goods in the Celtic Revival style. In the background hangs a 'Seagull Portière', embroidered by Lily in wool and silk thread on blue poplin from a design by Jack Yeats's wife, Mary Cottenham Yeats (known as 'Cottie').[33] The piece was exhibited in New York in 1905 and purchased by John Quinn, who paid $45 (£9) for it. Quinn was under the impression that it was the work of Lily Yeats, but pointed out in a letter that he was unsure which pieces in the Fair were her work and which were Miss Gleeson's.[34] Above the mantelpiece in the photograph hangs a banner designed and worked by Lily Yeats, which is very much in keeping with her Arts and Crafts movement training and the *fusion des arts* noted in 'The Morris Bed'. It includes an apple blossom pattern

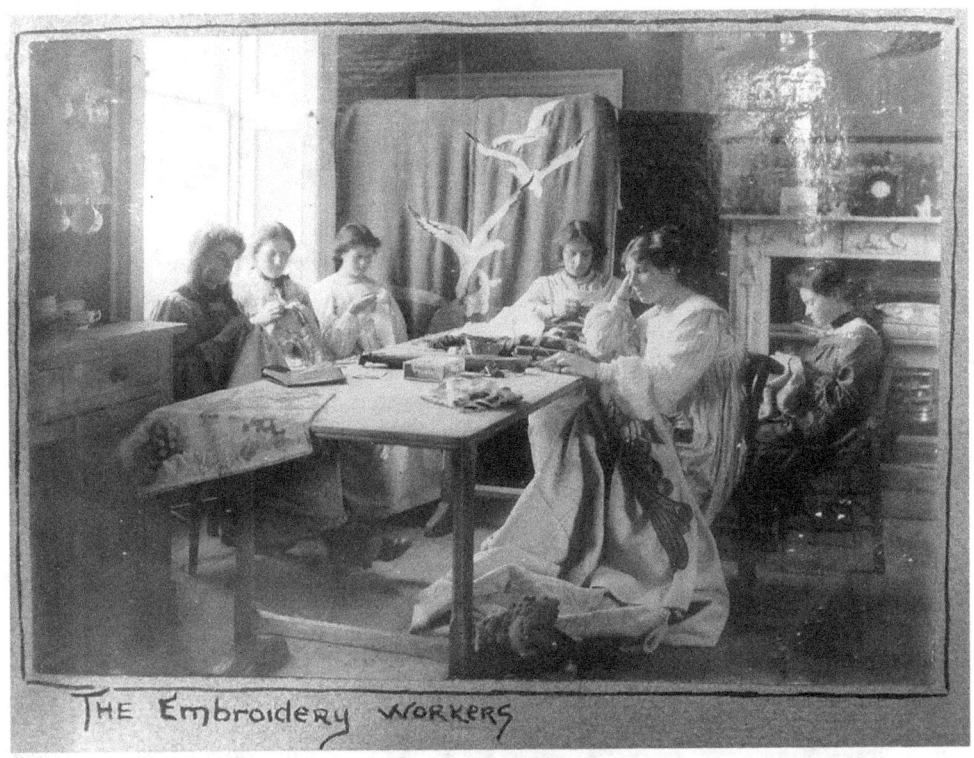

2.2 The Embroidery Room at Dun Emer, Dublin, 1905

entwined with a passage of text from WBY's *The Land of Heart's Desire*: 'By love alone God binds us to himself and to the hearth; And shuts us from the waste beyond His peace.'[35] The textile is as fine an example of the realization of the poet's vision for the arts as 'little children playing about the chimney', and the importance of the quotation to Dun Emer staff is recorded in their scrapbook from 1904 (Figure 2.3).[36]

Other links between WBY's work and the Dun Emer embroidery department are evident in a decorative fan, hand-painted by Elizabeth Yeats in 1905 and inscribed with his poetry, and also in an early costume design for his *The King's Threshold* (produced in 1904) (Figure 2.4).[37] This 1903 photograph of Catía ní Cormac as the 'Youngest Pupil' in the play shows her dressed in the clothes of the Irish peasantry, carrying a mock Irish harp and standing on a Celtic-inspired mat, no doubt woven by the Dun Emer Industries. Behind her can be seen the 'Seagull Portière', also visible in Figure 2.2.[38]

The managerial separation of the Industries in 1904 may have brought temporary relief from the difficult relationship between Gleeson and the Yeats

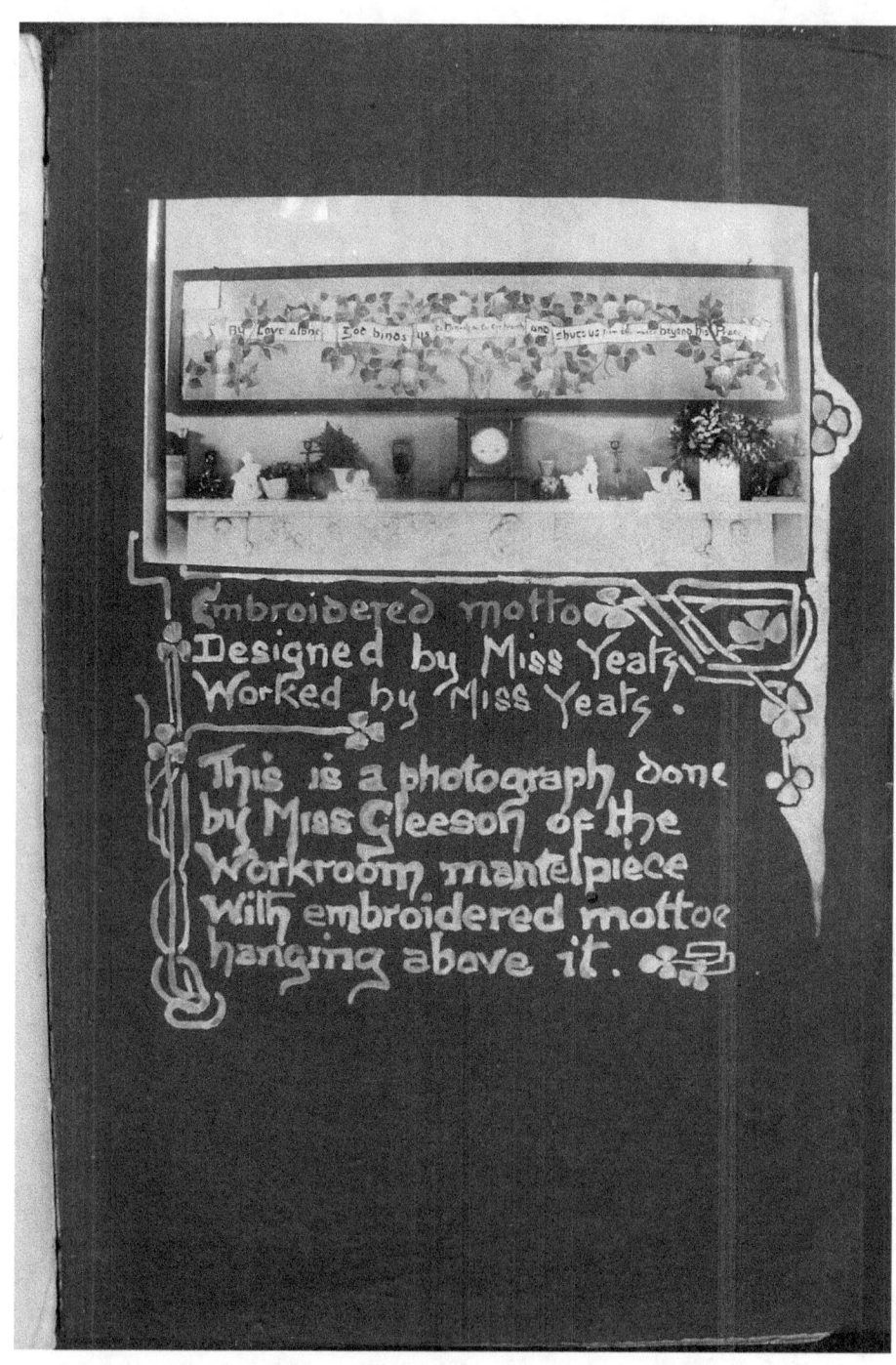

2.3 Embroidered banner by Susan Mary (Lily) Yeats (1866–1948)

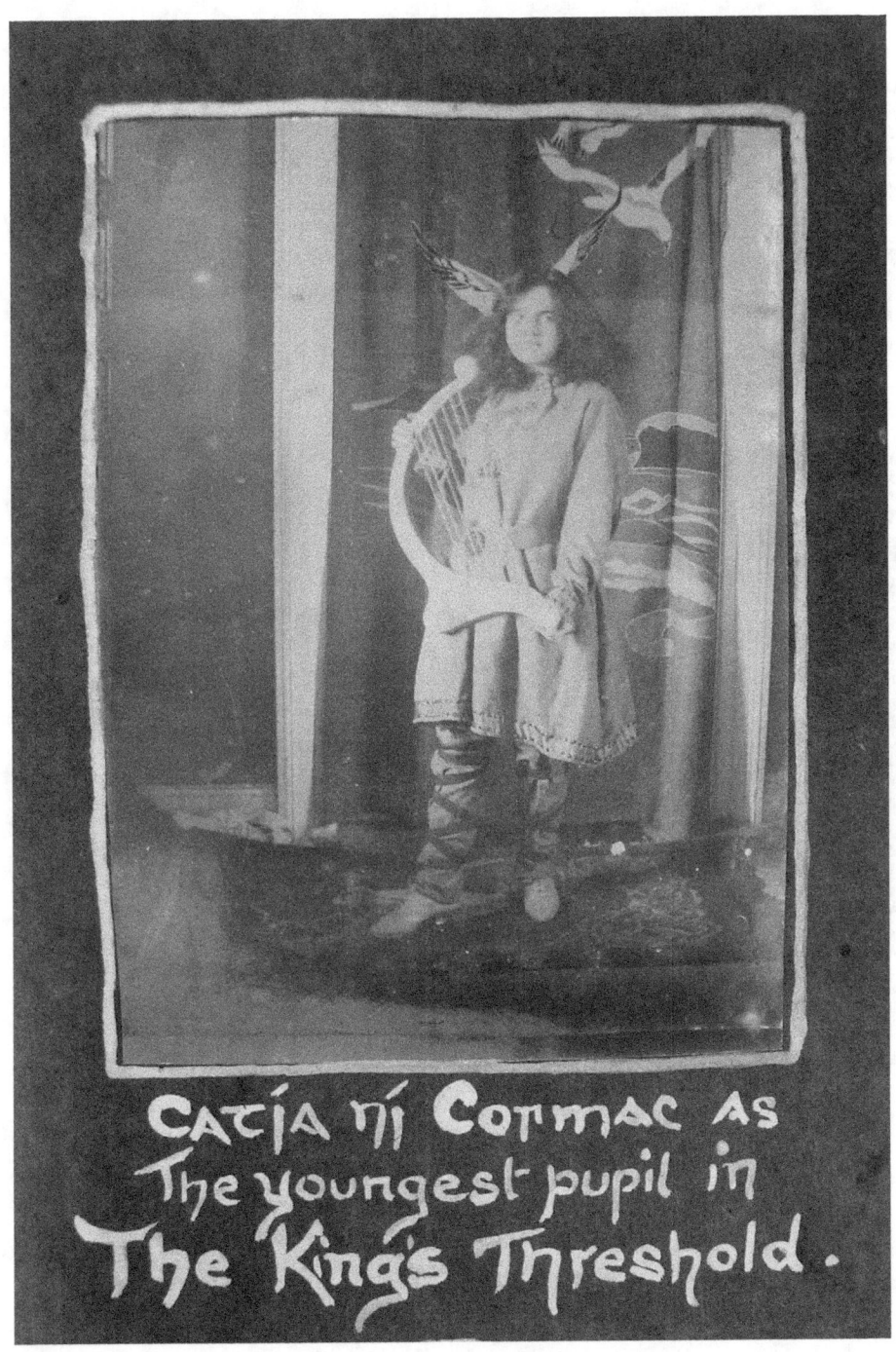

2.4 Catía ní Cormac as the 'Youngest Pupil' in W.B. Yeats's *The King's Threshold* (1903)

2.5 'Yeats, Father of Irish Poet, Brings Message to America', *New York American* (n.d.)

sisters, but the situation between the sisters themselves was also fraught. Elizabeth was prone to outbursts of anger and depression, while Lily's constitution, which was never strong, at times affected her ability to work.[39] In 1908 Lily and Gleeson travelled independently to America to market goods. Lily accompanied her father in December (Figure 2.5) and returned the following June, while Gleeson returned to Ireland in January 1909.[40]

As Figure 2.5 indicates, the Yeatses were clear about the market they were appealing to, thanking the American people for their 'appreciation of [Irish] nationalist cause'. During her time in the United States, Gleeson gave lectures at the local Twentieth Century Club and the Arts and Crafts Society, and marketed her philanthropy towards 'Irish girls' in *The Boston Herald* without one mention of her former colleagues (Figure 2.6).

Then, during the six months after her return, Elizabeth found Gleeson's managerial role in the Industries intolerable, so on the advice of her brother William, and Lady Gregory, she initiated a total separation from Dun Emer. The sisters found cottage premises at Churchtown, Co. Dublin and founded the 'Cuala Industries'.

Gleeson continued to produce tapestries and carpets, selling them in direct competition to the Yeats sisters. Both Industries

BOSTON HERALD—MONDAY, FEBRUARY 8, 1908.

EVELYN GLEESON AIDS THE GIRLS OF IRELAND

Has Founded an Arts and Crafts School Near Dublin and Seeks to Revive Country's Industries.

NOW HERE AND HOPES TO WIN BOSTON INTEREST

"Wherever you go through Ireland you see the same sad story," said Miss Evelyn Gleeson, founder of an arts and crafts school for girls near Dublin. "The old people are left alone while the children go to a foreign country, because, for one thing, they can get no employment in Ireland, and, for another thing, the life there is so dull. The industries that once flourished have been artificially destroyed by legislation, combined with modern commercial competition.

"My own little industrial school was founded for the purpose of finding employment for Irish girls, and at the same time, of finding employment for them in the making of beautiful things, which is in itself an education. Thus we are doing a little toward reviving industries in our own country.

"About 22 girls, from 15 to 20 years old, are now members of the school; many more have applied, but we cannot afford to take them as yet. They pay no admission fees, but on the contrary are, after the first week, paid a small wage, which increases with their skill. Moreover, I have established two co-operative societies, the Dun Emer Guild, and the Dun Emer Industries, to one or the other of which every pupil belongs. At the end of the year, after expenses are paid, each girl is given a share in the profits.

"All of our work is done by hand. We teach weaving, book binding, enamelling of brooches and small trinkets, printing and embroidery. We are very proud of our books; some of them are done on vellum, beautifully illuminated; we do this sort of work for people who have special books that they want printed or bound. The first book we published five years ago, when the school was just started; it was worth $2.75 a copy then, and now it is worth $12.75, the value increasing because we print only comparatively few copies and then break up the type.

"Our chief work is done upon carpets, the patterns of which I myself design in the general style of the old Celtic ornamentation. At present we are at work on a copy of a 16th century Huntington tapestry for the Dublin Museum. The original was loaned to us by the South Kensington Museum. And I find in my morning mail an announcement of the fact that our carpets in the Milan International Exhibition have been awarded a silver medal. That makes us feel rather nice, when we were competing against all Europe.

"Beside these trades the girls are taught drawing, painting, sewing, cooking and the Irish language. So far as possible we use Irish materials in our work. It is wonderful how readily the girls learn to make these lovely articles. They take the deepest interest in their school, which is, by the way, an old-fashioned house in Dundrum, upon the slope of the Dublin mountains, four miles south of the city."

Miss Gleeson, who is now making a visit to Boston, has spoken on her projects before the Twentieth Century Club and the Arts and Crafts Society.

"My idea in coming to this country and telling of my school," said she, "is to interest rich Irish-Americans in the industries carried on by Irish girls, and thus establish a market for their work. I have already done this in New York, and hope by my exhibit in the Arts and Crafts Bureau here, to do in Boston."

HELPER OF IRISH GIRLS

MISS EVELYN GLEESON.

advertised in *Bean na hÉireann* (*The Woman of Ireland*), and often set up their craft stalls in opposition at Arts and Crafts fairs. Dun Emer carpets proved particularly successful, with sales as far-reaching as Canada, New Zealand, South Africa, the United States, Argentina and the West Indies, as well as France, England and Scotland.[41] Gleeson was the driving force behind Dun Emer, and thanks to the legacies of Ruskin and Morris in Ireland and the political agenda of the Gaelic League, her goods were at the cutting edge of Irish socio-political debate, of appeal to audiences sympathetic to the Irish nationalist cause, including those in North America.[42]

From 1909 the Yeats sisters had to make their own managerial decisions, and find fresh ways of relieving their financial difficulties. They named the new Industries 'Cuala' after the Irish place name of the barony. Elizabeth was in charge of the printing press, Lily in charge of the embroidery workshop. Together they acted as guarantors to the bank, and were loyally supported by their brothers.[43] Jack Yeats designed letter-headed paper illustrating their new premises (indeed, his illustrations were to be at the heart of their production until the mid-1920s). WBY had acted as editor for the Dun Emer and Cuala Presses from their foundation in 1903, sometimes assisting financially, and the Presses published limited editions of his writings. His son Michael B. Yeats has indicated that the attitude towards the Industries within the Yeats family was nevertheless always ambivalent:

On the one hand its very existence presented a constant threat of some financial disaster, on the other hand it was an enterprise of such artistic and literary importance that everyone was willing to endure a good deal of family tension and inconvenience in order to preserve it.[44]

Printed goods produced by Cuala combined the 'artistic and literary' talents of the family circle in distinctive ways, and an analysis of word and image relationships within these items builds on our understanding of the roles played by Dun Emer and Cuala in the dissemination of the Irish Cultural Revival. Many of the themes already established, including the marketing of genuinely Irish goods and the use of local materials, are also characteristic, making Mitchell's approach to word, image and ideology very relevant.

Like weaving and embroidery, fine printing should be reconsidered within the traditional hierarchy of the arts, which distinguishes between 'fine' art or literature, and the decorative arts or crafts.[45] As early as the 1880s and 1890s, it had been evolving in Ireland, with book covers by George Coffey and Sir Edward Sullivan (a founder member of the Arts and Crafts Society of Ireland in 1894) being shown in exhibitions of the English Arts and Crafts Society in London.[46] Yet in the first prospectus of the Dun Emer Press, the authors state that 'THOUGH many books are printed in Ireland, book printing as an art has been little practiced here since the eighteenth century. The Dun Emer Press has been founded in the hope of reviving this beautiful craft'.[47]

As we know, Elizabeth Yeats had learnt practical skills in London which enabled her to set up her printing press, but she also sought the advice of Emery Walker regarding book design. The typeface he recommended was Caslon, an eighteenth-century English typeface of Dutch origins that had been popular since its use by the Chiswick Press in 1837. According to the Dun Emer Press prospectus:

> ... [a] good eighteenth century fount of type which is not eccentric in form, or difficult to read has been cast, and the paper has been made of linen rags and without bleaching chemicals, at the Saggart Mill in the county Dublin. The pages are printed at a Hand Press by Miss E.C. Yeats, and simplicity is aimed at in their composition.

The books are characterized by simple typography and wide margins, and are comparable to Doves Press books in their modesty of illustration.[48] This restraint contrasts with books produced by the English Kelmscott Press, which are densely covered with type and ornament (see Figure 1.2), an extension of Morris's embroidery and tapestry work, incorporating similar designs and sharing an absence of blank space. In Dun Emer and Cuala production, however, there is a marked difference between their textiles and books. While embroidery, tapestry and carpet design may contain text, image and elaborate decoration (Figures 2.2 and 2.3), the books were very modest indeed.

It can be argued that in Morris's books, design work at times overpowers the text, resulting in a distortion of the original message. Take Burne-Jones's illustrations for the 'Kelmscott Chaucer' (Figure 1.2) as an example.[49] On the title page, words almost fade into the background decoration, and some letters extend into interlaced twines, metamorphosing into leaf pattern. The conflation of text and image on the page provokes a sensorial reading experience, involving both verbal and visual cognition, which raises the question of whether Irish publications were a reaction to this type of ornamentation, considering it excessive and unnecessary. In 'Art and Ideas', WBY advocated Morris's uniting of 'the arts once more to life by uniting them to use', and the legacy of this combination of text and image is evident in Figure 1.2. Nevertheless, the priority of text over image in Dun Emer and Cuala books indicates that book design occupied a second place for the poet.

Word, Image and Ideology in Dun Emer and Cuala Publications

The first book produced at the Dun Emer Press was WBY's *In the Seven Woods*, published in August 1903. Designed and produced with care, it contains no illustrations. A small publication measuring 210 × 145 mm (8¼ × 5¾ ins), it was

made of Swiftbrook paper from County Dublin. The typography is 14-point with wide margins, and the colophon is printed in red. WBY was pleased, as an inscription inside the copy sent to Quinn shows:

This is the first book of mine that is a pleasure to look at – a
pleasure whether open or shut. W.B. Yeats. March, 1904.[50]

The first use of decoration in a Dun Emer publication was in their second book, George Russell's (AE) *The Nuts of Knowledge* published in December 1903. It contains a circular device designed by the author based on the ancient Irish symbol *An Claidheamh Soluis* ('The Sword of Light'). The limited pictorial decoration in this book would become characteristic of both Dun Emer and Cuala editions, as WBY resisted elaborate illustration for some time.[51] In response to the *fraternité des arts* tradition, WBY advocated mutual support between the arts, but while he wrote admiringly of the imaginative resonance of Shelley's, Blake's and Rossetti's book covers, and collaborated with illustrators Thomas Sturge Moore, Gyles and others, he was still reluctant to include illustration in Dun Emer and Cuala books.[52]

The first book to contain an illustration proper (rather than a device) was *Stories of Red Hanrahan* (completed in 1904, published in 1905) by WBY himself. It includes an illustration by Robert Gregory of the four aces from a pack of cards spread over the four provinces of Ireland, 'The Four Green Fields'. The book was well received by G.K. Chesterton, who thought it a fine example of Irish publishing:

I may call this book in some special sense, or, rather, in some unusually actual sense, a book from Ireland, because it is written by an Irishman and printed by Irish people upon Irish paper. ... I repeat that it gives me as one interested in Ireland and the Irish cause a definite pleasure to feel that this book of Mr Yeats' [sic] short stories is Irish in the gross physical sense, is Irish as English oak is English or French claret is French, that the body of the thing has kinship with its soul, that it is not merely a question of Irish stories, but literally of an Irish book. ... This Dun Emer Press, in which Mr. W.B. Yeats' stories of Hanrahan the Red are published in an altered form, is a very interesting matter in itself, as a specimen of the new possibilities and the new works of Ireland. No one will deny that there has been a considerable stir and bustle of such experiments in that country in current times, and that those experiments have had behind them a certain number at least of the elements which go to make success anywhere – enthusiasm, a clear aim, a clear method, comradeship, and youth.[53]

Another commentator wrote that 'the spirits of poetry, patriotism and true craft have joined hands at Dun Emer'.[54] Critical reception of the Press was working: in the wider arena of the Irish Cultural Revival, Dun Emer and Cuala books encapsulated the Revivalist spirit. However, it is significant that most of them contained very little decoration, and given the importance of the Presses in the dissemination of the Irish *Literary* Revival, the feeling may have been that image perhaps had a lesser role to play.

Several mentors, including Elizabeth's, Emory Walker, came to exert considerable influence on the layout of Cuala books. The frontispiece idea for Synge's *Poems and Translations* (1909), for example, bears witness to a compromise. Once WBY had read the manuscript and expressed interest in publishing it, Walker advised Elizabeth on the layout, and in February 1909 she wrote to Synge enclosing a drawing by Jack Yeats as a possible frontispiece.[55] The frontispiece was never used, however, and an explanation is given in a letter of 16 July 1909 from John Quinn to Elizabeth:

When Jack's drawings are good they are very, very good, but when they are bad, they are like the little girl, they are awful ... The book of poems should have no illustrations. No book of poems should have illustrations, it seems to me, unless they are illustrations as fine as those of Rossetti and others made for Tennyson's poems or as fine as Rossetti made for his sister's poems. As a rule I like Jack's drawings tremendously, but this one I don't like at all. The younger of the two tinkers looks like an idiot – has the wild, vacant stare and open mouth of an idiot. It seemed to me very bad. The other tinker is good. If that drawing is published with Synge's book it will hurt the book itself and you will find hostile reviewers referring to the drawing and the idiot boy depicted in it as typical of the poems.[56]

This letter bears witness to the influential roles of editor, author and patron. Overall, however, the presentation of *Poems and Translations* shows an obvious debt to Walker's aesthetics. But WBY's affiliations with Symons and the Aesthetic movement in London in the 1880s and 1890s were also important influences. W.G. Blaikie-Murdoch records his first experience of Cuala books in Symons's home:

It was in a tidy study that I first saw these books. ... the home of Arthur Symons. Indeed, it was Symons himself who originally showed me the Cuala books. In his study the walls were a faint, delicate green; while there was a writing desk, quite possibly from the hand of Chippendale himself, and on the oak mantelpiece stood some little gems by Tanagra sculptors. The whole effect was infinitely quiet and charming ... and here ... we chanced to begin talking of the art of book production. ... The Vale and Kelmscott productions were duly applauded, while I referred enthusiastically to those of Eragny press, conducted by my friend, Lucien Pissarro. And then, going to one of his bookshelves, Symons produced a Cuala volume which delighted me at once, inasmuch as it disclosed qualities foreign, or largely foreign, to the books of those other hand presses aforesaid. That is to say, it was wholly simple, its beauty of a restful and unobtrusive kind, so that the slim, graceful volume seemed to harmonise faultlessly with the room enshrining it.[57]

Years later, Blaikie-Murdoch repeated his praise of Cuala books, this time comparing them favourably with books produced by Morris and Charles Ricketts:

William Morris erred pathetically in seeking to revive the cryptography of pre-Renaissance years. And even when he wrought in his lucid Golden type he

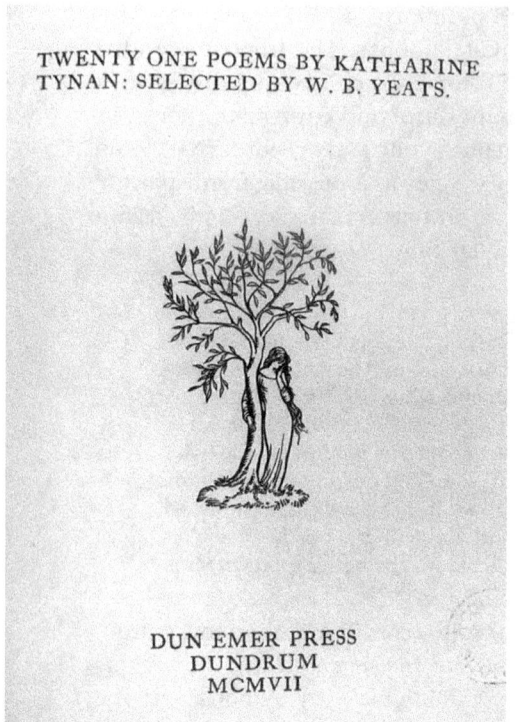

2.7 Elinor Monsell (1871–1954), 'Lady Emer Pressmark', in Katherine Tynan, *Twenty One Poems* (Dublin, 1907)

marred his books by prodigality in ornamentation. If Mr. Charles Ricketts, in the various fonts he devised for the Vale Press, showed himself something of a classicist, he, too, was prone to deal in unduly lavish adornments. ... If an ornament is to be found in the smaller books of the 18th century, commonly it is a vignette on the title page. And possibly with deliberate intent to strengthening Cuala consanguinity with that exquisite period, the decoration in question is the solitary one which Miss Yeats allows.[58]

The solitary illustration which Elizabeth Yeats printed in these early Dun Emer books was the 'Lady Emer Pressmark' (Figure 2.7), showing Lady Emer resting against a tree. Elinor Monsell had cut the pressmark for Katherine Tynan's book, *Twenty One Poems* (1907).

The 'lady' signifies the women managers and employees at Dun Emer, and her Pre-Raphaelite dress, hair and pose indicate the influence of that movement on the young Industries. This book was also the first to include the names of the printing staff in the colophon to acknowledge the work of the women producers, but did not intend to demean the status of the editor. In 1925, the Yeats sisters discarded the vignette of Lady Emer for a new motif of a fairy thorn tree in a rugged (Irish) setting, which was in keeping with the theme of publications currently focusing on folk and fairy tales. As one critic wrote later in a review of Robin Flower's *Love's Bitter Sweet: Translations from the Irish Poets of the Sixteenth and Seventeenth Centuries* (1926): 'There is a little title page by Miss Yeats – a bent thorn reed in silhouette upon a highland brae – which serves well to symbolize the old-time Gaelic literature, a storm-beaten and forgotten growth in a fair land.'[59]

Despite such positive acclaim for Cuala publications, there was continued unrest between members of the Yeats family. WBY found it particularly hard to tolerate Elizabeth Yeats's inability to manage bookkeeping and meet the bills. In August 1906, for example, the Dun Emer Press published *A Book of Saints of Wonders* by Lady Augusta Gregory, but by January 1907 neither she nor WBY had received royalties for their books. WBY wrote to his friend:

The explanation of my new controversy with my sister is this. On hearing from you that she hadn't paid the royalties I wrote to her saying that it was a rather delicate matter, but I would like to know if she was paying her writers as it would render my position as Editor very difficult if she were not. ... I have just dictated a long letter and God knows what will happen now. I hope it's all right, but I haven't got time to go over it very carefully, I know it is civil. I foresee that this controversy is going to enlarge itself in all directions in the usual way and to entirely lose sight of its original origin, but it is difficult to stop once it starts.[60]

The new Cuala Industries tried many initiatives to alleviate debt, without success, but from the beginning, their books were sold by subscription to a specialized market, and were time-consuming and expensive to produce.[61] They realized then that smaller, less expensive, illustrated products could be reproduced more quickly on cheaper paper than on top-quality Swiftbrook paper, and saw the appeal of word and image juxtapositions to the prospective customer. In 1908 the new Cuala Press began publishing a series of hand-lettered poems by WBY with hand-coloured illuminations or decorations which, along with other illustrated goods, proved popular. Figure 2.8, the Cuala Industries Stall in Belfast in 1909, shows the wide range of their goods on offer at this time, including embroidery, tapestry, a painted fan and illustrated poems.

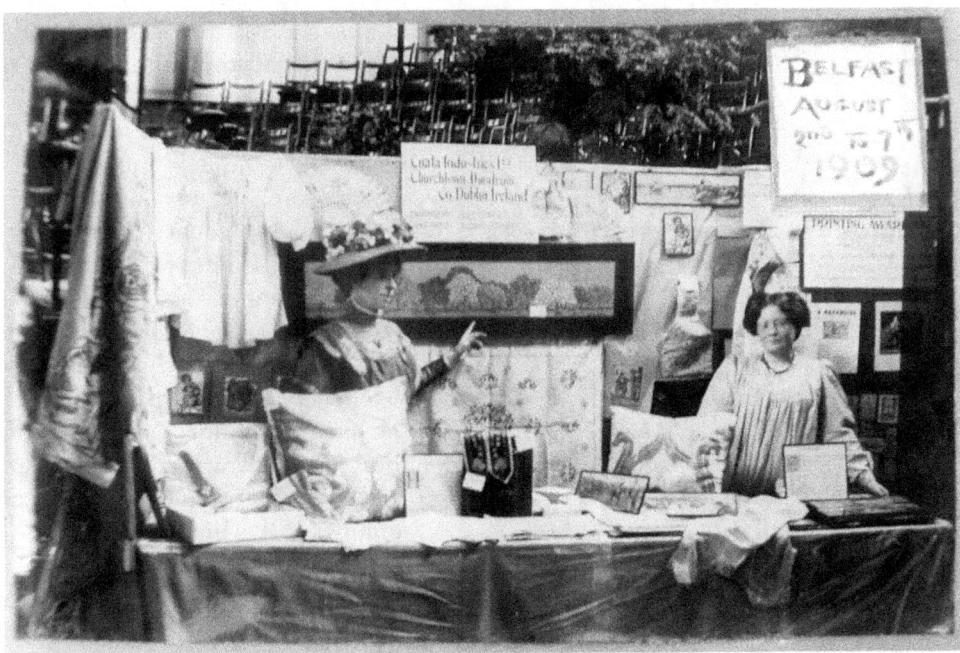

2.8 Cuala Industries Stall, Belfast (2–7 August 1909)

Within the Dun Emer and Cuala Press publications, a hierarchy of artistic genres then evolved (particularly during WBY's lifetime), as is clear from an examination of the extent of illustration in each publication.[62] Until the 1940s, books of poetry, novels and plays were published as limited editions, and included little if any illustration, while bookplates, greetings cards, hand-coloured prints, broadsheets and single illuminated poems with varying degrees of decoration were reproduced time and again.[63] It is apparent from the correspondence of both Presses that the objective behind the limited editions was largely economic, but prices increased steadily over time,[64] and Elizabeth Yeats and WBY were probably aware that they would become collector's items.[65]

Promotional activities were also significant. In 1905 Dun Emer exhibited in Leeds, Belfast, Cork, London, Bristol, Berlin and Bremen, amongst other venues.[66] Joan Hardwick records that by 1910 the Yeats sisters were routinely selling their wares by subscription to the public in Dublin, New York, Scotland and England, as well as to private, well-to-do customers such as the Chestertons and the Cadburys.[67] In total, over 150 hand-coloured greetings cards were published by the Cuala Press, many of them incorporating season's greetings, or poetry and verse by friends such as Susan L. Mitchell and Katherine Tynan, and before Christmas 1925 they sold over 7,000 of the cards.[68] In the context of the Irish Cultural Revival, these publications, which combine text and image in relatively 'equal' proportions, arguably disseminated Yeats family ideologies more widely than fine books. But a closer look at the words and images in these publications, together with a consideration of the potential impact they had on the contemporary reader/viewer, speaks clearly of Cuala's ideological affinities at this time.

In Figure 2.9, Elizabeth Yeats has drawn and hand-coloured a scene of a woman leading little children through the woods, to illustrate a poem by Susan L. Mitchell.

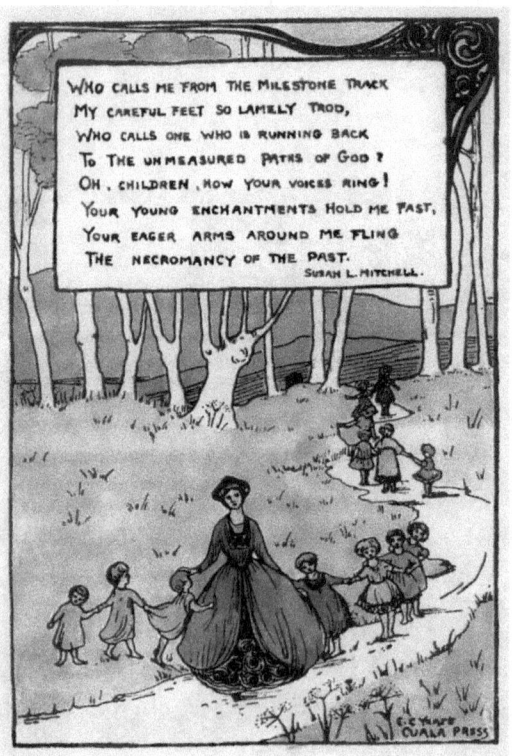

2.9 Cuala Press Greetings Card (Dublin, n.d.), National Irish Visual Arts Library, National College of Art and Design, Dublin

As with Gleeson's approach to textiles, the design needed to be marketable, and the best way of achieving this was to develop 'native' design. Even though the coloured drawing in this card seems, on first appearance, to be Victorian in style, with closer inspection it reveals a distinctly Celtic note in the border framing the poem, and in the spirals, pelta and interlacing pattern in the woman's dress. A review entitled 'Native Art: Advantages of Cultivating a National Style' (c. 1914) illuminates this point, and marks the departure from Gleeson's original design sources:

It is the distinctive Irish style, studied carefully and brought to perfection, that wins these cards high commendation wherever they go. This style does not consist in wreaths of shamrocks, ruined round towers in melancholy twilight, not even in pigs, wolfhounds, colleens, or harps. It is Irish almost unconsciously. The artist has drawn what he has seen around him. ... The moral is: cultivate a native style if you want to produce saleable goods.[69]

Despite all this success, the Industries were never very prosperous, and Elizabeth's bookkeeping continued to be very poor.[70] On 4 January 1913, Lily wrote to Quinn: 'We toil all day and all the year round and only get in at the Industry something over £800 a year – to pay ourselves what no man over 25 would do clerk work for, we want to get in another £250.'[71]

In both printed and embroidered goods, Cuala continued to attract buyers. The first illuminated print of 'St Patrick's Breastplate' was issued in 1912, incorporating a hand-coloured Celtic cross on the cover and a hand-coloured Celtic-style 'I', designed by Elizabeth Yeats, at the beginning of the text. Then in 1920, a second issue incorporated eight Celtic initials instead of one, thus emphasizing the 'Celtic' note. Similarly, in 1923 WBY and Thomas Sturge Moore advised Lily to incorporate more Celtic-style design into her embroidery, for WBY and his wife George felt that her designs and silk colours were a little out-of-date, and that this upgrading of native design would help to increase sales.[72] Around 1915, WBY's illuminated poems 'The Lake Isle of Innisfree' and 'Had I the Heaven's Embroidered Cloths' were being sold for £5–6s framed and 3s unframed,[73] and when his illuminated poem 'The Embroidered Cloths of Heaven' sold for 3s–6d. at the Cuala village industries stand at the Central Hall, Westminster Home Arts and Industries exhibition in 1925, one reporter wrote: 'It seemed to me that there was money in this poetry business, in spite of the cynics. ... You must be a little richer than your dreams to buy it.'[74]

Jack Yeats contributed hand-coloured prints, mostly of Irish characters, for his sister's press until 1926, and many of his illustrations became something approaching iconic in their appeal to an Irish nationalist market.[75] One of the main items sold by subscription was Jack's monthly illustrated *A Broadside*, which ran from 1908 to 1915, with a total of 84 issues.[76] It proved so popular that, by 1914, a range of purchasing options was being advertised – yearly

subscriptions, a complete set, or simply original drawings, available coloured or uncoloured.[77] His illustration for the Irish ballad 'Lament for Eoghan Ruadh' (Figure 2.10) is a good example of Cuala's strategic use of his illustrations.

It first appeared in *A Broadside* in February 1910, was later reproduced as *The Ballad Singer* independent of the text, and sold as a framed colour print by the Cuala Press. The female singer wears a peasant dress, like those recorded by Synge in *The Aran Islands*, and an old, stooped man is seated behind her. In the background, flags indicate a race meeting, which is also a common image in Jack Yeats's drawings. But when we consider this colour print alongside the ballad it illustrates, the image takes on new meanings. 'Lament for Eoghan Ruadh' commemorates an Irish national hero, and was first written by Thomas Davis:

'Did they dare, did they dare, to slay Owen Roe O'Neil?'
'Yes, they slew with poison him they feared to meet with steel.'
'May God wither up their hearts! May their blood cease to flow!
May they walk in living death, who poisoned Owen Roe![78]

The Irish ballad style, incorporating music and heroic or dramatic subject matter, was intended to have a profound and stirring effect on the sentimental psyche.[79] The politics of the Irish ballad during the Irish Cultural Revival have been addressed by critics David Lloyd, Luke Gibbons and others. Lloyd differentiates between Gaelic or peasant songs, street ballads, and literary or Anglo-Irish ballads, and discusses the ways in which each form potentially 'adulterates' the Irish nation.[80] The Yeatses reproduced each of these types of ballads in their broadsheets, combining word (the ballad) and image (an illustration of a ballad singer) to signify Irish cultural heritage, and arguably promoting Irish cultural nationalism. When an image such as *The Ballad Singer* is reproduced independently of the text it originally accompanied, however, it loses some of its political signification, promoting a more nostalgic reading.

As with Gleeson's textiles, details relating to the buyers of these goods and the fact that certain images were more popular than others are important. Only by researching the subject matter, as well as its context, readership and critical reception, can the cultural implications of Cuala productions be understood. *A Broadside* popularized ballads written in the English language, and illustrated them with Irish characters, mostly of the peasant class. They were produced as high-quality publications and were purchased mostly by English-speaking, educated clientele. The peasantry simply would not have had the desire or money to acquire them.[81] This uncovers the paradox common to all members of the Yeats family: how could they create an art form relevant to a predominantly Catholic, rural Ireland, without appropriating and commodifying their culture?[82] Synge anticipated this paradox when he wrote to Stephen MacKenna in 1905 regarding his commission for the *Manchester Guardian*:

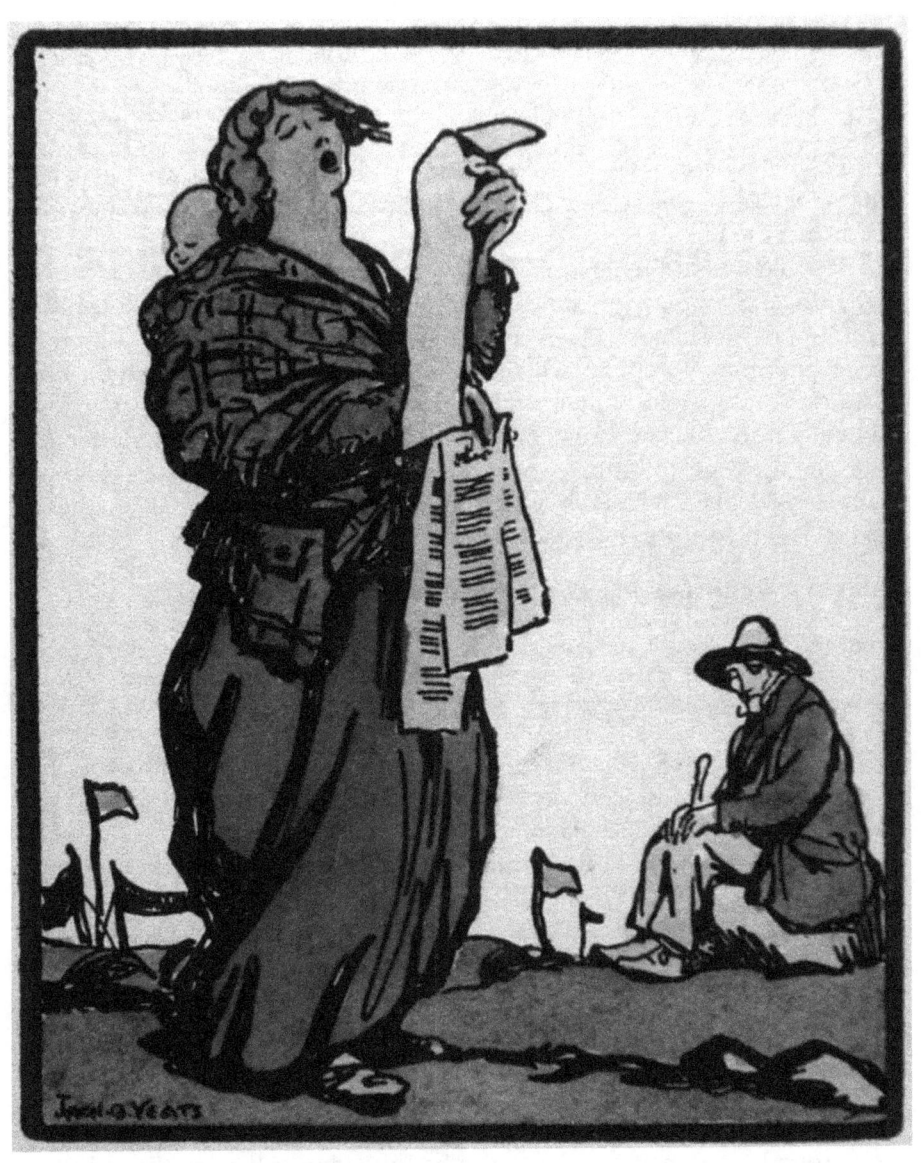
2.10 Jack Yeats, *The Ballad Singer*, in *A Broadside*, no. 9 (February 1910)

[it was] an interesting job, but for me a nervous one, it is so much out of my line, and in certain ways I like not lifting the rags from my mother country for to tickle the sentiments of Manchester. However terms are advantageous and the need of keeping some rags upon myself in this piantic country has to be minded.[83]

There is a dialectical tension between the Irish peasants portrayed in images like *The Ballad Singer* and their consumer, and Synge's letter shows his sensitivity to this.

It is likely that the main incentive in producing colour prints including *The Ballad Singer* was as much cultural nationalism as a keen attempt to earn money. Bruce Arnold records that probably very little of the profits from *A Broadside* went to Jack Yeats and his wife Cottie, although the artist did retain copyright of them and held all originals.[84] Each publication was initially printed in an edition of 300 and they were sold by subscription. But despite the time and care involved in their production and their charming appearance, the Cuala Press was still not selling enough of them to make a profit. With an eye to the American market, Lily asked Quinn:

Do you know any man who would write a good notice of Jack's Broadside in an American paper? We would send a couple of years of it to the writer and also lend any blocks he wanted for reproductions. We want more subscribers to make it pay – next month begins a new year of it ... We print 300 and want at least 200 regular subscribers – we have only 135.[85]

The production of *A Broadside* ended the following year, although Jack continued to produce and market some of his drawings and illustrations in his 'Life in the West of Ireland' exhibitions, and he increased the cost of his original drawings to five guineas for smaller ones, ten guineas for larger ones, by January 1918.[86] By 1915 the Industries had accumulated a debt of £665 with the bank, a debt exacerbated by the effects of the political upheavals in Ireland since 1912 and the Great War.[87] In August 1914 Lily again wrote to Quinn: 'We are very hard hit by this terrible war. We are hoping on and hoping, which is all we can do. All the sales we were engaged for are abandoned and we have twelve girls depending on us. Nothing is selling and all money going to war and relief funds.'[88] These troubles had also affected the mental health of the Yeats sisters.[89]

Around the same time, the sisters had the idea of turning the Industries into a limited company in an attempt to clear their debts. 'I am full of a scheme I have been turning over in my mind for some time,' Elizabeth wrote to Quinn:

– to turn Cuala into a 'Private Limited Company' for now we are supposed to be a cooperative society which is a great farce. A.E. rushed it on us years ago and I have had enough of all sorts of pretences. Lily and I have all the risk – there is no cooperation about it and yet the I.A.O.S. probably count us among their cooperative societies and their multitudes of blue papers to fill up

three or four times a year, the accountant who does our balance sheet twice a year says it would be a good plan. We have a large debt to the bank £665, the accumulations of years. It began long ago and this costs us £40 a year in bank interest and if we could have a few share holders (£1 a share) we could raise the money and pay off the bank and then we should be able to pay a small dividend of shares. ... Even with the war we paid our way this last six months.

The plan did not come to fruition, however, although in October 1915 Quinn did offer to take 25 one-pound shares if the sisters could secure £500 or £600.[90] Problems between Elizabeth and WBY were also brewing again. In 1915, WBY wanted to publish *Certain Noble Plays of Japan*, chosen from the manuscripts of Ernest Fenollosa by Ezra Pound and with an introduction by himself. The book, published in 1916, was a source of consternation for Elizabeth who considered that publishing a book by an American writer would be out of line with their Irish agenda. Her feelings were further frustrated when WBY asked Pound to make selections for the next book, *Passages from the Letters of John Butler Yeats*, published at Cuala in May 1917.[91]

By July 1917, however, the Industries were making £70 more profit than they had in the first half of 1916, by selling all of their goods by post rather than through exhibitions or Arts and Crafts sales.[92] They also allocated plots in the orchard to Cuala staff to grow vegetables, with the aim of providing each girl with enough provision for her household for a year.[93] Another money-making strategy employed by both Dun Emer and Cuala Presses was the re-publication of images, many of which were drawings by Jack Yeats. For example, the publication *A Broadside* continued to be sold after 1915 as a complete set for £4 in a special blue linen portfolio, and his hand-coloured, framed or unframed prints were sold for between £1 ('The Wren Boys') and £4 ('The Start of the Race', 'The Finish' and 'The Village').[94] By holding reproductions of their brother's drawings, the Yeats sisters could sell popular ones time and again.

The girls employed at the Dun Emer and Cuala printing presses were largely from working-class homes. They were paid a regular salary, and the Yeats sisters themselves worked tirelessly alongside them for a minimum wage. Employees at the Cuala Press by then counted Esther Ryan, Mairie Gill, Beatrice Cassidy and Eileen Colum, and a contented work ethos and sense of purpose is evident in Susan L. Mitchell's poem 'Cuala Abu!' of 1923:

Gladly we come to our work every morning
Daughters of Ireland, faithful and true;
Some setting stitches to help your adorning
Some printing magic words, Cuala, for you.
Let men talk politics, throw words or brandish sticks,
Little we care what their folly may do,
Ours not to talk or fight, but work with all our might
Building up home here in Cuala for you.

We are the daughters of Maeve and Fionnuala,
Of fair Fionavar and of great Granuaile,
Proudly we strive here as children of Cuala,
Still to be worthy the race of the Gael.
O Mother Country dear, surely your day draws near,
Let us not shrink aught that women may do,
But make ourselves more fair, and lovely homes prepare,
Fit for the Queen you were, Cuala Abu!⁹⁵

'Daughters of Ireland' translates into Irish as *Inghinidhe na hÉireann*. This links the poem to Maud Gonne's organization of the same name founded in 1900, which sought to promote Irish manufacture, the Irish language and Irish culture. Politically, the organization was dedicated to complete independence, and sought to combat English influence, which was injuring the artistic taste and refinement of the Irish people. The content of Susan L. Mitchell's poem is topical and even political, but the tone remains light-hearted. However, other members of staff at Cuala were forced to take their politics more seriously. In 1923, Lily told Quinn, CID men arrested two of the printing staff:

The two silly girls were members of Cumann na mBan and I think very active in the Republican cause. I talked to them til [sic] I was exhausted. I tried them every way, but could make no permanent impression. I warned them they would be arrested[,] all no use – one is out now – and the other will be out in a few days – it is a difficulty – as I would in many ways rather not have them back ... what they are supposed to have done I don't know? Mostly I think dealt out money doles.⁹⁶

'Cuala Abu!' suggests that politics and fighting are outside the female domain, and urges women to focus on decorating self and home for Cuala instead ('Let us not shrink aught that women may do, / But make ourselves more fair, and lovely homes prepare / Fit for the Queen you were, Cuala abu!'). The emancipation of women, as pioneered by Gleeson in the early twentieth century, was no longer a key concern for Susan L. Mitchell. Workers at Cuala were encouraged to perceive themselves less in competition with men than as 'authentically' Irish women. This was also the image they presented of themselves and their goods for sale at international industrial shows, a legacy of the 1888 Irish Exhibition at Olympia, London.⁹⁷

So the Industries held on through the storms of political unrest in early twentieth-century Ireland. Yet despite the positive attitude and sense of solidarity evident in Susan L. Mitchell's poem, the financial realities were far from satisfactory. In fact they were in continual debt after the first year of business, amounting to £2,000 by 1923.⁹⁸ Yet in August 1922, Lily Yeats reported with confidence: 'Cuala has held on through all the storms of the last eight years and I think may end by paying.'⁹⁹ The 'Statement

of Accounts' for January to May 1923, and the report by the chartered accountant, G.H. Turrloch, of July 1925, called attention to the urgency of the situation and detailed the financial situation between the Yeats sisters and WBY at this time.[100] Cuala Industries accounts showed a loss of £265–5–0d. from both embroidery and printing, and Turrloch reported that the sales from neither department realized sufficient money to cover wages and materials, or to pay expenses. Wages (£221–17–8d.), expenses (£98–6–7d.) and cost of materials in the printing department exceeded sales by £46–4–4d. He continued:

The position disclosed by the Balance Sheet is a serious one. ... The principal creditor is, of course, the National Bank, the amount due on the two overdraft accounts at 14 May 1925 being £1546, to which must be added £245 being the amount of the Bill signed by Miss Lily Yeats which was discounted some years ago for the benefit of the business and has been renewed from time to time. The Bank holds at present certain investments belonging to Miss E.C. Yeats and Miss Lily Yeats as part security for the overdraft, but they are pressing for a reduction of the overdraft, and if the business is to be carried on the introduction of fresh capital is imperative. I understand that Senator W.B Yeats is considering the question of making a loan for the purposes of wiping out the Bank overdraft. ... anyone lending money to it is taking a serious risk. I understand, however, that the partners will hand over to Senator Yeats the investments at present held by the Bank and to this extent at any rate he will be secured, but the proposal is that the partners are to continue during their lifetime to enjoy the income from these investments, and in these circumstances, the prospects of Senator Yeats receiving interest on his loan are somewhat remote.[101]

The Yeats sisters had received a weekly salary of £3–10–0d. each, but '[t]he system of book keeping in use is incomplete and unsatisfactory. ... The business has apparently been run on somewhat haphazard lines in the past, and if it is to be kept alive a strong effort will have to be made to run it on more businesslike lines in the future.'[102] WBY continued to lend money to the Industries until the end of his life, and when the lease on the cottage in Dundrum was ending in 1923, his wife George suggested that the sisters move to their home at 82 Merrion Square.[103] When WBY was in Sweden in 1924, receiving the Nobel Prize for literature, Elizabeth was still looking for new premises for the Cuala Industries, and in February 1925 they moved to 133 Lower Baggot Street in Dublin (Figure 2.11), where they remained until Elizabeth's death in 1940.

This city centre venue was used to showcase their work, and 'At Homes' were held where invited guests could drink tea and view Cuala goods for sale. Poems by WBY with decorated initial letters, and cards and engravings designed by Jack Yeats and others were routinely sold to an established clientele. As Roy Foster has observed, 'their printing *oeuvre* enshrined a particular version of the Irish Revival as well as a commodification of the Yeats family'.[104]

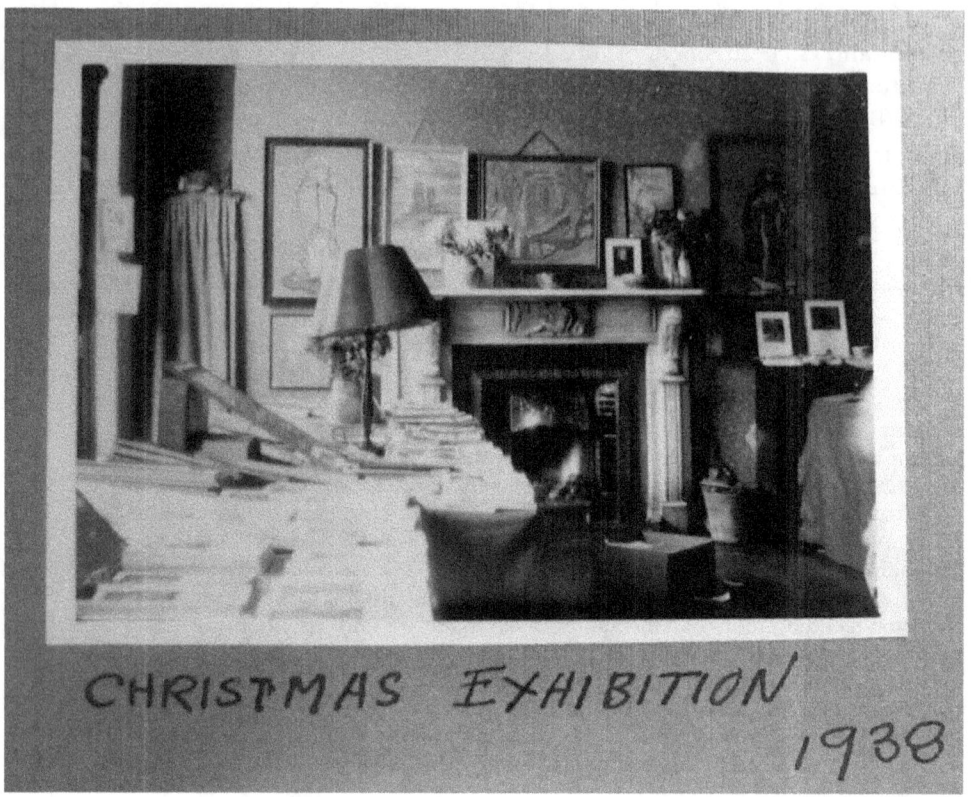

2.11 Cuala Industries Christmas 'At Home' exhibition, 1938

The renewed income undoubtedly encouraged the Yeats sisters, but by October 1925 Jack Yeats withdrew support. He needed to break away from illustration and devote himself to oil painting. On 31 October 1925 he wrote to his brother William: 'I know you are doing a good deal for Lily and Elizabeth and it is very good of you. But I can do no more. The last two or three drawings for prints I have given against my will. These reproductions are a drag and a loss to me in my reputation.'[105] His withdrawal did not stop the Cuala Press from continuing to reproduce and sell his early drawings, but he did no new illustrative work for Cuala between February 1926 and January 1935 when *A Broadside (New Series)* was launched by the Cuala Press.[106]

WBY's commitment to the Press kept going, and the books produced and sold there continued to disseminate Irish subject matter, catering for a market holding on to Celtic Twilight ideals. For example, Frank O'Connor's *The Wild Bird's Nest: Poems from the Irish* (1932) was reviewed in *The Guardian* as 'the passionate, primitive yearning and the fiercely passionate regret, the

intense brooding on the reality, that stamp these poems as characteristic of the native Irish lyrists', while Seán O'Faolain wrote in *The Spectator*:

Like Mr Frank O'Connor several have gone again to re-examine the material of the older Ireland to seek there for racial characteristics that will ring true to their own experience of Irish life. They thus continue to be moved by the same literature that moved Yeats and AE and Synge fifty years ago. But they are moved in an entirely different way.[107]

In a similar vein, John Lyle Donaghy's *Into the Light and Other Poems* (1934), also published by the Cuala Press, was reviewed in the *Glasgow Herald* under the heading 'Classic Tradition in Irish Poetry': 'This is a volume to be recommended to all who read modern verse, and, above all, to those who are interested in the future of Celtic literature. It is significant that Mr Donaghy and his fellow-poets in Ireland model their verse on Gaelic forms, but invariably write in English.'[108] Meanwhile, *The Listener* said of the same book:

The poet claims that his work, like all Irish poetry, is 'integrally classical and aristocratic; individual, concrete, humanly rich, learned in craft and proudly licensed, strict, puissant'. ... Mr Donaghy is most successful when he runs his accelerated rhythms through the accepted measures of pentameter and tetrameter. Using them freely, with the tricks of line-break so familiar now in the work of the most modern free-versifiers, who follow the petty chicaneries of Ezra Pound, Mr Donaghy loses strength, and with that loss he also loses speed, thus defeating the purposes of his experiments.[109]

Evidently, contemporary critics in Ireland and England preferred Irish poets to produce works demonstrating 'racial characteristics that will ring true to their notion of Irish life', rather than the free verse characteristic of Modern poetry by Ezra Pound and others. The Cuala Press, with WBY as editor, therefore held onto its reputation as the melting pot for Revival literature throughout the 1930s, distinctly contrasting with publications associated with the Modern movement in Irish literature.

In his own writing, WBY's themes and approaches demonstrate both continuity and change. Generally he resisted illustration in his books produced at the Dun Emer and Cuala Presses, with the notable exception of *Reveries Over Childhood and Youth* (1915) in which he used Jack Yeats's *Memory Harbour* (1900) as a frontispiece. But outside his sister's Press, he did, at times, commission decorative book cover designs, collaborating with several artists who shared his Arts and Crafts principles, such as Charles Ricketts, Thomas Sturge Moore and Althea Gyles (see Figure 1.3).[110] WBY's *The Stories of Red Hanrahan and the Secret Rose* (1927), illustrated by the Irish artist Norah McGuinness (1901–80) and published by Macmillan, is of particular interest in the context of this discussion (Figure 3.1). It exemplifies continuity in that it is a new edition of two stories published previously, *The Secret Rose* (1897)

and *Stories of Red Hanrahan* (1904), and it demonstrates change, both in the fresh commission for a book cover and in his presentation of the stories. New archival evidence relating to the conception and reception of this book reveals it to be an interesting example of collaboration between writer and illustrator, and it carries forward this investigation into the roles played by women artists within WBY's *fraternité des arts* tradition.

Notes

1. Evelyn Gleeson to Mr Gwynn, 16 July 1924 (TCD, MS 10676/18/11).

2. See Nicola Gordon Bowe's essays, 'The Irish Arts and Crafts Movement, 1886–1925', *Irish Arts Review Yearbook* (1990–91): 172–85, and 'Two Early Twentieth-Century Irish Arts and Crafts Workshops in Context: An Túr Gloine and the Dun Emer Guild and Industries', *Journal of Design History*, 2/2–3 (1989): 193–206.

3. Gleeson wrote several letters, at times very amusing, supporting the feminist cause. For example, she wrote in protest against a newspaper article in Friday's 'London Letters' (n.d.): 'The class of women, whether married or single, "who pass their time writing essays", is I fear numerically small. ... The average "old maid" is far more likely to be reading The Independent by her solitary fireside ...' (TCD, MS 10676/18/19).

4. Fintan Cullen and R.F. Foster, *Conquering England: Ireland in Victorian England* (London, 2005), p. 24.

5. *The Celt* (September 1903); quoted in Theo Snoddy, *Dictionary of Irish Artists: Twentieth Century* (Dublin, [1996] 2002), p. 193.

6. Bowe, 'The Irish Arts and Crafts Movement', p. 172.

7. See, in particular, Jeanne Sheehy, *The Rediscovery of Ireland's Past: The Celtic Revival 1830–1930* (London, 1980); Nicola Gordon Bowe and Elizabeth Cumming, *The Arts and Crafts Movements in Dublin and Edinburgh 1885–1925* (Dublin, 1998); Paul Larmour, *The Arts and Crafts Movement in Ireland* (Belfast, 1992); Liam Miller, *The Dun Emer Press, Later the Cuala Press with a Preface by Michael B. Yeats* (Dublin, 1973); Gifford Lewis, *The Yeats Sisters and the Cuala* (Dublin, 1994); Joan Hardwick, *The Yeats Sisters: A Biography of Susan and Elizabeth Yeats* (London, 1996); Hilary Pyle, *Yeats: Portrait of an Artistic Family* (Dublin and London, 1997).

8. Joan Hardwick's biography of the Yeats sisters aims to demonstrate why they 'are worth consideration in their own right and not just because they were the daughters of John Butler Yeats ... and the sisters of Jack Butler Yeats ... and W.B. Yeats' (*Yeats Sisters*, p. vii). However, a biography of the Industries' founder, Gleeson, awaits writing.

9. See, for example, Anthea Callen, *Angel in the Studio: Women in the Arts and Crafts Movement 1870–1914* (London, 1979); Janice Helland, 'Embroidered Spectacle: Celtic Revival as Aristocratic Display', in Betsey Taylor FitzSimon and James H. Murphy (eds), *The Irish Revival Reappraised* (Dublin, 2004), pp. 94–105. See also Elaine Cheasley Paterson, 'Crafting a National Identity: The Dun Emer Guild, 1902–8', in FitzSimon and Murphy (eds), *Irish Revival Reappraised*, pp. 106–18; Janice Helland, 'Authenticity and Identity as Visual Display: Scottish and Irish Home Arts and Industries', in Fintan Cullen and John Morrison (eds), *A Shared Legacy: Essays on Irish and Scottish Art and Visual Culture* (Aldershot, 2005), pp. 157–72; Maureen Murphy, 'Creating Cuala: Lily and Lollie Yeats and the Cuala Industries', in Janis Londraville (ed.), *Prodigal Father Revisited: Artists and Writers in the World of John Butler Yeats* (Cornwall, 2003), pp. 123–47.

10. William M. Murphy quotes JBY's advice to his daughters in a letter written 18 July 1908: 'The less you say against her the better. If anyone became her champion it would be because you were against her' (*Prodigal Father: The Life of John Butler Yeats (1839–1922)* [Ithaca and London, 1978], p. 334). See also William M. Murphy, *Family Secrets: William Butler Yeats and His Relatives* (Dublin, 1995), pp. 179–264.

11. Nora Fitzpatrick, 'The Cuala Industries: Their Real Founder and the Work of Miss Yeats' (n.d.), written in response to the article 'Miss Elizabeth Yeats and the Cuala Industries', *Daily Sketch*, Saturday 25 September 1909 (Evelyn Gleeson Scrapbook, TCD, MS 10676/9/1, p. 35 [recto]).

12. Gleeson, 'THE DUN EMER INDUSTRIES', prospectus printed at the Dun Emer Press, 1903–1904 (TCD, Cuala Press A ARCH, Box 49A, no. 2). Reprinted in Miller, *The Dun Emer Press*, pp. 15–17. In it, Gleeson records that William Morris called tapestry: 'The noblest of the weaving arts, being nearly as permanent as mosaic & as beautiful as painting' (Gleeson, 'Irish Hand-Knotted Carpets', TCD, MS 10676/5/7, p. 8). Gleeson's father gave up his career as a doctor in England to found the Athlone Woollen Mills in Ireland (Gleeson, untitled essay, n.d., TCD, MS 10676/5/8, p. 5).

13. Gleeson, 'Fragment of an Essay for the Irish Literary Society, probably 1907' (TCD, MS 10676/5/9, pp. 1–2).

14. Gleeson's contention echoes the theories of Leonardo da Vinci on painting and poetry, hearing and sight, in his *Paragone* (c. 1510). See Irma A. Richter, *Paragone: A Comparison of the Arts: With an Introduction and English Translation* (London, New York, Toronto, 1949), pp. 49–71. There is no evidence that this was a conscious reference on Gleeson's part.

15. See Helland, 'Embroidered Spectacle'.

16. Gleeson, 'Fragment of an Essay', p. 8.

17. These countries included England (William Morris); Hungary ('The Hungarian renaissance includes the revival of native craftsmanship, and seeks to emphasize the characteristics of its design and colouring. We in Ireland, who have followed with such absorbed interest the kindred story of Hungary, should also guard and develope [sic] all that is left of the old-time skill of our people' [Gleeson, 'Hand-weaving', *Bean na hÉireann* (*The Woman of Ireland*). Newspaper clipping, TCD, MS 10676/9/16]); Russia ('the Russian handicrafts though beginning to yield to machinery of modern consumerism, are still part of the national life, the old colour schemes and designs distinctive' [Gleeson, untitled essay, TCD, MS 10676/18/18]); and Italy ('In Italy a society has lately been formed under the patronage of the Queen for reviving and developing women's industries. In each province it has a local committee to encourage the workers [Gleeson, 'Fragment of an Essay', p. 8]).

18. For discussions of the term 'Celticism' in Irish cultural studies, see in particular Joep Leerssen, 'Celticism', in Terence Brown (ed.), *Celticism*. Studia imagologica 8 (Amsterdam, 1996), pp. 1–20. See also Joep Leerssen, *Remembrance and Imagination: Patterns in the Historical and Literary Representation of Ireland in the Nineteenth Century* (Cork, 1996).

19. Gleeson, 'Fragment of an Essay', p. 5.

20. Alice Hart experimented with the dyeing properties of wild plants in Donegal in the 1880s. See Larmour, *The Arts and Crafts Movement in Ireland*, p. 19.

21. 'The colours derived from our native own trees and plants are peculiarly harmonious and beautiful & combine with one another successfully' (Gleeson, untitled essay, n.d. [TCD, MS 10676/5/13], pp. 1–2).

22. This insistence on local produce and labour is linked to the ideas of Morris, who also used naturally treated substances and natural dyes, in the spirit of the Middle Ages.

23. Miss MacCormack, 'INTERVIEW DUN EMER GUILD', 'Woman's Magazine', broadcast 13 June c. 1970, 7.55 pm, Radió Éireann (TCD, MS 10676/5/6, p. 1). Katherine was daughter of Constance Gleeson, who lived at Dun Emer with Evelyn Gleeson. She was an accomplished weaver in her own right. Extant works are illustrated in Larmour, *The Arts and Crafts Movement in Ireland*, p. 68, p. 160.

24. Gleeson, 'Fragment of an Essay', pp. 1–2.

25. W.B. Yeats, 'Ireland and the Arts' (1901), *E&I*, p. 204.

26. Foster, *Yeats, Vol. I*, p. 275. Employees included Eileen Colum (sister of Padraic Colum) and Máire Nic Shiubhlaigh (Mary Walker) who acted at the Abbey Theatre.

27. For example, see advertisements in *An Claidheamh Soluis*, 21 March 1914.

28. See Gleeson to 'Tom' (T.P. Gill), 30 September 1904 (TCD, MS 10676/18/3). This letter details the reorganization of the Dun Emer Industries in 1904, and how she split a £120 grant from the Irish Development Fund into three.

29. See Sheehy, *The Rediscovery of Ireland's Past*, p. 148.

30. From August 1902 to August 1903, Elizabeth Yeats earned £125. See an excerpt from her day book reprinted in Miller, *The Dun Emer Press*, pp. 23–4.

31. Gleeson, Memo, 1904 (TCD, MS 10676/2/33).

32. Details of the new committee are found in Miller, *The Dun Emer Press*, pp. 38–41. See also Murphy, *Prodigal Father*, p. 266.

33. NGI, YMUS, Parcels 20, 21, 22.

34. Quinn to LY, 120 Broadway, New York, 23 October 1905 (NYPL, Quinn Coll.). In the same letter, Quinn states that he will do all he can toward disposing of leftover embroidery from the Fair to a shop or dealer, 'even at a slight reduction'.

35. W.B. Yeats, *The Land of Heart's Desire* (Portland, Maine, 1903), p. 16. The play was produced in London's Avenue Theatre in 1894. A piece of embroidery of fruit and flowers held in the Yeats Archive (NGI) appears to be a sample for this textile (NGI, YMUS, Parcel 21 [4]).

36. *E&I*, p. 355.

37. On this fan, a formal landscape is superimposed by a design of flowers and an inscription taken from the love song between Anashuya and Vijaya in W.B. Yeats's *Crossways* (1889) (NGI, YMUS, Parcel 19).

38. A photograph of the stage cast for *The King's Threshold* (Molesworth Hall, Dublin, 1903) shows that this costume was used by Yeats. See Plate 14 in Donald James Gordon (ed.), *W.B. Yeats: Images of a Poet* ([Manchester, 1961] Westport, CT, 1979), p. 67. Celtic-style costumes for *The King's Threshold* are also illustrated in plates 37 to 40 of George Sheringham and R. Boyd Morrison (eds), *The Robes of Thespis* (London, 1928). Interestingly, Jack Yeats produced a backcloth for *The King's Threshold* in which he adopts 'an almost abstract imagery' (Hilary Pyle, *The Different Worlds of Jack B. Yeats: His Cartoons and Illustrations* [Dublin, 1994], p. 25).

39. Lily Yeats's health deteriorated greatly in 1922: she told Quinn she had been in bed with 'shingles and neuritis' (LY, Dundrum, Co. Dublin, to Quinn, 13 August 1922 [NYPL, Quinn Coll.]).

40. JBY remained in America until his death in February 1922.

41. Gleeson, notebook, n.d. (TCD, MS 10676/5/1), p. 7.

42. On 10 January 1931, a Dun Emer carpet was presented 'as a State gift to His Holiness the Pope, on the occasion of the jubilee year of His Priesthood'. See an invitation from the Department of External Affairs to 'The Misses MacCormack and Party' to the viewing at Kildare Street School, 14–16 January 1931 (TCD, MS 10676/19/25).

43. ECY to Quinn, 10 July 1917 (NYPL, Quinn Coll.).

44. Miller, *The Dun Emer Press*, p. 8.

45. For this approach in relation to the book art of Rossetti, see Elizabeth K. Helsinger, 'Rossetti and the Art of the Book', in Catherine J. Golden (ed.), *Book Illustrated: Text, Image, and Culture 1770–1930* (Delaware, 2000), pp. 147–93.

46. For illustrations, see Larmour, *The Arts and Crafts Movement in Ireland*, p. 8.

47. 'THE DUN EMER PRESS', prospectus printed at the Dun Emer Press, 1903–1904 (TCD, EPB PRESS A CUALA ARCH, Box 49A, no. 3). The development of printing in Ireland was also topical in contemporary press cuttings relating to the new Dun Emer Press. For example, an article in the *Cork Constitution*, 22 March 1909, stated: 'In the eighteenth century the art of printing had reached a very flourishing state in Ireland. Cork and Dublin seemed to have quite bristled with printing-presses, but smaller towns like Kilkenny, Limerick and Newry had also known printing firms, who turned out an amount of interesting and creditable work' (TCD, EPB PRESS A CUALA ARCH, Box 52, no. 2, p. 26). See also 'Early Printing in Limerick and Ennis', *The Irish Book Lover*, 3/10 (May 1912) (TCD, EPB PRESS A CUALA ARCH, Box 52, no. 2, p. 42).

48. The Doves Press *Catalogue Raisonné* stated that it was founded to 'attack the problem of pure Typography, ... keeping always in view the principle laid down in The Book Beautiful, that "The whole duty of Typography is to communicate to the imagination, without loss by the way, the thought or image intended to be conveyed by the author"' (Miller, *The Dun Emer Press*, p. 21).

49. For a detailed analysis of this dynamic, see Edward Hodnett, 'The Kelmscott Burne-Jones', in *Image and Text: Studies in the Illustration of English Literature* (London, 1982), pp. 197–218.

50. Allan Wade, *A Bibliography of the Writings of W.B. Yeats* (London, 1958), p. 65.

51. See also Chapter 3 concerning WBY's negotiations with Macmillan publishers.

52. In the case of *The Nuts of Knowledge*, for example, WBY expressed concern to his sister Elizabeth that George Russell's (AE) device was perhaps 'a little large as well as a little vague in design' (Miller, *The Dun Emer Press*, p. 35).

53. Newspaper clipping: G.K. Chesterton, '"A Book of the Day" A Book from Ireland. *Stories of Red Hanrahan* by William Butler Yeats, The Dun Emer Press, Dundrum, 12s 0d' (Gleeson Scrapbook, TCD, MS 10676/9/1, p. 10 [recto]).

54. Newspaper clipping: 'An Artistic Industry' (Gleeson Scrapbook TCD, MS 10676/9/1, p. 22 [verso]).

55. Synge's reply to Elizabeth Yeats's letter has not survived. Miller records correspondence relating to Synge's publication, but does not include Synge's letter (Miller, *The Dun Emer Press*, pp. 56–62).

56. Quinn to ECY, 16 July 1909 (NYPL, Quinn Coll.).

57. Aileen M. Goodwin, 'The Cuala Press in Ireland: A Woman's Contribution to Fine Printing in Ireland', *The Birmingham Post*, 12 September 1930 (TCD, EPB PRESS A CUALA ARCH, Box 53, no. 1, p. 52).

58. W.G. Blaikie-Murdoch, 'The Cuala Press', *The Bookman's Journal and Print Collector*, July 1922, pp. 109, 111 (NGI, YMUS, Parcel 1 [Misc. Journals]). On the centenary of Morris's birth, *The Times Literary Supplement*, 12 April 1934, also wrote of his printing, that within the remit of fifteenth-century essentials, in 'paper and type, as well as in the placing of the type-page, Morris was undoubtedly successful. But in the matter of spacing he cannot be said to have achieved his intention of producing books which "should be easy to read and should not dazzle the eye or trouble the intellect of the reader"' (TCD, EPB PRESS A CUALA ARCH, Box 52, no. 1).

59. *The Irish Times*, 8 March 1926 (TCD, EPB PRESS A CUALA ARCH, Box 53, no. 1, p. 33).

60. WBY, 18 Woburn Buildings, Euston Road, N.W., to Lady Gregory, 21 January 1907 (NYPL, Berg Collection).

61. WBY, Coole Park, Gort, N.W., to Quinn, 12 September c. 1904 (NYPL, Berg Collection).

62. For a full list of publications by the Dun Emer and Cuala Presses, see Miller, *The Dun Emer Press*, pp. 105–31.

63. For an early critique of Cuala bookplates, see Blaikie-Murdoch, 'The Cuala Press and its Bookplates', in *The Bookplate Booklet* (Kansas City, 1919), 1.1 (Third Ser.), pp. 9–20. Murdoch mentions Elizabeth Yeats, Mrs Jack Yeats, Miss Eileen Greig, Miss Maunsel, Miss Pamela Coleman-Smith and Mr Jack Yeats as bookplate designers. Gifford Lewis has observed that the bookplates show 'a clear division between the before and after of Irish independence. Before we have the shamrockery, wolfhounds and harps of Home Rulers, Greek quotations and temples for Trinity classicists, armorial bearings for the Anglo-Irish – and after independence a flourish of good Irish lettering, Irish language and a taste for Jack Yeats landscapes' (Gifford Lewis, *The Yeats Sisters and the Cuala* [Dublin, 1994], p. 121).

64. An account book dated before 1905 records that Douglas Hyde's *The Love Songs of Connacht* sold for 9s–6d. each, and that W.B. Yeats's *Red Hanrahan* sold for £1–5–0d for two (TCD, MS 10676/2/41). In 1908, W.B. Yeats's *Stories of Red Hanrahan* sold for 12s–6d, and Jack Yeats's monthly *A Broadside* was being sold by subscription for 12s a year, post free (Dun Emer Press Catalogue, May 1908 [TCD, EPB PRESS A CUALA ARCH, Box 49A, nos 6, 7). By 1914, ten copies of W.B. Yeats's *Responsibilities* had been sold to Quinn for £4–15s (Invoice from the Cuala Press to Quinn, 26 May 1914 [NYPL, Quinn Coll.]). By around 1917, a complete set of *A Broadside*, from June 1908 to June 1915, was being sold for £4–4s (with the blue linen portfolios to hold the set costing an additional 5s–6d) (Advertising Slip [c. 1917] TCD, EPB PRESS A CUALA ARCH, Box 49A, no. 15).

65. As early as 1923, a set of Cuala books (33 volumes) was sold in London for 100 guineas (Lewis, *The Yeats Sisters and the Cuala*, p. 166). Lewis quotes an article from the *Dublin Evening Telegraph*, 3 September 1923. The sale could also have been capitalizing on WBY's Nobel Prize in 1923.

66. Commissions, exhibition venues and prizes awarded in 1905 are recorded in 'Notes and News' in the Dun Emer Scrapbook for 1905 (TCD, EPB PRESS A CUALA ARCH, Box 1A, no. 3, pp. 81–5).

67. See Hardwick, *The Yeats Sisters*, p. 163. See also the accounts for the printing department up to July 1903 (TCD, MS 10676/2/15). Money received from books was £33–8–5d., and money spent on printing, paper, and so on was £53. Authors were paid £31–1s.; the girls were paid £4–2s; binding cost £8–4s; and postage of books cost £4–1–3d. Elizabeth Yeats was paid £114–8s.

68. 'An Irish Visitor: Miss Elizabeth Yeats on Ireland and its People. Sister of Famous Poet', *The Birmingham Mail* (August 1926).

69. Kevin J. Kenny, 'Native Art: Advantages of Cultivating a National Style', c. 1914, newspaper unrecorded (TCD, EPB PRESS A CUALA ARCH, Box 52, no. 2, p. 56). In 1915, WBY also advised Lily Yeats to incorporate more 'Celtic Irish' designs into her embroidery. See Hardwick, *The Yeats Sisters*, p. 191.

70. Judgement based on evidence in the account books in the Cuala Press Archive. See also Lewis's conclusions in *The Yeats Sisters and the Cuala*, pp. 168–9.

71. LY to Quinn, 4 January 1913 (NYPL, Quinn Coll.).

72. See Lewis, *The Yeats Sisters and the Cuala*, p. 166.

73. Advertising Brochure, c. 1915 (TCD, CUALA PRESS A ARCH, Box 49A, no. 13).

74. *Daily News*, 18 June 1925. Quoted from Lewis, *The Yeats Sisters and the Cuala*, p. 169.

75. *The Ballad Singer* was selling for £3.85 in 1979. See *List of Books, Booklets, Hand Coloured Prints and Ballad Sheets* (Dublin: The Cuala Press, 1979) (TCD, MS 10676/4/28). In the same booklet, WBY's 'The Lover Tells of his Rose' is advertised as illuminated, and measuring 381 × 280 mm (15 × 11 ins) and priced £3.30.

76. *A Broadside* (1908–15) was derived from *A Broad Sheet* which Jack Yeats had published with Pamela Coleman Smith (1878–1951) in London in 1902–1903, printed by Elkin Mathews. When Smith lost interest in the publication in January 1903, Jack Yeats was in charge. A letter written to John Quinn clarified his intentions: 'The Broadsheet will be going on and I hope to soon print Fanny Parnell's fine verses with this fine idea – I hope to make the Broadside more Irish in 1903' (Jack Yeats to John Quinn, 16 January 1903, NYPL, Quinn Coll.). See also Jack Yeats to John Quinn, 15 December 1902 (NYPL, Quinn Coll.) in which he commented on Smith's erratic nature and stated that most of their buyers were in England or America, rather than Ireland.

77. *A Broadside* advertisement (TCD, CUALA PRESS A ARCH, Box 49A, no. 9).

78. Thomas Davis, 'Lament for the Death of Eoghan Ruadh O'Neill Commonly Called Owen Roe O'Neil', stanza 1. Reprinted from Jack Yeats (ed.), *A Broadside*, 9 (February 1910), fol. 1 (recto).

79. An example of the power of the ballad is apparent in the closing scene of James Joyce's *The Dead*, when Gabriel Conroy discovers that his wife Gretta still harbours feelings for a man from her past. By chance she hears the ballad 'The Lass of Aughrim', which her dead suitor used to sing in the West of Ireland. As Luke Gibbons points out: 'For Joyce, it is this remnant of oral culture, ... which is characteristic of the most resilient strains in Irish nationalism' (*Transformations in Irish Culture* [Cork, 1996], p. 134).

80. For this post-colonial reading of the Irish ballad, see David Lloyd, 'Adulteration and the Nation', in *Anomalous States: Irish Writing and the Post-Colonial Movement* (Dublin, 1993), pp. 88–124. WBY had anticipated this uneasiness, and in his essay 'J.M. Synge and the Ireland of his Time' (1910), he took great care in contextualizing Thomas Davis's celebration of the peasant and other stock Irish characters in essays, songs and stories. See Foster, *Yeats, Vol. I*, pp. 418–19.

81. Luke Gibbons has pointed out how 'idealisations of rural existence, the longing for community and primitive simplicity, are the product of an *urban* sensibility, and are cultural fictions imposed on the lives of those they purport to represent' (Gibbons, *Transformations in Irish Culture*, p. 85).

82. Gibbons quotes Mikhail Bakhtin: 'cultural and literary traditions are preserved and continue to live, not in the subjective memory of the individual nor in some collective "psyche", but in the objective forms of culture itself' (Gibbons, *Transformations in Irish Culture*, p. 10).

83. Synge, Crosthwaite Park, to Stephen MacKenna, 30 May 1905 (quoted in Bruce Arnold, *Jack Yeats* [New Haven and London, 1998], p. 134). Arnold notes that 'piantic' is Synge's anglicanization of an Irish word for painful or troublesome.

84. Arnold, *Jack Yeats*, p. 186. Jack Yeats married the painter Mary Cottenham White ('Cottie') in 1894.

85. LY to Quinn, 25 May 1914 (NYPL, Quinn Coll.).

86. See a catalogue of Jack Yeats's exhibition, c. 1915 (TCD, CUALA PRESS A ARCH, Box 49A, no. 12). See also an advertisement for Jack Yeats's original drawings, January 1918 (TCD, CUALA PRESS A ARCH, Box 49A, no. 17).

87. For historical background, see R.F. Foster, 'War and Revolution', in *Modern Ireland 1600–1972* (London and New York, 1988), pp. 461–93.

88. LY to Quinn, 28 August 1914 (NYPL, Quinn Coll.).

89. For an account of the sisters' feelings about Irish affairs during these upheavals, see Hardwick, *The Yeats Sisters*, pp. 177–96.

90. ECY to Quinn, 19 October 1915 (NYPL, Quinn Coll.).

91. See Hardwick, 'Lolly and Ezra', in *The Yeats Sisters*, pp. 197–205.

92. LY to Quinn, 9 July 1917 (NYPL, Quinn Coll.).

93. ECY to Quinn, 10 July 1917 (NYPL, Quinn Coll.). At the beginning of 1915, the Yeats sisters had been worried that they might need to send off some of their girls. See LY to Quinn, 13 January 1915 (NYPL, Quinn Coll.). For WBY's resignation from the Cuala Press as editor in 1921, see Foster, *Yeats, Vol. II*, p. 186.

94. Cuala publicity leaflet, n.d. [post-1915] (NYPL, Quinn Coll.).

95. Reprinted in Michael B. Yeats's introduction to Miller, *The Dun Emer Press*, pp. 79–80. This poem is also analysed in Maureen Murphy, 'Creating Cuala: Lily and Lollie Yeats and the Cuala Industries', in Janis Londraville (ed.), *Prodigal Father Revisited* (Cornwall, 2003), pp. 123–47.

96. LY to Quinn, 31 July 1923 (NYPL, Quinn Coll.).

97. See Cullen and Foster, *Conquering England*, p. 75.

98. See Miller, *The Dun Emer Press*, pp. 23–4. Beatrice Cassidy's wage for working at the printing press in 1903 was 1s–6d. per week.

99. LY to Quinn, 13 August 1922 (NYPL, Quinn Coll.).

100. 'The Cuala Industries. Statement of Accounts for the period from 1st January 1925 to 14th May 1925 and report thereon. By G.H. Tulloch', Craig, Gardner & Co., Chartered Accountants, Trinity Chambers, Dublin (TCD, EPB PRESS A CUALA ARCH, Box 1, no. 14).

101. 'The Cuala Industries. Statement of Accounts', pp. 4–5.

102. 'The Cuala Industries. Statement of Accounts', pp. 6–8.

103. Foster, *Yeats, Vol. II*, p. 240.

104. Foster, *Yeats, Vol. II*, p. 240. Lily Yeats became ill towards the end of the year, received treatment for tuberculosis and was unable to work while the Cuala Press work continued.

105. Lewis, *The Yeats Sisters and the Cuala*, p. 168.

106. *A Broadside (New Series)*, eds Dorothy Wellesley and W.B. Yeats, nos 1–12 (Dublin: Cuala Press, 1937). Foster has pointed out that the revival of *A Broadside* was intended to 'boost Cuala's flagging fortunes', and that it was also the first collaboration between WBY and Jack Yeats since the 1920s (Foster, *Yeats, Vol. II*, p. 504). *A Broadside (New Series)* has the same format as Jack Yeats's *A Broadside*, and was also published in a set of 300 copies. The main differences were that the new publication set Irish ballads to music, and illustrators included Jack Yeats, Victor Brown, Eileen Peet, Maurice McGonagall, Harry Kernoff and Sean O'Sullivan, whose styles differed considerably. One of the most striking differences between this publication and the 1908–15 *A Broadside* is the combination of different illustrative styles in one issue. The implication is that for the new editors, unity between text and image was less important. *The Times Literary Supplement* of 4 March 1935 was not long in pointing this out: 'Mr Victor Brown's delicate, formal illustration to the modern poem is in direct contrast with the rustic vigour of Mr Jack B Yeats's illustration. As a result the broadside lacks unity of design.' Of greater urgency to the new editors was the relationship between words and music.

107. '"Irish Lyrics": The Wild Bird's Nest by Frank O'Connor', *The Guardian*, August 1932 (clipping, YMUS); 'On the Wild BIRD'S Nest: Poems from the Irish by Frank O'Connor. With an essay on the character in Irish literature by AE', Reviewed by Seán O'Faolain, *Spectator*, 27 August 1932 (clipping, YMUS).

108. 'Classic Tradition in Irish Poetry', *Glasgow Herald*, 14 December 1934 (clipping, YMUS). Contrast this with comments from the *Sunday Observer*: 'what he says of the Irish tradition would be equally true of the English. In fact this "classic" Irish tradition seems to produce in Mr Donaghy (except for a few themes and allusions and a good many proper names) just good English poetry. … There need be no hostility between poetry and propaganda. A poet can be a very potent propagandist; but to be a good propagandist is not the same thing as to be a good poet.' *Sunday Observer*, 21 October 1934 (clipping, YMUS).

109. [Anonymous and untitled review], *The Listener*, 24 October 1934 (clipping, YMUS).

110. See Joan Coldwell, '"Images That Yet Fresh Images Beget": A Note on Book Covers', in Robin Skelton and Ann Saddlemyer (eds), *The World of W.B. Yeats: Essays in Perspective* (Dublin, 1965), pp. 152–7. See also Ursula Bridge (ed.), *W.B. Yeats and T. Sturge Moore, Their Correspondence, 1901–1937* (London, 1953).

W.B. Yeats, Norah McGuinness and Irish Modernism

I was still a student at the College of Art when I first met W.B. Yeats. It was at the Arts Club. I still retain a vivid impression of his appearance at this first meeting. He lived up to my young idea of what a great genius should look like. I was greatly impressed.

Shortly afterwards I was brought to his house in Merrion Square to see a performance of one of his Noh plays, I think. Naturally I was very much in awe of him but on all the following occasions I found him exceedingly kind and considerate. About this time he asked me to do masks and costumes for his Noh play – 'The Only Jealousy of Emer.' Edmund Dulac had previously done some very beautiful masks for him which he showed me. I did the masks – baking them in my gas oven!

The play was to have 2 performances in the Abbey Theatre produced by the Dublin Dramatic Society.

'Recollections of William Butler Yeats. By Norah McGuinness' (c. 1926)[1]

A discussion of gender and the decorative arts is relatively untouched in histories of Irish art. And yet scholarship on the role of women in stage design, book illustration and the more 'ornamental' genres is growing in the history of art in England, Scotland and other cultural contexts.[2] As Janice Helland has argued, women producers effectively displaced the idea of 'individual genius' (associated with male-produced art), through *collaborative* projects, and evidence seen in the Dun Emer and Cuala Industries supports her conviction.[3]

Within the confines of a male-dominated society, Elizabeth Yeats's early agendas in book design and publication (in tandem with Gleeson and Lily Yeats's aims in textiles) were to provide employment for local girls, to encourage an Arts and Crafts ethos in an Irish context, and to disseminate the Irish Cultural Revival. By the 1920s, however, women artists such as Norah

McGuinness, Mainie Jellett (1897–1944) and Evie Hone (1894–1955) fought for both equality and the early promotion of Modernism in Irish painting. The main difference between their generation and Gleeson's lay in the fact that by the 1920s, women had more independence and opportunities to travel and pursue their careers. As fine artists and as women, they were expected to paint 'pussy wussies and doggie woggies',[4] but instead they pioneered abstraction in Irish painting through creation, collection and display.

A fresh and detailed appraisal of McGuinness's career expands upon the existing discussion of gender and the decorative arts in Ireland. It instances an important collaboration between an artist (McGuinness) and a poet (WBY), and reveals how word and image relationships, discussed in the context of the Irish Cultural Revival, became metamorphosed into one form of Irish Modernism.[5] The artist and poet met in the early 1920s when McGuinness was a student at the Metropolitan School of Art in Dublin, and when WBY was developing his interest in Japanese Noh dance plays.[6] By then, his focus had changed from the public stage of the Abbey to the more intimate setting of the drawing room, and the incantatory role of rhythm, noted in his poetry, was being extended into drama through dance.[7] In 1916 he had produced his dance play, *At the Hawk's Well*, in the drawing room of Lady Cunard in Cavendish Square, London. Edmund Dulac designed the costumes and masks, and the Japanese dancer, Michio Ito, performed the play. Not only space but also time was manipulated, enhancing the symbolic aspects and stimulating the audience to visualize images in the mind's eye.

In early 1926, just after WBY had published *A Vision* for the first time, the young artist McGuinness was invited to the poet's house in Merrion Square. During dinner, his wife George and the children, who were suffering from measles, were kept upstairs while WBY talked about *A Vision* to McGuinness, despite the fact that she had not read it.[8] In the aftermath of their discussions, WBY invited her to stay and participate in his 'Monday night' gathering with the young writers Frank O'Connor, Seán Ó'Faoláin and others. McGuinness records that she was embarrassed by her lack of knowledge about literature, but that in fact Ó'Faoláin had thought she was 'the worst blue stocking they had ever seen and were quite terrified of her'.[9] Despite her apparently intimidating mien, however, McGuinness's first commission from WBY ensued – the set design and costumes for a performance of *Deirdre* at Dublin's Abbey Theatre in March 1926.[10] Later in the same year, he invited her to contribute to an Abbey production of *The Only Jealousy of Emer*, designing the costume and masks for the 'Woman of the Sidhe' and 'Cúchulainn'.[11] But over time, McGuinness found stage design 'too transitory – meaningful to-day; broken up tomorrow, it is an appalling, thankless job and directors can never make up their minds',[12] and in the late 1920s, this aspect of her career, along with her painting, was replaced by book illustration for a few years.

Early in her career McGuinness was strongly influenced by the work of stained glass artist and illustrator Harry Clarke (1889–1931) (whose work was in turn derived from the *décadent* illustration of Aubrey Beardsley [1872–98]), and it was not until the early 1920s that she encountered Impressionist paintings and the work of Cézanne, Van Gogh and Braque for the first time.[13] Following a period of study at Chelsea Polytechnic, working within the financial and institutional confines of her situation, McGuinness gained an income and a reputation in the world of literature and the decorative arts before she did so in painting, and she explored abstraction through these media at a time when Irish critics were condemning abstract painting.[14] To record her contribution to Irish visual culture faithfully, therefore, requires analysis not only of the few later oil paintings represented in major collections, but also of the less often acknowledged art and artefacts which she (like many women artists of her time) produced, not least in her book illustrations.[15] Key to this discussion is the important commission from WBY to illustrate his new book, *The Stories of Red Hanrahan and the Secret Rose*, published by Macmillan in August 1927 (Figure 3.1).[16] In this monograph, McGuinness's 1926 book cover and illustrations provide an especially important instance of writer and illustrator working together, demonstrating not only aspects of David Peters Corbett's 'collaborative resistance',[17] but also the role that a woman artist played in the conception and reception of WBY's book.

Writer and Illustrator: *The Stories of Red Hanrahan and the Secret Rose*

WBY first mentions McGuinness as a potential book illustrator in a letter of April 1925 to Sir Frederick Macmillan, in which WBY gave his views on book illustration. It also contextualizes the importance of the ensuing commission for the young McGuinness:

> You spoke of the work of Miss Norah McGuinness, the artist, and asked me if I could suggest a book for her to illustrate. I don't want any of my own work done for I always refused illustrators and would give offence if I made an exception. Have you ever thought of reprinting what was once Le Fanu's most famous book 'With a Glass darkly' [sic]? It is a book of ghost stories, and I have often tried to get a copy. It has long been out of print and so I may exaggerate its merits. I am confident however that it would suit the talent of that particular artist and there has been a revival of interest in Le Fanu of late.

But a series of letters between poet and publisher over the following two years show that WBY changed his mind.[18] Eventually, he wrote to McGuinness (by then Mrs Phibbs) inviting her and her husband Geoffrey to dinner, stating that he had in mind a new edition of *The Stories of Red Hanrahan and the Secret*

3.1 Norah McGuinness (1901–80), book cover, W.B. Yeats, *The Stories of Red Hanrahan and the Secret Rose* (London, 1927)

3.2 Norah McGuinness, frontispiece and title page, W.B. Yeats, *The Stories of Red Hanrahan and the Secret Rose* (London, 1927)

Rose (Figures 3.1 and 3.2), decorated with Byzantine-style illustrations, no doubt influenced by a six-week tour of Sicily and Capri with George Yeats in 1924. Afterwards he wrote to Macmillan:

About a year ago you asked me if I would care to have a book of mine illustrated by Miss Norah McGuinness, a young artist whom I had just recommended to you, and who has since illustrated your edition of Sterne's 'Sentimental Journey'. I said I had always objected to having my work illustrated, which was quite true, but was only true because I was in dread of having my tales emptied into some very British nursery. I suggested to Miss McGuinness the other night that she might, if you cared for the idea, illustrate some stories of mine in the style of Byzantine wall pictures – we spent the evening looking through photographs of Sicilian mosaics and the like, and she went away full of ideas. The reason why I want Byzantium is that there was great Byzantine influence upon Ireland. In two Irish private collections there are wooden crucifixes entirely Byzantine in type and of great beauty, and these crucifixes continued to be made in North Connaught & perhaps elsewhere until about 80 years ago.

I think that there are two sections in my Early Poems & Stories either of which would suit admirably for a first experiment. I would suggest a little book containing Red Hanrahan and The Secret Rose stories. I think this should make a book about the same size as the 'Sentimental Journey', or, if you preferred you could begin with the

Celtic Twilight which is perhaps better known but not so suitable for illustration. On the other hand, the two sections could be put together if you wanted a longer work.[19]

Clearly one of the main motivations behind WBY's proposal lay in his appreciation of Byzantine art and the importance he attributed to it in Ireland. Byzantine art (created in the Eastern Empire from the sixth to the fifteenth centuries) had been of increasing interest to the poet for some time. When he travelled to Ravenna with Lady Gregory on a tour of Northern Italy, he had encountered Byzantine architecture, characterized by decorative arches, domes and colourful mosaics. Then after 1918, he embarked on the historical study of the city and culture of Byzantium, and the art of this period became important to his writing. His linking of Byzantium and Ireland has been accounted for in several ways. R.F. Foster suggests that Byzantium's break from Rome could be perceived as an echo of Ireland's from imperial England (as analysed by T.R. Henn), while the *Book of Kells* (c. 800) and a decorated crozier, contemporaneous with (the middle and late periods of) Byzantine art were artefacts admired by WBY in the National Museum.[20] Further evidence is located in a short address of 1926 to the Guild of Irish Art Workers at their annual Christmas exhibition, in which WBY linked Byzantine art to Celtic art by reminding listeners that Celtic ornament was part of the great Byzantine civilization. He advised workers to become learned in their craft, for 'they had their own civilization to look back to; they had the examples of the great Irish art of the Middle Ages'.[21]

Evidently, the link between Byzantium and Ireland remained significant in Irish culture for some time.[22] In 1907, Evelyn Gleeson had found affinity between Byzantine arts and early Irish Celtic art in her paper for the Irish Literary Society, and by aligning himself with Byzantine art, WBY also manifested the importance of the *visual* arts for his writing.[23] It is arguable that his conception of the poems 'Sailing to Byzantium', and later 'Byzantium', were based on visual (more than verbal) iconography and ideals.[24] Yet by 1927, 'Byzantium' meant many different things to the poet, and it is interesting to consider what conception of the city and its culture inspired *The Stories of Red Hanrahan and the Secret Rose*, and how this related to McGuinness's artistic understanding of it. There is no evidence that McGuinness made an in-depth study of Byzantine art in the way that WBY had. However, he may have shown her his photographs of mosaics in Ravenna and recent holiday photographs from Sicily (Figure 3.3), as well as one of his books on Byzantine arts, that evening in Merrion Square.[25] O.M. Dalton's *Byzantine Art and Archaeology* (1911), which was in his collection, could equally describe the stylized cover design by McGuinness:

It is greatest, it is most itself, when it frankly renounces nature; its highest
level is perhaps attained where, as in the best mosaic, a grave schematic
treatment is imposed, where no illusion of receding distance, no preoccupation
with anatomy, is suffered to distract the eye from the central mystery of

the symbol. The figures that ennoble these walls often seem independent of earth; they owe much of their grandeur to their detachment. They exert their compelling and almost magical power just because they stand on the very line between that which lives and that which is abstracted.[26]

Many of these ideas are at work in WBY's poem 'Sailing to Byzantium'. The speaker in the poem takes 'Ireland', mortality and the body as his points of departure ('That is no country for old men …') and travels to an imagined Byzantium in an attempt to transcend the effects of old age ('And therefore I have sailed the seas and come / To the holy city of Byzantium'). As Donald Gordon and Ian Fletcher have explained:

The personal application of the symbol is intensified by Yeats's obsession with old age, change, decay and death, and with the wisdom that outlasts them. The symbol, then, expresses the permanence of the artist in the perfection of his artifices; but it contains more than this, for Byzantium, at its highest point, represented for Yeats a civilization in which all forms of thought, art and life interpenetrated one another, and where the artist 'spoke to the multitude and the few alike'.[27]

A letter from WBY to Macmillan explains how 'Sailing to Byzantium' came to be included in his illustrated book:

Miss McGuinness tells me that you would like to have my poem 'Sailing to Byzantium' as a prelude to the volume of my stories which she is illustrating. I thought first of doing a preface to explain why I put it there but I think the dedication to the maker of the pictures a better explanation.

I enclose the poem which should be followed by 'To the secret Rose' the old preface to the book. 'To the secret rose' should be dated 1896, I have dated 'Sailing to Byzantium' 1926.[28]

Although the publisher initiated the inclusion of the poem, WBY clearly felt comfortable linking it to the young illustrator and her pictures. When this decision was made, McGuinness was in the process of producing illustrations consolidating the link made by WBY between Byzantium and Gaelic Ireland in his writings.[29]

McGuinness's contract was secured in January 1927, and stipulated that she was to be paid £100 on delivery of the images.[30] Adapting her style to the poet's needs, she adopted a different aesthetic to past commissions by employing simplified, geometric shapes. They are not composed within a traditional perspective, but rather exaggerate the flatness of the picture plane by appearing to 'float' in an undefined space.[31] In February 1928, WBY wrote to Lady Gregory:

I am sending you the new edition of Red Hanrahan with the archaic illustrations. I lent the artist a lot of Byzantine mosaic photographs and photographs of old Irish crucifixes and asked her to re-create such an art as might have been familiar to the first makers of the tales. The result is I think amusing and vivid.[32]

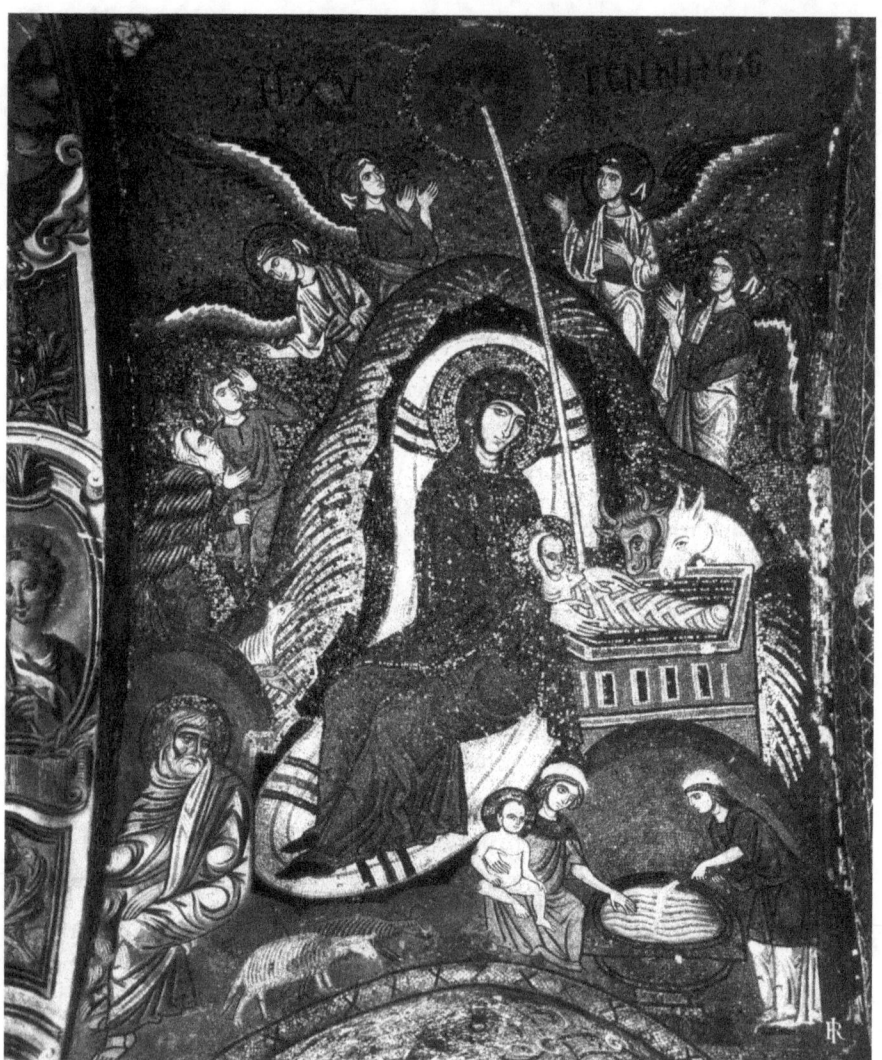

3.3 Photograph which belonged to W.B. Yeats, 'Natività di Gesù', Church of the Martorana, Palermo

McGuinness's illustrations may have been 'amusing and vivid' to the poet, but the evidence questions the extent to which she 're-created' the art of the photographs he showed her. There are approximately twelve such photographs amongst Yeats's Library, held in the National Library of Ireland,[33] and one of these is reproduced here for comparison (Figure 3.3).

Beyond her appropriation of the flatness of the picture plane, the stylization of the figures and faces and the departure from naturalism, McGuinness has

borrowed some ideas for composition such as the cave and the placing of figures around it. Her simple designs and limited colour range do not embrace the sophistication and spirituality inherent in the Byzantine mosaic, but she successfully adopts the 'framing' (to borrow Foster's term) of WBY's text using images in Byzantine style at intervals throughout the book. The effect is that her illustrations re-enact the function of iconographic Byzantine church wall paintings, based on the liturgy.[34] The best recreation of 'Byzantium' by both poet and painter can be seen in the book cover of *The Stories of Red Hanrahan and the Secret Rose* (1927), which was bound in blue leather and embossed with gold (Figure 3.1). It was a style influenced by William Morris, in keeping with Arts and Crafts principles and with Dun Emer and Cuala books, and demonstrated a concern for craftsmanship and fine materials. It also presents an artistic equivalent of the cloisonné technique (coloured enamel within gold frames) used in Byzantine art, and in early Irish metalwork such as the *Ardagh Chalice* (c. 800–899 AD).[35] Morris and his followers adopted the technique because they had been drawn to Byzantium through the decorative arts in particular. An emphasis on pattern over mimetic representation is evident in Morris's tapestries, book decorations and interiors, just as it is in WBY's book cover.

When WBY commissioned Gyles to produce the book cover for *The Secret Rose* (1897) (Figure 1.3) in the 1890s, he described her as being amongst poets 'who seek to express indirectly through myths and symbols, or directly in little lyrics full of prayers and lamentations, the desire of the soul for spiritual happiness. ... Her drawings and book-covers, in which precise symbolism never interferes with beauty of design, are as yet her most satisfactory expression of herself'.[36] The cover of *The Secret Rose* incorporates the hermetic imagery of a cross and rose, with the 'tree of life' and kissing faces. By contrast, McGuinness's cover for the later publication, *The Stories of Red Hanrahan and the Secret Rose*, encompasses two stories and combines characters from both. Beyond this, the difference in design indicates a change in the aesthetic interests and intentions of the author himself between 1898 and 1927.

Gyles's cover for *The Secret Rose* emphasizes the symbolic qualities of the writer's work, and presents a recognizably 'Irish' design. She uses the symbols of the tree of life, the serpent and a four-leaved flower motif, also seen in the rose and cross design on the cover of WBY's *Poems* (1899), and employs complex interlacing designs both above the skeleton prostrate on the sarcophagus, and in the 'tree of life' itself. Cable patterning appears along the border and Celtic-designed lettering is used throughout. All of these designs have a lineage in early Irish book illumination, although Gyles has avoided using rigid geometry and symmetry. By contrast, McGuinness's design (Figure 3.1) is simple and strictly geometric, reminding us of Charles Ricketts's work, which is characterized by the use of the vertical line and emblem rather than decoration, and although her flower motif is stylized

and emblematized in a way similar to that in the first edition, it now has five petals. The sword, which appears on the spine of the first volume entwined with a rose, is now held by Hanrahan, whose face is more stylized than the kissing faces emerging from the tree in the first volume, and is more in keeping with the flat, mask-like and primitive qualities of Byzantine mosaics and wall painting. Furthermore, the typography in the McGuinness illustration has moved away from Celtic lettering to the more classic style used by Macmillan.

In his essay 'A Symbolic Artist and the Coming of Symbolic Art' (1898), WBY pointed out that 'the Rose' was Gyles's central symbol.[37] Richard Ellmann has analysed the symbolism of WBY's rose and made a detailed examination of Gyles's book cover for *The Secret Rose*.[38] He describes the four petals as, chiefly, the four elements, the three roses at the top of the tree representing the three principal states of being (Sephiroth).[39] As with many of WBY's symbols, the rose unfolds itself to his readers, as it mutates from one text to the next. In McGuinness's cover for *The Stories of Red Hanrahan and the Secret Rose*, the symbolic element seems to have been reduced, and the implication is that by 1926–27 WBY had shifted his focus from the Romantic 'Twilight' symbolism of the late nineteenth and early twentieth centuries, to 'Byzantium', with all its connotations of unity, craftsmanship and transcendence. This shift is indicated by the disappearance of the 'tree of life' seen in Gyles's design, the use of the rose as an emblem rather than a central motif, and the inclusion of two embossed, golden birds either side of a crucifixion figure.[40] There are also fish either side of the figure, and dots (perhaps signifying meteors or mosaics) on the inside of the domed area above the figure's head. The golden birds at each side of the cover face inwards, and are a feature in Byzantine art. McGuinness's birds are, however, herons (repeated on pages 154, 155 and 156 of the text), an allusion to the herons in the section 'Old Men of the Twilight' in the stories.[41] This 'golden bird' motif (representing the purified soul in Hermetic imagery) was to become a key symbol in WBY's later poem 'Byzantium'.

Turning to the inside of the book, other new departures from both his earlier text and from his father's 1897 illustrations (Figure 1.4) are apparent. In the preface to *Mythologies* (1925), WBY describes the first version of *The Secret Rose* as being 'written in that artificial, elaborate English so many of us played with in the "nineties"', whereas in his later edition, he worked with Lady Gregory to make changes towards a simple English style 'learned from her Galway countrymen'.[42] Colin Meir highlights several significant instances of this change in style, citing, for example, this passage from 'The Twisting of the Rope' in the 1897 edition of *The Stories of Red Hanrahan*:

There is a moment at twilight in which all men look handsome, all women beautiful, and day by day as he wandered slowly and aimlessly he passed

deeper and deeper into that Celtic twilight in which heaven and earth so mingle that each seems to have taken upon itself some shadow of the other's beauty. It filled his soul with a desire for he knew not what, it possessed his body with a thirst for unimagined experiences ...

This writing style is quintessential 'Celtic Twilight' literature of the Irish Renaissance, with its shadowy, shifting images and light, muted tones, unconscious imaginings and spiritual insight. By contrast, the 1904 edition of the story presents what Meir describes as a 'more down-to-earth picture of the "rough clad peasant": what he feels is evoked by the details of his experience, not by an encumbrance of "Celtic Twilight" dreams'.[43] This change in style and intention is developed further in WBY's 1927 edition of *The Stories of Red Hanrahan and the Secret Rose*, with its shift towards Byzantine art and new choice of illustrator.

A series of letters from WBY regarding the commissioning of McGuinness's book illustrations, overlooked by most Yeats scholars, are not reproduced in publications of his letters, such as Allan Wade's *The Letters of W.B. Yeats* (1954). Yet they reveal significant instances of 'collaborative resistance' between poet and illustrator.[44] The first in the series, written around 1926, explains the kind of stylization of the Tudor rose used by McGuinness in both her book cover and her illustrations, and highlights the restrictions under which she was working:

I think your own work is excellent but the method and colour reproduction destroy it. The effect of your colour design depends upon the variety of tint in the colour masses. Had you worked for this three colour process you would have had to break up the flat colour with patterns, or in some similar way – I have seen Dulac spend days on a pattern made by the scales of a fish – but your method is different. You work by suggestion not only in your colour but your design. Your hand and finger convention, for instance, would not go with patterns which by nature is the opposite of suggestion. A Tudor Rose, for instance, must be completely realized in its convention like a letter of the alphabet [...] I saw a colour reproduction of a drawing by my brother in a shop window yesterday – the frontispiece to a book of West of Ireland Sketches – which gave all the variety of the kind you want.

If you cannot get a right process do without colour. If the right process is too expensive suggest one only in colour (the three women and Hanrahan and the hounds). That design needs colour greatly and would help the book as a frontispiece.[45]

An examination of the 1927 publication shows that McGuinness paid heed to the advice: her frontispiece of the women, Hanrahan and the hounds is in colour, the majority of illustrations in the text are black and white, and a compromise must have been reached to include full-page, coloured illustrations for certain chapters, including 'The Crucifixion of the Outcast' (Figure 3.4).[46]

3.4 Norah McGuinness, illustration, 'The Crucifixion of the Outcast', in W.B. Yeats, *The Stories of Red Hanrahan and the Secret Rose* (London, 1927), pp. 88–9

The second letter in the series indicates the poet's increasing satisfaction:

I wired to you when I got your letter from Dublin but the storm had broken the wires. And then your parcel of book covers came. You have made a fine design and thereby done a great deal for the success of my book, but you have not told me which colour you yourself prefer. We are both of opinion that the darkest blue is best. It is a fine colour in itself and shows up the gold. You might send me a postcard to say if Macmillan allowed you to do that second coloured picture you thought of.[47]

The next then confirms his delight:

Your pictures in 'Red Hanrahan' have been a great pleasure to me and I think exactly right. I like their powerful simplicity. I especially like that facing page 73 ... the little design facing page 82, and those after the half-title 'Proud Costello' etc. But indeed I like them all. Lady Gregory especially likes that to 'The Heart of Spring' ... You have done me a great service and I thank you.[48]

WBY's approval of the new designs marks a change in his views on book illustration. Gyles's book cover for *The Secret Rose* functions as a talismanic image with spiritual, symbolic and imaginative qualities (the 'tree of life', the large rose, the skeleton, the kissing heads), whereas McGuinness's book cover design signifies both the tangible world (figures, birds, fish) and the other-worldliness of Byzantium (the dome, the crucifixion and the use of gold embossing).

The differences between *The Secret Rose* of 1898 and *The Stories of Red Hanrahan and the Secret Rose* of 1927 go beyond these impressive book covers, however, to the illustrations by JBY and McGuinness within the text. JBY provided illustrations for the first book, and these were retained in the 1905 reprint. They are Pre-Raphaelite-Symbolist in style, and contrast greatly with McGuinness's images, especially the two frontispieces. In his frontispiece, JBY provides an iconic image of Symbolism, the severed head (Figure 1.4), while McGuinness presents a stylized picture (Figure 3.2). Both retell the first few pages of WBY's story, but the first one recalls links

between father and son, in respect of their allegiance to Symbolism. Both illustrators provide full-page images to introduce the different sections of the text. JBY illustrates 'The Crucifixion of the Outcast' (Figure 3.5), 'Out of the Rose', 'The Curse of the Fires and of the Shadows', 'The Heart of the Spring', 'The Twisting of the Rope and Hanrahan the Red' and 'The Rose of the Shadow', each with a single, representational image in watercolour.

By contrast, McGuinness uses three pages to introduce each section: her strategy functions as a sort of 'storyline', with the first two pages featuring single figures in action, and the third a more complicated design.

A comparison of the illustrations for 'The Crucifixion of the Outcast' by each artist is revealing. Firstly, each image occupies an entire page and is situated at the beginning of the chapter. However, JBY's illustration is located on the second page of the chapter (Figure 3.5), while McGuinness's precedes a title page (Figure 3.4). The location of JBY's illustration suggests that it is 'secondary' to the text, but the location of McGuinness's illustration infers its importance. Secondly, JBY painted a vigorously expressive portrayal of human suffering on the cross, a scene reminiscent of Jesus's crucifixion, and the emotional impact is heightened by the expression on the Outcast's face, by the ravens pecking at the cross and by the running dogs.[49] By contrast, McGuinness's simplistic depiction of the crucifixion is in keeping with the other-worldliness of Byzantine art and the dedicatory poem, and portrays transcendence from the earthly body through art as its theme. Her figures are stylized, the facial expressions are simplified with downcast or smiling mouths, the composition is very symmetrical, and the colour range of blue, green, yellow and brown is not obviously portentous. Also, her use of yellow for the cross is reminiscent of gold, which, in conjunction with blue, suggests Byzantine imagery.

3.5 John Butler Yeats, illustration, 'The Crucifixion of the Outcast', in W.B. Yeats, *The Secret Rose* (New York and London, 1897), facing p. 36

It may be fair to conclude that in draughtsmanship, McGuinness's talent is far inferior to JBY's. Her illustrations are much less nuanced, but they do invite the reader's involvement with the text. JBY's frontispiece to *The Secret Rose* illustrates several pages of text, and makes sense only in retrospect, whereas McGuinness's chapter title pages are each followed by a sequence of illustrations that introduce the theme of the chapter. For example, the title page of 'The Twisting of the Rope' is followed by a series of single-image dancing figure illustrations on consecutive pages, then a full-framed illustration, followed by the beginning of the chapter text. Their sequence functions like a narrative, where meaning is signified gradually as a story unfolds (or the rope becomes twisted). In effect, this type of illustration involves the reader/viewer in a more imaginative way than the traditional type of illustration provided by JBY.

WBY was pleased with McGuinness's illustration, but contemporary critical comment was negative. *The Times* pronounced:

In a new prefatory poem to this book of early stories Mr Yeats reasserts the quest of 'unageing intellect' ... works back to the hard or bright in image, whether of altar stone or metal. ... The illustrations in colour and line by Miss McGuinness are in harmony with that later mood of return rather than with the text. A modernized influence of the Primitives is apparent in them, but their art, being an inconsistent reduction to symbolic simplicity, is at best a negative one.[50]

A critic for *The Spectator* similarly made a disparaging comment:

To open this reprint of some of the stories of Mr Yeats' early period is to recover a past experience of glamour. Once more the Celtic Twilight is stealing amethystine over the 'nineties while the black and gold banners of the décadents droop back to the Venusberg ... The Byzantine modernism of Miss Norah McGuinness, as illustrator, is slightly disturbing. Some of the black and white patterns are charming, some are merely grotesque, none can suggest the images evoked by the stories to the fanatics of Mr Yeats' earlier work.[51]

The critic's phrase 'Byzantine modernism' is significant, because it draws attention to shared aesthetics. By eliminating Renaissance perspective and ideals, Modernist art links with Byzantine art both physically and spiritually, which implies that contemporary Irish critics were beginning to accept the concept.

Yet this change prompts queries about where McGuinness's experimental style sprang from, and whether evidence can be found to link it with abstract painting. In 1926, references to Modernism were made in relation to McGuinness's curtains for *Deirdre*. One critic wrote: '... I did not particularly care for the curtains, but they served to throw into relief the costumes, which had a fine barbaric remoteness',[52] and concerning her backdrop curtains for an Abbey production of Oscar Wilde's *The Importance of Being Earnest* (first performed in 1895 in London), the same critic commented:

My only quarrel with the fantastic garden scene is that Miss Norah McGuinness, when she let her imagination run riot, forgot that her job was to provide a back-ground, and splashed colour in a fashion that, instead of heightening the appeal of the acting, left the impression of forlorn and irrelevant figures battling feebly against a sea of paint.[53]

This reception of McGuinness's curtain design reveals that she was considered too experimental, too Modern for the contemporary audience. However, her costume design was perceived to be more in keeping with WBY's style of writing.[54]

McGuinness, like Jellett and Hone, is remembered for her early abstract painting. In 1923 she travelled to London and saw for the first time an exhibition of work by the French Impressionists, and the following year she spent several months studying at Chelsea Polytechnic. Anne Crookshank attributes her departure from Dublin in 1924 to her introduction to Modern art, and speculates that in Chelsea the artist 'saw and absorbed the great changes that followed on impressionism'.[55] Further evidence lies in an interview for *The Irish Times*, in which McGuinness said that after visiting her first Impressionist exhibition, 'I was in a whiz about Cezanne [sic], Van Gogh and Braque; their colour almost knocked me sideways'.[56] Yet McGuinness, Jellett and Hone were part of a generation of Irish women artists whose desire to succeed as 'fine artists' was curbed within traditional hierarchies of the arts. Textual evidence proves that their struggle was in fact at odds with advancements in equal rights in other women's professional careers, a point made succinctly in an essay by the critic and poet Thomas MacGreevy:

Trinity College was the first university to grant degrees to women, the first woman elected to parliament in these islands was Madam Markievicz and at least one of the Dail Eireann's [sic] accredited representatives abroad has been a lady. But the Royal Hibernian Academy can apparently only titter at the idea of a woman artist.[57]

Working within the financial and institutional confines of her situation, McGuinness is a good example of an artist who was obliged to begin her career by gaining an income and a reputation in the worlds of literature and the decorative arts before her painting career became established (in the 1930s). As her illustrative career prospered, it became possible for her to explore abstraction but at a time when it was largely shunned in Dublin.

The Gender of Irish Modernism in Painting

A pertinent illustration of Irish resistance to European Modernism is to be found in the now well-known reception of Jellett's *Decoration* (1923) (Figure 3.6). When the picture was first exhibited at the Society of Dublin Painters in October 1923, academicians were horrified. The review in *The Irish Times* was

3.6 Mainie Jellett (1897–1944), *Decoration* (1923), National Gallery of Ireland, Dublin

headed 'Two Freak Pictures', and asked the reader to 'provide a solution'.⁵⁸ George Russell (AE) similarly described Jellett's work in his review in *The Irish Statesman* as 'a late victim to Cubism in some sub-section of this artistic malaria' and a 'sub-human art'.⁵⁹

By contrast, the critic MacGreevy, not long back from his post of *lecteur d'anglais* at the Ecole Normale Supérieure in Paris, continued to see things differently. He remembered Jellett 'in her studio in Fitzwilliam Square chain-smoking and discovering Irish nationality in terms of art history', and he interpreted her work as a combination of Modernism, religion and a search for national identity.⁶⁰ MacGreevy defined abstract principles, such as those seen in *Decoration*, in the following terms:

The problem was effectively to produce a work of art in which the illustrative element (human figures, animal figures, landscape, atmosphere), was eliminated; and which consisted in filling a given space with a composition in which forms, planes, colours, values, line and pattern were blended into a harmony that was sufficient in itself to provide the spectator with aesthetic interest and pleasure.⁶¹

In fact, MacGreevy was one of the few critics who gave *Decoration* a favourable reception in the press. In his well-known essay 'Picasso, Mamie [*sic*] Jellett and Dublin Criticism', he commented: 'in front of her very pleasant piece of Byzantine decoration the Dublin world of criticism gasped and asked "what does it mean? What does it symbolise?" And when you told them that it meant nothing, symbolised nothing, they could only say "Why exhibit it then?".'⁶² He compared the style to illuminations in the *Book of Kells*, or to a 'Hicks' chair: 'There is pattern in all these things, and it is either beautiful pattern or it is not', he stated, and went on to illustrate his point by analogy with literature:

In so far as we care for the art of writing, we read for the sake of words and phrases. In so far as we care for thought we read for the ideas that words and phrases convey. As for Miss Jellett, her words and phrases, her colours and her relating of them to each other that is to say, produced, it seemed to me, a pleasing harmonic effect.

MacGreevy helped to promote Modernism in the context of Irish visual arts, and he supported Modern art and literature equally. To his mind, Jellett and Hone were the 'first Irish artists not merely to study but fully to master and then to introduce into the practice of painting in Ireland the principles and the idiom of the modern French approach to the painter's problems'.⁶³ Interestingly, he also translated Albert Gleizes's 'Hommage à Mainie Jellett' of August 1948, a paper recounting the working relationship (which involved theorizing Cubism) between Gleizes and the young painters Jellett and Hone.⁶⁴ However, MacGreevy's advocacy of Irish women artists and Modernism stretched beyond the matriarchs, Jellett and Hone, to others who were overshadowed, including McGuinness, Mary Swanzy, Nano

Reid and Elizabeth Rivers. He described McGuinness's work in *The Irish Times*, for example, as 'somewhat eclectic but always interesting and very accomplished'.[65] At a time when the predominant discourse in art history was patriarchal and strongly linked to the Academy system, each of these critiques addresses gender issues in Ireland in a way that has been overlooked. In his paper 'Fifty Years of Irish Painting, 1900–1950', MacGreevy stressed the artistic importance of many Irish women artists who 'were quicker than the men to show the influence of the modern continental movement in painting', and continued to praise their rigour:

as time went on it became clear that Mainie Jellett and Evie Hone had accepted the new Parisian canons in art, not at all in order to épater les bourgeois, but purely with a view to submitting themselves to a rigorous discipline which, eliminating the merely journalistic element in painting, concentrated on aesthetic essentials. (I say eliminating 'journalese,' in painting, not literature in painting for literature in painting means, or should mean, that element which is not merely legitimate but unavoidable, the psychological, the personal content, the varying degrees and kinds of vitality with which a genuine artist cannot help informing his work).[66]

He went on to make the point that in Ireland a man 'stands a better chance of recognition and of increased orders that recognition brings, merely because he is a man', and suggested that '[t]he dissenting members of the board of the Royal Hibernian Academy might consider what the world will think if they persist in excluding women. It will think that it is because the women are better artists than they.'[67] Similar views can be read in exhibition reviews, such as that in *The Irish Times*, of the 1943 Irish Exhibition of Living Art: 'as is to be expected at an exhibition on the organisation of which women artists have had as much say as men, there is everywhere evidence of that elusive quality – good taste.'[68] So what was it exactly that MacGreevy appreciated in modern paintings by Jellett, Hone, McGuinness and others?

Terence Brown has singled out Mainie Jellett's 'Modern Art and the Dual Ideal of Form Through the Ages' (1931) and Samuel Beckett's 'Recent Irish Poetry' (1934) as 'the two indisputably modernist manifestoes issued by Irish artists in that decade'.[69] It is significant that Brown couples painting and literature in his discussion of Modernism in Ireland, but even more surprising that he does not refer back to MacGreevy's paper 'Picasso, Mamie [sic] Jellett and Dublin Criticism', written a decade earlier. There are many similarities in the contents of Jellett's and MacGreevy's articles. Both emphasize the two-dimensionality of Modern painting, a reaction against realism and materialism, and the impact of Cubism. MacGreevy published his essay in *The Klaxon*, a Dublin journal with a Futurist cover design that included seven articles on Modern art and literature.[70] The journal lasted only one issue, reflecting a resistance to avant-gardism in 1920s Ireland, but it did expose the aspiration of some painters and poets at that time for a universal *fraternité des arts* in Ireland.[71]

In 'Evie Hone and Mainie Jellett', MacGreevy observed that the two artists incorporated 'the idiom of the modern French approach to painter's problems', thus eliminating the 'illustrative element' in order to conceive a painting as a 'given space', filled with a harmonic composition of 'forms, planes, colours, values, lines and pattern'.[72] This forceful view confirms that for MacGreevy, Modern painting was characterized by abstraction, defined as a breakaway from traditional perspective.[73] Both MacGreevy and Jellett believed that after Paul Cézanne, painting could be free of representation and could render depth by the manipulation of shapes and colour within a given space. Jellett's *Decoration* (Figure 3.6) demonstrates this approach by abandoning traditional perspective. The composition consists of abstract shapes layered on top of one another using different colours, and framed within a pentagonal shape (reminiscent of an altar piece), the use of bright yellow an intimation of the gold leaf found in religious icons.[74] The flatness of the picture plane is also characteristic of the book illustrations that McGuinness produced for WBY, potentially situating the book as a piece of Modern art. But MacGreevy implies that the Modern artist must move away from illustration to advance their fine art, and this recalls Jack Yeats's need, in the mid-1920s, to produce less illustration for the Cuala Industries in order to progress with his painting career.

In terms of collaboration between word and image, *The Stories of Red Hanrahan and the Secret Rose* is perhaps more pivotal in Irish cultural history than first appears. Produced in 1926, the artist's illustrations were acceptable to Ireland's most esteemed writer, and were reproduced in a book that would attain wide distribution. This environment enabled McGuinness to project a new, Modern style into the public arena based on influences from France (the Impressionists; Cézanne, Van Gogh and Braque, seen at the 1923 London exhibition), England (Beardsley; studies at Chelsea Polytechnic) and Ireland (Harry Clarke), as well as Byzantine art. WBY's preoccupation with Byzantium at this time was also indicative of a new departure for the poet, and by implication for Irish writing, for even though the subject matter of the book was located within the category of Revival literature, its presentation was new. The astute critic's description of McGuinness's illustrations as 'Byzantine modernist' alludes to shared aesthetic preoccupations, but MacGreevy had made this coupling as early as 1923 in 'Picasso, Mamie [sic] Jellett and Dublin Criticism', when he described *Decoration* as a 'very pleasant piece of Byzantine decoration'. He did not then elaborate on the juxtaposition, but in 'Evie Hone and Mainie Jellett', he drew attention to the link between Jellett and Hone's work and Byzantine art:

> It is significant that their personal researches were carried out at
> Ravenna and Chartres, amongst the illuminated pages of the early
> manuscripts and the remains of Irish Romanesque and gothic [sic]
> architecture and sculpture, as well as in Paris and Florence. For in these
> the abstract element played its richly inventive, decorative part.[75]

MacGreevy then continued to focus on Jellett's work, describing how she paints:

without defining facial features, or even hands, in any detail ... endeavouring, through line and colour harmonies and eliminating what to her were extraneous aids, to convey something of the humanly devotional, yet gravely dignified, temper that gives Fra Angelico's work its universal and dignified appeal.[76]

The description could equally fit McGuinness's 'Byzantine' illustrations, or MacGreevy's own poetry – not least that written in response to the visual arts.

MacGreevy is best remembered as a friend and confidant of many leading literary and artistic figures in the first half of the twentieth century, including Jack Yeats, James Joyce and Samuel Beckett. In recent years, literary critics have developed a lively debate about Irish poetry of the 1930s, focusing on definitions of Modernism in an Irish context,[77] paying particular attention to Denis Devlin and Brian Coffey, or with reference to a stock list of MacGreevy's poems, notably 'Aodh Ruadh Ó Domhnaill' and 'Nocturne of the Self-Evident Presence'.[78] MacGreevy has been categorized as a 'Modernist' poet who experimented with techniques associated with Joyce, T.S. Eliot and Ezra Pound, but whose attempted Modernist disjunctions have had much less posterity.[79] Leaving questions of influence aside, however, what differentiates MacGreevy most from his contemporaries is his poems written after paintings.

In 1913, WBY had yearned for a time when 'all the arts play like children about the one chimney',[80] and MacGreevy's verbal and visual enquiries respond to this call. Before him, the manner in which Gleeson and the Yeats sisters engineered this was to produce art on a par with literature to achieve the aims of the Irish Cultural Revival. This they did within the confines of society through the decorative arts of weaving, embroidery and book illustration. By the late 1920s and early 1930s, relationships between poetry and painting in the Yeats circle had changed. WBY allowed his printed work to be illustrated by McGuinness, while in 1935 and again in 1937, he initiated *A Broadside (New Series)* through his sister's Press, incorporating word and image in new and interesting combinations. But it was the younger Yeats brother, Jack, who carried word and image relationships furthest towards a new, creative synthesis in the second quarter of the twentieth century, and MacGreevy was one of the first Irish art critics to champion his work.

MacGreevy's appreciation of Jack Yeats coincided with his praise for Jellett, Hone and McGuinness. Yet when contemporary paintings such as Jellett's *Decoration* (Figure 3.6) and Jack Yeats's *Communicating With Prisoners* (c. 1924) (Figure 3.7) are seen together, two very different styles are observed: the first is a Cubist painting, heavily indebted to the artist's experiences in France; the latter is a loose, experimental representation of an historic moment in Ireland.

3.7 Jack Yeats, *Communicating With Prisoners* (c. 1924), The Niland Collection, Sligo

The apparent antithesis in style, of 'Modern' and 'national', is rendered more complex by MacGreevy's observations and criticism. Investigating both his writings on the arts and his poems written after paintings advances our understanding of verbal and visual relations in the Yeats family circle.

Notes

1. Norah McGuinness, 'Recollections of William Butler Yeats. By Norah McGuinness', n.d. (NLI, Norah Allison McGuinness Collection, Acc. 5908).

2. See in particular Bridget Elliott and Janice Helland (eds), *Women Artists and the Decorative Arts 1880–1935: The Gender of Ornament* (Aldershot, 2002), and Karen E. Brown, 'Introduction', in Karen E. Brown (ed.), *Women's Contributions to Visual Culture, 1918–1939* (Aldershot, 2008), pp. 1–9.

3. Janice Helland discusses the Macdonald sisters in this respect. In the context of 1890s Scotland, the decorative arts presented women with opportunities not available elsewhere. The Macdonald sisters' work merged Celtic mysticism and Art Nouveau-inspired design, and was at the cutting edge of arts practice of the time (Helland, *The Studios of Frances and Margaret Macdonald* [Manchester, 1996]). Nicola Gordon Bowe is preparing a monograph on the stained glass and graphic artist Wilhelmina Geddes (1887–1955).

4. From an interview with Mary Swanzy, quoted from Marianne Hartigan, 'Irish Women Painters and the Introduction of Modernism', in James Christian Steward (ed.), *When Time Began to Rant and Rage: Figurative Painting from Twentieth-Century Ireland* (London, 1999), p. 64.

5. See Karen E. Brown, 'Norah McGuinness, W.B. Yeats and the Illustrated Book', in Brown (ed.), *Women's Contributions*, pp. 101–16.

6. WBY's attraction to *Japonisme* and the impact of it on his stage design arguably began in the 1890s when Symons showed him Japanese prints in the British Museum. It was quite some time later, in 1916, that the Cuala Press published versions of Noh plays adapted by Ezra Pound from Ernest Fenollosa. See R.F. Foster, *W.B. Yeats: A Life, Vol. II: The Arch-Poet, 1915–1939* (Oxford and New York, 2003), pp. 34–6.

7. For a discussion, see Donald James Gordon (ed.), *W.B. Yeats: Images of a Poet* ([Manchester, 1961] Westport, CT, 1979), pp. 56–80.

8. W.B. Yeats, *A Vision* (London, 1925). This incident is recorded in '"The Saturday Interview" Caroline Walsh talks to Norah McGuinness', *The Irish Times*, 1 May 1976, p. 5.

9. 'The Saturday Interview', *The Irish Times*, 1 May 1976, p. 5.

10. W.B. Yeats, *Deirdre. Being Volume Five of Plays for an Irish Theatre* (London and Dublin, 1907).

11. W.B. Yeats, *The Only Jealousy of Emer*. Produced by Lennox Robinson and staged for the Dublin Drama League's annual meeting at the Abbey Theatre, Dublin, 9 May 1926. See Steven Winnett (ed.), *The Only Jealousy of Emer and the Fighting of the Waves: Manuscript Materials by W.B. Yeats* (Ithaca and London, 2004), pp. xx–xxi. See also a cutting in the McGuinness archive, Thomas Bodkin, 'The Art of Norah McGuinness', *Studio* 1925/9, p. 168. In 1927, McGuinness also designed the set and costumes for Georg Kaiser's *From Morn to Midnight*, produced by Denis Johnston for the opening of the Peacock Theatre in 1927. This was translated by Ashley Dukes and staged by the New Players, 13 November 1927.

12. 'The Saturday Interview', *The Irish Times*, 1 May 1976, p. 5.

13. See Anne Crookshank, *Norah McGuinness: Retrospective Exhibition* (Dublin, 1968). For a discussion of Clarke's work, see Nicola Gordon Bowe, *Harry Clarke: His Life and His Work* (Dublin, 1989).

14. Paula Murphy observes: 'In newly independent Ireland, avant-garde art was considered too dangerously cosmopolitan, and had little immediate significance in a country that was trying to establish its national identity' (*Artists' Century: Irish Self-Portraits and Selected Works, 1900–2000* [Dublin and Belfast, 2000], p. 17).

15. McGuinness's painting *Garden Green* (1962) is held in the Municipal Gallery of Modern Art, Dublin. See Elizabeth Mayes and Paula Murphy (eds), *Images and Insights: Hugh Lane Municipal Gallery of Art* (Dublin, 1993), pp. 134–5.

16. W.B. Yeats, *The Stories of Red Hanrahan and the Secret Rose*, illustrated and decorated by Norah McGuinness (London, 1927).

17. David Peters Corbett, '"Collaborative Resistance": Charles Ricketts as Illustrator of Oscar Wilde', *Word & Image*, 10/1 [January–March 1994]: 22–37. See Chapter 1 of this book for a discussion of this term.

18. See also Karen E. Brown, 'Norah McGuinness, W.B. Yeats and the Illustrated Book'.

19. WBY to Sir Frederick Macmillan, 14 December 1926 (NLI, Norah McGuinness Coll.).

20. T.R. Henn, *The Lonely Tower: Studies in the Poetry of W.B. Yeats* (London, 1950), p. 222. The crozier referred to by WBY may have been the Clonmacnoise Crozier (late 11th–15th centuries), although there is no evidence to support this speculation. See Michael Ryan (ed.), *Treasures of Ireland: Irish Art 3000 B.C.–1500 A.D.* (Dublin, 1983), p. 67 and pp. 165–6. Foster quotes from notes to accompany a broadcast on 8 September 1931 (Foster, *Yeats, Vol. II*, p. 326, n. 105). Foster also draws our attention to how, in *A Vision*, WBY reiterated Morris's belief that the organic unities of Gothic art were Byzantine in origin (Foster, *Yeats, Vol. II*, pp. 328–9).

21. 'The Arts and Crafts. Christmas Exhibition in Dublin', *The Irish Times*, 7 December 1926, p. 5.

22. In her analysis of *A Vision* and the visual arts, Loizeaux highlights the impact that Byzantine ideals for unity of art and life had on the poet's work (*Yeats and the Visual Arts* [New Brunswick and London, 1986], pp. 118–34). WBY's Library contains over 130 books, journals and catalogues on art (NLI, Ms Coll. List 96).

23. Evelyn Gleeson, 'Fragment of an Essay for the Irish Literary Society, probably 1907' (TCD, MS 10676/5/9, p. 2).

24. '[T]he painter, the mosaic worker, the worker in gold and silver, the illuminator of sacred books,' wrote WBY, 'were almost unpersonal, almost perhaps without the consciousness of individual

25. design, absorbed in their subject-matter and that [sic] the vision of a whole people' (W.B. Yeats, *A Vision*, pp. 279–80).

25. WBY's photographs are held in his Library, NLI, Ms Coll. List 96. WBY's Library contains a wide range of books relating to Byzantium, including Edward Gibbon's *The Decline and Fall of the Roman Empire* (1788), W.G. Holmes's *The Age of Justinian and Theodora* (1905) and O.M. Dalton's *Byzantine Art and Archaeology* (Oxford, 1911). John Ruskin's *The Stones of Venice* (1853) describes the Byzantine church, St Marks. See Herbert J. Levine, 'Yeats's Ruskinian Byzantium', in Richard J. Finneran (ed.), *Yeats Annual*, 2 (New Jersey, 1983), pp. 25–34.

26. Gordon and Fletcher, 'Byzantium', in Gordon (ed.), *W.B. Yeats: Images of a Poet*, p. 85.

27. Gordon and Fletcher, 'Byzantium', in Gordon (ed.), *W.B. Yeats: Images of a Poet*, p. 86.

28. WBY, 82 Merrion Sq., Dublin, to Sir Frederick Macmillan, 23 August [c. 1927] (NLI, Norah McGuinness Coll.).

29. Thomas McAlindon prioritizes the influence of William Morris on WBY's conception of 'Byzantium' in his 'The Idea of Byzantium in William Morris and W.B. Yeats', *Modern Philology* (May 1967): 307–19, especially p. 311.

30. Macmillan to McGuinness, 6 January 1927 (NLI, McGuinness Coll.). The book was published on 11 November 1927. The edition consisted of 1,885 copies.

31. The single images on the pages leading up to 'The Twisting of the Rope' section offer clear examples. See W.B. Yeats, *The Stories of Red Hanrahan and the Secret Rose*, pp. 20–23.

32. WBY to Lady Gregory, 24 February 1928, in *The Letters of W.B. Yeats*, ed. Allan Wade (London, 1954), p. 737.

33. WBY Library, NLI, Collection List 96.

34. The art of storytelling through pictures was also characteristic of Byzantine book illumination. For a discussion, see Kurt Weitzman et al., *The Place of Book Illumination in Byzantine Art* (Princeton, 1975). WBY's letter to Macmillan evidences that Byzantine wall paintings and mosaics were discussed in Merrion Square on the evening that the illustration commission was conceived.

35. See Ryan (ed.), *Treasures of Ireland*, pp. 124–7.

36. W.B. Yeats, prefatory note to Gyles's contribution to *A Treasury of Irish Poetry* (Robin Skelton and Ann Saddlemyer (eds), *The World of W.B. Yeats: Essays in Perspective* [Dublin, 1965], pp. 153–4). The new cover for W.B. Yeats's *Poems* was produced in reaction to a cover produced by H. Granville Fell for *Poems* published by Fisher Unwin in 1895. WBY objected to the 'facile meaninglessness' of Fell's cover, and he continued to employ Gyles's cover for re-publications of *Poems* until 1929 (Skelton and Saddlemyer [eds], *The World of W.B. Yeats*, p. 153).

37. W.B. Yeats, 'A Symbolic Artist and the Coming of Symbolic Art', in *The Dome* 1/3 (December 1898): 235.

38. Richard Ellmann, *The Identity of Yeats* (London, 1954), pp. 62–84.

39. Ellmann, *The Identity of Yeats*, pp. 64–5.

40. WBY added a note to the fourth stanza of 'Sailing to Byzantium': 'I have read somewhere that in the Emperor's palace at Byzantium was a tree made of gold and silver, and artificial birds that sang' (W.B. Yeats, *The Collected Poems of W.B. Yeats* (New York, 1933), p. 450). Ellmann traces WBY's symbolic rose seen in Gyles's cover design to the meteor in his book *Oisin*, his poem 'The White Birds', and his play *The Shadowy Waters* (1900), in which the poet flees with his beloved in the form of a bird. He also links the symbol of the bird in 'The White Birds' with the golden bird symbol in the Byzantium poems. In WBY's work, explains Ellmann, 'although Byzantium is historically the holy city of Eastern Christendom, he makes it a secular city of the poetic imagination' (Ellmann, *The Identity of Yeats*, p. 149).

41. See Gordon and Fletcher, 'Byzantium', in Gordon (ed.), *W.B. Yeats: Images of a Poet*, pp. 81–90. The authors point out that when WBY and his wife George visited Rome in February 1925, the couple had admired the mosaic at La Zisa, Palermo, with two palm-trees between peacocks (emblems of immortality) (p. 83).

42. W.B. Yeats, *Mythologies* (London, [1925] 1959), p. 1.

43. Colin Meir, *The Ballads and Songs of W.B. Yeats* (London, 1974), pp. 69–70.

44. Foster acknowledges the collaboration as significant. He records that although WBY usually resisted the illustration of his work, he 'decided to "launch" McGuinness in an experimental artistic project, in which his early stories were framed by illustrations consciously modelled on Byzantine motifs' (Foster, *Yeats, Vol. II*, p. 326). The other three letters are reproduced in Crookshank, *Norah McGuinness*.
45. WBY to Mrs Phibbs [Norah McGuinness], [c. 1926] (NLI, Norah McGuinness Coll.).
46. Note that McGuinness's signature is now reduced to the monogram 'NmcG'.
47. WBY, Ballylee, Gort, to Mrs Phibbs [Norah McGuinness], 25 June 1927 (NLI, Norah McGuinness Coll.).
48. WBY, Albergo, Rapello, Italy, to Mrs Phibbs [Norah McGuinness], 13 March [1927] (NLI, Norah McGuinness Coll.). WBY's consultation with Lady Gregory regarding the book design is an interesting detail, because it shows that, as well as consulting her on the re-drafting of his stories for this later edition, he also consulted her about the illustrations.
49. I thank Dr Paula Murphy (University College Dublin) for pointing out the potential influence of the German artist-illustrator Lovis Corinth (1858–1925) on JBY.
50. *The Times*, c. 28 November 1927.
51. *The Spectator*, 28 November 1927.
52. J.W.G., '"Deirdre" Revived at the Abbey', 9 March 1926 (clipping, NLI McGuinness Archive).
53. J.W.G., 'An Abbey Revival. The Importance of Being Earnest', November 1926 (clipping, NLI McGuinness Archive).
54. See Karen E. Brown, 'Norah McGuinness, W.B. Yeats and the Illustrated Book', pp. 102–3.
55. Crookshank, *Norah McGuinness*, p. 5. Crookshank records that McGuinness did not meet Jellett and Hone until 1927.
56. 'Saturday Interview', *The Irish Times*, 1 May 1976, p. 5.
57. Thomas MacGreevy, 'The Position of Women Artists in Ireland' (TCD, MS 8002/21).
58. Bruce Arnold, *Mainie Jellett and the Modern Movement in Ireland* (New Haven and London, 1991), p. 80.
59. *The Irish Statesman*, 27 October 1923, pp. 207, 208.
60. Thomas MacGreevy, Untitled Memories of Mainie Jellett (TCD, MS 8002/7), pp. 1–2.
61. Thomas MacGreevy, 'Evie Hone and Mainie Jellett', n.d., [c. 1942] (TCD, MS 8002/4), p. 1.
62. Thomas MacGreevy, 'Picasso, Mamie [sic] Jellett and Dublin Criticism' (TCD, MS 8002/8), p. 2. Published in *The Klaxon* 1/1 (Winter 1923–24): 23–7.
63. Thomas MacGreevy, 'Evie Hone and Mainie Jellett', p. 1. In his review 'Dublin Painters' Exhibition: Expressing Irish Ideas', he also wrote:

 Though the Dublin Painters' Society includes some artists who are regular exhibitors at the Academy it does, in the main, tend to represent the break-away from the English academic canon that prevailed (in Ireland as in England) from the days of Joshua Reynolds to those of William Orpen, ... what Paris had to teach such artists as Nano Reid, Mainie Jellett, Norah McGuinness, Frances Kelly ... and others of the Dublin painters, was to be, to the highest degree of consciousness of which they were capable, their Irish selves (*The Irish Times*, 6 February 1942, p. 2).

64. TCD, MS 8002/5. Both versions are reproduced in Eileen MacCarvill (ed.), *Mainie Jellett, the Artist's Vision: Lectures and Essays on Art* (Dundalk, 1958), pp. 25–34; 35–56. Other papers by MacGreevy discussing European Modernist art include reviews of the Exhibition of Contemporary Art in Dublin in August 1944. See 'Art from the Continent', *The Irish Times*, 12 August 1944, p. 3.
65. Thomas MacGreevy, 'Norah McGuinness's Exhibition', *The Irish Times*, 8 October 1943, p. 3. See also Thomas MacGreevy, 'A Distinguished Painter: Mary Swanzy Exhibition', *The Irish Times*, Friday 19 March 1943, p. 3; Thomas MacGreevy, 'Nano Reid Exhibition: A Stylist in Art', *The Irish Times*, 27 November 1942, p. 3; Thomas MacGreevy, 'Elizabeth Rivers Exhibition', *The Irish Times*, 28 April 1942, p. 3; Thomas MacGreevy, 'Miss Sarah Purser's "One Man Show"' (TCD, MS 8002/10).

66. Thomas MacGreevy, draft of 'Fifty Years of Irish Painting, 1900–1950' (TCD, MS 8002/13), p. 9. Final version published in *The Capuchin Annual* (Dublin, 1949), pp. 497–512. The women artists critiqued by MacGreevy include Mrs Paul Henry, Mrs Harry Clarke, Mary Swanzy, Wilhelmina Geddes, Beatrice Elvery, Sarah Purser and May Guinness.

67. MacGreevy, 'Fifty Years of Irish Painting, 1900–1950' (TCD, MS 8002/13), p. 9.

68. Thomas MacGreevy, 'Living Art – A New Departure', *The Irish Times*, 16 September 1943, p. 3.

69. Terence Brown, 'Ireland, Modernism and the 1930s', in Patricia Coughlan and Alex Davis (eds), *Modernism and Ireland: The Poetry of the 1930s* (Cork, 1995), p. 30. See also Mainie Jellett, 'The Dual Ideal of Form Through the Ages', in MacCarvill, *Mainie Jellett*, pp. 64–7. Andrew Belis [pseud. of Samuel Beckett], 'Recent Irish Poetry', *The Bookman*, 86 (August 1934): 235–6. Rept. in Samuel Beckett, *Disjecta: Miscellaneous Writings and a Dramatic Fragment* (London, [1983] 2001), pp. 70–76.

70. MacGreevy, 'Picasso, Mamie [sic] Jellett and Dublin Criticism'. As well as MacGreevy's article, *The Klaxon* contains a photograph of a wooden African sculpture, a translation of Brian Merriman's 'The Midnight Court' by Percy Arland Ussher, an article entitled 'The Ulysses of Mr James Joyce', and poems by F.R. Higgins, F. Stuart and G. Coulter.

71. The editors proclaimed it 'an Irish International Quarterly, published in Dublin, concerned with the activities of all Nations in matters of Art, Music, and Literature' (*The Klaxon* 1/1 [Winter 1923–24], p. 1).

72. Thomas MacGreevy, 'Evie Hone and Mainie Jellett' [c. 1942] (TCD, MS 8002/4), p. 1.

73. His critique may be linked to another paper entitled 'The Daemon of French Painting' (1924), in which MacGreevy acknowledged the importance of developments in nineteenth-century French painting: '[T]he nineteenth century in France was more free, more experimental, more courageous in every sphere of human activity than almost any period in any country in the history of modern civilization – Cézanne completed the work begun by Delacroix – or as some maintain by Louis Gabriel Moreau – of emancipating French painting from the tyranny of the Italian Renaissance' ('The Daemon of French Painting', *The Dublin Magazine* [August 1924] pp. 30–34). For a discussion of the 'flatness' of the picture plane as the defining characteristic of modern art, see Clement Greenberg, 'Modernist Painting', in Francis Franscina and Charles Harrison (eds), *Modern Art and Modernism: A Critical Anthology* (New York, [1983] 1984), pp. 5–10.

74. For an interesting discussion of Jellett's work in relation to theology, see Gesa Elsbeth Thiessen, *Theology and Modern Irish Art* (Dublin, 1999), pp. 37–45; 125–30.

75. MacGreevy, 'Evie Hone and Mainie Jellett' (TCD, MS 8002/1), p. 2.

76. On another occasion, MacGreevy wrote that 'Byzantine art can be regarded as a reaching out to the eternal, to what was sublime and unalterable, unmoving, from a world that was collapsing, that was in fact the very synthesis of all that is sublime and unalterable' (untitled handwritten essay, n.d., [TCD, MS 8008/5]).

77. See in particular Coughlan and Davis (eds), *Modernism and Ireland*, including J.C.C. Mays, 'How is MacGreevy a Modernist?', pp. 103–28; Alex Davis, 'Irish Poetic Modernisms: A Reappraisal', *Critical Survey* (1996): 186–97; Edna Longley, '"Modernism", Poetry, and Ireland', in Marianne Thormählen (ed.), *Rethinking Modernism* (Basingstoke, 2003), pp. 160–79; Alan Gillis, *Irish Poetry of the 1930s* (Oxford, 2005).

78. Thomas MacGreevy, 'Aodh Ruadh Ó Domhnaill', first printed in *The Irish Statesman*, 6/8 (1 May 1926): 204–5; Thomas MacGreevy, 'Nocturne of the Self-Evident Presence', first printed in *The Irish Statesman*, 7/3 (25 September 1926): 57–8. Both poems were originally published using the pseudonym 'L. St Senan'.

79. Robert Garratt, for example, has linked MacGreevy's 'Crón Tráth na nDéithe' to Joyce's 'Sirens' chapter in *Ulysses*, given the mix of high and low culture (*Modern Irish Poetry: Tradition and Continuity from Yeats to Heaney* [Berkeley, Los Angeles and London, 1986], p. 96).

80. *E&I*, p. 355.

1 Jack Yeats, *Draughts* (1922), National Gallery of Ireland, Dublin

2 Jack Yeats, *Low Tide* (1935), Dublin City Gallery, The Hugh Lane

3　Jack Yeats, *Storm/Gaillshion* (1936). Private Collection

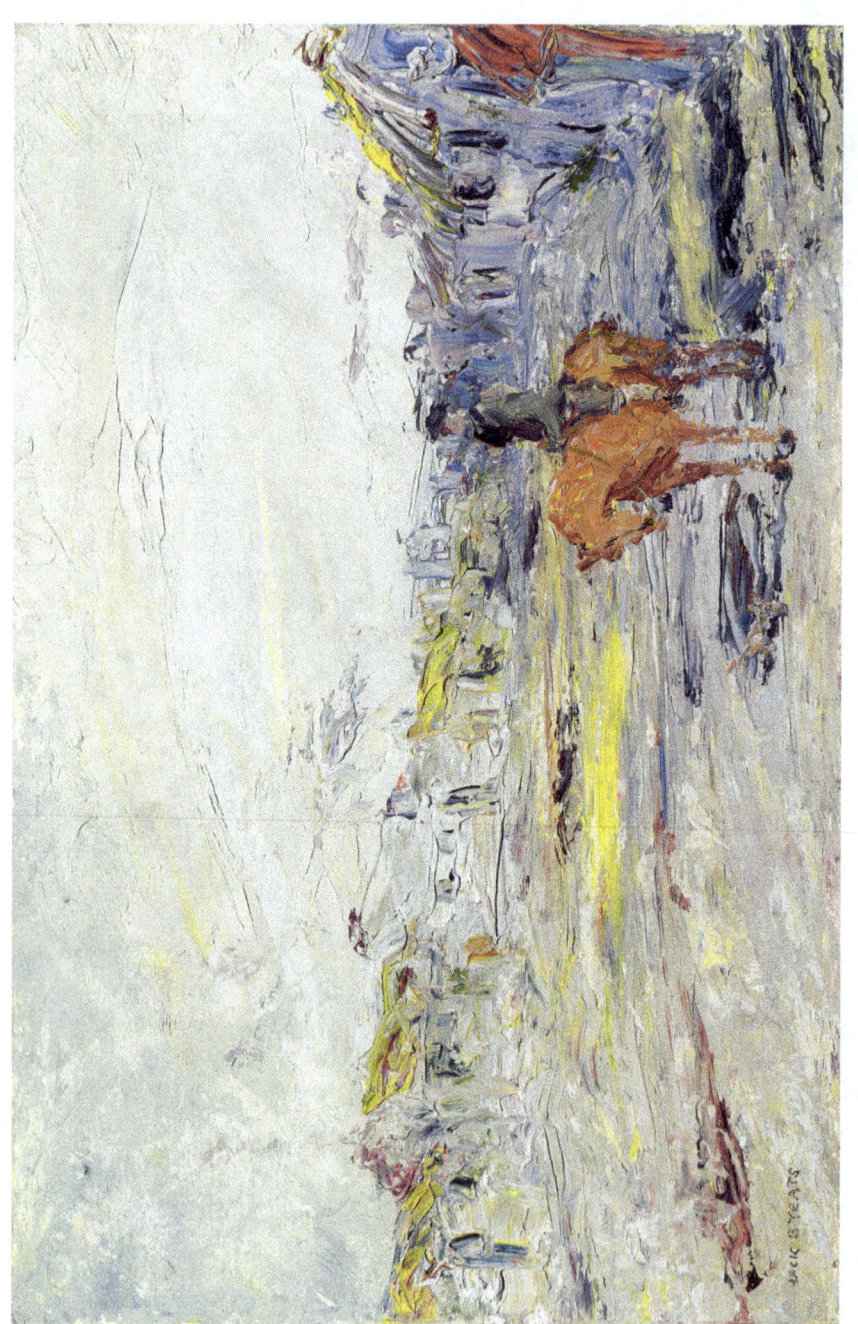

4 Jack Yeats, *A Morning* (1936), National Gallery of Ireland, Dublin

4

The Pictorialist Poetics of Thomas MacGreevy

Modern Irish writing – an extraordinary thing in a mainly Catholic
country – is almost entirely devoid of a visual sense. And yet
the greatest writing has always owed a great deal to painting,
as the greatest painting owes a great deal to literature.

Thomas MacGreevy, 'Apropos of the National Gallery' (1936)[1]

Investigations into the relationship between poetry and painting, the study of 'pictorialist poetics',[2] have been discussed at length in relation to France and England.[3] In the context of Irish Modernism, while the importance of the visual arts for the career of WBY is now well established, only a few critics have discussed post-Yeatsian examples of poetry after paintings and considered their significance for Irish literary and visual culture. MacGreevy is one example of an Irish writer who in fact wrote numerous poems in response to the visual arts. And yet this aspect of his work has been under-represented in both biographies and in debates concerning 1920s and 1930s Irish poetry.[4] His case study exemplifies the importance of these relationships for understanding the links between painting and poetry in early twentieth-century Irish Modernism, and for contextualizing the interdisciplinary career of Jack Yeats.

Like Baudelaire, MacGreevy was at once an art critic and a poet, and in his writings, both prose and poetry, he frequently interlaces a discussion of painting with that of literature to elucidate his points. Modern poetry, like Modern painting, began by playing with familiar traditional poetic and pictorial structures, and effectively broke down expectations to create a new art form capable of signification. For example, Baudelaire's poem 'Correspondances' (1857) manipulates the traditional sonnet form to create new poetic patterns; his poems after paintings by Delacroix re-enact the sensual qualities of oil painting, and his 'prose poems' break down definitions of literary genres. As David Scott has discussed, many poets in France at this time borrowed ideas from paintings perceived as being in harmony with their poetic goals.[5]

Yet such a discussion is missing in Irish cultural history. MacGreevy's work is a good example of the exchange between poetry and painting in an Irish context, and carries the analysis of relationships between word and image in book illustration and the decorative arts in the first quarter of the twentieth century into the arts of painting and poetry in the second quarter. To read his pictorialist poems in relation to associated art criticism is to gain new insights not only into them, but also into the roles played by word and image in the emergence of Irish Modernism.

MacGreevy's poetry cannot be categorized amongst Celtic Revivalist writers such as Austin Clarke or early WBY, for his subject matter is taken from actual events rather than mythology, and his poetic form is more akin to the fragmented images of T.S. Eliot and Ezra Pound. But the Ireland of his time was not receptive to his poems, which he published largely in London and France. Indeed, his only book of poetry, entitled *Poems*, was published in England in 1934, after which time he virtually ceased to write poetry at all.[6] In his provocative essay 'Recent Irish Poetry' (1934), Beckett discusses MacGreevy in relation to Denis Devlin and Brian Coffey as poets who left Ireland in the 1920s and 1930s to forge careers in Paris.[7] In 1981, Terence Brown revisited this topic when he wrote:

Their literary work ... has received little critical attention in Ireland or elsewhere. Its intellectual, often theological concerns, its unselfconsciously urban preoccupations, its modernist experiment, its assured familiarity with European civilization, set their work apart from what most Irishmen and women had come to expect from their contemporary writers. For these writers Ireland could be most herself not through a self-absorbed antiquarianism but through acceptance of her position as a European nation with links to the intellectual and artistic concerns of the continent. Their highly experimental work therefore represents an important strand in modern Irish literary and cultural history, which because of the prevailing nationalist ideology that celebrates the rising of a peasant people against oppression has become almost as hidden an Ireland as Corkery's eighteenth-century Munster.[8]

Brown's approach to 'Modernism' in relation to Irish culture also helps to contextualize the lack of appreciation for MacGreevy's poetry, both in his own day and subsequently:

Modernism, in as much as it can as a term provide descriptive insights on widely variegated phenomena, is radically internationalist in scope and vision, cosmopolitan in its dramatis personae. Its characterizing conditions are literary and artistic exile, déraciné, cosmopolitan and metropolitan rather than national foci, a highly self-conscious eclecticism and near-universality of cultural forms. A nationalist revolution values none of these things ...

Artistic and cultural expression in the Irish Free State in the 1920s and especially in the 1930s would certainly give the cultural historian apparently sufficient ground for concluding that modernism and post-colonial nationalism (another capacious and accommodating term) are antithetical in their manifestations.[9]

Brown, and more recently Alan Gillis, break down this paradigm in their studies of 1930s Irish poetry, Brown by attempting to establish the 'sociocultural construction of modernism', Gillis by exploring 'the ways in which poems impose a purposeful shape upon historical pressures in what might be called an immanent manner'.[10] Both agree with Alex Davis that WBY complicates the issue by his movement away from the 'Celtic Twilight' ideal by the 1930s,[11] and indeed an exposition of the 'Byzantine modernism' of WBY and his illustrator Norah McGuinness has confirmed their theses.[12] An enquiry into affinities between word and image in MacGreevy's *oeuvre* builds on this debate, for just as MacGreevy's poetry can be understood as *transitional* in Irish literature, so his art criticism has an interesting position in relation to the development of Modernism in Irish visual arts. Further, the two media inform each other and create fusions of the arts, advancing our understanding of the term in early twentieth-century Ireland.

Susan Schreibman has pioneered a fresh appraisal of MacGreevy's poetry in her annotated *Collected Poems of Thomas MacGreevy* (1991) and in the digitization of his published works.[13] Following this lead, the work of 'Irish poets of the 1930s' has engendered lively debate in recent literary criticism. However, discussions tend to pay more attention to Devlin and Coffey, or refer to a stock list of MacGreevy's poems, in particular 'Aodh Ruadh Ó Domhnaill' and 'Nocturne of the Self-Evident Presence'.[14] Close readings of MacGreevy's poems responding to the visual arts and architecture, most of which were written between 1924 and 1934, lead to conclusions about the interdisciplinary nature of Irish Modernism, and they can only be fully understood in the context of variegated dialogues between MacGreevy, Beckett and Jack Yeats.

When the young Thomas MacGreevy arrived in Dublin in 1919, Ireland had not yet expressed its national identity through painting as it had in literature, and this theme he addressed in earnest in his early art criticism.[15] The Irish struggle for independence, the formation of the new Irish Free State in 1921 and the ensuing Civil War became the subject matter for many of his poems at that time, and he contended that visual artists should feel this responsibility as well. In a paper entitled 'Contemporary Art in Ireland', he observed:

the winning of self-government for Ireland in 1921 has led to a considerable outburst of artistic activity. True, the foundations were laid earlier, as the foundations of modern French art were laid before the revolution. It may or may not be true that the technique of the Impressionists derived from Constable, but it is certain that their human approach derives from the philosophes. Before the Irish revolution of 1916–1921 The Irish Literary Revival was a matter of world-wide discussion.[16]

In the same paper he compared the painting of Jack Yeats to that of Rembrandt, both artists who lived to see the independence of their countries: 'as with Rembrandt, Yeats ... has seemed to devote his genius to the interpretation – consciously or unconsciously, nobody knows – of his country's dream of

itself, of its aspirations, of its feeling for human essentials, of the way in which it regards the problems of existence'.[17] For MacGreevy, Jack Yeats responded to the clarion call for a 'national' Irish art in post-independence Ireland, and so a life-long commitment to the promotion of the painter's work ensued.[18]

MacGreevy's writings on Jack Yeats are often cited as representing the most nationalist stance, in the Republican sense.[19] What is less well known is that between 1926 and 1929, MacGreevy published three poems – 'Aodh Ruadh Ó Domhnaill', 'Crón Tráth na nDéithe' and 'Dysert' – which he maintained were influenced by the artist's paintings.[20] From the perspective of word and image analysis, it is possible to read these poems in the light of his art criticism, to address the role of the image in the creation of the word, and to evaluate the implications of these dialogues for early twentieth-century Irish visual culture.

Thomas MacGreevy's Poems after Jack Yeats

MacGreevy's pictorialist poetry of the 1920s and 1930s responds to the visual arts in many different ways. At times the poet simply alludes to a painter, painting or a period of art by referring to them in the title, such as 'Homage to Hieronymus Bosch',[21] or in the body of the poem, for example, 'O Grünewald! / 'O Picasso!' ('Gloria de Carlos V').[22] At other times, his debt to painting takes on a more formal role, as he attempts to re-enact something of the sensual qualities of a particular style, or something of the historical background of the work. In his early poems written in Ireland and London between 1919 and 1925, and in his later works written in the cultural milieu of late 1920s and early 1930s Paris, painting informs and shapes MacGreevy's poetry on both semantic and syntactic levels.

In a letter to Jack Yeats dated c. 1929–30, MacGreevy wrote of his recently published poem 'Crón Tráth na nDéithe': 'People think probably rightly that it's Joyceish but actually I have the illusion that it's pictures I'm most influenced by. You are certainly behind Red Hugh as behind even more certainly the enclosed.'[23] The poem was written in 1926 and published in 1929, not long after MacGreevy had published 'The Catholic Element in *Work in Progress*' for inclusion in Joyce's *Our Exagmination Round His Factification for Incamination of Work in Progress* (1929).[24] The reference to 'Red Hugh' alludes to 'Aodh Ruadh Ó Domhnaill' published by MacGreevy in 1926 under the pseudonym 'L. St Senan', and dedicated to MacGreevy's Trinity College friend, the Irish journalist and Gaelic Revivalist, Stephen MacKenna.[25] His statement that Jack Yeats was 'behind' the poem, however, is significant. It links back to the illustration for the Irish ballad 'Lament for Eoghan Ruadh' (Figure 2.10), and provokes a deeper enquiry into the relationship between the artist and his champion.

MacGreevy first met Jack Yeats during the poet's college years, but it was not until he returned to live permanently in Ireland in the 1940s that the two men became firm friends.[26] In the 1920s, before Jack Yeats delved into writing literature, his oil painting underwent a change from a representational mode to a more subjective and experimental one. By producing less illustration, his imagination was freed to work more profoundly. He began to produce paintings based on memory such as *Draughts* (1922) (Plate 1), *Riverside (Long Ago)* (1922), and others based on political events in Ireland, such as *Communicating With Prisoners* (c. 1924) (Figure 3.7) or *The Funeral of Harry Boland* (1923).[27] In many of his paintings of this time, there is a predominance of the colours sepia, burnt sienna, blue and grey. Hilary Pyle picks out *Draughts* as a good example of a painting for which the 'mood contrasts with the pure reportage of his early style and preludes the elated emotion of his later work'.[28] But the darkness of this painting may reflect the artist's experience of depression between c. 1915 and 1918, as well as the political upheaval in Ireland.[29] Of perhaps greater significance, however, is Jack's move away from representational, drawn images in pen and ink or watercolour, towards a new confidence in oil painting. Years later, he explained to Sir John Rothenstein:

I believe ... that the painter always begins by expressing himself
with line – that is, by the most obvious means; then he becomes
aware that line, once so necessary, is in fact hemming him in, and as
soon as he feels strong enough, he breaks out of its confines.[30]

The change in painting style undergone by Jack Yeats in the 1920s is comparable to the process that some young poets experienced in the early twentieth century. Having learnt poetic formulae such as the sonnet, and techniques such as metre and rhyme, poets such as MacGreevy felt compelled to create what Beckett in 'Recent Irish Poetry' called 'rupture of the lines of communication' in their poetry.[31] However, as Beckett's article makes clear, many Irish readers, even by the 1930s, could not accept poetry written in a modern idiom because they still expected stock early Revival themes. Jack Yeats faced a similar adverse reception for his experimental work in Ireland.[32] In 1924 one critic wrote: 'His painting is now and then so crude as to border on amateurishness. Whilst his compositions are generally pleasing, his brushwork is shallow and flat and careless. His colour, too, is dirty and depressing, or impossibly theatrical',[33] and another concluded that he 'is far less happy with oils than with the simple medium of pen and ink'.[34] The transition in Jack Yeats's technique (from an objective, representational and illustrative mode, to a more subjective, experimental style) has been explained in various ways. In relation to his writings, Nora McGuinness (not to be confused with the Irish artist) has discussed it in Freudian terms and emphasized the artist's disillusionment with Irish politics post-independence as being the root cause of his inward gaze; a contention which has been taken up again recently by David Lloyd.[35]

This interpretation, which draws direct links between art and politics, is the one which MacGreevy adopted, and many subsequent commentators have echoed it, from Edward Sheehy, who in 1945 claimed that Jack Yeats 'certainly did collaborate in that renaissance of the spirit which culminated in the Rebellion and the Anglo-Irish war; and by so doing he liberated his art from the hitherto unrelieved provinciality of painting in Ireland',[36] to Brian O'Doherty, who wrote in 1971 that 'Thomas MacGreevy (that unfrocked courtier lost in his own dream of Ireland) was right in claiming that Yeats is to Ireland as, say, Watteau is to France'.[37] Textual evidence proves that Jack Yeats was affected by political unrest in Ireland and that he shared MacGreevy's Republican ideals, but it also reveals that he was a pacifist. For example, in 1921 Jack Yeats wrote to John Quinn:

Things political in Ireland are still black, but one thing I am certain and that is that Sinn Féiners will not quit ... I would not fight for what is technically a republic, but I think Ireland should govern herself the same as Canada and South Africa do.[38]

Then, in his speech on Modern art given at the Irish Race Congress in Paris in 1922, he stated:

when painting takes its rightful place it will be a free nation, for though pictures speak all the languages the roots of every art must be in the country of the artist, and no man can have two countries ... we must look to ourselves for the springs of our art ... We must not look to Paris or London for a pace-maker.[39]

When MacGreevy was writing poetry in the 1920s in Ireland, he felt impelled to broach politics through art, and when he wrote poems after paintings, his ideologies were reflected in the way he read them, not least those of Jack Yeats. MacGreevy avoided critical comments about his poetry in Ireland by adopting a pseudonym and publishing outside the island. He published 'Dysert' under the pseudonym 'L. St Senan' in T.S. Eliot's *The Criterion* in 1926, and republished it under his own name in 1931 in *The European Caravan*, with the title 'Homage to Jack Yeats':

Grayer than the tide below, the tower;
The day is gray above;
About the walls
A curlew flies, calls;
Rain threatens, west;
This hour,
Driving,
I thought how this land, so desolate,
Long, long ago, was rich in living,
More reckless, consciously, in strife,
More conscious daring-delicate
In love.

And then the tower veered
Grayly to me,
Passed ...
I meditated,
Feared
The thought experience sent,
That the gold years
Of Limerick life
Might be consecrated
Lie,
Heroic lives
So often merely meant
The brave stupidity of soldiers,
The proud stupidity of soldiers' wives.[40]

The poet explained the new title in a letter to George Reavey:

The title of my poem is what it is because I think both the landscape and sentiment of it are akin to the landscape and sentiment in J.B.Y's [Jack B. Yeats] paintings.[41]

Published within three years of the troubles in Ireland, MacGreevy's 'Dysert' responds to Jack Yeats's paintings, not only through poetic imagery, but also through technique. 'Dysert' translates from Irish as 'hermitage' and is cognate with such Latinate words as 'desert'. There are several places in Ireland called Dysert or Dysart, including Dysert O'Dea in Co. Clare, while Schreibman suggests that a possible setting for the poem is Dysert Castle in Co. Limerick.[42] The poem opens with reference to the colour grey, the most opaque colour in the colour spectrum.[43] In colour theory, grey is also one of the most interesting colours, formed by an un-equal mix of primary or complementary colours. Tinged green, or pink, or blue, or indeed any colour in the spectrum, greys can appear rather lifeless, or they can be made luminous. They can be warm or cold.[44] For example, in *Draughts* (1922) (Plate 1) there are warm greys in the bricks of the harbour wall, the pier and the ship (echoed in the sepia and burnt umber tones in the men's clothing), and cold greys in the jacket of the man in the foreground.

In 'Dysert', it is the tower that impressed MacGreevy with its greyness, starkly expressed in the second stanza when the tower veered 'Grayly' to him. The oiliness and opacity characteristic of Jack Yeats's use of oil paint in the mid 1920s is also cleverly echoed in MacGreevy's poem, firstly by the repetition of the word 'gray' as though building up layers of colour, and secondly by the imagery of tide and impending rain. From the point of view of composition, it could be argued that in his first stanza, MacGreevy paints a picture by directional framing devices such as 'below', 'above', the curlew which flies 'about' and 'west', building a composition in the imagination of the reader akin to painting on canvas. A Jack Yeats painting could typically

contain the images of a tower, grey skies, a curlew, and indeed this is the type of scene that appealed to poets of the Irish Revival. However, it would also have appealed to cultural nationalism after the formation of the Free State when there was a new urgency for art to express national identity. The landscape of the West of Ireland took on a special significance at that time as representing a way of life removed from the influences of Anglicization and industrialization, a phenomenon that has been discussed at length in Irish art history by Catherine Nash, James Christian Steward and others.[45] In 1924, George Russell (AE) described the RHA exhibition as 'art without national roots',[46] and through time, artists Jack Yeats, Seán Keating and Paul Henry, in particular, were grouped into a 'realist school' of painting which did not espouse European Modernism, but rather looked to the roots of their own country for inspiration (just as Gleeson had done at the turn of the century in creating Irish textiles).[47]

MacGreevy's poetic reverie is interrupted, however, in line seven, when we discover that the poet is in fact 'Driving'. This introduces an industrialized world of speed and consumerism. Almost immediately, in the following line the poem becomes more subjective with the introduction of a narrator in 'I thought', and the tone becomes more nostalgic, again in keeping with the mood of Celtic Twilight literature. The land is described as 'desolate' and 'rich', reflecting the grey mood with which the poem opened and reminding us of the title of the poem, which connotes isolation and solitude associated with the way of life once led in Limerick or the West of Ireland. It might also remind us of the more existential aspect of MacGreevy's work which is understood in his early poem 'Nocturne', and the phrase 'Long, long ago' might remind the Irish art historian of the title of Jack Yeats's painting *Riverside (Long Ago)* (1922).

Harmony is further interrupted by the words 'reckless' and 'strife', reminding us of the history of conflict in Ireland, which is nostalgically remembered by MacGreevy as:

More conscious daring-delicate
In love.

Moving into the second stanza, he returns to visual perception, understood again as a subjective, surreal experience:

And then the tower veered
Grayly to me,
Passed ...

This action is then interrupted with 'I meditated', which halts the thought process and emphasizes a swing between objective and subjective realities, movement and stasis. The jarring manner in which this is done confirms

the experimental aspects of his poetry, links him to the broken syntax of Eliot or Ezra Pound, and separates him from the poetry of contemporaries such as George Russell (AE). As the stanza progresses, MacGreevy evokes reminiscence in 'the gold years', introducing the first note of colour and warmth. Without warning, however, he interrupts too hazy a reflection of the past by rhyming Limerick 'life' with 'Lie', heroic 'lives' and 'soldiers' wives'. This suddenly links history with war, and mocks heroism and patriotism as:

The brave stupidity of soldiers,
The proud stupidity of soldiers' wives.

It could be argued that the typographical layout of the poem engenders visual as much as aural experience. For example, in linking the sounds of the words 'life', 'lie' and 'lives' in the second stanza, the poet creates both semantic and visual links between the words, producing an arc of thought which approaches a synæsthesia of sound. When considering the relationship between text and image in poetry and painting, this offers a good example of how a poet can reproduce in language the sensuous effect of paint by creating patterns. These form an aural equivalent to the role which colour plays in painting when it is repeated in various places on a canvas to create semantic links in the imagination of the viewer, or when the play of contrasting and complementary colours stirs an emotion in the viewer. In a poem such as 'Dysert', the poet exploits the blank space of the page to create this effect. This is achieved, as I have said, by breaking away from formal rhyme and stanzaic systems and by the free use of punctuation, such as 'passed ...', and the use or omission of the comma. In the context of literature, including the work of writers such as Beckett and Eliot, this blank space is often interpreted as silence, which can be transposed metaphorically to represent a metaphysical void. '[O]nly silence is valid ... words are a strain on silence', Beckett told Giacometti, while in Eliot's poetry, it is indicative of the rupture in communication and order engendered by war, as the poet struggles to find appropriate words.[48]

MacGreevy's poetry, written after the formation of the new Irish Free State, evinces at once a cultural nationalism and influences from both Paris (modern French poetry) and London/America (Eliot, Pound), and it was for this reason that Beckett singled him out, in his essay 'Recent Irish Poetry', from the 'antiquarians' as represented by the followers of early WBY (including F.R. Higgins, Monk Gibbon, James Stephens and Austin Clarke) and 'others' (Brian Coffey, Denis Devlin). Beckett described MacGreevy as 'an independent ... an existentialist in verse, the Titchener of the modern lyric ... and probably the most important contribution to post-War Irish poetry'.[49] Beckett did not include himself in the list, but the implication is that he belonged with the 'others'. To clarify his distinction, Beckett then discussed 'the old thing that has happened again, namely the breakdown of the object, whether current,

historical, mythical or spook', but importantly, Beckett did not simply adduce poetry in his Modernist manifesto, but also the paintings of Jack Yeats:

> The artist who is aware of this may state the space that intervenes between him and the world of objects; he may state it as no-man's-land, Hellespont or vacuum, according as he happens to be feeling resentful, nostalgic or merely depressed. A picture by Jack Yeats, Mr Eliot's 'Waste Land', are notable statements of this kind.[50]

So what was the common denominator between modern poetry and painting for Beckett? The *space between* the poet/painter and the phenomenal world of which he wrote or painted may be linked to the Modernist conception of the *void*, a concept stemming from French literature of the late nineteenth century and from the poetry of Stéphane Mallarmé in particular. Mallarmé's *Un coup de dés jamais n'abolira le hasard* demonstrates the most developed use of this space, where the poet seemingly 'threw' words across the blank page to create a constellation of words, based on chance. In sculpture, the void is manipulated in the work of Alberto Giacometti who, in *Hand Holding the Void (Invisible Object)* (created 1934, cast 1954–55)[51] and other works, saw the space between two objects or between the artist and his subject as being of more interest than the object itself.[52] In 'Recent Irish Poetry', Beckett categorized MacGreevy as an existentialist (linking him to his own work in which the void is a signifier of existential solitude), and quoted the most existential of MacGreevy's poems, 'Nocturne':

> I labour alone in a barren place,
> Afraid, aware, blundering, lonely thing;
> Far away, stars wheeling on through space,
> About my feet, earth voices whispering.[53]

Beckett then explained that when the (old) 'thing' happens, 'it is the act and not the object of perception that matters'. Process is prioritized over referent, subjective over objective, and poetry (or painting) takes on an 'inevitable unveiling'.[54]

MacGreevy's art criticism demonstrates a comparable awareness of the void and the subjective process of creativity. For example, in his essay 'St Brendan's Cathedral, Loughrea 1897–1947', he wrote:

> With every new subject a writer undertakes he has to begin at the beginning all over again. He must wait on his theme and let it determine the form, the phrases, the individual words even, of his writing. ... And the more experienced he is, the more aware he is of the inadequacy of words. ... I remember Degas writing from Madrid to his friends in Paris after he had been to see the pictures by Velazquez at the Prado, 'there are no words. No, there are no words', and leaving it at that, adding nothing in extenuation of his sense of verbal inadequacy. ... But now all the words are written and I come back to the thing for which there weren't any adequate words, the harmony that exists between all the works,

the harmony that each one of them helps to create, yet that subdues them all to its own principle of being. And that principle of being? Wordless prayer? Blessedness? 'There are no words', said Degas. No, there are no words.⁵⁵

Evidently, the void could signify different things for him. When he was writing poetry in the 1920s and 1930s, it was linked at once to the poet's disillusionment in the face of war, to the Romantic poets' imaginative response to the limitations of language and to the spatial awareness of poets such as Mallarmé. Above all, however, a poem such as 'Dysert' offers an example of how MacGreevy attempted to formally transpose elements of painting into poetry, in this instance, works by Jack Yeats. At the top of an unpublished typescript about the painter, MacGreevy added a handwritten quotation by Constantin Brancusi: 'Les Théories sont des échantillons sans valeurs. Ce n'est que l'action qui compte' [Theories are examples without worth. Only actions count].⁵⁶ The addition points towards his belief that Jack Yeats was *the* 'national' Irish painter because he tackled socio-political themes in his work. In a similar fashion, in 'Dysert' and other poems, MacGreevy coupled art and social activism, working out and expressing his ideologies through his poetry.

Another example of a poem *after* painting demonstrating this compulsion towards socio-political comment is MacGreevy's 'Homage to Hieronymus Bosch'. Schreibman records that the earliest reference to the poem was in October 1926, which would mean that it was written when MacGreevy was working as an occasional lecturer in the National Gallery of London (1925 and 1926), and after he had visited the Prado Museum in Spain (1924).⁵⁷ However, MacGreevy stated in a later paper that he wrote the poem in 1923.⁵⁸ The poem was not published until March 1932 in Paris, in Eugène Jolas's *transition* with the title 'Treason of Saint Laurence O'Toole'.⁵⁹ The subject matter of the poem is the hanging of Kevin Barry during the time MacGreevy was at Trinity College in Dublin. MacGreevy and his peers had been aware of struggles between good and evil in Ireland when they appealed to the Provost of the College to petition the hanging of Kevin Barry, without success.⁶⁰ The poem begins:

A woman with no face walked into the light;
A boy, in a brown-tree Norfolk suit,
Holding on
Without hands
To her seeming skirt.

The faceless woman and handless son are portrayed as surreal characters in an undefined space. The narrator is introduced in the second stanza: 'and I, in terror, stopped, staring', after which point we visualize the poet, the woman and the boy as witnesses to an horrific scene. Although the location of the scene is not specified, there is an intimation of depth and movement, for there

are shadowy figures lurking behind the woman, and '... the little world was spinning on'. Words are also presented as surreal, useless things: the women's words '... fell, / Lay wriggling, on the ground'. When the effigy of one of the shadowy figures attempts to speak, he is thwarted by the nursery governor, and by the governor's own words '... went *pingg!* Like bullets, / Upwards past his spectacles – *Say nothing, I say, say nothing, say nothing!*' The poem demonstrates Modernist preoccupations including the employment of *vers libre* and an Eliot-style approach to poetry in the face of war. The portrayal of the figures, whilst it may certainly be defined as surreal, is also linked to MacGreevy's conception of Modernism expounded in relation to Mainie Jellett.[61]

In MacGreevy's darkest poetry there are times when the poet soars above the despair of earthly scenes. In 'Homage to Hieronymus Bosch', this high note occurs in the ninth stanza, situating the scene of the poem in Dublin, and more specifically in the grounds of, or near to, Trinity College:

High above the Bank of Ireland
Unearthly music sounded,
Passing Westwards.

The stanza is preceded by the scene of the nursery governor mutating from an effigy to a near-life figure, then filming back to an effigy again, and is followed by a scene of thousands of rats emerging from the sewers to dance and cry out on top of the collapsed woman with no face. Years later, in a paper entitled 'How Does She Stand?' (1949), MacGreevy quotes these three lines from his poem to illustrate the change in Irish poetry since the Irish Cultural Revival when the poets 'were the expression of the resurgence of the spirit of the nation in the new and better times that were beginning to prevail', and he gives the following context for his poem:

The west, meaning all Ireland of which Dublin in the east is but the
capital expression – was going to sleep again. But every student
of Irish history knows that the spirit operates as surely, however
differently, when the west is asleep as when it is awake.[62]

When MacGreevy sent *Poems* to Wallace Stevens, the American poet responded by writing a poem adapting imagery from 'Homage to Hieronymus Bosch' and entitled 'Our Stars Come from Ireland'. It includes the stanza: 'Over the top of the Bank of Ireland, / The wind blows quaintly / Its thin-stringed music, / As he heard it in Tarbert'.[63] Evidently, Stevens recognized that looking over the Bank of Ireland from Trinity College, the poet was looking towards the West of Ireland (and on a more personal level to his hometown), with all of its cultural implications for post-independence Ireland. MacGreevy grew up in Tarbert, and just as Jack Yeats claimed that

Sligo was his 'spiritual home always, and the foundation of everything I paint is Sligo',[64] so for MacGreevy happy memories of a childhood in the south west of Ireland represented hope. He later wrote of the 'appreciation of the wonders of creation – which are so very near to one in the West of Ireland and which, practically without one's realizing it, turn one's perception into something very like prayer'.[65]

In 'Homage to Hieronymus Bosch', the poet in Dublin city centre remembers this feeling of elation in the midst of tragedy, and his imagined West of Ireland manifests itself as prayer. This moment of clarity is the type Beckett referred to when he reviewed MacGreevy's *Poems* in 1934:

All poetry, as discriminated from the various paradigms of prosody, is prayer. ... It is from this nucleus of endopsychic clarity, uttering itself in the prayer that is a spasm of awareness, and from no more casual source, that Mr McGreevy evolves his poems.[66]

Beckett quotes moments from MacGreevy's poems 'Gloria de Carlos V', 'Seventh Gift of the Holy Ghost', 'Crón Tráth na nDéithe', and 'Nocturne of the Self-Evident Presence', all of which, at some point, reach a level of radiance characterized as 'Giorgionesque elucidations'. Each of the quotations makes reference to light and brightness, and generally involve the poet-as-witness looking out from a squalid scene, whether up to the sky above Dublin, or to the stars above the snow-capped Alps. Beckett concludes:

To know so well what one values is, what one's value is, as not to neglect those occasions (they are few) on which it may be doubled, is not a common faculty; to retain in the acknowledgement of such enrichment the light, calm and finality that composed it is an extremely rare one. I do not know if the first of these can be acquired; I know that the second cannot.[67]

MacGreevy's 'unearthly music' manifests itself in other poems as similar, prayerful utterances signifying hope in the face of tragedy. The strongest example of this occurs in the last stanza of 'Gloria de Carlos V' where the poet alludes to Titian's *La Gloria* (1554–57),[68] which he had seen at the Prado Museum in Spain:

My rose of Tralee turned gray in its life
A tombstone gray
Not pearled
But for a moment now I suppose
For a moment I may suppose
Gleaming blue
Silver blue
Gold Rose
And the light of the world
 Prado Museum, Madrid[69]

Colour is manipulated throughout 'Gloria de Carlos V' to create contrast between hope and despair. In the first stanza, the poet adduces a strongly drawn imperial context ('Golden horns / And silver gilded horns – / Con- / Stantinople'), followed in the second stanza by a juxtaposition of:

Here 'twas scarlet and black,
Green and Black,
Starch white streaked with cadaver black.
Yes, Grünewald
And Picasso[70]

By naming Constantinople (former capital of the Christian Roman Empire), MacGreevy invokes the art and civilization of WBY's imagined Byzantium, and as in WBY's poems, the empire is set up as an 'other' to the poet's experience of contemporary Ireland. In the second stanza, the colour black is referred to three times, once in juxtaposition with its opposite, white, and on the other occasions contrasted with the complementaries red and green (opposites in the colour spectrum). Death is connoted through reference to red (blood?) and 'cadaver' black. However, in MacGreevy's poem, as in Titian's painting, which represents 'the Triumph of the Trinity', a sense of hope is imparted by a change in perspective experienced by the reader/viewer. In the poem, this shift occurs when the poet realizes that for a moment he 'may suppose' bright colours signifying the redemptive possibilities of faith in Jesus ('the light of the world' [John 8:12]); in the painting, the viewer is 'elevated to the level of apparition itself'.[71]

MacGreevy names Picasso and Grünewald as artists who signal images of war, destruction and so on in the mind of the reader. References to painters of dark images are employed in this (and in other poems including 'Homage to Hieronymus Bosch') as a mechanism to set the poet's moment of illumination into relief.[72] MacGreevy wrote of 'Gloria de Carlos V':

I associated the names of Picasso and Grünewald in order to contrast their effective nightmare with Titian's realization of ideal beauty. I did not know that Picasso had studied Grünewald's great crucifixion at Colmar, and that it inspired him to a remarkable series of drawings directly related to the picture.[73]

In 1945, MacGreevy again cited Picasso and Bosch as artists who portrayed contrasts in their own paintings, 'in the uneasy world of the present day':

An artist like Pablo Picasso who often represents nightmare forms will sometimes turn away from them to paint figures of more or less orthodox classical perfection as, in the disintegrating medieval world of the fifteenth century, Hieronymus Bosch would occasionally turn from his usual forms of terror to paint such relatively orthodox and sympathetic figures as those in *The Adoration of the Shepherds* at Brussels – not to speak of the natural loveliness of the landscape and atmosphere against which, by way of contrast, he always depicted the forms of horror that haunted his imagination.[74]

For MacGreevy, Grünewald and Picasso were artists who responded to socio-political disintegration in their countries, and this was the calling felt by MacGreevy in 1920s Ireland. 'Crón Tráth na nDéithe' reflects the sense of uncertainty in Ireland after the events surrounding the Rising, the War of Independence and the ultimate establishment of the Free State government. The poem was begun in 1924, shows a debt to Eliot's *The Waste Land*, and was first published in *transition* in November 1929. The topography of the poem is essentially Dublin city. This links it to Jack Yeats's involvement with Dublin life from 1919 to 1922 and to MacGreevy's comment that Jack Yeats was 'behind' the poem, and it also provokes comparisons with Joyce's *Ulysses*, begun in 1914.[75] Stylistically, 'Crón Tráth na nDéithe' has been classified as 'Modern' and linked to Joyce owing to its fragmented nature, what Beckett described as 'the breakdown of the object, whether current, historical, mythical or spook'.[76] The poem begins:

School of ...
By Thomas McGreevy

EASTER SUNDAY NIGHT (Free State)

 She died of a fever
 And no-one could save her
 And that was the end of sweet
 Molly Malone
 But ...
 Prelude
Ter-ot. Stumble. Clock-clock, clock-clock.
Heavy turning wheels of lurching cab
On midnight streets of Dublin shiny in the rain.
 No trams squirt wide the liquid mud at this hour.

 The dark-and-light-engulfing cab
 Wheels through the wetness
 Bringing me
 From empty, healthy air in Mayo
 To Dublin's stale voluptuousness.[77]

'Crón Tráth na nDéithe' refers to Classical and Irish mythology, the Great War, Irish architecture and Irish history. The poem also contains Catholic prayers and combines European with Irish references.[78] It traces a cab journey from Broadstone Station in Dublin (near Kings Inns, where the train from Mayo arrived), via Dominick Street and O'Connell Street, to Leinster House (Merrion Square West). The contents of the poem are highly visual, making constant references to street scenes in the aftermath of Civil War, not least the architecture and architectural detail seen by the poet from the cab window. As Schreibman has pointed out: '[m]uch of Dublin's city centre, particularly on

the north side of the river Liffey, was devastated from the events of the Rising and the Civil War. Three-quarters of the buildings on O'Connell Street were destroyed.'[79]

This mix of verbal and visual signifiers is indicative of MacGreevy's research into Dublin architecture as much as his visual sensibility. In several of his later art-critical papers, MacGreevy wrote about Dublin architecture and sculpture, and it was important to him to find examples amongst them which were designed by Irish (as opposed to English) architects and sculptors.[80] For example, he later claimed the 'Irishness' of Irish architecture in his essay 'Developments in the Arts' (1951):

Thomas Cooley, presumably the architect of the City Hall (1769) and the first architect of the Four Courts, was the son of a Dublin 'plasterer' (i.e. builder) and was a student at the Dublin Society Schools. This discovery emphasizes the fact, already recognised by many scholars, that our so-called 'Georgian' architecture should more properly be described as Irish Classical.[81]

He also discussed eighteenth-century architects and sculptors working in Dublin in 'The Historical Background to Irish Art (Chiefly Architecture)' (1944), in relation to what he called 'the Irishness of architecture (and the subsidiary to it)' in Ireland.[82] Thus, in 'Crón Tráth na nDéithe', MacGreevy calls James Gandon 'Gaulish Gandon', drawing attention to the architect's Huguenot roots. He also names the ornamental sculpture carved by the Irish sculptor Edward Smyth. Examples of Smyth's work are seen on the Four Courts (designed by Gandon on the Inns Quay in the late eighteenth century, and bombarded and burnt by Free State troops in 1921), and the Custom House (built by Gandon and set on fire by the Dublin Brigade of the Irish Republican Army during the Civil War in 1922). Edward McParland has described Smyth's carvings as 'snarling lions and haughty unicorns [which] support the arms of the kingdom of Ireland in the most beautiful heraldic sculpture ever carved in stone in Ireland', echoing MacGreevy's emulation of his craftsmanship.[83] By the end of his poem, MacGreevy's cab journey reaches Leinster Lawn where, on 12 August 1923, a cenotaph had been erected to commemorate Michael Collins and Arthur Griffith, inscribed 'to the glory of God and the honour of Ireland', and placed in front of the statue of Prince Albert.[84]

Looking for stylistic comparisons, Robert Garratt has linked 'Crón Tráth na nDéithe' to Joyce's 'Sirens' chapter in *Ulysses*, given the mix of high and low culture.[85] Garratt also points out that the poem mixes extracts 'from Roman Catholic ritual and from various literary works including Modern German and Spanish literature, and an unabashed echo of T.S. Eliot: "So Dublin's rows / Of Michelangelo"'.[86] The manner in which the poet brings these sculptural and historic references together is an awkward attempt at Modernist poetic dissonance: 'When the Custom House took fire / Hope slipped off her green

petticoat / the Four Courts went up in spasm / Moses felt for Hope'. Certainly, the style of the poem is indicative of Modernist preoccupations such as industrialized urban living ('Trot / trot / Clock-clock / Lurch'), but it also reflects the poet's inability to reconcile the Irish Civil War to his Christology ('Veni Creator ... / Vivificantem ... // How long? / How long?').[87] The latter problem began, of course, with the poet's experiences at the Somme where he was wounded twice, and it is evident in the poem 'De Civitate Hominum' in which he recalled events from his experiences in the Salient of Ypres.[88] However, Garratt's interpretation of the poem must be considered in relation to MacGreevy's statement that Jack Yeats was 'behind' the poem. Turning to Jack Yeats's paintings, and more specifically to MacGreevy's criticism of them, brings evidence to sustain this premise.

MacGreevy wrote in a short, untitled paper about how Jack Yeats had 'lived through a terrible period in Irish history, a period that was bound to have a profound effect on a nature of the most acute sensibility',[89] and described him as the first painter to express the 'Ireland that matters', painting Ireland's people at a time when the nation was seeking an identity. The implication is therefore that MacGreevy also aimed to express contemporary national identity through his poetry. As early as 1922 MacGreevy had called Jack Yeats the first truly Irish painter because he 'painted pictures that are as Irish as Teniers's pictures are Dutch'.[90] He also adduced other European nations that had achieved independence to stress the need for an Irish national art:

There were painters in Holland before the 17th century, but the establishment of Dutch Independence in the year 1609 was followed by such a deepening of national consciousness as to produce, within a generation, a school of art that ranks with the greatest schools of painting in history, and does so primarily because it is marked by characteristics that are peculiarly its own. ... a Velazquez is as Spanish as a Rembrandt is Dutch, or as a Watteau is French.[91]

The comparisons with other European countries, in terms of their expression of national identity through art, echoes the claims made for Irish Arts and Crafts and illustrated books produced during the Revival period, discussed in Chapter 2. To recall one example, Dun Emer books were described as 'Irish as English oak is English or French claret is French'.[92] MacGreevy also compares Ireland to the Spain of Goya's day. He points out that like Goya (1746–1828), Jack Yeats painted during 'a period in which a savage war was fought between the people and their conquerors, ...'.[93] In conclusion, he states, before Jack Yeats, painting in Ireland had been 'gay', occasionally 'tragic', but now:

The tragic dominates, the gaiety which still happens and which could scarcely be more tender than of old, is somewhat less frequent, and the plaintive has been practically altogether eliminated. ... In Ireland at least all Yeats's admirers look forward to a day when will many examples of

his landscapes hang together in the national collections, and when such pictures as *A Republican Funeral* will be considered as important a part of the nation's history as the Goya's *3rd May* is to the Spanish art lover.[94]

The comparison between Goya and Jack Yeats clarifies MacGreevy's beliefs concerning Ireland and the arts: his sympathy lay with Irish Republicanism, and for him, Jack Yeats was *the* painter of the Irish *petit peuple*. The references in MacGreevy's 'Crón Tráth na nDéithe' to tragic, historical events in Ireland link it to paintings by Jack Yeats which MacGreevy appreciated in the 1920s, including *Communicating With Prisoners* (c. 1924) and *The Funeral of Harry Boland* (1923), which proved to him the importance of national historical events for Modern Irish art.[95] However, as Bruce Arnold has pointed out, Jack Yeats's so-called 'political' pictures are in the minority of his output. Of greater interest to the art historian today is the artist's idiosyncratic use of colour and technique.[96]

By 1926, when MacGreevy began writing his poems 'Crón Tráth na nDéithe', 'Homage to Hieronymus Bosch' and 'Aodh Ruadh ó Domhnaill', Jack Yeats's painting style had undergone a transition from the works painted in the period 1922 to 1924. *Crossing the Metal Bridge* (1926) exemplifies this change.[97] The painting shows a woman crossing the Ha'penny Bridge in Dublin at either dawn or dusk. The sky is brooding, but is relieved by a splash of yellowy-white paint, signifying light breaking through the clouds, which barely illuminates the city and river below. As in *Draughts* (probably located in Dublin's docklands), there is a predominance of the colour grey, but there is a marked difference between the murkiness of the earlier work and the vitality of the latter. He achieved this by dashing in thin, streaked highlights of yellow, red and white on the bridge and on the woman's clothing, hair and earring, and by painting more freely in the 'break' in the clouds above the city, which the woman strains her neck to face towards. It is as though Jack Yeats has lifted himself from the opacity of the early 1920s, and is reaching towards a new freedom of expression, for which the woman's elevated emotion acts as a metaphor.

Arnold discusses how, by the mid-1920s, Jack Yeats had reached a resolution to his 'transitional style'.[98] Critics have variously dated this transition to 1921 (Ernie O'Malley: 'It is hard to explain a change in direction, but one of the factors may have been the heightened sensibility which could result from the tension of life during the struggle for freedom for Ireland'); 1922 (John Rothenstein: 'like a rocket emitting a shower of multi-coloured sparks ... The later subjects are less specific, less firmly fixed in time and space, and they are suffused by a poetry which is no less passionate on account of its abstraction'); and 1927 (Terence de Vere White: 'quite suddenly, when over fifty years of age, he began to paint in an expressionistic style').[99] The new confidence in Jack Yeats's oil painting technique brought a new luminosity,

and the emotional impact of his work is analogous to MacGreevy's conception of 'prayer' in poetry. This was experienced for the poet (as for the woman crossing the metal bridge), when looking up above Dublin city, and if the woman in the painting is looking westwards, then the comparison may be taken even further. However, the religiosity of MacGreevy's work is more obvious, less metaphorical, than that of Jack Yeats. For example, after the scene of destruction in 'The Six Who Were Hanged', the poem ends 'And still, I too say, / *pray for us*'.

In reference to 'Crón Tráth na nDéithe', Beckett commented:

Even the long Cab Poem, the darkest, as I believe it to be the least characteristic, in this small volume of shining and intensely personal verse, climbs to its Valhalla, in this blaze of prayer creating its object:-

 Brightness of brightness,
 Towering in the sky
 Over Dublin ...

obliterating the squalid elements of civil war.[100]

The tropism towards light (symbolizing redemption) experienced by the speaker as he looked up over Dublin buildings stems from the poet's faith. Stevens astutely commented in a letter to MacGreevy, 'You were ... a young man eager to be at the heart of his time', but he was also one who had been affected by 'the nostalgie du divin' [the nostalgia of the divine].[101] MacGreevy himself addressed this potential contradiction in the quotation cited at the opening of this chapter, namely that 'modern Irish writing' was 'an extraordinary thing in a mainly Catholic country'.[102] Terence Brown has linked MacGreevy's poetic 'nostalgie du divin' to endemic religious nostalgia in 1930s Dublin, but in fact many of the poets working in a Modernist idiom in France were affected by a similar yearning.[103] Paul Claudel, for example, was deeply religious ('Mon Coeur gémit vers vous, délivrez-moi de moi-même parce que vous êtes!'), and his spirituality is often manifested in the blank areas of his sustained, lengthy poems.[104] As well as his aesthetics of fragmentation (derived from post-conflict Dublin and 'Modern' poetry), both Stevens and Beckett recognized how intrinsic MacGreevy's theology was to his poetry.

Turning again to MacGreevy's art criticism, there is much textual evidence concerning his desire to link art and religion in Ireland. In one of his earliest pieces of criticism, 'Religious Art and Modern Ireland' (1922), MacGreevy credited WBY with resurrecting religious art in Ireland 'after it had been buried under international politics for a thousand years', by bringing Pre-Raphaelitism to Ireland (as well as Blakeism).[105] This, he contended, led to the Stained Glass movement as pioneered by Sarah Purser and Wilhelmina

Geddes who, along with Jack Yeats, were concerned with 'the most profound expression of the spirit'. MacGreevy then formulated the relationship between faith and art in a paper written about stained glass work at the Spiddal Stations:

God may be worshipped in many ways. For some He is the Great Judge, for some the Great Father; to persons of sensibility He is before all else the Great Creator, the Great Artist. Art is perhaps the most godlike of human activities. For out of the apparent chaos of life the artist evolves order, symmetry, grace, movement, as out of the void God evolved the worlds spinning rhythmically in space. And the man who stands awed before the stained glass at Chartres or delighted in Raphael's frescoes in the Vatican is reacting to something that is, in the truest sense of the word, divine.[106]

For MacGreevy, standing in front of the stained glass in Chartres in France (or later in Spiddal or Loughrea in Ireland), Christ is revealed through the medium of stained glass, and therefore the artist-creator of this stained glass acts as a mediator between man and God. As a devout Roman Catholic, it was expedient for MacGreevy to find an art form in Ireland capable of expressing his religion, and one constituting such an important element of national identity as part of political and societal change.[107] MacGreevy had earlier recorded:

The fact that much Irish art will have of necessity to be religious art is a matter of consolation to the more sensitive lovers of art in this country. Religious art imposes on the artist the necessity for some preoccupation with nobler, which is also to say more purely aesthetic, types and moods. For aesthetic perception is akin to religious vision. Aesthetic is a large part of every vision of the city of God. The modern reaction is towards religious and away from domestic art, towards Chartres and Florence and away from Holland and England ... That is why we in Ireland are in a particularly fortunate position with regard to art. We are increasing our productivity in art at a time of religious stress. And we are the only country in Europe, except, perhaps, Russia, where Christianity is still reality to the mass of the people, and where there is likely to be demand for genuinely religious art. Artists are the expression of the religious life of their times, and the degree of sensitiveness with which they express it determines the value of their work.[108]

Reading MacGreevy's poetry in the light of such art criticism confirms the religiosity of his work, and Beckett's description of MacGreevy's poetry climbing 'to its Valhalla, in this blaze of prayer creating its object', relates directly to MacGreevy's statement that: 'For out of the apparent chaos of life the artist evolves order, symmetry, grace, movement, as out of the void God evolved the worlds spinning rhythmically in space.'[109] In his poetry MacGreevy creates a void, signifying post-conflict disillusionment, only to fill it with bright, glorious and colourful images. This represents the hope in the face of despair offered by Jesus to his faithful people, through the gift of prayer. In painterly terms, MacGreevy's illuminations re-enact qualities

of paintings in which a comparable *jouissance* is expressed through high notes of colour. Jack Yeats's *Tinker's Encampment: The Blood of Abel* (1940) demonstrates this technique, for even though the title and juxtapositions of black, red and green paint connote tragedy, the luminosity of colour signals hope. In 1945 MacGreevy described Jack Yeats as giving 'true and good and beautiful artistic expression' to the life of the Irish people (the key triad of aesthetic terms of value in Immanuel Kant).[110] The phrase is reminiscent of John Keats's 'Beauty is truth, truth beauty, – this is all / Ye know on earth, and all ye need to know', and while this links MacGreevy to the Romantic tradition, the phrase also stems from his schooling in scholastic philosophy and the writings of St Thomas Aquinas.[111] Such views appear wholly consonant with MacGreevy.

One evening MacGreevy went to Jack Yeats's studio in Fitzwilliam Square, where the artist told him that he had been trying to find a definition of the beautiful. MacGreevy recorded:

That is a problem which has exercised philosophers as well as artists all down through history from Plato, Aristotle and Plotinus to St Augustine, St Thomas and the thinkers of our own day. Jack Yeats's definition was 'The beautiful is the affection which binds people and things to other people and things'. You see that covers the beauty that animal painting and even the painting of abstract shapes can have.[112]

For MacGreevy, Modern art in Ireland, stemming from WBY and developed through the Irish Stained Glass movement, was necessarily religious, and he admired this quality in the abstract, universalist work of Jellett and Evie Hone, as he did in the more representational work of Jack Yeats. What may seem at first appearance to be antithetical stylistic strains in Irish art were therefore linked by MacGreevy through his scholasticism and his understanding of *beauty* in art.

The 1942 'Rouault Row' in Dublin casts light on this topic. When the Municipal Gallery of Art in Dublin turned down the offer of Georges Rouault's *Christ and the Soldier* (1927) (Figure 4.1) from the Friends of the National Collections of Ireland, Jellett led a petition. She enlisted MacGreevy to give a talk on religious painting, and she and Hone spoke on Rouault's life and work.

In his discussion of the row, Arnold draws attention to the influence of the French Roman Catholic philosopher Jacques Maritain, who 'constructed a philosophy of art derived from his understanding of St Thomas Aquinas', and who was 'greatly appreciated by the Irish catholic intelligentsia'. He quotes an extract from Jellett's paper 'Rouault and Tradition', presented to the White Stag Group in December 1942:

The tone organisation of colour is closely akin to the organisation of sound in music. The colour scheme of a picture is similar to the key in which a piece

4.1 George Rouault (1871–1958), *Christ and the Soldier* (1927), Dublin City Gallery, The Hugh Lane

of music is written ... I feel this harmonic quality of colour is particularly strong in Rouault, and linked to the musical sense is the drama in the subject matter. Velvety black lines used to emphasise the rhythm of the form, luminous blues and wine reds accentuating the mystic quality.[113]

Jellett then continued to support Rouault's work by describing how he pointed back to Byzantine and Sienese painting where, 'with primitive Christian art and Celtic Christian art', a purity of conception could be felt. The comparison between Byzantine and Celtic Christian art emphasizes the 'Modern' search for pre-Renaissance spiritual directness; it also strengthens links between the aims of Jellett's *Decoration* (Figure 3.6) and WBY and McGuinness in *The Stories of Red Hanrahan and the Secret Rose*. But how does Jack Yeats's work measure up to this 'Byzantine/Celtic Christian' Modernism? Could MacGreevy really advocate two such seemingly disparate styles as 'Modern'? A closer consideration of how each artist engaged with the spiritual in their art elucidates his ideas.

In his essay 'Evie Hone and Mainie Jellett', MacGreevy wrote that 'Before they died Evie and Mainie had become religious artists' and stated that he admired Jellett's 'capacity to apply, without loss of integrity, the principles of abstract painting to religious themes'.[114] Two exhibition reviews from 1941 show him developing this thesis. In one he wrote: 'Miss Hone has something of the larger Mediæval humanism, which, unlike the profane and aristocratic humanism of the Italian High Renaissance, derived from a humility of attitude that was inculcated by religious teaching.'[115] In another, he claimed that Jellett's *The Ninth Hour* (1941) 'is the kind of art which shakes us out of our complacency', and concluded by linking (by now predictably) the two women's spirituality to patriotism:

Now I know, more certainly than I had ever known before, that Evie and Mainie, always, when they did not know and when they did, had, in the mysterious ways of providence been guided. They had at all times worked in the spirit of our own great tradition 'for the Glory of God and the Honour of Ireland'.[116]

Jellett herself wrote several essays on painting,[117] and affinities with MacGreevy's philosophy of art and religion may be discerned in these. For example, in 'The Importance of Rhythm in Modern Painting', Jellett cited Aquinas's elements of beauty (*'integritas, consonata, claritas'*), and in keeping with the links between Romanticism (Pantheism in particular) and Thomism, she wrote that the work of art is first 'born in the mind' from 'the joys, the sufferings, the gropings towards the infinite, the almost burning joy that may come from contemplation of Nature's beauty in the highest sense'.[118] In 'Art as a Spiritual Force' she then asserted (almost echoing MacGreevy's thoughts) that '[i]n the end, it is only the great artist who can really appreciate great art, as a great saint can penetrate the eternal beauties of the faith'.[119]

In the work of Jack Yeats, MacGreevy recognized what he called a 'divine light': 'One remembers that Jack B. Yeats's canvases are illuminated with something of the divine light that, for the seeing eye, always is not only on land and sea but in the human countenance too.'[120] In relation to *Tinker's Encampment: The Blood of Abel*, MacGreevy contended: 'in its combination of artistry and topicality, its colour, which was comparable to that of a glowing stained glass window at Chartres, and its application of the words of the Gospel to the conditions obtaining in the world to-day, was nothing less than a great work of modern art.'[121] The juxtaposition of Rouault's 'Modern' painting *Christ and the Soldier* with Jack Yeats's *Tinker's Encampment: The Blood of Abel* enables new readings of Jack Yeats's work. In terms of subject, they both relate to Christ's passion: when Cain murdered Abel (Genesis 4) he prefigured the New Testament sacrifice of Christ, which was also owing to the sin of human nature after the Fall. In terms of style, both paintings employ dark, brooding colours applied in a free manner. However, thick, black ('velvety') lines dominate the composition of Rouault's painting, while Jack Yeats had abandoned the linearity of his early work by 1942. Each painting does resemble stained glass: the 'tracery' is more evident in Rouault's painting, but the colour juxtapositions and kaleidoscopic effect of standing in front of stained glass art is common to both.

MacGreevy's opinion was that the man standing 'awed' before the stained glass at Chartres 'is reacting to something that is, in the truest sense of the word, divine', and that 'aesthetic perception is akin to religious vision'. In his appreciation of art, as in his creation of poetry, MacGreevy accordingly believed that he was responding to his times in Ireland, that religion was an inevitable strain in Irish Modern art, and that both Jellett and Jack Yeats expressed their faith in terms of painting better than any other artists of the time in Ireland. Thomist philosophy, which links Aristotle's naturalism with Christian revelation, therefore has resonance in both MacGreevy's criticism and in his poetry. For MacGreevy, divinity, beauty and prayer could be expressed through all the arts, irrespective of genre, and this philosophy also helps to explain his appreciation of the writings of Joyce. The principal link between MacGreevy and Joyce, and which MacGreevy was quick to point out, was their Roman Catholicism.

In a review published in 1927 of Señor Marichalar's introduction to the Spanish translation of *Portrait of the Artist as a Young Man*, MacGreevy wrote that 'Joyce is no doubt a Thomist *en al tallo*, and understanding of his æsthetic, as of everything about his work, depends so much on the reader's knowledge of and sympathy with Roman Catholic tradition'.[122] MacGreevy also published three pieces about Joyce in *transition*: 'A Note on Work in Progress' in 1928; a poem on Joyce entitled 'For an Irish Book, 1929' in which he read Joyce's work as growing out of two roots, English literature and Catholic theology;[123] and

'The Catholic Element in *Work in Progress*' which focused on the link between Joyce's Catholicism and Modernism:

> The splendour of order, to use Saint Thomas's phrase, has not been the dominating characteristic of modern English prose and it is partly because the quality was demonstrated on a vast scale in Ulysses that that book marked a literary revolution ... when a really great Catholic writer sets out to create an inferno it will be an inferno. For Ulysses is an inferno. As Homer sent his Ulysses wandering through an inferno of Greek mythology and Virgil his Aeneas through one of Roman mythology so Dante himself voyaged through the inferno of the mediaeval Christian imagination and so Mr Joyce sent his hero through the inferno of modern subjectivity.[124]

MacGreevy first met Joyce through the artist Patrick Tuohy in Paris in 1924, and when he became resident there in 1927, MacGreevy re-established contact with the Joyce family.[125] In his memoirs MacGreevy wrote: 'What Joyce found puzzling was my preoccupation with pictures. "Where did you pick up that way you have of talking about painting?" he once asked me. "Yeats has it. Pound has it. I never had it."'[126] In 1929, defending Joyce's *Work in Progress* to the Irish public, MacGreevy wrote to *The Irish Statesman*:

> Mr Joyce's work has made an undeniably profound impression. There is no younger writer of intelligence who has not been influenced by him. To me, personally, he seems the most suggestive figure in the history of European art or literature since Leonardo da Vinci.[127]

The debt to Joyce's 'suggestiveness' is clear in a poem such as 'Crón Tráth na nDéithe', both in form and language. But in what ways could an artist like Leonardo da Vinci be a suggestive figure to the poet who was primarily concerned with post-independence Irish cultural nationalism expressed through a Modern poetic idiom?

MacGreevy held the post of *lecteur d'anglais* at L'École Normale Supérieure in Paris for three years, starting in January 1927. During this time he translated Paul Valéry on Leonardo da Vinci, and when Beckett followed him as *lecteur* in July 1930, he remained in Paris until December 1933.[128] Joyce introduced MacGreevy to Jolas, founder and editor of *transition* magazine, and besides Marianne Moore's *The Dial* and Eliot's *The Criterion*, *transition* became one of the main outlets for MacGreevy's poetry. After the publication of his poems in the magazine in 1928–29, he published 'Elsa' (reprinted in *Poems* as 'Gioconda'), and 'Treason of Saint Laurence O'Toole' (reprinted as 'Homage to Hieronymus Bosch') in 1932.[129] During his time in Paris he also acted as secretary to the English edition of the beaux-arts journal *Formes*, and he published *T.S. Eliot: A Study* (1931), and *Richard Aldington: An Englishman* (1931).[130]

The hillsides were of rushing silvered water,
Down
And around

And all across
And about the gleaming tree stumps,
Far as sensitive eyesight could see,
On both sides of the valley
And beyond,
Everywhere,
The silvered swirling water!

The clouds,
Blue gray,
Lined with pink
And edged with silver
Meditated.

The sun did not rise or set
It was not interested in the activities of politicians.

White manes tossed like spray.
Bluish snakes slid
Into the dissolution of a smile.[131]

Before publishing 'Elsa' in *transition*, MacGreevy had variously called the poem 'Departure of the Unknown' and 'Homage to Leonardo'. Archival evidence indicates that MacGreevy had spent time with the painting of the Mona Lisa when in Paris, and his translation from Valéry also signals his interest in the artist's work.[132] In the history of art, *La Gioconda*, or the *Mona Lisa* (c. 1503–1505), is famous for the enigmatic smile of the sitter, and for being one of the first paintings to encompass landscape into portraiture.[133] This tradition was developed to signify land ownership in formal portraiture, particularly in the eighteenth century. In the *Mona Lisa*, the juxtaposition of the woman and the land is most likely intended to symbolize fertility. From a technical point of view, the portrait initiates several new departures, including the use of *sfumato*, or the hazy effect that unites the components of the painting by eliminating hard edges. The enigmatic quality of the portrait is due to the eyes 'following' the viewer (achieved by the sitter looking directly at the portraitist), and to the sitter's smile. The viewer can never determine the exact emotion being expressed by the Mona Lisa. Leonardo also employed largely aerial perspective, whereby a sense of distance is achieved by gradations of tone and light, but the viewer's eye is also led into the landscape by following sinuous rivers and rock formations.

In 'Elsa', he has attempted to translate these compositional elements of the painting into poetry. On reading the poem in its entirety, the first thing to notice is that the poet has concentrated on the landscape background rather than the figure of the Mona Lisa, until the last line in which the sitter's famous smile is used to signify her all-embracing presence. In the first stanza, MacGreevy dissolves the hillsides into 'rushing silvered water', which continues to

rush around the picture. As though wheeling a paintbrush around a panel, MacGreevy describes the water as moving 'Down', 'around' and 'about', leading the imagination of the reader, as Leonardo does in his painting, to the horizon, 'Far as sensitive eyesight could see'. The effect of the silvered water rushing and swirling in the first stanza is emphasized by the use of *vers libre*, by varying lengths of line, and by the use of an exclamation mark in the last line.

Aurally the onomatopoeic use of the letter 's', particularly in the first line, evokes the sound of rushing water. The silver and white imagery of the first stanza shifts in the second to encompass pastel-colours in the clouds, and the movement and flow of the first stanza is halted by the final word, 'Meditated'. This is similar in technique to that used in 'Dysert', where the poem moves from description to a more interior, subjective world. In this case, the poet personifies the clouds, giving them the ability to meditate. The technique is in keeping with the meditative gaze of the Mona Lisa herself, and with the effect of painting on the viewer. This timeless quality is then developed in the next line where 'The sun did not rise or set'.

In the next line MacGreevy introduces 'politicians', which is somewhat at odds with the flow of the painting. But above all else it is indicative of the preoccupations of the poet, and his sympathy with the art of the French painter and tapestry designer Jean Lurçat. MacGreevy met Lurçat in the late 1920s in Paris and reviewed his work, on show in Victor Waddington Galleries, Dublin, as 'an enchanting landscape painter ... for a Frenchman of to-day any landscape is the world in little and the world is in a state of apocalyptic ruin'.[134] Between the wars, Lurçat's work became increasingly dark and preoccupied with the devastation of the world. As in 'Dysert', therefore, MacGreevy incorporates his socio-political preoccupations into his poetry. In the final stanza, the poet returns to the imagery of water, now in the form of animals with 'White manes', or as 'Bluish snakes', where the 's' sound predominates again. The poem then ends as it began, with a reminder that all is not as it seems. At the opening of the poem, hillsides were dissolved into water, re-enacting, in effect, the painterly device of *sfumato*, while in the last line, the poet returns to this idea by dissolving the whole scene into a smile. Although he has spent the entire poem evoking the background of the painting, it is the smile of the Mona Lisa that ultimately holds the key to the poem, as it does in the painting.

'Elsa' was published in the same year and month (March 1932) as the optimistic 'Poetry is Vertical' manifesto was published in *transition*. MacGreevy was one of the signatories to this, along with Hans Arp, Beckett, Eugene Jolas and others. In the manifesto, they championed 'the autonomy of the poetic vision. The hegemony of the inner life over the outer life', and MacGreevy carried this optimism forward when he published *Poems* in 1934, marking a key point in his poetry career.[135] By then, he had published the

majority of his poems in France and England, established himself as an art critic in Ireland, London and Paris, and received the greatest of praise from Beckett for his poetry, both in 'Recent Irish Poetry' and 'Humanistic Quietism', Beckett's review of his *Poems*.[136] Explanations as to why MacGreevy's career as a poet virtually ended in 1934 include his move back to London to take up the position of lecturer in the National Gallery of London in 1934, the lack of appreciation for his poetry outside Paris and London, and his move back to Ireland in 1939 where, as Beckett saw it, conventional poets were nurturing a 'flight from self-awareness'.[137] But in his memoirs, MacGreevy recorded:

There was a time when I dreamed of being a writer. As things worked out I never became more than a part-time writer. That could be due to economic circumstance. It could be due as well to my psychological make-up. I think I may say that I have always been as much interested in living as in writing about living. When, for a short time at the École Normale in Paris and later, for a short period at the hotel in the Quarter, Samuel Beckett and I had adjoining rooms and breakfasted together, Sam would go straight from his morning tea or coffee to his typewriter or his books, his biblical concordance, his dictionaries, his Stendhal. I, on the contrary, had to go out and make sure that the world was where I had left it the evening before. What is more, it was only a possibility that I would go back and work for myself during the day. I wrote best in the stillness of the night when there was no outside work to be done and nobody to talk to.[138]

After 1934 MacGreevy chose instead to focus on his career as a commentator on the arts. In London he wrote for *Ireland To-Day* and *The Studio*, and on his return to Ireland after the Blitz, he published *Pictures in the National Gallery* (1945) and *Jack B. Yeats: An Appreciation and an Interpretation* (1945), to which Beckett responded.[139] This essay is, arguably, MacGreevy's best-known art criticism, and in it he formalizes his opinion that Jack Yeats was *the* 'national' Irish painter. However, Beckett's contention that Jack Yeats was producing Modernist pictures comparable to Eliot's *The Waste Land* frees the artist up a little from such culturally nationalist interpretations. Before looking at MacGreevy and Beckett's texts in more detail, it is important to consider the relationship between MacGreevy, Beckett and Jack Yeats in context. To establish what they knew of each other's work in word and in image at once situates their critiques historically, and informs an understanding of verbal and visual ties in Jack Yeats's career.

Verbal and Visual Ties: Thomas MacGreevy, Samuel Beckett and Jack Yeats

Jack Yeats first made contact with the young Beckett in Dublin in 1930. A letter from MacGreevy to Jack Yeats in November 1929 explains how this came about:

Joyce asks for news of you and Mrs Joyce changed her drawing
room recently and re-hung your pictures to great advantage.

My last year's colleague and my successor Samuel Beckett is still in Dublin
for a little while. He's a nice fellow the nephew of Cissie Sinclair. I told him to
introduce himself to you from me if he saw you but I suppose he hasn't done so.
He lives at Cooldrinagh, Foxrock. It would be a charity to ask him round one
afternoon and show him a few pictures and drop all the conversational bombs
you have handy without pretending anything. But the luck will be all on his
side, he says very little especially at first, and you might find him not interesting,
so don't do it unless you feel like doing nothing one day. Joyce does like him
however and I'm genuinely fond of him tho' he's maddeningly young.[140]

Then, in December 1930, MacGreevy wrote again to Jack Yeats saying that he would soon be visiting Ireland for about two weeks to see his mother, and that he hoped to visit the painter in Dublin. He continued:

Beckett wrote me about his visit to you. I'm glad you liked him. He was completely
staggered by the pictures and though he has met many people through me he
dismissed them all in his letter in the remark 'and to think I owe meeting Jack
Yeats and Joyce to you!' He's got a good sense of values all right. A good lad
though still younger than he'll be yet – if he can manage to avoid the fate of poor
Geoffrey Phibbs, but I think there's no fear of his thinking any down town Jewess
from New York has 'the greatest intelligence in Europe'. I still weep over the loss
of Geoffrey. Norah is in India now but will be back here in April or May.[141]

Although Arnold has detailed the friendship between Jack Yeats, MacGreevy and Beckett in his biography, a closer look at the contrasting interpretations of the artist's work by his two friends yields further insight into the roles of word and image in the formation of his Modernism. Beckett's first critique of Jack Yeats's paintings occurs in his 1934 essay 'Recent Irish Poetry'. But Beckett's separation of contemporary Irish writers into 'antiquarians' and 'others', with MacGreevy situated somewhere in the middle, has proved somewhat controversial. As Gillis has indicated, this polarization has led to too simplistic a history of two camps of Irish art: 'conservative writers working within hackneyed Irish modes, on the one hand, and overtly experimental and European-influenced Modernists, on the other'.[142] New analyses of 1930s poetry break down this paradigm, but it is also helpful to consider carefully Beckett's reference to Jack Yeats's paintings in his essay, and to contextualize 'Recent Irish Poetry' in the cultural *milieu* in which it was written.

In his essay, Beckett states that WBY 'wove the best embroideries' and that his followers, the 'twilighters', were preoccupied with Revival themes of 'Oisin, Cuchulain, Maeve, Tir-na-nog, the Táin Bo Cuailgne, Yoga, the Crone of Beare'.[143] On the other hand, poets Coffey and Devlin were developing the 'bankrupt relationship' between subject and object in line with the Modern

poets 'Corbière, Rimbaud, Laforgue, the *surréalistes* and Mr Eliot, perhaps also Mr Pound'.[144] Notably, several of the writers of the Irish Revival attacked by Beckett published literature with the Dun Emer and Cuala Press, including George Russell (AE), Austin Clarke, Frank O'Connor and John Lyle Donaghy, and as contemporary reviews (see Chapter 2) suggest, the contrast between the reception of their 'antiquarian' endeavours in Ireland and Beckett's point of view from France was significant.

The Cuala Press, with WBY as editor, was the melting pot for Revival literature, and so it is unsurprising that neither Beckett nor the writers he praised were published there. Yet Beckett's minority group included Jack Yeats, who had been actively involved with the Press until 1926. Given that MacGreevy had been advocating Jack Yeats as the 'national' Irish painter since the early 1920s, it is worth considering what indications exist that this artist would have situated *himself* in the camp of Beckett's 'others' by the 1930s. Jack Yeats's career as a writer confronts this question. However, before probing this aspect of his career, it is prudent to expound the antithetical approaches of MacGreevy and Beckett to their friend's work.

Debates between MacGreevy and Beckett over Jack Yeats's paintings came to a head in the late 1930s. After over 20 years of contact with Jack Yeats, MacGreevy encapsulates in *Jack B. Yeats: An Appreciation and an Interpretation* many of the art-historical opinions he had formulated through his career. For MacGreevy, Jack was:

[t]he first genuine artist ... who so identified himself with the people of Ireland as to be able to give true and good and beautiful artistic expression to the life they lived, and to that sense of themselves as the Irish nation ... his work was the consummate expression of the spirit of his own nation at one of the supreme points in its evolution.[145]

The majority of the essay was written by 1938 in London, but MacGreevy could not find a publisher for it. He sent a draft to Beckett, and his friend responded, famously expressing his:

chronic inability to understand as a member of any proposition a phrase like 'the Irish people', or to imagine that it ever gave a fart in its corduroys for any form of art whatsoever, whether before the union or after ... God love thee, Tom, and don't be minding me. I can't think of Ireland the way you do.[146]

MacGreevy went ahead to publish his essay with Victor Waddington in Dublin in 1945, adding a postscript covering the past seven years of the artist's work. Beckett then wrote a review entitled 'MacGreevy on Yeats' (1945) for *The Irish Times*, which begins with the diplomatic statement: 'This is the earliest connected account of Mr Yeats's painting. To it future writers on the subject will, perhaps, be indebted ... – indebted for an attitude to develop, or correct, or reject.'[147] Beckett then publicly challenged his friend's presumptions:

The national aspects of Mr Yeats's genius have, I think, been over-stated, and for motives not always remarkable for their aesthetic purity ... He is with the great of our time, Kandinsky and Klee, Ballmer and Bram van Velde, Rouault and Braque, because he brings light, as only the great dare to bring light, to the issueless predicament of existence, reduces the dark where there might have been, mathematically at least, a door. The being in the street, when it happens in the room, the being in the room when it happens on the street, the turning to gaze from land to sea, from sea to land, the backs to one another and the eyes abandoning, the man alone thinking (thinking!) in his box – these are characteristic notations having reference, I imagine, to processes less simple, and less delicious, than those to which the plastic *vis* is commonly reduced ...[148]

The comment is significant, and the contrast between the art-critical approaches of the two men holds the key to an interdisciplinary discussion of Jack Yeats's work. Beckett's interpretation confronts the 'national' hegemonic paradigm pioneered by MacGreevy for Jack Yeats. However, Beckett's reading is in turn to be understood in the context of Beckett's own relationship with Ireland and the arts.

Lloyd has written about the relationship between Jack Yeats, MacGreevy and Beckett, discussing how MacGreevy 'not only makes no secret of his political affiliations, but insists on articulating both a republican interpretation of recent Irish history and his sense of the relation of Yeats' work to republicanism'.[149] He also claims that Jack Yeats demonstrates 'the enactment of a failure of representation' after 1922 because of his 'postcolonial disaffection'. Lloyd contends that Jack Yeats shares this aesthetic with Beckett for whom 'the nation-state not only stands as an acknowledgement of the failure of a certain political promise but spells equally the disintegration of a coeval aesthetic project of representation'.[150] His argument is compelling, and demonstrates the importance of the relationship between the three men to contemporary Irish studies. However, his approach is tempered by readings of Beckett's dissonant poetics in terms other than his Irish background, and an analysis of word and image relationships in this instance disrupts 'nationalist' and 'Modernist' readings of Jack Yeats even more.[151]

When Beckett wrote 'MacGreevy on Yeats' in 1945, he did so with an awareness of the relationship between the two media in Jack Yeats's *oeuvre*. In 1938 he had reviewed Jack Yeats's novel *The Aramanthers* (1938) in *The Dublin Magazine* as 'An Imaginative Work!' – a thing which MacGreevy, curiously, never did.[152] Here, some of the themes of Beckett's 1945 review were already taking shape: 'The moments are not separate, but concur in a single process: analytical imagination. ... There is no allegory ... There is no symbol ... stages of an image. There is no satire.'[153] Just as it is beneficial, if not imperative, to read MacGreevy's poetry in the light of his art criticism, so it is important to consider Jack Yeats's paintings in relation to his writings. Archival evidence demonstrates that Jack Yeats was conscious of relationships between word and image, and the fact that he moved towards writing novels in the early 1930s,

before his last great phase of oil painting in the 1940s and 1950s, should not be overlooked. As Alan Gillis has pointed out: '[i]n Irish literary history, the 1930s are overshadowed, and almost eclipsed, by the previous three decades. After the creative booms and imaginative highs that helped drive Ireland towards Independence, the 1930s seem an almighty comedown.'[154] Gillis demonstrates, however, that there was in fact a wide range of achievement in that decade, and breakthroughs in MacGreevy's pictorialist poetry and Jack Yeats's writings back up his premise.

At times in his criticism from the 1930s and 1940s, MacGreevy looked back on the arts in Ireland during his career and discussed the roles that the verbal and visual arts had played in relation to Irish history. By the end of the 1940s, MacGreevy thought that the great flourishing of literature during the Irish Cultural Revival was effectively over:

Forty years ago, the name of Dublin was associated, in the minds of cultivated people everywhere, primarily with the idea of poets and poetry. And with good reason. Though they did not all realise it clearly, Irish people at the time instinctively knew why, in Ireland just then, poetry had taken on an unwonted urgency, momentum and splendour. ... To-day, it can hardly be claimed that poetry is what the name of Dublin suggests to the world. ... the tide of great poetry receded precisely as the great national stir of the early years of the century subsided and the unified movement that was the outward manifestation of it disintegrated.[155]

MacGreevy made similar assertions in *Jack B. Yeats: An Appreciation and an Interpretation*: 'In the very worst times there had been good and sometimes great literature that was Irish in spirit ... Literature can be produced when there is no more than a bare minimum of social organisation, but architecture and the plastic arts can only flourish under a securely established social order.'[156] He argued that before 1924 'in the life of Ireland fact and poetry had parted company', and that after the Civil War, painting in Ireland separated into two camps: the subjective and the objective tendencies.[157] After 1924, Jack Yeats belonged to the subjective camp: 'Jack Yeats's work became a passionate recall to poetry – to the splendour of essential truth ... the balance between observation and imagination has, in fact, altered.'[158] Then, in his critique of Jack Yeats's painting *California* (1937), MacGreevy again invoked 'poetry' to explain himself, writing that the people and scene in the picture 'flashed simultaneously into the pure fire of living poetry ... In this different world of the imagination landscape and figures can be and are at one with each other.'[159] This method of applying poetry to an appraisal of painting echoes his statement that 'the greatest writing has always owed a great deal to painting, as the greatest painting owes a great deal to literature', pointing to painting's ability to take on the *subjective* nature of its sister art, poetry.[160]

An examination of MacGreevy's work focuses on relationships between transitional verbal and visual arts in the extended Yeats circle in the 1920s

through to the 1940s, and signals a resurgence of interest in dialogues between the verbal and visual arts in Ireland, but it leaves open questions surrounding the role of these dialogues in the transition from the Celtic Revival to Irish Modernism. Even so, in the light of Beckett's writings, and with the benefit of hindsight, conclusions can be drawn about Jack Yeats's dialogue with the *fraternité des arts* tradition and the emergence of Modern Irish painting, an emergence which began in earnest when he dedicated himself to subjective art around the year 1926.

Notes

1. Thomas MacGreevy, 'Apropos of the National Gallery', *Ireland To-Day* (December 1936): 57. Published works by MacGreevy are available in the online Thomas MacGreevy archive, <http://www.macgreevy.org>. Other references to MacGreevy's writings are unpublished manuscripts located in his archive, TCD, MSS 7985–8190.

2. I borrow the term 'pictorialist poetics' from David Scott, *Pictorialist Poetics: Poetry and the Visual Arts in Nineteenth-Century France* (Cambridge, 1988).

3. For example, David Scott, *Pictorialist Poetics*; Roger Little, *The Shaping of Modern French Poetry: Reflections on Unrhymed Poetic Form, 1840–1990* (Manchester, 1995); Barbara Wright, *Eugène Fromentin: A Life in Art and Letters* (Bern and New York, 2000); Catherine J. Golden (ed.), *Book Illustrated: Text, Image, and Culture 1770–1930* (Delaware, 2000).

4. See also my essay, 'Thomas MacGreevy and Irish Modernism: Between Word and Image', in Edwina Keown and Carol Taaffe (eds), *Irish Modernism: Origins, Contexts, Publics* (Bern and New York, 2009), pp. 95–110.

5. This argument is formulated in Scott, *Pictorialist Poetics*.

6. Thomas MacGreevy, *Poems* (London, 1934).

7. Andrew Belis [pseud. of Samuel Beckett], 'Recent Irish Poetry', *The Bookman*, 86 (August 1934): 235–6. Reprinted in Samuel Beckett, *Disjecta: Miscellaneous Writings and a Dramatic Fragment* (London, [1983] 2001), pp. 70–76.

8. Terence Brown, *Ireland: A Social and Cultural History 1922–2002* (London, 2004), p. 156.

9. Terence Brown, 'Ireland, Modernism and the 1930s', in Coughlan and Davis (eds), *Modernism and Ireland* (Cork, 1995), p. 25.

10. Brown, 'Ireland, Modernism and the 1930s', p. 35; Alan Gillis, *Irish Poetry of the 1930s* (Oxford, 2005), p. 3.

11. Davis attempts to read WBY's early poem 'The Song of the Happy Shepherd' as 'modernist in its preoccupations', and contrasts it with MacGreevy's 'Crón Tráth na nDéithe': 'In comparing these two very different texts – texts separated by over thirty years – we can see the presence of certain strains of what we now think of as modernism: anxiety over the social function of art; the collapse of realist conceptions of thought and language, alienation from an object world that cannot be transcended fully ... – the predicament, in short, inherited by a post-Baudelairian poet' (Alex Davis, 'Irish Poetic Modernisms: A Reappraisal', *Critical Survey*, 8/2 [1996]: 195).

12. Edna Longley and Gillis have taken this appraisal further by demonstrating the influence of WBY on the *soi-disant* 'modernists' Coffey, Devlin and MacGreevy. See Longley, '"Modernism", Poetry, and Ireland', in Marianne Thormählen (ed.), *Rethinking Modernism* (Basingstoke, 2003), 160–79, and Gillis, *Irish Poetry of the 1930s*. Taking his lead from Longley, Gillis also considers the poetry of Louis MacNeice and John Hewitt in order to take the new contexts opened up in the work of Irish Modernists further, and to fill in the lack of British context. See in particular Longley, *The Living Stream: Literature and Revisionism in Ireland* (Newcastle upon Tyne, 1994), pp. 252–70; Longley, *Poetry and Posterity* (Northumberland, 2000), pp. 134–66.

13. Susan Schreibman (ed.), *Collected Poems of Thomas MacGreevy: An Annotated Edition* (Dublin and Washington DC, 1991). Susan Schreibman (ed.), *The Thomas MacGreevy Archive* <www.macgreevy.org>.

14. Thomas MacGreevy's 'Aodh Ruadh Ó Domhnaill' was first printed in *The Irish Statesman*, 6/8 (1 May 1926): 204–5; his 'Nocturne of the Self-Evident Presence' was first published in *The Irish Statesman* 7/3 (25 September 1926): 57–8.

15. In *The Irish Statesman* of September 1923, MacGreevy responded to Bodkin's article on the painter Nathaniel Hone for whom Bodkin had claimed, '[n]o Irish painter, living or dead, has equalled, much less surpassed, the purely aesthetic quality of his art'. MacGreevy argued that Jack Yeats was a greater painter than Hone (Bruce Arnold, *Jack Yeats* [New Haven and London, 1998], p. 223).

16. MacGreevy, 'Contemporary Art in Ireland', unpublished, n.d. [c. 1925] (TCD, MS 8002/15). There is also an unpublished version of this essay in French, 'L'art contemporain en Irlande' (TCD, MS 8001/15b).

17. MacGreevy, 'Contemporary Art in Ireland'. Rembrandt was in his 40s when the Treaty of Westphalia (1648) brought independence to Holland, while Jack Yeats was almost 50 when self-government came to Ireland.

18. For a discussion, see Síghle Bhreathnach-Lynch, 'Framing Ireland's History: Art, Politics and Representation 1914–1929', in James Christian Steward (ed.), *When Time Began to Rant and Rage: Figurative Painting from Twentieth-Century Ireland* (London, 1999), pp. 40–51.

19. See Bruce Arnold, 'Jack Yeats: The Need for Reassessment', in Yvonne Scott (ed.), *Jack B. Yeats: Old and New Departures* (Dublin, 2008), pp. 47–56.

20. MacGreevy's 'Crón Tráth na nDéithe' was first published as "School of …", in *transition* (November 1929): 114–18. 'Dysert' was first printed in *The Criterion*, 4/1 (January 1926): 94; reprinted as 'Homage to Jack Yeats', in *The European Caravan* (1931): 496.

21. Other examples include 'Homage to Marcel Proust'; 'Giorgionismo'; 'Gioconda'; 'Arrangement in Grey and Black' (a reference to James Whistler's 1871 painting of the same name).

22. Other examples include '… Rubens or Domenichino' ('Nocturne of the Self-Evident Presence'); 'Con / Stantinople' (Gloria de Carlos V').

23. MacGreevy to Jack Yeats, n.d. [c. late 1929 or early 1930], in Susan Schreibman (ed.), *Collected Poems of Thomas MacGreevy*, p. 107.

24. MacGreevy, 'The Catholic Element in *Work in Progress*', in James Joyce, *Our Exagmination Round His Factification for Incamination of Work in Progress* (London, 1929), pp. 117–29.

25. MacGreevy's 'Aodh Ruadh Ó Domhnaill' was first published in *The Irish Statesman*, 6/8 (1 May 1926), pp. 204–5. Red Hugh O'Donnell was an Irish chieftain of the early 1600s who, during the 'Flight of the Earls', was detained and died in Spain, and when he printed the poem, MacGreevy included an historical addendum to clarify the subject matter. For a discussion of Red Hugh O'Donnell's role in the war against England, see Darren McGettigan, *Red Hugh O'Donnell and the Nine Years War* (Dublin, 2005).

26. MacGreevy records that he met Jack Yeats in 1919 at 'one of Miss Purser's second Tuesdays' (untitled paper on Jack Yeats, [TCD, MS 7999/5], p. 1).

27. *Riverside (Long Ago)* (1922), Collection: Ulster Museum, Belfast; *The Funeral of Harry Boland* (1923), Collection: Sligo County Museum, Sligo.

28. Hilary Pyle, *Yeats: Portrait of an Artistic Family* (Dublin and London, 1997), p. 208.

29. Lily reported: 'Jack is not very well – overwork – he has to rest and the doctor does not allow him to work more than a couple of hours a day … He has always worked too hard – that black and white work means no break even for a week, and this terrible war like a dense fog over all – no one wants pictures or any artist's work, except for nothing [sic] to put in "The Queen's Giftbook" or "Princess Mary's Scrap Album"' (LY to Quinn, 29 November 1915 [NYPL, Quinn Coll.]). See also Arnold, *Jack Yeats*, pp. 185–201 and Hilary Pyle, *Jack B. Yeats: A Biography* (London, 1970), pp. 118–20.

30. Pyle, *Jack B. Yeats: A Biography*, p. 127.

31. Beckett [Belis], 'Recent Irish Poetry', in Beckett, *Disjecta*, p. 70.

32. See Arnold, *Jack Yeats*, pp. 226–33.

33. Unsigned review, *The Referee*, 13 January 1924; quoted from Arnold, *Jack Yeats*, p. 227.

34. *Illustrated Sunday Herald*, 6 January 1924; quoted from Arnold, *Jack Yeats*, p. 228.

35. Nora McGuinness, *The Literary Universe of Jack B. Yeats* (Washington DC, 1992). For a discussion of the relationship between these three men within a post-colonial framework, see David Lloyd, 'Republics of Difference: Yeats, MacGreevy, Beckett', *Field Day Review* (2005): 43–69.

36. Edward Sheehy, 'Jack B. Yeats', *Dublin Magazine*, 10/3 (July–September 1945), pp. 38–41. YMUS Jack B. Yeats 3 (1), Parcel 3–2.

37. Brian O'Doherty, 'Jack B. Yeats: Promise and Regret', in Roger McHugh (ed.), *Jack B. Yeats: A Centenary Gathering* (Dublin, 1971), p. 80. See also Bruce Arnold, 'Jack Yeats and the Making of Irish Art in the Twentieth Century', in Steward (ed.), *When Time Began to Rant and Rage*, pp. 52–62. Arnold claims that Jack Yeats's contact with Eamon de Valera through the 1922 Race Conference in Paris provoked his increasing alliance with Sinn Féin (Republicans) in Irish politics.

38. Jack Yeats to Quinn, 12 June 1921 (NLI, Foster-Murphy).

39. Jack B. Yeats, *Modern Aspects of Irish Art* (Dublin, 1922). Series F. 8, p. 4.

40. Thomas MacGreevy, 'Dysert', first printed in *The Criterion*, 4/1 (January 1926): 94.

41. MacGreevy to George Reavey, 28 October 1932, quoted in Schreibman, *Collected Poems of Thomas MacGreevy*, p. 127. MacGreevy sent the poem to Jack Yeats who responded: 'Now I have only the time to say I like "Dysert" very much [,] that I have not got *transition* from Robinson' (Jack Yeats to MacGreevy, 22 March 1929 [TCD, MS 10381/103]). Three years later, Jack wrote to thank MacGreevy for 'Caravan': 'The lines to Jack Yeats are as fine as ever. I am very glad to have them' (Jack Yeats to MacGreevy, 24 January 1932, [TCD, MS 8105/19]).

42. See Schreibman, *Collected Poems of Thomas MacGreevy*, pp. 126–7. I thank Professor Roger Stalley of Trinity College Dublin for pointing out that there is no 'Dysert' in Ireland beside the coast.

43. In his poetry, MacGreevy makes a feature of the American spelling 'gray' for the English spelling 'grey'. In his *The Oxford Book of Modern Verse 1892–1935* (Oxford, 1935), W.B. Yeats includes the poem entitled 'Homage to Jack Yeats' and changes the spelling to 'grey'.

44. The colour grey was also used by Wassily Kandinsky in interesting ways. For example, his *Im Grau* ('In Grey') (1919) (Collection: Centre Pompidou, Paris. Musée national d'art moderne); and in his *Rosa im Grau* ('Rose in Grey') (1926) (Private Collection), grey tones are used to connote a landscape background from which contrasting colours and shapes can stand out. There is no evidence in the Yeats Museum regarding the extent of Jack Yeats's familiarity with Kandinsky's writings or paintings.

45. Catherine Nash writes:

 The celebration of the West as an archetypal Irish landscape was part of an attempt to identify with a landscape which was a confirmation of cultural identity. It was not simply or only that the West was farthest from England and therefore most isolated from the cultural influences of anglicanisation, but that its physical landscape provided the greatest contrast to the landscape of Englishness.

 ('"Embodying the Nation": The West of Ireland Landscape and National Identity', in Michael Cronin and Barbara O'Connor (eds) *Tourism in Ireland: A Critical Analysis* [Cork, 1993], p. 91). See essays in Steward (ed.), *When Time Began to Rant and Rage*.

46. Y.O. [George Russell (AE)], 'The Hibernian Academy', *The Irish Statesman*, 2 (19 April 1924): 166.

47. Jack Yeats, Seán Keating and Paul Henry all painted the West of Ireland. In 1973, Dorothy Walker wittily describes Paul Henry's painting, rather than imitating nature, as succeeding in '... making the landscape look like his painting' ('Paul Henry: An Alternative View', *Irish Arts Review*, 20/1 [Spring, 2003]: 61) For a reappraisal of Keating's work, see Fintan Cullen, *Visual Politics: The Representation of Ireland, 1750–1930* (Cork, 1997), pp. 160–74. Edna Longley has discussed the appropriation and politicization of the West of Ireland in relation to the writings of WBY in her book *Poetry and Posterity*, pp. 90–133.

48. Samuel Beckett to Alberto Giacometti, in John Kobler, 'The Real Samuel Beckett', *The Connoisseur* (July 1990): 57. See in particular the final stanzas of Eliot's *The Waste Land* (1922).

49. Beckett [Belis], 'Recent Irish Poetry', in Beckett, *Disjecta*, p. 74.

50. Beckett [Belis], 'Recent Irish Poetry', in Beckett, *Disjecta*, p. 70.

51. Alberto Giacometti, *Hand Holding the Void (Invisible Object)* (created 1934, cast 1954–55), bronze, 59 ⅞ × 12 ⅞ × 10 inches (152.1 × 32.6 × 25.3 cm). Collection: Museum of Modern Art, New York.

52. For an excellent analysis of the relationship between Beckett and Giacometti, see Matti Megged, *Dialogue in the Void: Beckett and Giacometti* (USA, 1985). This space is also present in the work of the contemporary Irish artist Deborah Brown (b. 1927), whose recent work links Beckettian themes with Irish mythology. See Hilary Pyle (ed.), *Deborah Brown: Painting to Sculpture* (Dublin, 2005).

53. MacGreevy, 'Nocturne', published as 'Nocturne, Saint Eloi, 1929', *The Irish Statesman*, 2/4 (28 September 1929): 69.

54. Beckett [Belis], 'Recent Irish Poetry, in Beckett, *Disjecta*, p. 74.

55. MacGreevy, 'St Brendan's Cathedral, Loughrea 1897–1947', n.d. [c. 1946] (TCD, MS 8002/12), pp. 1 and 15; published in *The Capuchin Annual* (1946–47): 353–73.

56. MacGreevy, untitled paper on Jack Yeats, n.d. (TCD, MS 7999/1), p. 1.

57. Schreibman, *Collected Poems of Thomas MacGreevy*, p. 104. Hieronymus Bosch, *The Garden of Earthly Delights* (c. 1500). Collection: Prado Museum, Madrid.

58. See MacGreevy, 'How Does She Stand?', *Father Mathew Record* (September 1949): 3. In a letter dated 2 October 1926, Jack Yeats wrote to MacGreevy: 'Many thanks for your kind letter and for Bosch which is very fine and worth doing so well. I am glad to have it' (TCD, MS 8105/12). In a letter dated 25 November 1926, Jack Yeats then asked MacGreevy: 'Has your Bosch poem been published anywhere?' (TCD, MS 8105/13).

59. MacGreevy, 'Treason of Saint Laurence O'Toole' (For Alexander Andreyevitch Balascheff); first published in *transition*, 21 (March 1932): 178–9.

60. MacGreevy wrote to M.E. Barber, the general secretary of the Society of Authors: 'When I was a student a number of us, 17 in all I think, who were ex-British officers asked the Provost of Trinity College to send an appeal on our behalf for the reprieve of a student of the National University who was captured in an ambush and condemned to be hanged. It was believed that he had been tortured by the Black and Tans ... But the Provost refused to have anything to do with the appeal and Kevin Barry was hanged' (Schreibman, *Collected Poems of Thomas MacGreevy*, p. 104).

61. Juxtapose, for example, the opening stanza of this poem with MacGreevy's explanation of her work: 'without defining facial features, or even hands, in any detail ... endeavouring, through line and colour harmonies and eliminating what to her were extraneous aids' (MacGreevy, 'Evie Hone and Mainie Jellett' [TCD, MS 8002/1], p. 2).

62. MacGreevy, 'How Does She Stand?', p. 3. The title of his essay is taken from the ballad 'The Wearing of the Green'. Interestingly, in an annotated version of this cutting, MacGreevy changed the paragraph to read: 'The west, ... But every student of Irish history knows that, like the Wala, the Earth Goddess in Wagner's <u>Ring</u> the spirit operates as surely, however differently, when asleep as when awake.' The changes imply the complicity between 'the west' and 'spirit' for MacGreevy.

63. These lines also echo the second stanza of MacGreevy's 'Homage to Hieronymus Bosch': 'High above the Bank of Ireland / Unearthly music sounded / Passing Westwards'.

64. Quoted from Jack B. Yeats and Thomas MacGreevy, BBC interview, recorded 6 November 1947, broadcast 17 May 1948 (NGI, YDisc).

65. Thomas MacGreevy, *Jack B. Yeats: An Appreciation and an Interpretation* (written 1937; published Dublin, 1945), p. 24.

66. Beckett, 'Humanistic Quietism', *Dublin Magazine* (July–September 1934): 79–80, reprinted in Beckett, *Disjecta*, pp. 68–9.

67. Beckett, 'Humanistic Quietism', in Beckett, *Disjecta*, p. 69.

68. Titian, *La Gloria* (1554–57), Collection: Prado, Madrid.

69. MacGreevy, 'Gloria de Carlos V', *transition*, 18 (November 1929): 119, lines 15–23.

70. MacGreevy, 'Gloria de Carlos V', lines 10–14.
71. Erwin Panofsky, *Problems in Titian Mostly Iconographic* (London, 1969), p. 64.
72. The naming of artists in poetry is a technique fostered by Charles Baudelaire in 'Phares', in which seven of the eleven stanzas begin with the name of an artist. Curiously, Baudelaire also adduces the colours red and green in his poetry and art criticism to create a jarring effect on the reader.
73. Schreibman, *Collected Poems of Thomas MacGreevy*, p. 138.
74. MacGreevy, *Jack B. Yeats: An Appreciation and an Interpretation*, pp. 7–8.
75. See Arnold, *Jack Yeats*, pp. 202–16.
76. Beckett [Belis], 'Recent Irish Poetry', in Beckett, *Disjecta*, p. 70.
77. MacGreevy, 'Crón Tráth na nDéithe', lines 1–10.
78. For a long exposition of the multiple references in the poem, see Schreibman, *Collected Poems of Thomas MacGreevy*, pp. 107–22.
79. Schreibman, *Collected Poems of Thomas MacGreevy*, p. 112.
80. For example, MacGreevy, 'Dublin – City of Art', *Father Mathew Record* (September 1944): 5; MacGreevy, 'Some Statues by John Hogan', *Father Mathew Record* (August 1943): 5–6; MacGreevy, 'How Does She Stand?'
81. MacGreevy, 'Developments in the Arts', *Studies* (December 1951): 475–8.
82. MacGreevy, 'The Historical Background to Irish Art (Chiefly Architecture)', *The Capuchin Annual* (1944): 241–9.
83. See Edward McParland's discussion of Gandon's designs for the Four Courts and the Custom House (*Public Architecture in Ireland 1680–1760* [New Haven and London, 2001], pp. 116–19), and Jacqueline O'Brien and Desmond Guinness, *Dublin: A Grand Tour* (London, 1994), p. 177.
84. Schreibman, *Collected Poems of Thomas MacGreevy*, p. 122.
85. Robert F. Garratt, *Modern Irish Poetry: Tradition and Continuity from Yeats to Heaney* (Berkeley, Los Angeles and London, 1986). For a discussion of the politics of Joyce's allusions to Irish cultural nationalism through forms such as Gaelic love songs in *Ulysses*, see David Lloyd, *Anomalous States: Irish Writing and the Post-Colonial Movement* (Dublin, 1993), pp. 100–110. MacGreevy's title, the Irish equivalent of 'Götterdämmerung' [Twilight of the Gods] is taken from Wagner's opera 'Der Ring des Nibelungen', and is coupled with the Irish street ballad 'Cockles and Mussels'.
86. Garratt, *Modern Irish Poetry*, p. 96.
87. 'Veni Creator Spiritus' ('Come, O creator, [Holy] Spirit'), from Hymn to the Holy Sprit sung at Pentecost. Vivificantem (Credo) in Spiritum sanctum Dominum et Vivificantem, '(I believe) in the Holy Spirit, the Lord, and giver of life', from the Nicene Creed (Schreibman, *Collected Poems of Thomas MacGreevy*, p. 120).
88. MacGreevy was a gunner in the artillery regiment from 1917 and was wounded twice at the Somme, returning to England after the second injury for medical treatment.
89. MacGreevy, untitled paper on Jack Yeats, n.d. (TCD, MS 7999/1), p. 3.
90. MacGreevy, 'The Rise of a National School of Painting' (1922) (TCD, MS 8002/19), p. 2.
91. MacGreevy, 'The Rise of a National School of Painting', p. 1.
92. G.K. Chesterton, 'A Book of the Day' [review of *Stories of Red Hanrahan* by William Butler Yeats], Gleeson scrapbook, TCD MS 10676/9/1, p. 10 (recto).
93. MacGreevy, untitled paper on Jack Yeats, n.d. (TCD, MS 7999/1), p. 3.
94. MacGreevy, untitled paper on Jack Yeats, n.d. (TCD, MS 7999/1), pp. 4–8.
95. A discussion of these works is included in MacGreevy's paper, 'Three Historical Paintings by Jack B. Yeats', *The Capuchin Annual* (1942): 238–51.
96. See Arnold, 'Jack Yeats: The Need for Reassessment', pp. 47–56. See this new approach in Yvonne Scott, 'Chaos Theory', in Scott (ed.), *Jack B. Yeats*, pp. 84–99.
97. Jack Yeats, *Crossing the Metal Bridge* (1926), Private Collection.

98. Arnold, *Jack Yeats*, p. 196.

99. Ernie O'Malley, 'The Paintings of Jack B. Yeats', in *Jack B. Yeats: A Centenary Gathering*, ed. and introduced by Roger McHugh (Dublin, 1971), p. 68; John Rothenstein, 'Visits to Jack Yeats', *New English Review* (July 1946): 43; Terence de Vere White, *A Fretful Midge* (London, 1957), pp. 111–12. Each of these reviews is quoted at length in Arnold, *Jack Yeats*, pp. 230–31.

100. Beckett, 'Humanistic Quietism', in Beckett, *Disjecta*, p. 69.

101. For an account of MacGreevy's and Stevens's correspondence, see Peter Brazeau, 'The Irish Connection: Wallace Stevens and Thomas McGreevy', *The Southern Review*, 17 (Summer 1981): 533–41.

102. Thomas MacGreevy, 'Apropos of the National Gallery', p. 57.

103. Brown, 'Ireland, Modernism and the 1930s', p. 29.

104. Paul Claudel, Manuscrit AI, p. 328, line 42, *Cinq Grandes Odes. La Cantate à Trois Voix* (1913) (Paris, 1966). In fact, the link between MacGreevy's poetry and French poetry since Baudelaire has been greatly under-explored. Other links between MacGreevy and French poetry include his quotation of Baudelaire's 'Je suis belle ô mortels!' in 'Moments Musicaux' (quoted from Baudelaire's 'La Beauté': 'Je suis belle, ô mortels! Comme un rêve de pierre,' [line 1]). Claudel also wrote a 'Processionnal' and Mallarmé wrote poems entitled 'Hommage', which MacGreevy employs in 'Homage to Hieronymus Bosch', 'Homage to Jack Yeats' and 'Homage to Marcel Proust'. 'Homage' is of course often used in the title of paintings as well, such as Henri Fantin-Latour's *Homage to Delacroix* (1864) (Musée d'Orsay, Paris).

105. MacGreevy, 'Religious Art and Modern Ireland', *The Gaelic Churchman* (April 1922), pp. 128–9.

106. MacGreevy, 'The Spiddal Stations', n.d. (TCD, MS 8002/17), p. 1.

107. MacGreevy also noted that the stained glass pieces 'above all at Loughrea ... are there to induce that mood of meditation and recollection which only genuine works of religious art can induce, and more profanely considered, to constitute standards of taste and artistic points of departure ...' ('Michael Healy: Personal Reminiscences', *The Capuchin Annual* [1944]: 113). For a discussion of the depth of Catholic conservatism in 1930s Ireland, see Brown, *Ireland: A Social and Cultural History*, pp. 138–9.

108. MacGreevy, 'Irish Stained Glass', *The Leader*, 23 December 1922, p. 497.

109. MacGreevy, 'The Spiddal Stations', n.d. (TCD, MS 8002/17).

110. MacGreevy, *Jack B. Yeats: An Appreciation and an Interpretation*, p. 10.

111. John Keats, 'Ode on a Grecian Urn' (1820), lines 49–50. See Jacques Maritain, *Art and Scholasticism: With Other Essays* (London, 1947), p. 123. The poet Brian Coffey spent most of the 1930s researching a thesis on Aquinas at the Institut Catholique de Paris, mainly under the French philosopher Jacques Maritain. For a discussion, see Gillis, *Irish Poetry of the 1930s*, pp. 109–19.

112. MacGreevy, untitled paper on Jack Yeats, n.d. (TCD, MS 7999/5), p. 3.

113. Bruce Arnold, *Mainie Jellett and the Modern Movement in Ireland* (New Haven and London, 1991), pp. 191–2.

114. MacGreevy, 'Evie Hone and Mainie Jellett' (TCD, MS 8002/4), p. 2.

115. MacGreevy, 'Evie Hone Exhibition', *The Irish Times*, 27 November 1941, p. 4.

116. Mainie Jellett, *The Ninth Hour* (1941), Collection: Dublin City Gallery: The Hugh Lane. MacGreevy, 'Mainie H. Jellett Exhibition', *The Irish Times*, 21 November 1941, p. 3.

117. These essays include 'Art as a Spiritual Force' (lecture given to the White Stag Group, May 1941), 'My Voyage of Discovery', 'The Dual Ideal of Form in Art' and 'The Importance of Rhythm in Modern Painting'. Many of these essays are printed in the collection edited by Eileen MacCarvill, *Mainie Jellett, the Artist's Vision: Lectures and Essays on Art* (Dundalk, 1958). 'My Voyage of Discovery' is reprinted in Fintan Cullen (ed.), *Sources in Irish Art: A Reader* (Cork, 2000), pp. 86–91.

118. Jellett, 'The Importance of Rhythm in Modern Painting', in MacCarvill (ed.), *Mainie Jellett*, p. 101.

119. Jellett, 'Art as a Spiritual Force', in MacCarvill (ed.), *Mainie Jellett*, p. 69.

120. MacGreevy, untitled paper, n.d. (TCD, MS 8003/6), p. 6.

121. 'Royal Hibernian Academy Exhibition (First Notice)', *The Irish Times*, 30 March 1942, p. 3.

122. MacGreevy, 'el Artista Adolescente (Retrato)', *The Criterion* (January 1927): 158. See also the link made between Joyce and St Thomas Aquinas by MacGreevy in 'A Note on Modern Irish Poetry' (TCD, MS 8003/1), p. 5.

123. A rich fig tree
The large leaves lovely to see
The fruits delicious to taste
It was manured with a dung of English literature
And a slag of Catholic theology
But these have been tried elsewhere
Here the earth was fertile
The root strong
The gardener knew how to entrap the sun
And to anticipate the listing
Of even the gentlest wind.
 (*transition*, 18 [November 1929]: 119).

MacGreevy, 'The Catholic Element in *Work in Progress*'. In his early career, Joyce was under the influence of Walter Pater and the Jesuit teaching he had received during his school years. See William T. Noon, *Joyce and Aquinas* (USA, 1970).

124. MacGreevy, 'The Catholic Element in *Work in Progress*', p. 123.

125. Schreibman, *Collected Poems of Thomas MacGreevy*, pp. 157–8. Schreibman also reproduces this letter from MacGreevy:

Some little time after I had got installed in my fine room on the second floor of the École, I wrote to James Joyce and announced my presence in Paris. At nine thirty the next morning he was on the telephone. Could I go round to the flat in the Square Robiac that afternoon. I could. Thus began the few years of regular interchange with all the Joyces (p. 158).

126. Hugh J. Dawson, 'Thomas MacGreevy and Joyce', *James Joyce Quarterly*, 25/3 (Spring 1988): 313.

127. *The Irish Statesman*, 16 February 1929, pp. 475–6. This letter to *The Irish Statesman* was written in reaction to a critical review in the paper of Joyce's *Work in Progress* by Seán Ó'Faoláin in January 1929.

128. Thomas MacGreevy, *Introduction to the Method of Leonardo da Vinci*, by Paul Valéry (London, 1929).

129. Thomas MacGreevy, 'Elsa. To Jean Lurçat', *transition*, 21 (March 1932): 180. Note the echo of Walter Pater's poem after the *Mona Lisa*.

130. Both books were published by Chatto & Windus, London in 1931.

131. MacGreevy, 'Elsa'.

132. Thomas MacGreevy, 'The Daemon of French Painting' (TCD, MS 8004/8), p. 2. Later published in *The Dublin Magazine* (August 1924): 30–34, MacGreevy refers in his essay to 'Pater's reverie on the symbolism of the Monna [sic] Lisa'. He also writes about the work in his feature article 'Notes from Paris', *The Connoisseur*, 78/312 (August 1927): 251–2.

133. Leonardo da Vinci, *La Gioconda*. Collection: Louvre Museum, Paris.

134. MacGreevy, 'Ways to Approach the French Exhibition', *The Sunday Independent*, 11 May 1947.

135. *transition* (March 1932): 147–88. Other signatories were Carl Einstein, Georges Pelorson, Theo Rutra, James J. Sweeney and Ronald Symond.

136. For a reappraisal of these critical essays, see Seán Kennedy, 'Beckett Reviewing MacGreevy: A Reconsideration', *Irish University Review*, 35/2 (Autumn/Winter 2005): 273–87.

137. Beckett [Belis], 'Recent Irish Poetry, in Beckett, *Disjecta*, p. 71.

138. Thomas MacGreevy, unpublished memoirs, in Schreibman, *Collected Poems of Thomas MacGreevy*, p. xxx.

139. Samuel Beckett, 'MacGreevy on Yeats', *The Irish Times*, 4 August 1945, p. 2. Reprinted in Beckett, *Disjecta*, pp. 95–7. MacGreevy was appointed Director of the National Gallery of Ireland in 1950, after which he published *Nicolas Poussin* (1960), his *Some Italian Pictures in the National Gallery of Ireland* (Dublin, 1963), and his *Concise Catalogue of Oil Paintings* for the National Gallery of Ireland (Dublin, 1963). In 1962 he organized the Jack Yeats exhibition for the Venice Biennale,

and in the same year was made Officer of the Legion of Honour by the French government. He retired in 1963.

140. MacGreevy to Jack Yeats, November 1929 (NGI, Yeats Archive).
141. MacGreevy to Jack Yeats, December 1930 (NGI, Yeats Archive). The reference to the 'down town Jewess' alludes to Laura Riding who fell in love with Geoffrey Phibbs in the late 1920s. 'Norah' refers to the artist Norah McGuinness.
142. Gillis, *Irish Poetry of the 1930s*, p. 2.
143. Beckett [Belis], 'Recent Irish Poetry', in Beckett, *Disjecta*, p. 71.
144. Beckett [Belis], 'Recent Irish Poetry', in Beckett, *Disjecta*, p. 74.
145. MacGreevy, *Jack B. Yeats: An Appreciation and an Interpretation*, p. 10.
146. Beckett to MacGreevy, 31 January 1938, in Deirdre Bair, *Samuel Beckett* (London, 1978), pp. 281–2.
147. Beckett, 'MacGreevy on Yeats', in Beckett, *Disjecta*, p. 95.
148. Beckett, 'MacGreevy on Yeats', in Beckett, *Disjecta*, pp. 96–7.
149. See Lloyd, 'Republics of Difference', pp. 462–71.
150. See Lloyd, 'Republics of Difference', p. 469.
151. See in particular Gillis, *Irish Poetry of the 1930s*, pp. 119–40.
152. Beckett, 'An Imaginative Work!', in Beckett, *Disjecta*, pp. 89–90.
153. Beckett, 'An Imaginative Work!', in Beckett, *Disjecta*, p. 90.
154. Gillis, *Irish Poetry of the 1930s*, p. 1.
155. MacGreevy, 'How Does She Stand?', p. 3.
156. MacGreevy, *Jack B. Yeats: An Appreciation and an Interpretation*, p. 19.
157. MacGreevy, *Jack B. Yeats: An Appreciation and an Interpretation*, pp. 26–7.
158. MacGreevy, *Jack B. Yeats: An Appreciation and an Interpretation*, pp. 27–8.
159. Jack Yeats, *California* (1937). Private Collection. MacGreevy, *Jack B. Yeats: An Appreciation and an Interpretation*, p. 29.
160. MacGreevy, 'Apropos of the National Gallery' (1936): 57.

Word and Image Relations in the Later Career of Jack Yeats

The novelist, who respects his workshop more than life, can make breasts heave, and arms wave, and even eyes flash. But he cannot give his people pulses. To me a man is only part of a splendour and a memory of it. And if he wants to express his memories well he must know that he is only a conduit. It is his work to keep that conduit free from old birds' nests and blowflies. Man cannot invent. When he thinks he is inventing he is only stirring with a wooden spoon. But they forget it every now and then. There need be none of this stirring in painting, and that is why painting is greater than writing. Painting is direct vision and direct communication.

Jack Yeats to Thomas MacGreevy, 21 March 1919[1]

After living and working in England for a number of years, Jack Yeats and his wife Cottie were settled in Dublin in the 1920s.[2] Scenes from around the city such as *Crossing the Metal Bridge* (1926) became the subject matter for his work, and as MacGreevy observed, his painting style was becoming more subjective.[3] As was suggested in Chapter 2, this subjective turn was made possible by the artist's move away from black-and-white work, although he continued in secret to create drawings for the English periodical *Punch* (Frontispiece) using the pseudonym 'W. Bird' to gain an income.

By 1919, as the letter cited above reveals, the artist was also pondering questions of hierarchy in the arts, and when related textual evidence from the 1920s is examined, it becomes apparent that the issue was gathering importance for him. For example, in 1920 he wrote to John Quinn in New York, reiterating concerns he had expressed to Thomas MacGreevy:

Man cannot invent. When he thinks he is inventing he is only stirring with a wooden spoon ... There need be none of this stirring in painting and that is why painting is greater than writing. Painting is direct vision and direct communication ... communication by the ear has reached the apex of its power and is coming down. Now up communication by the eye.[4]

In *Modern Aspects of Irish Art* (1922), he pursued the subject, this time clarifying distinctions between the arts in terms of sensorial difference:

> Literature appeals to us through our sense of hearing, and poetry is the highest form of literature. Painting, sculpture, architecture, and all the different forms of decorative art appeal to us through the sense of sight, and the first is painting. The painter's vision has not to be translated into words; if he has seen his vision clearly and if his hand is sure, he can give us his vision as it came to him, and painting can reach as high as men can reach.[5]

Later, in 1927, he wrote to Blaikie-Murdoch somewhat clumsily: 'the pictorial is different from all the arts. It has never yet stood up free … I can say nothing of music. I have to say, with sorrow. "I have no ear". But literature has no relation to painting. Literature is a translation. Right painting is no translation. It is the thing itself.'[6] It is clear, then, that in the 1920s Jack Yeats believed painting to be a superior art form to literature. Furthermore, he considered that it was timely for painting to take its rightful place because 'literature had reached the apex of its power and was coming down'. If he was principally referring to Irish arts, we can only conclude that he was drawing attention to the lesser role which painting had played in early twentieth-century Irish culture. My discussion throughout has substantiated this point: within the Yeats circle, Evelyn Gleeson, the Yeats sisters, Norah McGuinness and MacGreevy all used different art forms for cultural expression in line with contemporary issues in Irish literature.

At the beginning of the twentieth century, Gleeson had argued that Irish art should have a 'nationalising' function. Her solution was to revive Gaelic art in 'material surroundings', producing and disseminating Irish decorative arts through the Dun Emer Industries, and this was conceived in harmony with the aims of the Irish Cultural Revival. Jack Yeats's early illustration work for his sisters' Press also helped to disseminate these ideals. However, by the 1920s, the Irish Revival had largely run its course. It is evident that Jack Yeats held the decorative arts in higher esteem than literature, but placed painting as the superior visual art form. He also believed that painting could express the memory of a 'splendour' of which the artist was a part, which was a return to age-old debates.[7] Moreover, his standpoint changed little from 1919 to 1927, which suggests that he was fighting a difficult battle with his peers.

During this period there was significant political unrest in Ireland, provoking an enquiry into the relationship between Jack Yeats's contestation of the arts and surrounding ideologies, both personal and national. His turn towards subjective art coincided with his move from an English 'rural' to an Irish 'urban' life, but it was also influenced by depressive illness from 1915 to 1918. Arnold claims that few sales during this time was a reason for the artist's nervous breakdown, and critics have differed over the extent to which the current political unrest affected both his mental health and his painting style.[8] Jack was a pacifist Republican, and after 1916 he and his brother WBY were politically divided.[9] 'He was very Republican,' wrote Beckett, '[a]nd he didn't at all agree with his brother's attitude in 1916, when the rebellion broke down.

He was exclusively Republic. He broke up indefinitely with his brother, with whom he had never been close. He dismissed all that senatorial activity.'[10] In view of Jack Yeats's affiliations, it is tempting to look for evidence of political reaction or didacticism in his paintings, particularly in those relating to volunteer activities, as MacGreevy, Edward Sheehy, Ernie O'Malley, Síghle Bhreathnach-Lynch and David Lloyd (to name but a few) have done.[11] However, in Arnold's view, Jack Yeats has been appropriated as 'the Irish nationalist' artist for too long. Arnold refutes claims that *Bachelor's Walk: In Memory* (1915) is an overtly political painting, maintaining that *The Funeral of Harry Boland* (1922) and *Communicating With Prisoners* (c. 1924) (Figure 3.7) are the only two works which one can properly define as '"national" art, in the political or "republican" sense'.[12]

In relation to Jack Yeats's career as a writer, critics are also divided. For example, the American critic, Nora McGuinness (not to be confused with the Irish artist), has linked changes in Irish culture and society after 1922 to Jack Yeats's sense of Modernist identity as a writer. Her explanation has sympathy with that of Lloyd (who naturalizes links between painting and politics in his explanation of the artist's 'post-colonial disaffection'), but her discussion emphasizes Jack Yeats's new subjectivity as a writer:

By turning inward, by seeking forms to express his vision, he transcended the despair that the revolution's failure to create a new Ireland might have induced. His primary theme became the need to transcend present reality, to accept change, chance, and randomness by uniting oneself to the spiritual forces of the universe, those larger than the individual.[13]

By contrast, John Purser contests McGuinness's linking of the change in Jack Yeats's style to Irish politics, claiming that he never lost his vision of Ireland after the establishment of the Free State.[14]

A study of Jack Yeats's writings *in relation to* his paintings builds on this debate, and elucidates what 'old birds' nests and blowflies' the artist had to free himself from in order to pursue his goal.[15] In 1925 he wrote to WBY that he would not produce any more illustrations for their sisters, for they were a loss to his reputation as an artist. This move away permitted his imagination to work more freely, and allowed him as an artist to act as a 'conduit' to the 'splendour' of which he considered himself to be a part. The following year he recorded the transition he was experiencing in very positive terms:

I am having a kind of new birth. I have been swimming with my head loose for two or three years now and my work is as I wish it to be. I do not do any illustrations now and I have only a mild piano interest in the illustration I have done in the past. I am very glad to send you some photographs of my later work.[16]

In 1929, Jack Yeats and Cottie moved to a new first-floor flat on the corner of Merrion Square. He wrote to MacGreevy: 'We like our new place here. The

studio window does not look on the wide ocean but down Fitzwilliam Street. Anyway the wide ocean can be worn like the Andeans Poncho by making a round hole in it and putting your head up through it from below.'[17] Hilary Pyle has appropriately described Jack Yeats's changing painting technique as 'memory into poetry', citing a letter from him to Joseph Hone of 1922: 'No one paints ... the artist assembles memories.'[18] She goes on to claim that by the end of his career in the 1940s and 1950s, he had brought about 'an individual revolution in Irish painting that broke through the barriers of nationalism and raised painting into the forefront of twentieth-century art'.[19] Yet before his last, 'great' phase of painting, he dedicated a substantial part of the 1930s to *writing*, and this prompts an enquiry into why he turned to this 'inferior' art form, and what impact it had on his assembling of memories.

Arnold suggests that Jack Yeats's writing career was driven by economics rather than aesthetic ideals, while Pyle has stated that 'Yeats had no particular reason for writing, other than the unburdening of his very active mind'.[20] Arnold details evidence which demonstrates that, by the end of the 1920s, Jack Yeats was well recognized as an artist, but that he was still not selling very well. This was understandably due to public confusion over his new experimental painting style.[21] However, Jack Yeats's writings also met with confusion rather than applause from the Irish public. A joint review of his 1930 exhibition, held at the Alpine Club Gallery in London, and his first novel *Sligo* (1930) asserts: 'Mr Yeats cares not one iota for you, his reader or his spectator. He just "jettisons" like a playful ocean depositing confetti on the sands after a carnival ... You never in your life saw such a medley, such a profusion such a confusion of gems – in prose or pigment.'[22]

Jack Yeats experimented with both literature and painting, producing seven plays for the miniature theatre, nine plays for the larger theatre, and numerous works in prose, including seven novels throughout his career. He also actively sought to produce and publish them until the 1940s,[23] yet today they are largely forgotten and have 'failed so to impress'.[24] Most of the plays and novels have not been reprinted, are difficult to obtain from libraries, and more often than not are overshadowed in Yeats scholarship by a discussion of his paintings.[25] Indeed in his biography of the artist, Arnold sidesteps a detailed assessment of them by referring the reader to Purser and McGuinness. Interestingly, in his last years Jack Yeats himself expressed the wish that his books should be forgotten and his paintings remembered.[26] However, from an interdisciplinary perspective, it is helpful, if not imperative, to consider Jack Yeats's *oeuvre* in its entirety, and to take seriously the implications of his verbal and visual ties.

Nora McGuinness and John Purser have dedicated monographs to Jack Yeats's writings, but of all Jack Yeats scholars, Pyle has made the most reference to the thematic continuity in his work in both media.[27] Robin Skelton has addressed the issue of the accessibility to his writings by publishing a

collected edition of his plays in 1971, and in 1991, a selection of his later writings, where Skelton concludes:

His work fits more easily, it might be said, into modern European literature of our time than does that of his brother. It may be some time before his prose work is properly appreciated and evaluated. ... Moreover, once the complete writings are set alongside the drawings and paintings, it will become apparent that there is, in all Jack Yeats's work, an extraordinary unity. Not only do paintings illustrate and extend themes of the writings, but the writings explore and investigate symbols and scenes presented in the painting.[28]

This chapter surveys only a small part of the terrain anticipated by Skelton, as a discussion of word and image relationships in Jack Yeats's world must also take into account correlations between his work and that of his literary peers. So far, these discussions have ranged from his involvement in the Dun Emer and Cuala Industries, where his broadsheets incorporated word (in the form of ballads and poetry by himself and other writers) and image (in the form of illustration), to his relationship with MacGreevy and Modern Irish poetry. His relationship with WBY and Beckett will also be addressed.

An investigation into Jack Yeats's writing from the 1930s leads the reader beyond details of kinship and friendship to more aesthetic concerns. In particular, it carries discussions hinging on claims for the nationalism and Modernism of his work introduced earlier, through to his last, great phase of oil painting in the 1940s and 1950s. In addition to Arnold's 'economic' and Pyle's 'unburdening' explanations for Jack Yeats's writing career, it is worth exploring the evidence concerning his familiarity with contemporary writing, found in his letters and in his personal library.[29] Correspondence between Jack Yeats, MacGreevy and Beckett is complemented by correspondence between members of the Yeats family and Quinn. In fact Quinn (living in New York) and MacGreevy (living in Paris) were eager to keep Jack Yeats up to date with contemporary literature. Quinn sent a book of Eliot's verse, for example, for which Jack Yeats thanked him, adding: 'They are amusing.'[30] Quinn also sent him initial periodical segments of *Ulysses* published in *The Little Review*,[31] and MacGreevy sent him extracts from Anna Livia Plurabelle in 1929. On 3 April 1930, Jack Yeats wrote to MacGreevy: '"Analivia" [sic] has not come yet. But I am sure there is in his writing, and my painting, a place where we each pulse about from an unsuspended animate [?] core which is the private property of each.'[32] A day later he reported: 'The extract from Anna Livia Plurabelle has just come. Please thank Joyce for having it made for me. It is lovely and wonderful and it makes me proud and happy to see the resemblances between this writing and my painting, especially my later painting ... There is a reason I am sure why they should be alike. But I get headachey from reasons.'[33] In 1929, MacGreevy sent him Joyce's work in *transition* through Lennox Robinson, and a copy of 'Dysert', which Jack

Yeats wrote that he 'liked very much'.[34] Then in 1930 MacGreevy sent him his poem 'Crón Tráth na nDéithe', to which Jack responded:

Some of your lines shake my mane of course more than others ... I daresay people are right if they think you would not have written so if Joyce had never written. But the gate does not matter so much if it opens on to the prairies' roll or perhaps these gates are watergates opening onto the wide ocean.[35]

Exploring Jack Yeats's library also provides evidence of his familiarity with modern literature. Books include: Honoré de Balzac's *Père Goriot: A New Translation* (1902); Pound's *Cathay: Translations* (1915), *Lustra of Ezra Pound with Earlier Poems* (1917), and *Pavannes and Divisions* (1918); Baudelaire's *Oeuvres Complètes: Les Fleurs du Mal* (1917); MacGreevy's *Thomas Stearns Eliot: A Study* (1931); Beckett's *Proust* (1931), *More Pricks Than Kicks* (1934), *Echo's Bones and Other Precipitates* (1935) and *Murphy* (1938); works by WBY, including his edited anthology *The Oxford Book of Modern Verse, 1892–1935* (1936); and four volumes of Proust's *Remembrance of Things Past* (1941). These books sit alongside those issued from his sisters' Press amongst many others.[36] By contrast, his art history collection is rather limited, counting *Hokusai: His Cartoons: Volume II Complete* (c. 1879), *An Album of True Paintings Copied from Hokusai* (1892), *Goya* (1900), *The Life of Michelangelo Buonarroti* (1901), *Renoir* (n.d.), *Daumier and Gavarni* (1904), *The Colour Prints of Japan* (1904), *James Ensor* (1929), and *The Changing World. 6. Modern Art* (1932) (a BBC London radio recording).[37] Moreover, the illustrations within these books are somewhat limited. His book on Renoir (written in French) contains poor quality black-and-white plates. His biography of Michelangelo has been marked in pencil in places (perhaps by Jack Yeats?), but the illustrations are again faint and sepia in tone. There are some interesting exhibition catalogues in his archive, including shows of works by James Whistler, James Ensor, Paul Cézanne and 'Younger European Painters'.[38] But in reality, his collection reflects his preoccupation with everyday life more than a study of 'high art'. There are many illustrated books on ships, toy boats and sailing craft, horses, physiognomy, as well as childhood books.[39] One idiosyncratic feature of the collection is his habit of glueing ephemera into some of his books, such as William Paley's *The Principles of Moral and Political Philosophy* (1881). A Greek dictionary which he has used as a scrapbook is the location for cigarette packaging, advertising slips such as a horse race meeting in Baldoyle, Co. Dublin, and a token for a drink at 'MART'S ON BROADWAY, NYC'.[40]

The Jack Yeats collection reveals both his pursuit of knowledge and the subject matter and themes of his work. For example, sailors and ships, horses and race meetings, humorous depictions of Irish 'characters' including tramps and ballad singers, are the subject matter of his earliest sketches in diaries and illustrations for *The Vegetarian* and *Punch* produced in London from the late 1880s onwards.[41] These subjects are also evident in his miniature dramas and

his illustrations in *A Broad Sheet* (1901–1903) and *A Broadside* (1912–15), in his novels and plays of the 1930s and the 1940s, and in his last phase of painting in the 1940s and 1950s. Any discussion of Jack Yeats's work necessarily looks backwards and forwards in time, owing both to the thematic continuity in his *oeuvre* and the importance of memory to his work. His depictions of the tramp through the theme of 'Two Travellers' is a key example, and a discussion of pictures and writings admired, reviewed or purchased by WBY and Beckett, including *Sligo* (1930) and *The Aramanthers* (1936), enrich analysis of the role of verbal and visual ties in Jack Yeats's career.

Sligo and *The Aramanthers*: Jack Yeats Experimenting with the Novel

Jack Yeats's first novel, *Sligo*, was published by Wishart & Co. of London in 1930. It begins with a character (the narrator) sitting on a hill-top looking down on a wooded scene below. He likens the vista before him to America, and then turns his gaze to a regatta about to begin on a lake below. The opening pages introduce the predominant writing style of all Jack Yeats's novels:

PERCHED on a bare rocky hill-top, all grey rock like the famous Rocky Mountains in the old engraving: but as I sit the green woods come creaming to my feet and I am not gazing on to prairies, with the buffalo thousands, and the business-looking American engine dragging its long snake of rumblers over the simple rails. Through the wood wanders a road, though I cannot see it through the tree-tops: and beyond the wood there is a lake. I see that there are green islands on it. One has a ruined Church: and my forefather called it Church Island. There were no frills at the Christenings in those days. The other Islands I suppose they called 'Island Islands'.

Until some bold lad gave them names, by deed, by deed poll done perhaps on some other bold lad's poll, 'Hatchet Island' or 'Nasty face Island'. The lake is dark blue with its depth: There is a regatta on it: a little group of boats. If you were at the water level you would hear a murmur of voices. Men are arguing before a race starts. They will argue again perhaps after the race.[42]

What is the reader to make of this writing style? The narrator seems to interpret his environs by way of his senses rather than rational analysis, and there is little attempt to communicate meaning using a logical narrative sequence. As the text continues, the reader is provided with no clear historical sequence or geographical specificity. The personalities of the characters are not developed, little attention has been paid to grammar, spelling and syntax, and by the end of the novel, one would be forgiven for questioning the point of it all. 'Even if there is but one character, and that character unnamed,' observes Arnold, 'fiction still requires that we identify with him or her, and follow fortune through space or time.'[43] In its review of *Sligo* in 1930, *The Standard* asked: 'How did it happen? ... Has some ill-advised leprechaun shown him a

page from the book of the Modernists, and advised him that it was simplicity itself to go and do likewise?'[44] The view from Sligo town itself was equally disparaging:

Pity the unsuspecting soul who innocently invests his six shillings in this volume
with the expectation of learning something of Sligo or the people who live there
... Occasionally our admiration is evoked by a sentence such as '... and hawk-
eyed boys talking straight into the cheeks of long-lashed, freckled girls'.

Here is Mr Yeats the painter, and surely it is strange that one who
would not expect to produce a picture by indiscriminately squirting
his paint over his canvas is yet content that a disorderly jumble of ideas
set down anyhow on paper is all that is required to make a book.

Sligo has little to commend it to the public. Despite its distorted style, however,
one cannot help thinking on reading it that had the author chosen to be a little less
eccentric and little less clever he had here the material to make a delightful book.

As it is the book is a hodge-podge. Mr Yeats is presumably quite satisfied,
but one can only ask, like the Somali warriors he tells us of in page
20 when they saw the boy on the roller skate, 'scooting towards the
setting sun' – 'Oh my father, oh, my mother, how does he do it?'[45]

Yet, from his correspondence with MacGreevy, it appears that Jack Yeats was proud of the book, telling his friend: 'I was delighted to get your letter about Sligo. I believed it would find you on that same long pasture which I skipped along when writing it.'[46] WBY admired the novel too, and gave Jack a personal critique:

A most amusing, animated work, showing more of the true mind and
life of Jack Yeats than Jack Yeats's biography will ever show. It is the best
of talk & the best of writing and at the top of a fine fashion. I think of
James Joyce's linked associations. 'My new book is about the night & I
have had to put language asleep' he said to me a few days ago.[47]

Evidently there is more to this book than first meets the eye. WBY alludes both to its importance in terms of biography, and to its engagement with contemporary literary issues by reiterating an association with Joyce. Furthermore, MacGreevy liked the book, and lent a copy to Beckett.[48] The memories Jack Yeats recalls in *Sligo* are mostly from Ireland and England: of regattas, race horse meetings and bookmakers, boxing matches, circus tents, ballad singers, plays he had seen, and scenes in New York including a trip to Coney Island and a walk in Central Park amongst others. These memories are random, as though scenes had floated up from the author's subconscious mind, triggered by chance encounters or associations. The approach may be compared to that of his brother WBY in *Reveries Over Childhood and Youth*, which begins: 'MY FIRST MEMORIES are fragmentary and isolated and

contemporaneous, as though one remembered some first moments of the Seven Days. It seems as if time had not yet been created, for all thoughts are connected with emotion and place without sequence.'[49] However, there is much more coherence and chronology in WBY's book than the seemingly involuntary associations in *Sligo*. And in the light of Beckett's arguments for MacGreevy's poetic 'Modernism', this may be the reason why Skelton concludes that Jack Yeats's writing might fit more easily 'into modern European literature of our time than does that of his brother'; or perhaps the synaesthetic processes of memory, reverie and dream have more to do with it.

In his treatise *Modern Aspects of Irish Art*, Jack Yeats theorized on the use of memory in painting, emphasizing the intrinsic connection between *observation* and memory, and reinforcing the fact that painting is 'communication by the eye':

The artist is a person who has developed observation and memory, which are common to all, though many by want of using this observation and memory have allowed them to become stiff and unworkable ... Those painters who have the greatest affection for their own country and their own people will paint them best. The roots of true art are in the affections, no true artist stands aloof.[50]

Jack Yeats's paintings are the result of a lifetime of looking and sketching. He maintained that painting is 'direct vision and direct communication' and literature is 'translation', and on several occasions he also stated that the reason he wrote literature was to 'jettison memories':

I suppose the collectors of curios are an attempt at a manufactured brainfull [sic] of memories. The real brain, soaked, indexed and counter indexed with memories, is handier and can be carried about with you; carried along too much perhaps, and that is why I am writing this book. To jettison some memories ... Buy or steal your memories instead of stuffing yourself with your own. Other people's memories are easier got rid of: other people's thoughts can be used quickly and discarded. Everything I break's my own, as the man said when he broke his word. But it is very difficult to break up your thoughts and keep them apart. We are nearly all chain Thinkers [sic]. And if anyone ever succeeded in working his thoughts in independent jolts, he would soon find himself seeking a specialist in these things.[51]

At the opening of his novel *And To You Also* (1944), Jack Yeats again referred to *Sligo* as: 'the book where I first began to jettison my memories which were filling up too well cabin and hold', reiterating in 1948: '[i]n it I explained that my reason for all writing was to jettison my ideas and that is, I believe, the true reason for all the books I have written.'[52]

But two main questions arise from Jack Yeats's explanation. Firstly, if he simply needed to 'jettison' his memories, then why did he publish them? Secondly, if the artist's mind was full to the brim of memories which he needed to offload, then why did he write them down, rather than produce

more sketches or paintings? Arnold's 'economic' explanation is supported by evidence in the novel itself: 'There is no padding in this book except the padding of the hoof. At the same time I write this Book because I want a couple of million (pounds) quickly, and as it may be the last Book written in the world it should have a very large sale.'[53] And again: 'I believe when this Book is all sold, and I join those millionaires, that I will be able to promise you not to be a too fastidious one.'[54]

But can such comments really be read as an explanation for Jack Yeats's literary turn, or are there more clues to help explain his writing career? It is helpful to return to WBY's critique and to draw in particular on his comparison between *Sligo* and the writings of Joyce,[55] although, as was the case with MacGreevy, comparison between any Irish writing in the 1930s and Joyce was a poisoned chalice. For example, the critic Victor B. Neuberg described *Sligo* to Jack Yeats as a 're-Joycing and not a rejoicing',[56] clearly stating where he believed the blame lay:

Mr James Joyce has a lot to answer for. His gigantic, wanton, wild, unkempt *Ulysses* is destined, clearly, to be the father of a whole lot of mis-shaped pygmies, all begotten upon chaos. It is impossible to make head or tale of the gist, drift, and significance of the grotesquely realistic study called *Sligo*.[57]

There is some evidence that Joyce admired Jack Yeats's new paintings; indeed, there were some in Joyce's Paris apartment.[58] Moreover, in May 1929, WBY wrote to Lady Gregory that his brother's new paintings were 'very strange and beautiful in a wild way. Joyce says that he and Jack have the same method.'[59] Given the date (1929), Joyce's comment was most likely made in relation to Jack Yeats's *paintings*, but it would be a mistake to dismiss his writing. In *Sligo* there are several passages reflecting on language and its use as a means of communication. For example, the narrator states that 'it is very difficult to break up your thoughts and keep them apart. We are nearly all chain Thinkers [*sic*]'.[60] On another occasion he contends (perhaps heralding Beckett): 'Before the end of the World speech will have died completely, it's likely. But there will be an exception. For the last man alive will be the skilled raconteur, talking alone.'[61] And again:

If this is going to be the last book written we cannot be very far away from the last thing 'said.' Speech is certainly on its last legs if it ever had legs. It certainly, when its time comes, will not have any legs to walk away on. What is it for anyway, information? We have sign posts. Communication of original ideas? They are not communicable, if they are original, through speech. To pass the time? It passes fast enough for a great many people – And for the others, there is no one who has a big enough vocabulary to fill the big long-shaped voids, except by echoing, which is headachy for the speaker and listener, and, not listening, is the hardest work of all. ... No, bury speech ... throw earth on it and gallop over it, and give little yells and yelps undecodable over it.[62]

The paradox is hard to ignore. However, whether it is a work of great or poor fiction, *Sligo* is undeniably akin to the modern literature of Jack Yeats's time because of its self-consciousness about language, associated with Joyce. *Sligo* demonstrates a Modernist disregard for traditional chapters, paragraphs and sentences, but may not be strictly described as a 'stream of consciousness' in Joycean terms (in comparison, for example, to Molly Bloom's long monologue in the final section of *Ulysses*). It would be tempting to describe his style as a precursor to the French *nouveau roman* of Nathalie Sarraute, Alain Robbe-Grillet and others, as Marilyn Gaddis Rose has done.[63] These writers similarly discarded conventional literary forms such as plot, chronology and character development, and yet the geographic relation is too tenuous to suggest that there is any causal link – Jack Yeats's narrators are too self-reflexive and philosophical to carry such a reading very far.[64] By contrast, Joyce's recognition of his own non-painterly awareness perhaps gives a measure of the distance travelled by Jack Yeats in *Sligo*.[65]

In contrast to WBY's *Reveries Over Childhood and Youth*, Jack Yeats's (autobiographical) novel *Sligo* portrays images *within the text* rather than as an appendage to it. For example, in the opening paragraphs, the reader is forced to visualize a sequence of images which seem rather unrelated and outside the narrator's world, but which nevertheless merge in the reader's imagination. This may be understood as what Roland Barthes has called a 'writerly' text, one which engages the reader's imagination in the construction of meaning.[66] In all of Jack Yeats's novels, this engagement provokes in the reader's mind a cumulative, visual image of the author's childhood around Merville and Rosses Point: the topography, environment and people. It is a 'pictorial' use of language, whereas his brother's writings are more consistently 'symbolic'.

At one point in *Sligo*, Jack Yeats theorizes about the potential for words to be comprehended visually as well as aurally when he fictionalizes a 'solid, memory-saturated man' (his alter ego perhaps):

my memory man was away from me quickly before he remembered that he was only a word painter. This word business is nearly played out unless some new language blossoms to give a few new mouthfuls. Hieroglyphics will be no use for they will only begin the dull circle over again. ... No more Word Painting.[67]

Evidently, the writer is conscious that before linguistics as we know it today, there existed a form of language (hieroglyphics) which fused word and image, and is therefore comparable to the 'Word Painting' of his memory man. Jack Yeats was questioning the language systems of the West as a means of communication, in tandem with the aesthetic concerns of contemporary writers such as Beckett: 'When language consisted of gesture,' wrote Beckett, 'the spoken and written were identical. Hieroglyphics, or sacred language, as he [Vico] calls it, were not the invention of philosophers for the mysterious expression of profound thought, but the common necessity of primitive

peoples.'[68] At two points in his narrative Jack Yeats also plays with the layout of words on the page to communicate his memories more effectively. In the first instance he suggests describing scents '[r]ecalled from memory's still room', as a game for a rainy day:

There is something odd about smells. ... Many perfectly sensible people, sensible in an ordinary way, believe that little streams have a composite smell, so subtly do all their smells appear to blend; they are woven perhaps into the general texture but they are not blended, and you know when you remember a little stream which smelt separately of

 moss
 wild garlic,
 rocks,
 rushes,
 clay,
 mud,
 gravel,
 water wagtails' feathers,
 Trout swimming under water,
 and wild flowers by the score,
all to be named by a really good nose.[69]

This passage might remind one of WBY's comments in relation to Jack Yeats's novel *The Charmed Life* (1938): 'His style fits his purpose for every sentence has its own taste, tint and smell.'[70] However, it is also a curious one because it breaks down traditional prose to take on the spatial characteristics most often associated with poetry. It is a technique that Jack Yeats also employed in *The Careless Flower* (1947).[71] The words above invoke both images and smells in the reader's mind, requiring him/her to recall personal memories of river smells,[72] creating a synæsthesia of the senses and setting the passage apart from the main body of the text. Jack Yeats's novelistic style is consistently visual, demonstrating that borders between word and image can, and should, be broken down using the verbal-visual nature of memory. Textual evidence confirms that the above passage stems from memory. In 1920, JBY wrote about his son:

There is a river meandering through the town of Sligo, spanned by two bridges. Beneath one of these bridges is a deep pool always full of trout. Jack told me that he has spent many hours leaning over that bridge looking into that pool and he regrets that he did not spend many more hours in that apparently unprofitable pastime.[73]

Jack Yeats's second published novel, *The Aramanthers* (1936), tells more of a 'story' than *Sligo*.[74] The narrative begins on an island near a city, and describes a large arch, a skyscraper, a hotel and a lake on the highest point of the island to which island-men make pilgrimages. The first section of the novel follows a disjointed story of the trials of the 'Aramanthers' club members who, when

raided after allegations of being 'A Communistic Nest', escape to the island where they reinvent themselves in a six-storey skyscraper ('the aramanth').[75] The second part tells the tale of half-Irishman James Gilfroy who, like many of Jack Yeats's characters such as Mr No Matter and Bowsie in *The Charmed Life*, is a restless man. Eventually, James sails from Dublin to South America and, after travelling for many months, presents himself at Railway Headquarters to claim his inheritance from shares. Here he is given the President's splendid railway coach in lieu of money. He travels widely in the coach and happens to be near the island of Part I when a hurricane hits, at which point James joins rescuers travelling to the island. The skyscraper has collapsed, which exposes the fact that the 'secret' activity of the Aramanthers was making and playing with model ships and railways in wonderfully elaborate settings. Shamefacedly, the club members escape with James in his splendid cream-coloured coach.

As with *Sligo*, Jack Yeats's second novel was received with more frustration than applause. *The Sunday Times* wrote:

I must confess that I missed the point of Mr Jack Yeats's satirical fantasy 'THE ARAMANTHERS'. The numerous verbal jests amused me, but I failed to see the big joke behind it all. And the style irritated me. It is not English, nor is it Irish. Mr Yeats has not studied the anatomy of a sentence in any language. He is fond of relative clauses without any principal clause – this sounds an impossibility, but he does it, with the most disconcerting effect. In his painting, would he draw a man with his shoulders rammed down upon his hip-bones and no room for the vital organs? Perhaps he would; with Modern Art you never can tell. But when he does it to sentences, the result is nonsense. English syntax is so easy and elastic that there seems no excuse for writing nonsense, nor is satire improved by nonsense.

Pictorially, the book is excellent; whatever the scene and the colouring Mr Yeats wants us to see, he puts them before us as swiftly and certainly as though he were working in that other medium in which he is so much more at home.[76]

The main themes unfolding in this novel are travel, chance and change. It is a consistently painterly novel because of the very *visual* descriptions, particularly of nature, such as that of Mahone's visit to the lake where he went 'to see the eyelid of the dawn lift', or in the depiction of the 'mop-headed girl' who 'when pale green evening sky was lit ... put on her hat of reticent mauve'.[77] But worthy of note is the following incident anticipating paintings by Jack Yeats such as *Tinker's Encampment: The Blood of Abel* (1940) or *Grief* (1951). At one point on their journey back to the island, James and his sometime guide 'Ohoh' dine with a Governor called Pensamiento (who speaks 'Ohoh's language), and his wife Phénicie. After dinner, James and his friend are taken to the living room where four pictures hang, and there follows a description:

In contrast to the long living peace of that house, and the land about it, there were four pictures in the living-room, which, when they were printed, they

were wild rough lithographs, were intended to cause in the youngest beholder a longing for the glory of war. The colours were red and blue and a gamboges yellow, red for fire and blood, blue for smoke, swords and uniforms. Yellow for fire also, that is when homes were burning, and faces and epauletes.[78]

Like *Sligo*, the novel explicitly enquires into visual language, and a good example is shown when James finds himself in a land where the 'indians' live, and attempts to communicate with an innkeeper. They do not understand each other, and so the innkeeper grabs 'the scissors of Babel' and takes cut-outs from 'illustrated sheets from the Weekly Editions of a newspaper far-away city in that country. The illustrations were almost all from photographs, chocolate-coloured.'[79] In this way the two men are able to discuss James's travels, village life and topics as diverse as 'football, churches, bears, paintings, pictures made by hand, and also of course pictures made by the camera (the stills and the moving ones); people who wore masks, and book-makers'.[80] This quizzical tale draws attention to the potential for communication through purely visual language (enhanced by some miming), and it recalls Jack Yeats's life-long habit of cutting out illustrations for his scrapbooks and boxes of aide-memoirs.[81] There are also very evocative descriptions of nature in the story. When James is at an inn, he drinks a 'long fresh mouthing of a grey, sour, mild, thirst-quenching mixture of spirit will-o'-the-wisp, essence of a heathery bloom, and the flavour and scent of a gardenia blossom'.[82] When he and 'Ohoh' walk along a countryside 'honeycombed with waterways' and sleep in trees, 'James got what he never got before, the realisation of the earth's roll'.[83]

MacGreevy apparently admired the book. In a letter dated 29 April 1936, Jack Yeats wrote to him: 'Thank you very much for the fine things you say so well about "The Aramanthers". I am proud and fond of all the personages of all kinds, in that book, so anything good you say about them, or their countries pleases me.'[84] The only favourable review of Jack Yeats's *The Aramanthers* found in the author's scrapbooks is written by his friend Beckett who emphasizes the Modernism and internationalism of Jack Yeats's novel, and praises its refusal of definitive interpretation, disclaiming its essential 'Irishness':

There is no allegory, that glorious double-entry, with every credit in the said account a debit in the meant, and inversely; but the single series of imaginative transactions. The Island is not throttled into Ireland, nor the City into Dublin, notwithstanding 'one immigrant, in his cups, recited a long narrative poem.'

There is no symbol. ... stages of an image. There is no satire.[85]

Yet Beckett's critique needs to be read in context. In his contribution to Joyce's *Work in Progress* and his review of MacGreevy's *Poems*, Beckett no doubt intended to be provocative, and so when we consider his comments on Jack Yeats in 'Recent Irish Poetry', 'An Imaginative Work!' and 'MacGreevy on Yeats', he may also have been writing in reaction to what he perceived

to be the parochialism of Irish art of the 1930s and 1940s. It is also worth remembering that Jack Yeats helped Beckett the following year to find a publisher (Routledge) for *Murphy* (1938).[86] Beckett's statement that there was 'no symbol' in *The Aramanthers* has proved particularly controversial and has been strongly refuted by Purser: 'we do not need Beckett's periphrastic approach'.[87] Curiously, the title *The Aramanthers* derives from the word 'aramanth', defined as an ornamental plant of a deep, purple colour such as the flower 'love-lies-bleeding'.[88] As a poetic conception, it is said to be an imaginary flower that never fades, and in the first publication of the book, a garland of small flowers is embossed on the cover. It would therefore be tempting to interpret the flower as a symbol, and as a rebuttal of Beckett. Perhaps the 'aramanth' is a symbolic name for a dream that never fades, the Aramanthers club, a society in which the members can act out childhood fantasies.[89] However, Jack Yeats was never *explicitly* Symbolist in word or image in the way that WBY was.

The most helpful part of Beckett's critique to understanding *The Aramanthers* is arguably his theory of 'stages of an image'. Since 'image' as a concept is at once verbal and visual, the theory is applicable to both writing and painting. A clear example of the 'stages of an image' in the novel is the story of James Gilfroy's memories of a ballad that Jack Yeats had carried with him since an incident on O'Connell Bridge in his early manhood. The first stage reads:

A small young man stood on the bridge and looked up the River Liffey towards the ragged sky ... James was looking about him in a merry way, perhaps that was the reason a ballad singer ... took one ballad from the bundle and put it in James' crumpled short left hand, the ballad singer waited for no money, but went pattering on his way. James sidled towards the parapet of the bridge, and turned his right cheek to the west so that, holding the ballad close to his face, he could make out the opening verse by the falling light. It was a verse of passion, of a kind that chilled James' forgotten stomach. It was what he called political, but he was reading on and leaning more upon the beam of light that came to him, when some eddy of wind came up from under the bridge, heavy with the smell of sewage meeting the water, caught the ballad, plucked it out of his hand and threw it on the ebbing tide. James looked stupidly at his empty left hand. Then he turned his face up the river and took into his glare the advertisements ... And he knew there was a train that left a station in the city every evening to the cry of 'This train stops nowhere'.[90]

James remembered the moment on the bridge at several points throughout his travels:

This picture in his mind had never yielded its place to fresher viewing of the first scenes. He stood on that bridge three or four times in his life each with an interval of years, and though the horse-trams were long gone, and the noise about him was changed, and the acrid smell gone from the water, still he saw the same arching madness of the sky, at least once again. But no nail could drive out the nail of that day in his youth so long ago.[91]

Then, towards the end of the novel, James recalls the ballad and it is indeed political:

I wear two lovely emblems I wear them on my breast
A harp entwined with shamrock are the emblems I love best
They're symbols of old Erin the land that gave me birth
The sacred soil of Ireland, the dearest spot on earth.⁹²

This sequence could allude to the important role that the (political) ballad played in Irish cultural memory and personal identity (see Chapter 2). The connection continues a theme from Jack Yeats's *A Broad Sheet* and *A Broadside*, wherein word (the ballad) and image (an illustration of a ballad singer) combine to signify Irish cultural heritage. Linked to MacGreevy's 'Homage to Hieronymus Bosch' ('High above the Bank of Ireland / Unearthly music sounded, / Passing Westwards'), the ballad scenes could be perceived to signify Jack Yeats's Irish nationalist affiliations. Yet Beckett persistently argues for the universality of Jack Yeats's paintings and literature in an effort to free up the artist from MacGreevy's 'throttling' his friend's work 'into Ireland'. When he reviewed *The Aramanthers* in 1936, Beckett denied a direct link between Jack Yeats's novel and the city of Dublin, stating that 'The Island is not throttled into Ireland, nor the City into Dublin'.⁹³ He acknowledges that the 'long narrative poem' recited in the novel (the ballad) situates it in Ireland, but argues for the originality of the work ('An imaginative adventure does not enjoy the same corsets as a reportage').⁹⁴

In the construction of meaning in *The Aramanthers*, the reader is presented with what the author would call 'assembled memories' ('No one paints ... the artist assembles memories') along the linear progression of the text, and the significance of the ballad sheet blowing away from James's hand is revealed to us through time. This facetted way of constructing narrative is associated with European Modernism in both poetry and painting. By breaking down conventions of traditional form, the reader/viewer has greater participation in the imaginative creation of a work. *The Aramanthers* is the only book by Jack Yeats which Beckett reviewed. On another occasion he stated: 'I didn't admire his writing too much. He had one play at the Abbey. What was it called? *In Sand*, that's it. But his paintings were wonderful.'⁹⁵ However, if the respect he showed for his friend's writing stemmed from politeness rather than awe, then it belies the impact that Jack Yeats's themes and subjects (held in common with his paintings) had on Beckett's later writing, which was profound. It is intriguing to speculate on the nature of the men's admiration for each other at this time and on conversations they might have had, both at Jack Yeats's Saturday 'At Homes' and on their long walks together in the 1930s. There is limited textual evidence of exchanges of ideas, but considering their works in tandem is revealing.⁹⁶ For example, in 1936, Beckett saw and admired the paintings *Low Tide* (1935) (Plate 2) which he described as 'overwhelming',

before proceeding to acquire a reproduction.[97] He also praised *Storm/Gaillshion* (1936) (Plate 3) and *A Morning* (1935/36) (Plate 4), which he bought.[98] Produced contemporaneously with *The Aramanthers*, *Low Tide* makes for an interesting comparative analysis, although the subject matter of the two paintings is not related.

Building on his experiments with impasto and a heightened use of colour in works from the 1920s, in *Low Tide* Jack Yeats uses pure pigment, manipulating the complementaries blue and orange, green and red, to create a push and pull effect, and to give the picture movement and depth, leading the viewer's eye inexorably upwards to the top right-hand corner.[99] The most 'overwhelming' aspect of the picture is the bright indigo colour. It is well known that indigo had special significance for Jack Yeats in 1936. In that year he published an essay entitled 'Indigo Height' in *The New Statesman and Nation*:

I know that indigo is not a primary colour. But it's an axle, the top of a Giant Stride ... Indigo was the strongest colour in the old pictorial theatre posters which used to decorate two or three corners in the seaport Town in the West of Ireland, where I first saw a strange play. ... When I went to the theatre I passed through a lovely town, small and compact, with no suburbs – a river conveniently looping so as to make two bridges necessary. By the Westernmost bridge the river fell, dyed with brown turf, over a weir to meet the salt tides which the Councillor said: 'Flow and ebb, ebb and flow, and flowing do reciprocate,' and it is my delight to know they do still; and that the sky over that town on a winter's night can be deep indigo. ... As I walked along to the Town Hall, the windows, all alight, would shine above me, and down below the salt and fresh water, reciprocating and commingled, would make a gurgling purring noise like a cat negotiating a tangled fur heap between her arm-pit and her breast bone ... Just below the Town Hall lay the quays, and so the theatre and the sea were close together in my imagination ... Sometimes the tide, as I walked above it, was in and welling. Sometimes it was out and trickling further. But always the river place was dark with its own colour, ever, it seems to me now, reflecting the indigo above. Though, once or twice, a theatrical eyed moon glistened on the broken water. But even so the foam had its own bogy water yellow with none of that shining Blue Soap effect so loved by those who saw the moon but once – a transparent once, a transparent one, dancing over a canvas sea.[100]

Jack Yeats's comment that 'the theatre and the sea were close together in [his] imagination' is key because many of his paintings demonstrate an awareness of the three-dimensionality of the theatre. Beyond the Expressionism of Jack Yeats's use of colour and his gestural method of applying paint, a picture such as *Low Tide* could equally be described as 'theatrical': the buildings presented on the left-hand side of the painting resemble 'props' for the stage, and the lighting effects seem too bright, too heightened to be natural. *Low Tide* is in the collection of the Dublin City Gallery, The Hugh Lane, but one of the most striking associations the visitor can make in the

Yeats Museum, National Gallery of Ireland, is between the reconstructed miniature theatre and the composition of his later paintings. For example, works such as *Above the Fair* (1946) and *Grief* (1951) stage figures in the middle of high-sided buildings, like those in his miniature stage sets.[101] In *The Aramanthers*, there is a lengthy description of a play put on at the 'Hope On' hotel.[102] The stage set mounted on the gallery above the bar is described in detail, including a pale blue American cloth hung in loops to suggest water, and the importance of the audience viewing the play from below is emphasized.[103] Both in his miniature theatres and in *The Aramanthers*, Jack Yeats's preferred viewpoint is that of a child, and his club members live in a world of childhood fantasy.[104]

As in many of Jack Yeats's later works, in *Low Tide* areas of canvas are covered only with a wash of paint, while other areas are built up using heavy impasto. The water and figures in a boat in the bottom right-hand foreground are realized with thin paint, reflecting the luminosity of the night sky just visible above the rooftops of buildings. In contrast, the river's edge and building above it are rendered with thick, layered paint. The viewers' visual perception is at first disjointed because we are forced to understand the image in stages, thus building up a cumulative image in the mind. This is comparable to his novels, where 'meaning' is most often revealed to the reader over time and in retrospect, and the procession of scenes and random events is like life's journey. At the end of the novel, the Aramanthers travel up a mountain in the garlanded engine. Purser reads this as a journey to a world transcending life and death, whereas Beckett sees it as a metaphor for the 'issueless predicament of existence'.[105] He ends his review stating that 'The end, the beginning, is among the hills, where imagination is not banned', and quotes from the penultimate page of *The Aramanthers*:

And first you begin to stop emptying your heads, every time they begin to fill with thoughts, and then you will begin to think, and then you will stop thinking and begin to talk. ... And then you will stop talking and begin to fancy, and then you will stop fancying and begin to imagine. And by that time it will be morning. Some morning.[106]

In the light of his review, it is no surprise that when Beckett saw Jack Yeats's painting *A Morning* (Plate 4), he was determined to purchase it, for (he said) it was 'a long time since I saw a picture I wanted so much'.[107] He described it to MacGreevy as 'always morning, and a setting out without the coming home', and borrowed £10 to pay the first instalment, intending to pay the remaining £20 over time.[108] *A Morning* depicts a lone rider on a horse before a deserted village. He looks as though he is about to set out on a journey, and there is a suggestion of a figure in red at a doorway on the right. The grey light is broken by the first, yellow warmth of dawn in thick impasto, and the overall mood is one of promise.[109]

In novels such as *The Charmed Life*, Jack Yeats's characters traverse unspecified coastal roads of Ireland like that seen in *Storm/Gaillshion*. But Brian O'Doherty asks: 'what if there is no origin or destination – just travelling? Then the missing origin and destination become mythological inventions and travel, deprived of its ends, is laden with symbolic meanings.'[110] This is a good description of Beckett's reason for loving and buying *A Morning*. Moreover, travel as a metaphor for life, and in particular for life spent in exile, is a theme permeating both Jack Yeats's paintings and his writings. The travellers he portrays with pen and with brush are most often characters he met around Sligo in his childhood, including tinkers, gypsies, sailors, circus performers, actors, ballad singers and tramps. For all of these types of people, travel is a way of life, and Jack Yeats shares this implied identification with his brother WBY and his friends J.M. Synge and Beckett, bringing issues of personal and cultural identity to the fore. To understand the theme of the traveller in his work is to gain a deeper understanding of how word and image relations affected his transition from illustrator to Ireland's greatest painter, and the theme of 'The Two Travellers', the title of his oil painting purchased by London's Tate Gallery in 1957 (cover image), is a key.

'The Two Travellers' in the Work of Jack Yeats, W.B. Yeats, J.M. Synge and Samuel Beckett

Throughout his school years, Jack Yeats lived with his Pollexfen grandparents at Merville, Co. Sligo, and his early sketchbooks are charming records of these years.[111] In *A Broad Sheet* and *A Broadside*, as well as in his early plays for the miniature theatre, characters such as tramps, ballad singers, pirates, sea captains and the fishermen whom he met on the Sligo quaysides feature strongly. He wrote: 'As to the plays, I write them all myself. So what shall I say of them, but that I admire them all but I like the piratical ones best.'[112] These boyish interests were kept alive in maturity through his friendships with John Masefield and J.M. Synge, and in his later writings and paintings there is an ambiguity between real and imagined worlds, reflecting the influence of Sligo on his impressionable childhood imagination. The artist shares this repetition of themes and characters with his brother WBY, but his playfulness contrasts with the seriousness of WBY's memories of Sligo. Symons aptly described this difference between them in 1908:

> In his way, he is as much a visionary as his brother; but while Mr W.B. Yeats sees heroic and fairy things with delicate precision, Mr Jack Yeats sees all the real and unreal world of boy's romance, and he renders them like the penny toys.[113]

Classic examples of repetition from WBY's work are the themes of love and death, his invented characters Red Hanrahan and Michael Robartes, and

idealized characters such as the fisherman and the peasant. In Jack Yeats's work, we also find the theme of death, and recurrent characters of the fisherman, the tramp and the ballad singer. Hilary Pyle and, more recently, Calvin Bedient have analysed shared themes, symbols and aesthetics in the work of the Yeats brothers. Pyle emphasizes a shared love of Sligo and a devotion to the idea of an Ireland free from foreign domination, while Bedient explores Modernism's 'love of motion' in a selection of WBY's poems and Jack Yeats's paintings to prove their complicity.[114] One of the principal differences between the brothers, in relation to word and image, however, is that while WBY assimilates aspects of the visual arts into his literature, Jack Yeats experiments in both media. In 1971, Pyle made an astute comparison:

The tramp and the misfit, well known about the country roads, are
central to the themes of both men, W.B. creating Red Hanrahan
and Crazy Jane, and Jack B. bringing Bowsie, as well as tinkers
and characters he observed, into prose and paintings.[115]

Red Hanrahan was a peasant hedge-school master and wandering poet who features in both the prose and poetry of WBY. The character Crazy Jane is based on a Sligo peasant woman and a character from a traditional ballad. Pyle's comparison opens up a discussion of the different relationships that WBY and Jack Yeats had, not only with Sligo, but also with the tramp and the misfit.

In his vision for Irish cultural identity and the arts, WBY coupled the 'noble and the beggar-man', believing in a nation where aristocracy and peasantry could live together and form an Irish identity, a vision which emerged in 'The Municipal Gallery Revisited':

(An image out of Spenser and the common tongue).
John Synge, I and Augusta Gregory, thought
All that we did, all that we said or sang
Must come from contact with the soil, from that
Contact everything Antaeus-like grew strong.
We three alone in modern times had brought
Everything down to that sole test again,
Dream of the noble and the beggar-man.[116]

His poem commemorates 'the images of thirty years' (l.1) hung in the Municipal Gallery of Art (now Dublin City Gallery, The Hugh Lane), but it also demonstrates his vision for an Irish literature as epitomized by the work of Synge, 'that rooted man' (l. 48). Tramps and misfits feature strongly in both word and image during the Irish Cultural Revival, and a closer look at this character type in the work of Jack Yeats, WBY, Synge and Beckett is revealing.

Jack Yeats's illustration for *Punch* (Frontispiece) depicts an artist and a tramp meeting in the countryside. The artist asks the tramp: 'Would you mind me making a sketch of you as a tramp?' To which the tramp replies: 'Not if you don't mind me making a sketch of you as an artist.'[117] The comparison between the two men is both humorous and pertinent, reflecting the artist's respect for those who walk the road as his equal. Throughout their lives, Jack Yeats and Synge walked particularly long distances around country roads in Sligo, the Wicklow hills and other rural and coastal areas, and in the early twentieth century it would have been common to meet tramps or beggars in these remote locations. Strangers would walk together and converse for a time before heading off in their own direction, and Synge's essay 'On the Road', in his *In Wicklow, West Kerry and Connemara*, describes one such event:

One evening after heavy rains I set off to walk to a village at the other side of some hills, part of my way lying along a steep heathery track. The valleys that I passed through were filled with the strange splendour that comes after wet weather in Ireland, and on the tops of the mountain masses of fog were lying in white, even banks. Once or twice I went by a lonely cottage with a smell of earthy turf coming from the chimney, weeds or oats spouting on the thatch ...

Further on, as I was going up a long hill, an old man with a white, pointed face and heavy beard pulled himself up out of the ditch and joined me. We spoke first about the broken weather and then he began talking in a mournful voice of the famines and misfortunes that have been in Ireland. ...

Soon afterwards we passed into a little village, and he turned down a lane and left me. It was not long, however, till another old man that I could see a few paces ahead stopped and waited for me, as is the custom of the place.[118]

Jack Yeats's illustration *Tramps* (1908) (Figure 5.1) carries this theme of the wandering countryside tramp or misfit on into his work for the Yeats sisters' Cuala Press, appearing in the August 1908 edition of the new, updated publication, *A Broadside*.

The image repeats the 'The Two Travellers' motif noted in his illustration for *Punch*, but on close observation of *Tramps*, there are marked differences between the two men. One of them (whose appearance bears an uncanny resemblance to WBY) wears the clothes of a middle-to-upper class person, with knickerbockers, shooting jacket and leather shoes. The other wears trousers tied up at the waist with a piece of rope, a loosely tied scarf, and an old, wide-brimmed hat. The juxtaposition of the two types are reminiscent of WBY's 'noble and beggar-man', or the 'wise and simple' fisherman in the poem 'The Fisherman' (1916), or in *The Wild Swans at Coole* (1917).[119] It also forms links with Synge's *The Aran Islands* (1906),[120] illustrated by Jack Yeats, where the Irish peasant had been idealized in a comparable way:

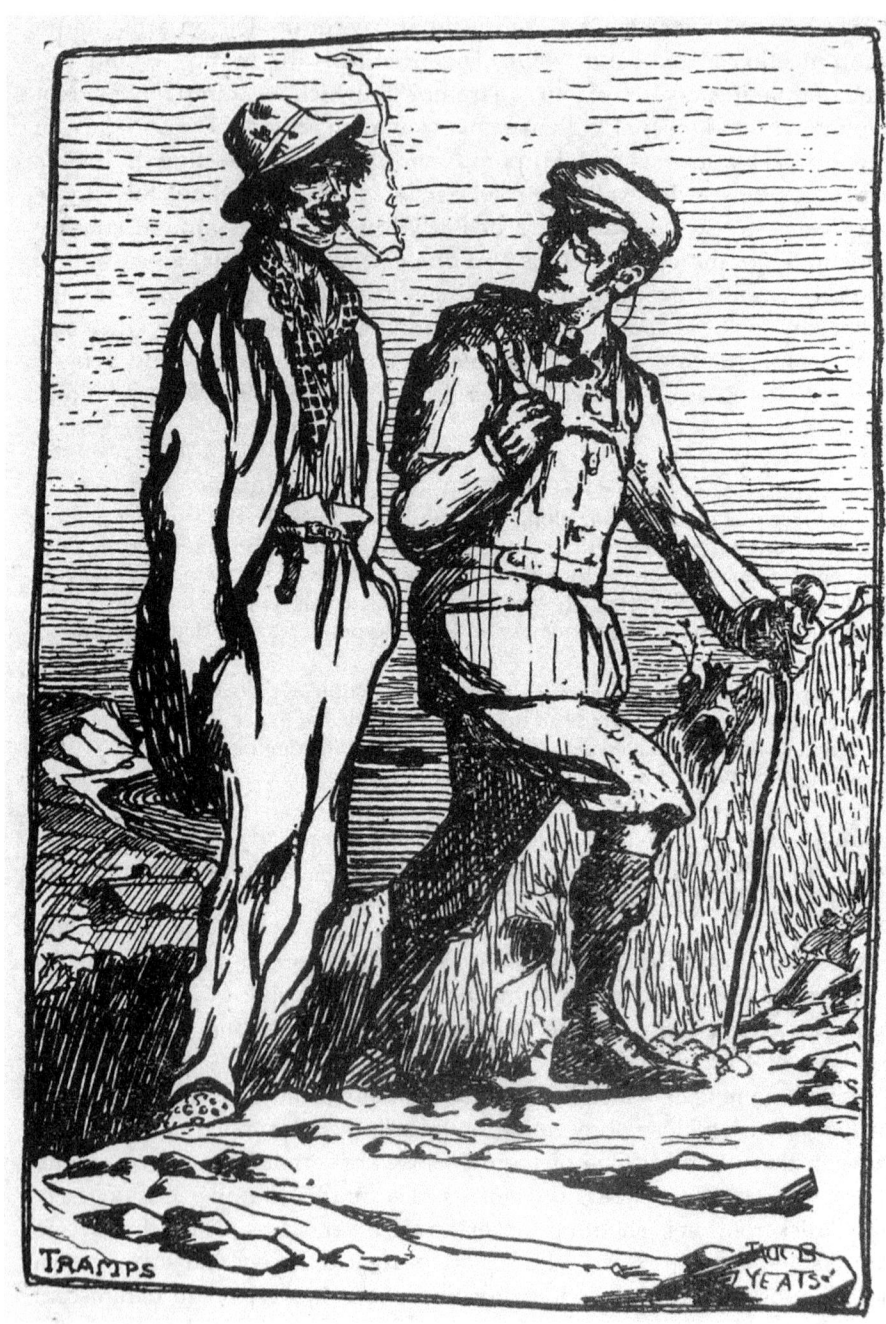

5.1 Jack Yeats, *Tramps*, illustration in *A Broadside*, no. 3 (August 1908)

Their way of life has never been acted on by anything much more artificial than the nests and burrows of the creatures that live round them, and they seem, in a certain sense, to approach more nearly to the finer types of our aristocracies – who are bred artificially to a natural ideal – than to the labourer or the citizen, as the wild horse resembles the thoroughbred rather than the hack or cart-horse.[121]

In the words of George Russell (AE): 'I suspect Jack Yeats thinks the life of the Sligo fisherman is as good a method of life as any, and that he could share it for a long time without being in the least desirous of a return to the comfortable life of convention.'[122] And several commentators have compared Jack Yeats's, Synge's and WBY's depictions of Irish peasants from the point of view of primitivism, or even colonialism.[123] The important thing to note, however, is that the three men identified with the Irish peasant, a person they perceived as caring little for the material goods associated with growing urbanization in Ireland, and who was situated, like the artist, on the margins of society.

In the novels *Sligo* (1930), *Sailing, Sailing Swiftly* (1933), *The Charmed Life* (1938) and *The Careless Flower* (1947), as well as in certain plays including *The Old Sea Road* (1933) and *The Green Wave* (1964), Jack Yeats also presents us with vagabond characters, travelling the roads. In *Sligo*, the two travellers are John Thady O'Malley from Mayo and the Englishman Jasper Newbigging, and in *The Charmed Life*, the two men are Mr No Matter (the narrator) and Bowsie, who travel together along coastal roads in a part of the west of Ireland in a manner reminiscent of Jack Yeats's *Memory Harbour* (1900). In *The Charmed Life*, the relationship between the two men reflects Jack Yeats's idiosyncratic style of storytelling. The narrative consists of Mr No Matter's descriptions of the land and the people they meet, and musings about his 'worn old friend' Bowsie:

Now out along the westerly road towards the port, you know the road well. On the crest of the hill that'll make three-quarters of a mile out. We will climb up on the bank beside the gate and look out over the sea nailed down under the moon with the house, Crooked Dell, down below us on the south-east and the tops of low cliffs before us. Keep in the shade and comfort of the hedge going up the hill. … I wonder what he [Bowsie] does think, or does he feel no need for thinking. Does he just turn what his eyes see, or what his reason tells him exists, before him into some easily assimilated condensed, sweetly rectified, spirit, and then drink it … Look at the wide melon slice of bay; see how the water lives where the moon spangles it, just like a beautiful photograph slightly blued. Can you imagine that sea full of ships of the old, decorated, broad-cheeked style, the ones of long ago. … Strange, deep thoughts, these, we might go further and fare worse. But we will continue a little further along the top level of this road.[124]

Long fictional walks such as this are an opportunity for Jack Yeats to 'jettison memories' by sketching various characters and places he remembers, such as the two 'carpenter ballad singers' who interrupt the narrative with

random songs, tales of young men gone to America, and character studies of innkeepers.[125] No Matter's and Bowsie's journey describes not only such encounters, but also the nature of their walking:

As we walk along we are wandering about on the roadway, walking carelessly, where up to this to-day we paced sturdily, side by side, keeping an even distance from ourselves. Now, our day's journey nearly done, we weave about, bump into each other, and use up the space of the road; one time going pigeon-toed, one time splay-footed. Until we come to the ford, and there the stepping-stones must be crossed with care.[126]

At one point, No Matter and Bowsie go their separate ways to 'commune with our own nonsensical souls, which at these times will not be said nay to, but peak up in their squeaky little voices, which it amuses them to think are human ones'.[127] No Matter takes a path up a muddy hill under the shade of fuchsias where there is a wooden seat to sit on, and the description of the scenery is exactly like that of *Storm/Gaillshion*. But inevitably the two travellers meet up again to continue their journey.[128] Then, at the end of the novel, Bowsie heads off for a government office job in Dublin, while No Matter strolls 'slowly along the dry, sandy, cream-coloured road'.[129] No Matter remains behind, saddened, but happy enough.

Contemporary reviews demonstrate that there was more understanding for this book than previous publications, but again, WBY's comments are very revealing.[130] In 1938, he described *The Charmed Life* as:

... my brother's extreme book, 'The Charmed Life.' He does not care that few will read it, still fewer recognise its genius; it is his book, his 'Faust,' his pursuit of all that through its unpredictable, unarrangeable reality. [sic] least resembles knowledge. His style fits his purpose for every sentence has its own taste, tint and smell.[131]

One astute critic for *John O'London's Weekly* also discerned continuity in Jack Yeats's novels in the theme of 'The Two Travellers'. He described Mr No Matter and Bowsie as 'trolls, leprechauns, rather than humans', and pointed out that the reader had met them before in Jack Yeats's novels as the two slightly more civilized characters in *Sailing, Sailing Swiftly* and again in *The Aramanthers*. He continued: 'But now the pace is faster and more furious. Not an idea comes into Mr Yeats's head, not an image before his eyes, without exfoliating and multiplying.'[132]

In *Modern Aspects of Irish Art*, Jack Yeats linked the countryside and people ('Those painters who have the greatest affection for their own country and their own people will paint them best'), and in 1924 Walter Sickert also praised him for relating the two so well:

Jack Yeats is doing what I would like to urge you young painters to do: painting the life of his own country ... much of our modern landscape has an imported air, and the figures are tucked away in corners. They are seldom

doing something in the landscape. Instead, the two elements should be knit together both psychologically and pictorially. The novelists know how to use landscape as part of the things that people feel and do. Yeats's landscapes are solidly constructed and occur behind figures which are active.[133]

Jack Yeats achieves this harmony in *The Charmed Life*, particularly when he describes travellers on the Irish roads. There is an episode where a tramp 'falls into step' with No Matter and Bowsie on one of their long walks, in a manner similar to that experienced by Synge in *In Wicklow, West Kerry and Connemara*.[134] The tramp, a 'thin stooped man', is identified with the road which 'waves up and down, too short the rise and fall to give it the name of undulating. It is a dancing road, a singing road.' He is described as being intuitive, eating only at dawn and dusk, sleeping in the hay, and treading lightly on the 'long strip of emerald grass, short as the fur on a young seal's back'. He is as pure as the bay they walk past: 'He is so cleanly shaven – so sea clean. Clean in his blood; he looks as if he lived on spring water, and the leaves of the ground.' After seven pages of such description, the tramp parts company from the two friends as cleanly as he arrived, for '[h]e has only a blow away interest in us, and why should he have more'.[135]

Passages such as this demonstrate a keen sense of nature, but the question of Jack Yeats's empathy with the tramp remains unresolved. Nevertheless, in 1937 he published a lesser-known story about 'a friend' who 'when a child saw artists under trees', and the story provides textual evidence of his empathy:

When my friend grew old enough to think about himself in relation to Art, he thought he would like to be a Bohemian, not absolutely the same as those first artists of childhood. They were bohemians of a flower-like kind. He wished to look wilder, though having all the time a heart of gold. He would have liked to have worn drooping clothes. But it was difficult to begin, to spring from your bedside dressed for a new part. He thought, and the thought persisted always, though he argued it away, that the true artist must come up from Grub Street, from hard times, rolled in the clay, but undefeated and full of fighting. He suggested this idea of his to his fellow students, and none agreed with him. Indeed, they were not very fond of discussions about beginnings. They were of all ages, so there was no fixed distance from the beginning. So my friend, he thought driven inward, decided that race and his own character were the greater moulds for the artist to tumble from.[136]

If the artists of a 'flower-like kind' refer to JBY's fellow-artists in late nineteenth-century London, then the above quotation makes interesting reading beside *Reveries Over Childhood and Youth*. In *Reveries*, WBY describes their philosophy as 'a misunderstanding created by Victorian science', and maintains that in his heart, he thought that 'only beautiful things should be painted, and that only ancient things and the stuff of dreams were beautiful'.[137] If 'A Painter's Life' is autobiographical, then the process of Jack Yeats being 'driven inward' to explore 'race and his own character' is also significant. The essay reflects his continued commitment to *painting* in 1937,

but there was more distance for the artist to travel before he could reach his goal of 'painter triumphant' in the 1940s.[138]

In *The Charmed Life*, the tramp, like other characters in the novel, takes his leave from No Matter and Bowsie to allow them to continue on their journey around the coastal roads. However, it is implied that No Matter and Bowsie are also 'trampish'. They have no fixed abode (although they can afford to stay in the hotels they visit), and No Matter introduces Bowsie as wearing 'a long overcoat weathered to a green shade about the shoulders and the rotundities of his rump. ... His neck was round and the light yellow neckcloth, with small brown spots on it, was always fresh as a primrose', adding later '[i]f he was down on all fours he couldn't be less important looking'.[139] No Matter is the narrator, and he explains Bowsie's thoughts as though he knows his friend's mind, but he also casts the part of each one of the characters described in the book, trying to 'draw aside the curtain, where permitted, and not only understand, but enter into, the feelings of my fellows'.[140] The following description reveals Jack Yeats's philosophy on writing and painting throughout his life: 'I have always held that affection was the greatest attribute that any painter or writer can have. I am not a writer in the ordinary sense but when I write I have affection for the things I write about and when I paint certainly have affection for everything I paint.'[141]

However, the character Bowsie complicates an interpretation of No Matter as author.[142] Together the characters present a dualism, as though they personify different sides of one character, such as 'philosopher' and 'rogue', or 'body' and 'spirit'.[143] Moreover, the intrinsic nature of their relationship is demonstrated by No Matter's existence, which depends on Bowsie *observing* him:

at times, without any effort as far as anyone could know, a way of almost
floating into the invisible. He was there. He wasn't there. A slow tick of
the clock and he was there again. ... There was one man from whom No
Matter never vanished, that was his worn old friend, Bowsie.[144]

Bowsie is also presented as an ethereal character who:

appears, at times, to be moving away, and then coming towards the beholder,
everlastingly. He goes away, into some ancient air, so choked with dimensions
that it's a jamb and no movement. Then, in a flash, he's back again, gazing straight
towards one, with his face flashing with clear bright light, and coloured darkness.[145]

At one point the two men take a 'stroll apart', and their separation is described in terms of light and darkness, creating contrast. No Matter tells Bowsie: 'You may see me illuminated by the sun shining behind your back, and through the pink of the ears. While I will see but a silhouette, a little gloomy silhouette, relieved only by the round blushes of the ears.'[146] James Knowlson has pointed out that few, if any, writers have used light and dark imagery as consistently

as Beckett in his plays and in certain of his poems, and interestingly in 1937 Beckett wrote to MacGreevy about Jack Yeats's paintings:

> What I feel he gets so well, dispassionately, not tragically like Watteau, is the heterogeneity of nature and the human denizens, the unalterable alienness of the 2 phenomena, the 2 solitudes, or the solitude and the loneliness, the loneliness in solitude, the impassable immensity between solitude that cannot quicken to loneliness and the loneliness that cannot lapse into solitude ... I find something terrifying for example in the way Yeats puts down a man's head and a woman's head side by side, or face to face, the awful acceptance of 2 entities that will never mingle.[147]

The description could apply equally well to *The Charmed Life*, and anticipates the increasingly marked contrast between two figures in Jack Yeats's paintings such as *Death for Only One* (1939), *The Two Travellers* (1942) (see dust jacket cover), *Two Men Walking* (1946), *Harvest Moon* (1946) and *Halt* (1951).[148] The subject matter of 'Two Travellers' therefore runs throughout Jack Yeats's *oeuvre* in both text and image, and reminds one of the artist's relationships with Synge, Beckett or MacGreevy, all of whom he accompanied on long walks in the Irish countryside. But it also forms relations with the literature of Beckett.

The Two Travellers depicts two tramps in a barren landscape, with an intimation of a headland resembling Ben Bulben in the background, reflecting the importance of memories of Sligo to the artist. Oscar Kokoschka, who became a friend of Jack Yeats in the 1940s, also admired this picture and wrote to him in 1956:

> Brigalove, the American who had visited you at Dublin, came to see us and you can imagine how lovingly we both and my wife, who later joined us, talked about you. To enhance the pleasure of your spiritual presence, he had the good idea to bring your painting with him, you know that one with the two men meeting in the country on a heath or dale, one with hat, the other one with ruffled black hair and leery eyes, but the air was as much Irish and tension between the two so vivid, that one could spin the yarn on for oneself without a verbally written story to support it.[149]

The 'tension' between the two men to which Kokoschka refers is in their stance. They are face to face and one is illuminated while the other remains in darkness. The vigorous Expressionist application of paint generates an intense atmosphere around the unspoken dialogue between the two men. This is Beckett's void, his 'no-man's land, Hellespont or vacuum' to which Jack Yeats 'brings light ... reduces the dark', achieved by a singular integration of figure and landscape which does not need 'a verbally written story to support it'.[150]

So what impact did such works have on his admirer Beckett, and what significance is there in the fact that many such themes were developed in Jack

Yeats's experimental *writing* before his later Expressionist paintings? James Knowlson has indicated that Beckett's appreciation of Jack Yeats's paintings informed the figures and characters of Beckett's mature prose and drama:

> two figures wandering across an alien landscape at the beginning of his novel, *Molloy*; Estragon and Vladimir in *Waiting for Godot*, together as they wait, but fundamentally alone; Krapp, separated from earlier versions of himself; Winnie, condemned to chatter away the rest of her existence to a largely unhearing, self-preoccupied, brutish companion; and the protagonist in *That Time* listening to three discrete accounts of different moments in his lonely life.[151]

After 1938, the motif of 'Two Travellers' in Jack Yeats's writing occurs again in *The Green Wave*.[152] Perhaps Beckett's tramps are more indebted to Jack Yeats's writings than has been recognized. Factors such as Jack Yeats's fragmented writing style, his conviction of the superiority of painting, and the overshadowing influence of his literary brother may all have influenced this oversight concerning the influence of one friend upon another. As Herbert Read remarked: 'I am aware that Yeats had a brother; it is a public misfortune if it prevents people reading the fantastic revelry of *The Aramanthers* or *The Charmed Life*.'[153]

A letter from F.W. Reid to Jack Yeats when he was living in Portobello nursing home takes this thesis to the extreme. Reid had attended a production of Beckett's *Waiting for Godot* (1957) and the ensuing discussion in San Francisco. 'I'm glad that Sam Beckett is at last a complete success (if having arrived in America is any criterion),' he wrote to Jack:

> It is interesting to see Beckett trundled about in the same carriage with Joyce, Kafka, and Sartre; but I've my own notion of his indebtedness. I say that 'Godot' is just a Beckettian 'Old Sea Road', with Gogo and Didi passing for John and Michael; only the latter did 'go'. And the itinerant Molloy and Malone are simple Bowsie or Jimmy Gilfoyle or Oliver J. Gaw, immersed by Beckett in the esthétique du mal or the mystique de la merde and offered anew to the world. But for my part I had rather that Beckett had exchanged his own flat and literal line for that metaphorical style of his master Jack Yeats. On the other hand, every man to his own taste. It is just that at times I regret that some of the better parts of poetry are seldom used these days.[154]

In 1939, Jack Yeats's play *Harlequin's Positions* was performed at the Abbey Experimental Theatre, produced by Ria Mooney, and later in life Jack Yeats gave credit for the success of the production of *La La Noo* to Mooney and the players.[155] The press heralded *La La Noo* as Ireland's first 'Surrealist' play, and lauded its minimal stage set.[156] When it was later published by the Cuala Press in 1943, Lennox Robinson wrote in *The Bell*:

> Jack Yeats submits a play. When I see his name as author, I shudder because I know, judging by my old-fashioned standards, that it will not be a 'well-made play'. I have been one of the Directors who have rejected other plays by him but I remember I was strongly for this play's acceptance. It had no chance of

being a popular success but it had originality and beauty, and in its production a hauntingly beautiful quality. Looking at it in the Abbey that Sunday last May I wondered whether it was Ria Mooney's sensitive production or the player's excellent performances which captivated me. Now, reading it in cold print – in Cuala cold print – I know that to the author does 'the greater praise belong'.[157]

Yet after this upward turn in critical reception, Jack Yeats's career as a writer virtually ended – he wrote only one more play, *In Sand* (1943), with the prologue *The Green Wave*. Perhaps the clue as to why this happened lies in the play itself. In *The Green Wave*, two elderly men debate a painting of a green wave displayed on an easel in the room, engaging in a conversation not unlike one from Beckett's *Waiting for Godot*:

2ND ELDERLY: What is it?
1ST ELDERLY: It is a wave.
2ND ELDERLY: I know that, but what sort of a wave?
1ST ELDERLY: A green wave – well – a rather green wave.
2ND ELDERLY: What does it mean?
1ST ELDERLY: I think it means just to be a wave.
2ND ELDERLY: I like things to mean something, and I like to know what they mean, and I like to know at once. […][158]

Like many of the themes and motifs in Jack Yeats's later work, the green wave is perhaps borrowed from an image used in his early career, in this case from an illustration he made for *A Broadside (New Series)* in 1937.[159] The play raises many of the questions surrounding modern art-historical discourse, including the reader's or viewer's search for 'meaning' and the role of the painter/author. In effect, Jack Yeats is foregrounding the triadic relationship between the author, the text or image, and the reader or viewer. The play ends with the 'Brown Girl' looking down on sand and saying: 'look at the sea's edge! The tide is coming in now fast, look, look, the waters are covering up and washing away everything that we have written.' The curtain closes, the text disappears and the images are metaphorically washed from the reader/viewer's mind.[160]

Jack Yeats now returned to painting, for he had 'jettisoned' his memories on the printed page and could, with a clearer mind, put brush to canvas. He wrote:

He knows now if he has bound on his forehead 'G' for Genius, and not a 'J' for Journeyman when he walks up to his clear waiting canvas with his empty palette on his thumb. Without warning, his attendant shades will squeeze out the colours for him, hand him his brushes, say nothing in his ear, and then push him into the pit where the fight is always to a finish, no time, no gong, and the sky the only roof.[161]

It is significant that the painting style he developed in his late career was Expressionistic, rather than the Cubist style being fostered by contemporaries

such as Jellett and Hone. Cubism, as described in Albert Gleizes's *Hommage à Mainie Jellett* (1948), involves a very methodical, almost mathematical process of production.[162] Several critics, to the consternation of Bruce Arnold and Brian Kennedy, have cited Jack Yeats's remark 'Who the blazes Gleizes?' as evidence of Jack Yeats's rebuttal of abstract Modern French painting.[163] Yet in the light of his goal of a non-literary painting, the comment regains significance.

Jack Yeats differentiated between the arts in terms of physical, 'sensible' boundaries (the eye and the ear), opening up a whole range of counter-arguments that theorists of word and image relationships since Leonardo da Vinci in his *Paragone* (c. 1510) have grappled with. For example, W.J.T. Mitchell has expounded the impossibility of meta-linguistic communication through painting as a topic of debate, and his discussion of 'Mute Poesy and Blind Painting'[164] raises questions about the extent to which Jack Yeats's painterly goal could ever be realized. After all, as Ernst Gombrich and Nelson Goodman have agreed before Mitchell, 'the innocent eye is blind'.[165] Despite these caveats, Expressionist painting involves a spontaneous, direct engagement of the painter with thick, strong colours such as indigo, yellow and red, so the viewer's response is necessarily more 'immediate' in terms of emotional impact than it would be with traditional, allegorical paintings, or Modern Cubist works. This could arguably result in more 'direct vision and direct communication' through gesture and colour, for as Kenneth Clark noted:

Colour is Yeats's element in which he dives and splashes with the shameless abandon of a porpoise. And colour knows no laws: it is the language of the free, the passionate, the impulsive, the intoxicated. We follow Jack Yeats breathless and a little drunk; and then when the roof is just about to blow off and the floor heave under our feet, we pass into the rooms of William Nicholson.[166]

Both Arnold and Pyle have claimed that Jack Yeats's exhibition in London's National Gallery marked a watershed for his real triumph as a painter, and that thereafter his activity as a writer waned.[167] Arnold also claims that his success as a painter in London encouraged a more favourable reception for his work back home in Ireland.[168]

Jack Yeats's aspirations towards painterly supremacy were articulated between 1919 and 1927, and analysis of word and image interactions in his experimental writing in the 1930s helps to contextualize his goal as a painter who, 'if he has seen his vision clearly and if his hand is sure ... can give us his vision as it came to him, and painting can reach as high as men can reach'.[169] Sligo was consistently Jack Yeats's 'jumping off place. It is my spiritual home always, and the foundation of everything I paint is Sligo', and his commitment to living in Ireland is linked to the primordial importance of his childhood.[170] When channelled through the 'prism of memory' and 'jettisoned' with words, the landscape, light, atmosphere and people he internalized from there became transformed. MacGreevy's insistent reading of Jack Yeats as *the* national Irish

painter therefore has credence. Yet at the end of 'MacGreevy on Yeats' (1945), Beckett wrote that his friend's paintings were of 'a world where Tir-na nOgue makes no more sense than Bachelor's Walk, nor Helen than the apple-woman, nor asses than men, nor Abel's blood than Useful's, nor morning than night, nor inward than the outward search'.[171] Beckett would no doubt have had in mind paintings such as *Bachelor's Walk in Memory* (1915), *Tinker's Encampment: The Blood of Abel* and *A Race in Hy Brasil* (1937), all of which could be read in a singularly Irish context.[172] However in 1954, when Beckett wrote 'Hommage à Jack B. Yeats', he again asserted his friend's independence, even from his 'brother', a remark suggesting the best location for drawing conclusions about the achievements of the writer-painter Jack Yeats:

De là cette étrangeté sans example et que laissent entière les
habituels recours aux patrimonies, national et autres.
...
L'artiste qui joue son être est de nulle part. Et il n'a pas de frères.[173]

Differences noted between Jack Yeats's and WBY's depictions of Irish characters such as the tramp and the ballad singer also help to contextualize Beckett's arguments. But there are further conclusions to be drawn from comparisons between them, linked directly to interactions between word and image.

W.J.T. Mitchell maintains that opening up the 'space between' word and image 'never appears as a problem without being linked, however subtly, to questions of power, value, and human interest'.[174] This book has demonstrated his point. When word and image are juxtaposed in historical context, either a search for synthesis or a struggle for precedence can be detected, which at times exposes a distortion of the original theoretical premise of the writer or painter. The career of Jack Yeats is one of the best examples of this. He adamantly asserted the superiority of painting over literature, and yet, paradoxically, spent most of a decade producing literature. His work metamorphosed from early prints and paintings associated with the Irish Cultural Revival into an intensely personal expression of Irish Modernism. By considering his paintings in isolation from his novels, a purely art-historical approach has missed seeing the influence of his writing on his subsequent work. Brian Kennedy has rightly drawn our attention to Jack Yeats's 'Modernist' affiliations, including his contribution to the New York Armory exhibition in 1913, and has made stylistic comparisons with Van Gogh, Rouault, James Ensor and Marc Chagall, as well as drawing in his friendship with Kokoschka after 1940. All these factors are important, but by excluding Jack Yeats's writing career, Kennedy's conclusion, that 'his changing style resulted from contact with contemporary European artists and not in isolation', is questionable.[175]

In comparison to WBY's '*fraternité des arts*' ideals, Jack Yeats's 'painterly writing' can be understood as an artistic *hybrid*, for by locating images *within the text* rather than as an appendage to it, he, like his brother, broke down

borders between word and image on his journey. By the 1940s, paintings by Jack Yeats could stand alone, arguably unencumbered by 'allegory', 'symbolism' or (more contentiously) by the need for 'translation' into words.[176] Although Jack Yeats created boundaries between the arts in his letters and essays, he in fact created painterly novels. This achievement sets his work apart from that of Joyce, and challenges Brian O'Doherty's remarks on literary supremacy in Irish cultural histories, quoted in my introduction.[177]

* * *

Investigating a familial 'relationship-in-difference' between literature and the visual arts in the Yeats family circle offers an alternative view of early twentieth-century Ireland.[178] At times this relationship was a search for synthesis towards a common agenda; at other times, the artists needed to assert media specificity to make their stand. The relay of semiotic and ideological struggles shows that the visual (and more specifically the dialogue between the visual and the verbal) contributes more to this transitional period of Irish cultural history than has been recognized hitherto. By the end of his life, WBY's vision for all the arts playing 'like children about one chimney' was enacted not only through friendly collaborations, but also through sibling tensions – not least between him, his brother and their family circle.[179]

Notes

1. Quoted in Bruce Arnold, *Jack Yeats* (New Haven and London, 1998), pp. 207–8.
2. Jack and Cottie moved permanently to Ireland in 1910, took a house in Marlborough Road in Dublin in 1917, and then one at 18 Fitzwilliam Square, Dublin in 1929. Jack joined the Dublin Arts Club in November 1920.
3. Thomas MacGreevy, *Jack B. Yeats: An Appreciation and an Interpretation* (Dublin, 1945), pp. 26–7. See also Arnold, *Jack Yeats*, p. 217; p. 239.
4. Jack Yeats, 61 Marlborough Road, Donnybrook, Dublin, Ireland, to John Quinn Esq., 31 Nassau Street, New York City, USA, 17 November 1920 (NYPL, Quinn Coll.).
5. Jack Yeats, *Modern Aspects of Irish Art* (Dublin, 1922) Series F. 8, pp. 3–4.
6. Jack Yeats, 61 Marlborough Road, Donnybrook, Dublin, Ireland, to Blaikie-Murdoch, 13 August 1927 (TCD, MS 10318/5).
7. See the introduction to this book, and W.J.T. Mitchell, 'Word and Image', in Robert S. Nelson and Richard Shiff (eds), *Critical Terms for Art History* (Chicago and London, 1996), p. 53.
8. Arnold, *Jack Yeats*, p. 185. See also Chapter 2 of this book.
9. Hilary Pyle notes that after his return to Ireland in 1910, Jack Yeats became 'deeply concerned with Irish internal affairs', his patriotism '… intense and of a deeply idealistic nature. To him the Free Staters were middle-class, while the Republicans represented all that was noble and free. His patriotism had nothing to do with war or the practicalities of the situation … His pictures of political subjects do not depict the conflict or moments of sacrifice, but the tragic or removed emotions of those who live on.' (*Jack B. Yeats: A Biography* [London, 1970], p. 117; p. 119.)

10. James Knowlson and Elizabeth Knowlson (eds), *Beckett Remembering Beckett: A Centenary Celebration* (New York, 2006), pp. 58–9.

11. Edward Sheehy claims: 'When politics ousted patriotism, collaboration ceased and the artist was thrust back into himself and his own past' ('Jack B. Yeats', *Dublin Magazine*, 10/3 [July–September 1945]: 41). See also Ernie O'Malley, 'The Paintings of Jack B. Yeats', in Roger McHugh (ed.), *Jack B. Yeats: A Centenary Gathering* (Dublin, 1971), pp. 64–70; Síghle Bhreathnach-Lynch, 'Framing Ireland's History: Art, Politics and Representation 1914–1929', in James Christian Steward (ed.), *When Time Began to Rant and Rage: Figurative Painting from Twentieth-Century Ireland* (London, 1999), pp. 40–51; David Lloyd, 'Republics of Difference: Yeats, MacGreevy, Beckett', *Field Day Review* (2005): 43–69.

12. *Bachelor's Walk: In Memory* (1915; Collection: National Gallery of Ireland, Dublin) depicts a flower girl commemorating the death of civilians shot by the army in 1914 in Dublin during an Irish Volunteers demonstration. See Arnold, *Jack Yeats*, pp. 191–6 and Arnold's 'Jack Yeats: The Need for Reassessment', in Yvonne Scott (ed.), *Jack B. Yeats: Old and New Departures* (Dublin, 2008), pp. 47–56. Calvin Bedient presents a fresh reading of *Communicating With Prisoners* in his *The Yeats Brothers and Modernism's Love of Motion* (Notre Dame, 2009), pp. 286–9. Bedient discusses the attire of the women standing outside Kilmainham jail in terms of Baudelairian modernity.

13. Nora McGuinness, *The Literary Universe of Jack B. Yeats* (Washington DC, 1992), p. 19.

14. John W. Purser, *The Literary Works of Jack B. Yeats* (Gerrards Cross, 1991), pp. 5–7.

15. Jack Yeats to Thomas MacGreevy, 21 March 1919, in Arnold, *Jack Yeats*, pp. 207–8.

16. Jack Yeats to MacGreevy, 13 August 1927 (TCD, MS 10318/5).

17. Jack Yeats to MacGreevy, 13 March 1930 (TCD, MS 10381/108).

18. Jack Yeats to Joseph Hone, 7 March 1922, in Pyle, *Jack B. Yeats: A Biography*, p. 128.

19. Pyle, *Jack B. Yeats: A Biography*, p. 136.

20. Pyle, *Jack B. Yeats: A Biography*, p. 139.

21. Arnold, *Jack Yeats*, pp. 238–9. Arnold contends that one of the main reasons behind Jack Yeats's literary career was the hope of financial gain, and states that a letter between Jack Yeats and T.M. Ragg, held in Reading University Library, provides clear evidence for this (Arnold, *Jack Yeats*, p. 240; p. 394). This opinion was reiterated by Arnold in his lecture for the symposium 'Jack B. Yeats: Amongst Friends', 9 September–14 October 2004, Trinity College Dublin, Irish Art Research Centre, 2005.

22. Joint review of Jack Yeats's 1930 exhibition at the Alpine Club in London and *Sligo* (London, 1930); newspaper unrecorded (Clipping, NGI, Yeats Archive, Parcel 25B [Press Cuttings 1925–33]).

23. See, for example, a letter from Jack Yeats to MacGreevy, 1 May 1933, in which he asks MacGreevy's advice on which reviewers to send copies of *Sailing Sailing Swiftly* (1933) (TCD, MS 10381/116).

24. Purser, *The Literary Works of Jack B. Yeats*, p. xi.

25. I count here both art publications including Arnold, *Jack Yeats* and Steward, *When Time Began to Rant and Rage*, and studies in Irish literature. Roy Foster, for example, makes reference to Jack's accomplishments as a painter, rather than as a writer. See R.F. Foster, *W.B. Yeats: A Life, Vol. II: The Arch-Poet, 1915–1939* (Oxford and New York, 2003), p. 2.

26. Marilyn Gaddis Rose, 'Mixed Metaphors: Jack B. Yeats's Writings', in Roger McHugh (ed.), *Jack B. Yeats: A Centenary Gathering*. (Dublin, 1971), p. 105.

27. McGuinness, *The Literary Universe of Jack B. Yeats*; Purser, *The Literary Works of Jack B. Yeats*. See, in particular, Pyle, *Jack B. Yeats: A Biography*. Marilyn Gaddis Rose and Gordon Armstrong have also drawn comparisons between Jack Yeats's writings and paintings, and between his paintings and the writings of WBY. See Gaddis Rose, 'Mixed Metaphors' and 'The Kindred Vista of W.B. and Jack B. Yeats', *Éire-Ireland* (March 1970): 67–79; Gordon S. Armstrong, *Samuel Beckett, W.B. Yeats, and Jack Yeats: Images and Words* (Lewisburg and London, 1990).

28. Robin Skelton (ed.), *The Collected Plays of Jack B. Yeats* (London, 1971); and *The Selected Writings of Jack B. Yeats* (London, 1991). Skelton (ed.), *Selected Writings*, pp. 34–5.

29. Anne Yeats donated the 'Yeats Archive' to the National Gallery of Ireland in 1998. It is a delightful, thorough and well-preserved collection of books, sketchbooks, records, letters and other memorabilia. See Hilary Pyle, 'To Be Loved as a Cupboard: The Yeats Archive in the National Gallery of Ireland', *Éire-Ireland* (Fall/Winter 2001): 212–25.

30. Jack Yeats to Quinn, 29 June 1920 (NYPL, Quinn Coll.). See also Jack Yeats to MacGreevy, 29 November 1930, in which he mentions the book from Quinn (TCD, MS 10381/112).

31. Arnold, *Jack Yeats*, p. 245.

32. Jack Yeats to MacGreevy, 3 April 1930 (TCD, MS 10381/104).

33. See the letters of Jack Yeats to MacGreevy (TCD, MS 8105 and MS 10381/81–182). At times it is unclear which article or poem the artist has read by MacGreevy, but it is clear that MacGreevy consistently sent him his writings to read and at times comment on. See in particular Jack Yeats to MacGreevy, 3 April 1929 (TCD, MS 10381/104), and 4 April 1929 (TCD, MS 10381/105).

34. Jack Yeats to MacGreevy, 22 March 1929 (TCD, MS 10381/103).

35. Jack Yeats to MacGreevy, 13 March 1930 (TCD, MS 10381/108).

36. Jack Yeats's library, held in the NGI, Yeats Archive, contains approximately 400 books.

37. For details of Jack Yeats's library, see the Bibliography.

38. 'Whistler's Oils watercolours, pastels & drawings' at M. Knoedler & Co., New York from 1914. Inscribed 'Jack B. Yeats from his father John B. Yeats'; 'The Works of James Ensor', an exhibition organized by the Arts Council of Great Britain and held under the auspices of the Tate Gallery at the National Gallery London, 1946, signed and inscribed to Jack B. Yeats from R.I. Herbert Bell; 'Catalogue of the Paul Cézanne (1839–1906) Exhibition, The Leister Galleries, London, 1925'; 'Younger European Painters', The Solomon R. Guggenheim Museum, New York. 1954. Including a business card from 'James Johnston Sweeny, Director'.

39. For example, G.C.V. Holmes, *Ancient and Modern Ships. Parts I* (London, 1900) and *II* (London, 1906); B.W. Hawkins, *The Artistic Anatomy of the Horse* (London, 1888); Theophrastus, *The Characters of Theophrastus: Illustrated by Physiognomical Sketches* (London, 1831); *Fun: The Extract of Fun: A Cordial for Young and Old* (London, n.d.); *Hood's Own Laughter from Year to Year* (London, n.d.).

40. William Paley D.D., *The Principles of Moral and Political Philosophy* (London, 1881). Other examples are illustrated in Hilary Pyle and Zoë Reid, 'From the Archive at the Yeats Museum', *Millennium Mini Exhibition Two* (Dublin, 14 September–9 November 2000).

41. For more illustrations, see Hilary Pyle, *The Different Worlds of Jack B. Yeats: His Cartoons and Illustrations* (Dublin, 1994); Arnold, *Jack Yeats*, pp. 38–9.

42. Jack B. Yeats, *Sligo* (London, 1930), p. 7.

43. Arnold, *Jack Yeats*, p. 243. In a letter to MacGreevy, 24 January 1932, Jack Yeats writes: 'I am sure your novel will come on well. The novel should be everyone's genre if we only had the knack of it. Or perhaps … we should be knackfree, and then we could do anything we had a mind for. I have discovered the whole trouble of the human race comes from the sheets of fussing in which they wind themselves' (TCD, MS 8105/19).

44. *The Standard*, n.d., c. 1930 (NGI, Yeats Archive, Press Cuttings 1925–33, Parcel 25B).

45. 'From Palette to Pen: Mr Jack B. Yeats's Literary Stampede', *Sligo Irish News*, 7 June 1930 (NGI, Yeats Archive, Press Cuttings 1925–33, Parcel 25B).

46. Jack Yeats to MacGreevy, 18 June 1930 (TCD, MS 1381/110).

47. WBY to Jack Yeats, 15 July 1930, in Arnold, *Jack Yeats*, p. 243.

48. Pyle, *Jack B. Yeats: A Biography*, p. 142. Pyle has agreed that *Sligo* is set in Sligo (although this is never stated), and that Jack Yeats gives the impression that he was 'setting out, in so far as he wished', to write an autobiography (p. 138).

49. *Au*, p. 5.

50. Jack B. Yeats, *Modern Aspects*, pp. 1–2.

51. Jack B. Yeats, *Sligo*, p. 28.

52. Jack B. Yeats, *And To You Also* (London, [1944] 1974), p. 5; Jack B. Yeats, 'Irish Authors: 36', *Eason's Bulletin*, 5 October 1948, p. 3. He continues: 'I must say that in every book there is somewhere in it a memory of Sligo, where I was brought up …' (p. 3).

53. Jack B. Yeats, *Sligo*, pp. 39–40.

54. Jack B. Yeats, *Sligo*, p. 127.
55. Purser contends that critics were perhaps too quick to link his works to Joyce (*The Literary Works of Jack B. Yeats*, pp. 127–36).
56. Victor B. Neuberg, 'Conversation with Jack Yeats', in *Gregory Journal*, 2 (14 July 1930): 539. Also quoted in Arnold, *Jack Yeats*, p. 241.
57. Victor B. Neuberg, untitled article, *Saturday Referee*, 6 July 1930 (Clipping, NGI, Yeats Archive, Press Cuttings 1933–40, Parcel 25C).
58. Jack Yeats to MacGreevy, 11 May 1929 (TCD, MS 10381/107); MacGreevy to Jack Yeats, November 1929 (NGI, Yeats Archive).
59. *The Letters of W.B. Yeats*, ed. Allan Wade (London, 1954), p. 764.
60. Jack B. Yeats, *Sligo*, p. 28.
61. Jack B. Yeats, *Sligo*, p. 89.
62. Jack B. Yeats, *Sligo*, pp. 42–3.
63. See Gaddis Rose, 'Mixed Metaphors'.
64. For example, Nathalie Sarraute's *Tropismes* (Paris, 1939). Sarraute creates unity in her novels through 'tropisms', movements crossing one's consciousness quickly as sensations rather than interior monologue.
65. Joyce asked MacGreevy: 'Where did you pick up that way you have of talking about painting? ... Yeats has it. Pound has it. I never had it' (Hugh J. Dawson, 'Thomas MacGreevy and Joyce', *James Joyce Quarterly*, 25/3 [Spring 1988]: 313).
66. See Roland Barthes, *Le Plaisir du Texte* (Paris, 1973).
67. Jack B. Yeats, *Sligo*, p. 18.
68. Samuel Beckett, 'Dante ... Bruno . Vico .. Joyce', in James Joyce, *Our Exagmination Round His Factification for Incamination of Work in Progress* (Paris, 1929). Reprinted in Samuel Beckett, *Disjecta: Miscellaneous Writings and a Dramatic Fragment* (London, [1983] 2001), p. 25.
69. Jack B. Yeats, *Sligo*, p. 120; pp. 121–2.
70. W.B. Yeats, *On The Boiler* (Dublin, 1938), p. 36.
71. See Jack B. Yeats, *The Careless Flower* (London, 1947), p. 48. Purser records that *The Careless Flower* was written in 1933 (*The Literary Works of Jack B. Yeats*, p. 24).
72. The ability of smell to trigger memory is of course developed in Marcel Proust's famous *madeleine* scene in his *Remembrance of Things Past*, and it is interesting to note that Jack Yeats owned a copy of Beckett's *Proust*. But this was not published until 1931, a year after Jack Yeats's *Sligo* was published.
73. JBY, *Christian Science Monitor*, 2 November 1920, in Pyle, *Jack B. Yeats: A Biography*, p. 19.
74. Jack B. Yeats, *The Aramanthers* (London and Toronto, 1936). Pyle separates Jack Yeats's novels into two main types, 'reminiscences of a scattered nature' (*Sligo*, *Ah Well* [1942] and *And To You Also* [1944]), and 'Victorian tales ... related by a twentieth-century writer' (*Sailing, Sailing Swiftly* [1933] and *The Aramanthers*) (*Jack B. Yeats: A Biography*, p. 138).
75. Arnold has suggested that the club is based on the Dublin Arts Club, while Purser has linked it to the Freemasons, of which Jack Yeats may have been a member (*The Literary Works of Jack B. Yeats*, p. 156). There is a Freemason's Handbook in Jack Yeats's library.
76. Review of Jack B. Yeats's *The Aramanthers* (1936), *The Sunday Times*, c. 14 April 1936 (NGI, Yeats Archive).
77. For a recent critique of *The Aramanthers* emphasizing this point, see Peter Miles, 'Vision and Narrative in Jack Yeats's *The Aramanthers*', in Janis Londraville (ed.), *Prodigal Father Revisited* (Cornwall, 2003), pp. 149–69. Jack B. Yeats, *The Aramanthers*, p. 68.
78. Jack B. Yeats, *Grief* (1951), Collection: National Gallery of Ireland, Dublin. Yeats, *The Aramanthers*, p. 202.
79. Jack B. Yeats, *The Aramanthers*, pp. 165–9.

80. Jack B. Yeats, *The Aramanthers*, p. 168.

81. The allusion to the cinema (a helpful comparison in terms of narrative construction) occurs at several points along the story.

82. Jack B. Yeats, *The Aramanthers*, p. 169.

83. Jack B. Yeats, *The Aramanthers*, p. 177.

84. Jack Yeats to MacGreevy, 29 April 1936 (TCD, MS 10381/133).

85. Beckett, 'An Imaginative Work! *The Aramanthers*. By Jack B. Yeats', *Dublin Magazine*, 11/3 July–September 1936, p. 81. Reprinted in Beckett, *Disjecta*, p. 90.

86. He wrote to T.M. Ragg that he had not yet read Beckett's manuscript, but that he had read *More Pricks Than Kicks* and had 'thought it the real thing' (Jack Yeats to T.M. Ragg of Routledge, 22 November 1937, in James Knowlson, *Damned to Fame: The Life of Samuel Beckett* [London, 1996], p. 292). Ackerley and Gontarski also record that Jack Yeats acted as a referee for Beckett's application for a job in the National Gallery London, and an academic appointment in Cape Town, but that nothing came of either. See C.J. Ackerley and S.E. Gontarski (eds), *The Grove Companion to Samuel Beckett: A Reader's Guide to His Works, Life, and Thought* (New York, 2004), p. 656.

87. Purser, *The Literary Works of Jack B. Yeats*, p. 138.

88. When the Yeats children were living at 8 Woodstock Road, Bedford Park, they planted flower gardens. WBY planted the flower 'love-lies-bleeding' (William M. Murphy, *Prodigal Father: The Life of John Butler Yeats (1839–1922)* [Ithaca and London, 1978], p. 118).

89. Purser maintains that Jack Yeats drew the word from his book *The Language of Flowers* by E.P. Dutton and reads the flower as a symbol of immortality and unfading love (*The Literary Works of Jack B. Yeats*, pp. 137–9). A potential correlation reinforcing this Christian symbolism is the fact that the Irish poet Brian Coffey wrote a poem entitled 'Aramanth' in 1933 in Paris. Alan Gillis demonstrates that poetic tensions between the 'blankness' of the poem and the red-purple colour of the aramanth signify the body and blood of Christ crucified (*Irish Poetry of the 1930s* [Oxford, 2005], pp. 109–19). This point is further substantiated when we consider the role of the flower in the novel *The Careless Flower*, where the 'careless flower', living by a natural spring, has special life-giving, almost spiritual properties: 'The flower was as big as an old five-shilling piece, and was always looking up carelessly into the falling haze of water which caught some distant light of the sky, or embodied some light within itself, for no actual sunbeam fell along that fall of water.' (Jack B. Yeats, *The Careless Flower*, p. 110).

90. Jack B. Yeats, *The Aramanthers*, pp. 115–16.

91. Jack B. Yeats, *The Aramanthers*, p. 130.

92. The last verse of the ballad reads:
I'd like to see old Erin's sons united heart and hand,
To eradicate the prejudice that spoils our dear old land,
Let's smother party feeling, and let the whole world see
We love our native emblems, and we live in unity.
(Purser, *The Literary Works of Jack B. Yeats*, p. 154).

93. Beckett, 'An Imaginative Work!', in Beckett, *Disjecta*, p. 90.

94. Beckett, 'An Imaginative Work!', in Beckett, *Disjecta*, pp. 89–90.

95. Quoted from Knowlson and Knowlson (eds), *Beckett Remembering Beckett*, p. 58.

96. For letters from Beckett to MacGreevy in which he mentions Jack Yeats in the mid-1930s, see TCD, MS 10402. Beckett evidently has respect for the artist and his work, and prizes their time alone together.

97. Beckett to MacGreevy, 5 May 1935 (TCD, MS 10402/75). See also Knowlson, *Damned to Fame*, p. 201; p. 754. MacGreevy records that this work was painted in 1936 and that it was a study of the Lee at Cork. He remarks: 'surely, had he [Hugh Lane] lived he would have rejoiced to see his dream coming true in Jack Yeats's great picture of Cork' ('The Dublin Municipal Gallery', *Father Mathew Record* [January 1946]: 4). Hilary Pyle notes that Jack Yeats must have passed through Cork on his way to Bantry in October 1933. See Pyle, *A Catalogue Raisonné of the Oil Paintings* (London, 1992), vol. 1, p. 412.

98. *Storm/Gaillshion* (1936), Collection: Victor Waddington, London is discussed in a letter from Beckett to MacGreevy, 14 August 1937, in Knowlson, *Damned to Fame*, p. 268. Jack Yeats, *A Morning* (1936), Collection: National Gallery of Ireland, Dublin.

99. Yvonne Scott has described 'Expressionism' in relation to Jack Yeats's paintings in terms of a 'gestural handling of materials, and departure from naturalistic and harmonious use of colour, as a means of articulating an emotional condition rather than a description of outward appearance', and her description fits *Low Tide* very well ('Jack B. Yeats in Context', in *Jack B. Yeats Amongst Friends: Catalogue for an Exhibition Held in Trinity College, Dublin* [9 September–14 October 2004], p. 22).

100. Jack B. Yeats, 'Indigo Height', *New Statesman and Nation*, 5 December 1936, p. 899. The scene is very similar to Jack Yeats's later work *Where Fresh Water Meets Salt Water* (1947), Collection: Waddington Galleries, London. Hilary Pyle has noted the similarity between Jack and WBY in their admiration for deep blue in her article '"Men of Destiny" – Jack B. Yeats and W.B. Yeats', *Studies* (Summer/Autumn 1977), pp. 188–213.

101. *Above the Fair* (1946). Collection: National Gallery of Ireland, Dublin. Beckett wrote to MacGreevy: 'And perhaps that is the final quale of Jack Yeats's painting, a sense of the ultimate *inorganism* of everything. Watteau stressed it with busts and urns, his people are *mineral* in the end. A painting of pure inorganic juxtapositions, where nothing can be taken or given and there is no possibility of change or exchange' (Beckett to MacGreevy, 14 August 1937, in Knowlson, *Damned to Fame*, p. 755). O'Doherty makes reference to the 'stage-set aspect of his painting, which continued to the end. His paintings use all the devices of the proscenium stage' (Brian O'Doherty, 'Jack B. Yeats: Promise and Regret', in Roger McHugh [ed.], *Jack B. Yeats: A Centenary Gathering* [Dublin, 1971], p. 88). See also Pyle, 'To be Loved as a Cupboard'.

102. Jack B. Yeats, *The Aramanthers*, pp. 74–111.

103. Jack Yeats writes:
 The effect of the stage so high above the audience gave a steadiness and a dignity to a play that some of the audience might have thought a bit flippity-jiggity. It sat on the eye level, or very little above it, and if the audience and the actors had changed places the whole fabric of the play would have been lost among the shoulders of the performers. The peg-top effect of the viewing from above would have killed all movement in the play (*The Aramanthers*, p. 76).

104. In 'My Miniature Theatre', quoted in Robin Skelton (ed.), *The Collected Plays of Jack B. Yeats* (London, 1971), p. 19, Jack Yeats states the exact dimensions of his proscenium stage (three foot nine inches wide and one foot nine inches high):
 This shape lending itself better to my mind to the artistic and realistic compositions of the scenes, than the lofty style of the real prosceniums which is responsible for the incongruity, which we sometimes see, of the heroine and her little boy, starving in the garret, with so much top room that they could have floors put in and let the place out in flats.

105. Beckett, 'MacGreevy on Yeats', in Beckett, *Disjecta*, p. 97.

106. Jack Yeats, *The Aramanthers*, p. 272.

107. Beckett to MacGreevy, 29 January 1936 (TCD, MS 10402/87).

108. Beckett to MacGreevy, 7 May 1936 (TCD, MS 10402/95).

109. Concerning *Storm/Gaillshion* (Plate 3), Beckett wrote to MacGreevy:
 And do you remember the picture of a man sitting under a fuchsia hedge, reading, with his back turned to the sea and the thunder clouds? One does not realise how still his pictures are till one looks at others, almost petrified, a sudden suspension of performance, of the convention of sympathy and antipathy, meeting and parting, joy and sorrow ... the landscape shelters or threatens or serves or destroys, his nature is really infected with 'spirit' ... God knows it doesn't take much sensitiveness to feel that in Ireland[,] a nature almost as inhumanly inorganic as a stage set.
 Beckett to MacGreevy, 14 August 1937, in Knowlson, *Damned to Fame*, p. 268; p. 755.

110. O'Doherty, 'Jack B. Yeats: Promise and Regret', p. 78.

111. There are 250 of Jack Yeats's sketchbooks preserved in the Yeats Archive. The NGI is currently digitizing these for public access.

112. Jack Yeats, 'My Miniature Theatre', p. 19.

113. Arthur Symons, article in *Outlook* (1908) (Jack Yeats Scrapbooks 1894–1925 [NGI, YMUS]).

114. In her outstanding scholarship, Hilary Pyle has drawn comparisons between the Yeats brothers since the 1970s. See in particular Pyle, '"Men of Destiny" – Jack B. Yeats and W.B. Yeats'. Calvin Bedient's *The Yeats Brothers and Modernism's Love of Motion* presents a more theoretical approach to their engagement with Modernism.

115. See Hilary Pyle, *Jack B. Yeats and His Family*, An Exhibition of the Works of Jack B. Yeats and his Family at the Sligo County Library and Museum, Sligo (29 October–29 December 1971), p. 9.

116. 'The Municipal Gallery Revisited', *VP*, p. 603, lines 40–47.

117. *Punch*, 8 September 1926.

118. J.M. Synge, *In Wicklow, West Kerry and Connemara by J.M. Synge*, With Essays by George Gmelch and Ann Saddlemyer (Dublin, 1980), pp. 39–40.

119. For a discussion of W.B. Yeats's 'The Fisherman', see Foster, *Yeats, Vol. II*, pp. 11–13. W.B. Yeats claimed that 'The Meditation of the Old Fisherman' (first published in *The Irish Monthly*, October 1886) sprang from a conversation with a Sligo fisherman.

120. J.M. Synge, *The Aran Islands*, With Drawings by Jack B. Yeats (Dublin, 1906).

121. Synge, *The Aran Islands*, pp. 25–6. Jack Yeats's well-known frontispiece to Synge's book, entitled *An Island Man*, is a classic example of the complicity between the visions of Ireland held by the two friends, and their faithful recording of the way of life on Aran.

122. George Russell, 'An Artist of Gaelic Ireland' (1902), in George Russell, *Imaginations and Reveries* (London, 1921), p. 81.

123. WBY's fisherman has been interpreted as an image of an ideal or imagined peasant. For a critique of Yeats and Synge as 'post-colonial' writers of the Irish peasantry, see Deborah Fleming, *'A man who does not exist': The Irish Peasant in the Work of W.B. Yeats and J.M. Synge* (Ann Arbor, 1995). Sinéad Garrigan Mattar discusses the term 'primitivism' in relation to the work of WBY, Lady Gregory and Synge, emphasizing that the subject is 'always more reflective of the person or society doing the idealizing than it is of the people or culture being idealized' (Garrigan Mattar, *Primitivism, Science and the Irish Revival* [Oxford, 2004], p. 3).

124. Jack B. Yeats, *The Charmed Life* (London, [1938] 1974), p. 2; pp. 22–3.

125. Jack B. Yeats, *The Charmed Life*, pp. 35–45.

126. Jack B. Yeats, *The Charmed Life*, p. 120.

127. Jack B. Yeats, *The Charmed Life*, pp. 74–5.

128. At this point Mr No Matter calls himself Hector or Alexander.

129. Jack B. Yeats, *The Charmed Life*, p. 232.

130. For example, in *The Guardian* (n.d.), [c. 1938]: 'The book is not intended to be realistic, but is kept on a plane between realism and fantasy' (NGI, Yeats Archive, Press Cuttings Book 1933–40, Parcel 25C). Also a reviewer in *Time and Tide*, 31 December 1938, wrote: 'This is an indescribable novel, but I think the reason it shines for me among novels of 1938 … is that it is a joyful celebration of humanity' (NGI, Yeats Archive, Press Cuttings Book 1933–40, Parcel 25C).

131. W.B. Yeats, *On the Boiler*, p. 36. Purser has understood WBY's allusion to 'Faust' as having 'an immediate and obvious relevance for a novel with such a title' and contends that Bowsie and No Matter embody the combat between flesh and spirit which are, in the end, separable (*The Literary Works of Jack B. Yeats*, p. 164).

132. *John O'London's Weekly*, 4 February 1938 (NGI, Yeats Archive, Press Cuttings Book 1933–40, Parcel 25C).

133. Walter Sickert, lecture to the Royal Institute, 1922, in *The Listener*, 8 January 1942 (Cutting, NGI, Yeats Archive, Press Cuttings Book 1933–40, Parcel 25C).

134. *In Wicklow, West Kerry and Connemara by J.M. Synge*, pp. 39–40.

135. Jack B. Yeats, *The Charmed Life*, pp. 137–44.

136. Jack B. Yeats, 'A Painter's Life', in 'The Artist Speaks', *The Listener*, 1 September 1937 (Clipping, NGI, Yeats Archive).

137. *Au*, p. 82.

138. 'Painter Triumphant 1943–45' is the title of Chapter 20 in Arnold's *Jack Yeats*.

139. Jack B. Yeats, *The Charmed Life*, p. 2; p. 230.

140. Jack B. Yeats, *The Charmed Life*, p. 230. No Matter tells us about a young man: 'he will have been within the part I had cast him for' (p. 167).

141. Jack B. Yeats and Thomas MacGreevy, BBC interview. Recorded 6 November 1947, broadcast 17 May 1948 (NGI, YDisc).

142. Armstrong states that Jack Yeats's *The Charmed Life* represents his 'prodigious effort to come to terms with his sixty years as an artist' and that the writer 'personifies the old memories he jettisons' (Armstrong, *Samuel Beckett, W.B. Yeats, and Jack Yeats*, p. 205; p. 208).

143. Pyle has read the two main characters as representing the opposite sides of Jack Yeats's personality: 'Mr No Matter is a philosopher and introvert, and a man of deep emotion; while Bowsie lives his creativity with hidden intuition: extrovert, clown, rogue, hero he is Don Quixote and Sancho Panza rolled into one' (*Jack B. Yeats: A Biography*, p. 153). This is a conclusion that McGuinness shares (*The Literary Universe of Jack B. Yeats*, p. 253). See also Purser, *The Literary Works of Jack B. Yeats*, pp. 169–70.

144. Jack B. Yeats, *The Charmed Life*, pp. 1–2.

145. Jack B. Yeats, *The Charmed Life*, pp. 101–2.

146. Jack B. Yeats, *The Charmed Life*, p. 75.

147. See James Knowlson, *Light and Darkness in the Theatre of Samuel Beckett* (London, 1972); quotation from Beckett to MacGreevy, 14 August 1937, in Knowlson, *Damned to Fame*, pp. 267–8.

148. *Death for Only One* (1939), Collection: National Gallery of Ireland, Dublin; *Two Men Walking* (1946), Private Collection, Dublin; *Harvest Moon* (1946), Collection: Dr Michael Smurfit, Dublin; *Halt* (1951), Private Collection. Jack Yeats describes his painting *Death for Only One* in a letter to MacGreevy as: '[a]n important picture of mine ... a dead tramp lying on a headland with another tramp standing by – and a dark sea and dark sky' (Jack Yeats to MacGreevy, 12 April 1939 [TCD, MS 8105/31]).

149. Oskar Kokoschka, II. XI. 56 rue Villeneuve, Vaud Switzerland, to Jack Yeats, c/o Victor Waddington Galleries, 8 South Anne Street, DUBLIN (EIRE), 11 November 1956. The envelope is addressed to 'Jack B. Yeats, the greatest painter (maybe the last!)' (NGI, Yeats Archive, YMUS Letters).

150. Beckett [Belis], 'Recent Irish Poetry', in Beckett, *Disjecta*, p. 70; Beckett, 'MacGreevy on Yeats', in Beckett, *Disjecta*, p. 97. Oskar Kokoschka to Jack Yeats, 11 November 1956 (NGI, Yeats Archive, YMUS Letters).

151. Knowlson, *Damned to Fame*, p. 268. Another example of potential influence of Jack Yeats's paintings on Beckett is his picture *Old Walls* (1945; Collection: National Gallery of Ireland, Dublin), which depicts a lone man in a room with three grey walls and a door. In Beckett's *Endgame*, Hamm and Clov converse inside a bunker-type stage. At one point Hamm lays his hand on the wall and says 'Old Wall! [Pause] Beyond is the ... other hell'. The stage set is painted grey, with two curtained windows up above and a door through which Clov enters and exits.

152. Purser speculates that *The Green Wave* was written around 1943 (*The Literary Works of Jack B. Yeats*, p. 24).

153. Jack B. Yeats, 'A Painter's Life'.

154. F.W. Reid, 630 Mansion Street, San Francisco 2, California, to Jack Yeats, n.d. (NGI, Yeats Archive, Box 20).

155. BBC Interview, MacGreevy and Jack Yeats.

156. In June 1942, a reviewer at *The Irish Tatler* wrote:

> In 'La La Noo' at the Abbey, Mr Jack B. Yeats gave Ireland its first surrealist play. The surrealism of Mr Yeats opened up a very wide and intensely interesting field. In the form we [sic] chose there was literally no subject he could touch on in the course of a single evening. His plot was negligible. His characters just talked casually, a word suggested a train of thought which was followed until another word suggested something quite different, then that particular hare was coursed until some more attractive prey presented itself. Of course, there was a subtle pattern in all this seeming artlessness. A nice balancing of grave and gay, thought and speech, but the general result was to give the author an immense freedom of range. We hope Mr Yeats will develop this medium of expression and we would welcome other venturers into the field.
>
> (NGI, Yeats Archive, Press Cuttings Book 1933–40, Parcel 25C).

157. Lennox Robinson, Review of *La La Noo* (1943), *The Bell*, July 1943 (NGI, Yeats Archive, Press Cuttings Book 1933–40, Parcel 25C).

158. Jack B. Yeats, *In Sand* (Dublin, [1943] 1964), p. 10.

159. *A Broadside (New Series)*, eds Dorothy Wellesley and W.B. Yeats, No. 4. (April 1937), fol. 1 [verso].

160. The image of the tide washing imprints away from the sand is no doubt based on Jack Yeats's memory of horse races on the 'long, deep stretch of sand' during spring tides at Drumcliffe Strand, which he recalled with affection during his BBC interview with MacGreevy.

161. Jack B. Yeats, 'A Painter's Life'.

162. Albert Gleizes, 'Hommage à Mainie Jellett', in Eileen MacCarvill (ed.), *Mainie Jellett, the Artist's Vision: Lectures and Essays on Art* (Dundalk, 1958), pp. 25–34.

163. See Arnold, *Jack Yeats*, p. 269; Brian Kennedy, *Irish Art and Modernism 1880–1950* (Belfast, 1991), pp. 27–8.

164. See W.J.T. Mitchell, 'Image and Word' and 'Mute Poesy and Blind Painting', in Charles Harrison and Paul Wood (eds), *Art in Theory 1900–1990: An Anthology of Changing Ideas* (Oxford, 1992), pp. 1107–11.

165. See Ernst Gombrich, *Art and Illusion* (Princeton, 1956); Nelson Goodman, *Languages of Art* (Indianapolis, 1976).

166. Sir Kenneth Clark, Introduction to the catalogue of a joint exhibition organized by Clark at the National Gallery of London in 1942, in Arnold, *Jack Yeats*, p. 301.

167. See Arnold, *Jack Yeats*, p. 307; Pyle, *Jack B. Yeats: A Biography*, pp. 162–4. Between 1938 and 1941, Jack Yeats produced only three to five canvases per year. However, in 1942 his output jumped to 20. See Arnold, *Jack Yeats*, pp. 311–13.

168. See Bruce Arnold, 'Jack Yeats and the Making of Irish Art in the Twentieth Century', in James Christian Steward (ed.), *When Time Began to Rant and Rage: Figurative Painting from Twentieth-Century Ireland* (London, 1999), p. 58.

169. Jack Yeats, *Modern Aspects of Irish Art* (Dublin, 1922) Series F. 8, pp. 3–4.

170. BBC Interview, Jack Yeats and MacGreevy.

171. Beckett, 'MacGreevy on Yeats', in *Disjecta*, p. 97.

172. MacGreevy compares Jack Yeats's *Tinker's Encampment: The Blood of Abel* to the spirit of Ireland's 26 counties being anti-blood-shed concerning partition in Ireland ('How Does She Stand?', *Father Mathew Record* [September 1949], p. 3). Jack Yeats, *A Race in Hy Brasil*, Collection: Allied Irish Banks (reproduced in Kennedy, *Irish Art and Modernism*, p. 301), in which the author comments that the setting is Tir na n'Og, the 'Land of Youth', and that the composition is 'the symbolic setting for the strand races he knew as a boy' (Kennedy, *Irish Art and Modernism*, p. 301).

173. It translates as 'Strangeness so entire as even to withstand the stock assimilations to holy patrimony, national and other./ ... The artist who stakes his being is from nowhere, and has no kith' (Beckett, 'Hommage à Jack B. Yeats' [Homage to Jack B. Yeats], in *Disjecta*, pp. 148–9).

174. W.J.T. Mitchell, 'Word and Image', in Robert S. Nelson and Richard Shiff (eds), *Critical Terms for Art History* (Chicago and London, 1996), p. 53.

175. Kennedy, *Irish Art and Modernism*, p. 28.

176. Beckett, 'An Imaginative Work! *The Aramanthers*. By Jack B. Yeats', *Dublin Magazine*, 11/3 (July–September 1936): 81, reprinted in Beckett, *Disjecta*, p. 90; Jack Yeats, 61 Marlborough Road, Donnybrook, Dublin, Ireland, to John Quinn Esq., 31 Nassau Street, New York City, USA, 17 November 1920 (NYPL, Quinn Coll.).

177. Brian O'Doherty, 'The Literary Tradition and the Visual Response', in *The Irish Imagination 1959–1971* (Dublin, 1971), p. 24.

178. Edna Longley, *The Living Stream: Literature and Revisionism in Ireland* (Newcastle Upon Tyne, 1994), p. 229.

179. W.B. Yeats, 'Art and Ideas' (1913), in *E&I*, pp. 346–55.

Bibliography

Manuscript Sources

National Gallery of Ireland:
 Jack B. Yeats Archive, Yeats Archive (YMUS)

National Library of Ireland:
 Norah Allison McGuinness Collection

New York Public Library:
 John Quinn Memorial Papers, 1900–24

Trinity College Dublin:
 Cuala Press Archive, PRESS A CUALA ARCH
 Evelyn Gleeson Papers, TCD, MS 10676
 Thomas MacGreevy Archive, TCD, MSS 7985–8190

Online Sources

Thomas MacGreevy archive <www.macgreevy.org>

Books Listed from Jack Yeats's Library, YMUS, National Gallery of Ireland

André, Albert. *Renoir* (Paris: G. Besson, n.d.).
Balzac, Honoré de. *Père Goriot* (London: H. Virtue & Company, 1902).
Barton, J.E. *The Changing World. 6. Modern Art* (London: BBC, 1932).
Baudelaire, Charles. *Oeuvres Complètes: Les Fleurs du Mal* (Paris: Librairie Alphonse Lemere, 1917).
Beckett, Samuel. *Proust* (London: Chatto & Windus, 1931).
____ . *More Pricks Than Kicks*. Inscribed 'For Jack Yeats from Sam Beckett. May 1934' (London: Chatto & Windus, 1934).
____ . *Echo's Bones and Other Precipitates* (Paris: Europa Press, 1935).

_____. *Murphy* (London: Routledge, 1938).
Fierans, P. *James Ensor* (Paris: G. Crès, 1929).
Fun: The Extract of Fun: A Cordial for Young and Old (London: 'Fun' Office, n.d.).
Hawkins, B.W. *The Artistic Anatomy of the Horse*. 10th edn (London: Windsor and Newton, 1888).
Hokusai. *Hokusai: His Cartoons: Vol. II Complete* (Tōshirō Chrōno, c. 1879).
_____. *An Album of True Paintings Copied from Hokusai* (Tokyo: Isaburō Meguro, 1892).
Holme, C. (ed.). *Daumier and Gavarni*, with critical and biographical notes by H. Frantz and O. Uzanne (London: Studio, 1904).
Holmes, G.C.V. *Ancient and Modern Ships. Part I. Wooden Sailing Ships* (London: Victoria & Albert Museum Handbooks, 1900).
_____. *Ancient and Modern Ships. Part II. The Era of Steam, Iron and Steel* (London: Victoria & Albert Museum Handbooks, 1906).
Hood's Own Laughter from Year to Year (London: Unwin, Gresham Press, n.d.).
MacGreevy, Thomas. *Thomas Stearns Eliot: A Study* (London: Chatto & Windus, 1931).
Paley, William, D.D. *The Principles of Moral and Political Philosophy* (London: Faulder, 1881).
Pound, Ezra. *Cathay: Translations* (London: Elkin Mathews, 1915).
_____. *Lustra of Ezra Pound with Earlier Poems* (New York: Knopf, 1917).
_____. *Pavannes and Divisions* (New York: Knopf, 1918).
Proust, Marcel. *Remembrance of Things Past: Cities of the Plain* (1 and 2) (Vols 7 and 8); *The Captive* (1 and 2) (Vols 9 and 10) (London: Chatto & Windus, 1941).
Rothenstein, W. *Goya*. The Artist's Library No. 4 (London: Unicorn Press, 1900).
Strange, E.F. *The Colour Prints of Japan* (London: Siagle, 1904).
Symonds, J.A. *The Life of Michelangelo Buonarroti*. 3rd edn. Vol. 1. (London: Macmillan, 1901).
Theophrastus. *The Characters of Theophrastus: Illustrated by Physiognomical Sketches* (London: Valpy, 1831).

Works Cited

Ackerley, C.J. and S.E. Gontarski (eds). *The Grove Companion to Samuel Beckett: A Reader's Guide to His Works, Life, and Thought* (New York: Grove Press, 2004).
Armstrong, Gordon S. *Samuel Beckett, W.B. Yeats, and Jack Yeats: Images and Words* (Lewisburg: Bucknell University Press; London: Associated University Press, 1990).
Arnold, Bruce. *Mainie Jellett and the Modern Movement in Ireland* (New Haven and London: Yale University Press, 1991).
_____. *Jack Yeats* (New Haven and London: Yale University Press, 1998).
_____. 'Jack Yeats and the Making of Irish Art in the Twentieth Century', in James Christian Steward (ed.), *When Time Began to Rant and Rage* (London: Merrell Holberton, 1999), pp. 52–62.
_____. 'Jack Yeats: The Need for Reassessment', in Yvonne Scott (ed.), *Jack B. Yeats: Old and New Departures* (Dublin: Four Courts Press, 2008), pp. 47–56.
Bair, Deirdre. *Samuel Beckett* (London: Jonathan Cape, 1978).
Barthes, Roland. *Le Plaisir du Texte* (Paris: Éditions du Seuil, 1973).
Baudelaire, Charles. 'Salon de 1846', *Oeuvres Complètes ii* (Paris: Gallimard, 1976).
Beckett, Samuel. 'An Imaginative Work! *The Aramanthers*. By Jack B. Yeats', *Dublin Magazine*, 11/3 (July–September 1936): 80–81. Reprinted in Beckett, *Disjecta*, pp. 89–90.

———. *Disjecta: Miscellaneous Writings and a Dramatic Fragment* (London: John Calder, [1983] 2001).
———. 'Humanistic Quietism', *Dublin Magazine* (July–September 1934): 79–80. Reprinted in Beckett, *Disjecta*, pp. 68–9.
———. 'MacGreevy on Yeats', *The Irish Times*, 4 August 1945, p. 2. Reprinted in Beckett, *Disjecta*, pp. 95–7.
Bedient, Calvin. *The Yeats Brothers and Modernism's Love of Motion* (Notre Dame: University of Notre Dame Press, 2009).
Belis, Andrew [pseudonym of Samuel Beckett]. 'Recent Irish Poetry', *The Bookman* LXXXVI (August 1934): 235–36. Reprinted in Beckett, *Disjecta*, pp. 70–76.
Bhreathnach-Lynch, Síghle. 'Framing Ireland's History: Art, Politics and Representation 1914–1929', in James Christian Steward (ed.), *When Time Began to Rant and Rage* (London: Merrell Holberton, 1999), pp. 40–51.
Blaikie-Murdoch, William. 'The Cuala Press and its Bookplates', in *The Bookplate Booklet* (Third Series) 1/1 (Kansas City, 1919): 9–20.
Bodkin, Thomas. 'John Butler Yeats', in *The Dublin Magazine* (January 1924): 478–87.
Bowe, Nicola Gordon. *Harry Clarke: His Life and His Work* (Dublin: Irish Academic Press, 1989).
———. 'Two Early Twentieth-Century Irish Arts and Crafts Workshops in Context: An Túr Gloine and the Dun Emer Guild and Industries', *Journal of Design History*, 2/2–3 (1989): 193–206.
———. 'The Irish Arts and Crafts Movement, 1886–1925', *Irish Arts Review Yearbook* (1990–91): 172–85.
——— and Elizabeth Cumming. *The Arts and Crafts Movements in Dublin and Edinburgh 1885–1925* (Dublin: Irish Academic Press, 1998).
Brazeau, Peter. 'The Irish Connection: Wallace Stevens and Thomas McGreevy', *The Southern Review*, XVII (Summer 1981): 533–41.
Bridge, Ursula (ed.). *W.B. Yeats and T. Sturge Moore, Their Correspondence, 1901–1937* (London: Routledge & Kegan Paul, 1953).
Brink, C.O. *Horace on Poetry: The 'Ars Poetica'* (Cambridge: Cambridge University Press, 1971).
Brown, Karen E. (ed.). *Women's Contributions to Visual Culture, 1918–1939* (Aldershot: Ashgate Publishing, 2008).
Brown, Terence. 'Ireland, Modernism and the 1930s', in Patricia Coughlan and Alex Davis (eds), *Modernism and Ireland: The Poetry of the 1930s* (Cork: Cork University Press, 1995), pp. 24–42.
———. *Ireland: A Social and Cultural History 1922–2002* (London: Harper Perennial, 2004).
Browning, Robert. *Pippa Passes, King Victor and King Charles, The Return of the Druses, A Soul's Tragedy* (London: Smith, Elder, 1889).
Burke, Edmund. *A Philosophical Enquiry into the Origin of our Ideas of the Sublime and Beautiful*. Ed. James T. Boulton (Notre Dame: University of Notre Dame Press, 1958).
Callen, Anthea. *Angel in the Studio: Women in the Arts and Crafts Movement 1870–1914* (London: Astragal Books, 1979).
Campbell, Julian. *The Irish Impressionists: Irish Artists in France and Belgium, 1850–1914* (Dublin: National Gallery of Ireland; Belfast: The Ulster Museum, 1985).
Caraher, Brian. 'Introduction', in his *Intimate Conflict: Contradiction in Literary and Philosophical Discourse* (Albany, NY: State University of New York Press, 1992), pp. 1–33.

Cheasley Paterson, Elaine. 'Crafting a National Identity: The Dun Emer Guild, 1902–8', in Betsey Taylor FitzSimon and James H. Murphy (eds), *The Irish Revival Reappraised* (Dublin: Four Courts Press, 2004), pp. 106–18.

Claudel, Paul. *Cinq Grandes Odes: La Cantate à Trois Voix* (1913) (Paris: Editions Gallimard, 1966).

Coldwell, Joan. '"Images That Yet Fresh Images Beget": A Note on Book Covers', in Robin Skelton and Ann Saddlemyer (eds), *The World of W.B. Yeats: Essays in Perspective* (Dublin: Dolmen Press, 1965), pp. 152–7.

―――. '"The Art of Happy Desire": Yeats and the Little Magazine', in Robin Skelton and Ann Saddlemyer (eds), *The World of W.B. Yeats: Essays in Perspective* (Dublin: Dolmen Press, 1965), pp. 40–53.

Coughlan, Patricia and Alex Davis (eds). *Modernism and Ireland: The Poetry of the 1930s* (Cork: Cork University Press, 1995).

Cronin, Michael and Barbara O'Connor (eds). *Tourism in Ireland: A Critical Analysis* (Cork: Cork University Press, 1993).

Crookshank, Anne. *Norah McGuinness: Retrospective Exhibition* (Dublin: Trinity College Dublin, 1968).

―――. *Irish Art from 1600 to the Present Day* (Dublin: Department of Foreign Affairs, Ireland, 1979).

Cullen, Fintan. *Visual Politics: The Representation of Ireland, 1750–1930* (Cork: Cork University Press, 1997).

―――(ed.). *Sources in Irish Art: A Reader* (Cork: Cork University Press, 2000).

―――and R.F. Foster. *Conquering England: Ireland in Victorian England* (London: National Portrait Gallery, 2005).

―――and John Morrison (eds). *A Shared Legacy: Essays on Irish and Scottish Art and Visual Culture* (Aldershot: Ashgate Publishing, 2005).

―――and William M. Murphy. *The Drawings of John Butler Yeats (1839–1922)* (Albany, NY: Institute of History and Art, 1987).

Davis, Alex. 'Irish Poetic Modernisms: A Reappraisal', *Critical Survey*, 8/2 (1996): 186–97.

Dawson, Hugh J. 'Thomas MacGreevy and Joyce', *James Joyce Quarterly*, 25/3 (Spring 1988): 305–21.

Donlon, Pat. 'Drawing a Fine Line: Irish Women Artists as Illustrators', *Irish Arts Review Yearbook*, 18 (2002): 93–103.

Elliott, Bridget and Janice Helland (eds). *Women Artists and the Decorative Arts 1880–1935: The Gender of Ornament* (Aldershot: Ashgate Publishing, 2002).

Ellis, Edwin John and W.B. Yeats (eds). *The Works of William Blake, Poetic, Symbolic, and Critical* (London: B. Quaritch, 1893).

Ellmann, Richard. *The Identity of Yeats* (London: Faber and Faber, 1954).

[Field, Michael]. *Works and Days: From the Journal of Michael Field*. Eds T. and D.C. Sturge Moore (London: J. Murray, 1933).

FitzSimon, Betsey Taylor and James H. Murphy (eds). *The Irish Revival Reappraised*. (Dublin: Four Courts Press, 2004).

Fleming, Deborah. *'A man who does not exist': The Irish Peasant in the Work of W.B. Yeats and J.M. Synge* (Ann Arbor: The University of Michigan Press, 1995).

Fletcher, Ian and Donald James Gordon. 'Byzantium', in Donald James Gordon (ed.), *W.B. Yeats: Images of a Poet* (Westport, CT: Greenwood Press, [1961] 1979), pp. 81–90.

Foster, John Wilson. *Colonial Consequences: Essays in Irish Literature and Culture* (Dublin: The Lilliput Press, 1991).

Foster, R.F. *Modern Ireland 1600–1972* (London and New York: Penguin, 1988).

———. *W.B. Yeats: A Life, Vol. I: The Apprentice Mage, 1865–1914* (Oxford and New York: Oxford University Press, 1997).
———. *W.B. Yeats: A Life, Vol. II: The Arch-Poet, 1915–1939* (Oxford and New York: Oxford University Press, 2003).
Franscina, Francis and Charles Harrison (eds). *Modern Art and Modernism: A Critical Anthology* (New York: Harper & Row, [1983] 1984).
Gaddis Rose, Marilyn. 'The Kindred Vista of W.B. and Jack B. Yeats', *Éire-Ireland* (March 1970): 67–79.
———. 'Mixed Metaphors: Jack B. Yeats's Writings', in Roger McHugh (ed.), *Jack B. Yeats: A Centenary Gathering* (Dublin: Dolmen Press, 1971), pp. 92–106.
Garratt, Robert F. *Modern Irish Poetry: Tradition and Continuity from Yeats to Heaney* (Berkeley, Los Angeles and London: University of California Press, 1986).
Garrigan Mattar, Sinéad. *Primitivism, Science and the Irish Revival* (Oxford: Clarendon Press, 2004).
Gibbons, Luke. *Transformations in Irish Culture* (Cork: Cork University Press, 1996).
Gillis, Alan. *Irish Poetry of the 1930s* (Oxford: Oxford University Press, 2005).
Golden, Catherine J. (ed.). *Book Illustrated: Text, Image, and Culture 1770–1930* (Delaware: Oak Knoll Press, 2000).
Gombrich, Ernst H. *Art and Illusion* (Princeton: Princeton University Press, 1956).
———. 'Image and Word in Twentieth-Century Art', *Word & Image*, 1/3 (July–September 1985): 213–41.
Goodman, Nelson. *Languages of Art* (Indianapolis: Hackett, 1976).
Gordon, Donald James (ed.). *W.B. Yeats: Images of a Poet* (Westport, CT: Greenwood Press, [1961] 1979).
Greenberg, Clement. 'Modernist Painting', in Francis Franscina and Charles Harrison (eds), *Modern Art and Modernism* (New York: Harper & Row, [1983] 1984), pp. 5–10.
Hagstrum, Jean. *The Sister Arts: The Tradition of Literary Pictorialism and English Poetry from Dryden to Gray* (Chicago: Chicago University Press, 1958).
Hardwick, Joan. *The Yeats Sisters: A Biography of Susan and Elizabeth Yeats* (London: HarperCollins, 1996).
Harrison, Charles and Paul Wood (eds). *Art in Theory 1900–1990: An Anthology of Changing Ideas* (Oxford: Blackwell, 1992).
Hartigan, Marianne. 'Irish Women Painters and the Introduction of Modernism', in James Christian Steward (ed.), *When Time Began to Rant and Rage* (London: Merrell Holberton, 1999), pp. 63–77.
Helland, Janice. *The Studios of Frances and Margaret Macdonald* (Manchester: Manchester University Press, 1996).
———. 'Embroidered Spectacle: Celtic Revival as Aristocratic Display', in Betsey Taylor FitzSimon and James H. Murphy (eds), *The Irish Revival Reappraised* (Dublin: Four Courts Press, 2004), pp. 94–105.
———. 'Authenticity and Identity as Visual Display: Scottish and Irish Home Arts and Industries', in Fintan Cullen and John Morrison (eds), *A Shared Legacy: Essays on Irish and Scottish Art and Visual Culture* (Aldershot: Ashgate Publishing, 2005), pp. 157–72.
Helsinger, Elizabeth K. 'Rossetti and the Art of the Book', in Catherine J. Golden (ed.), *Book Illustrated: Text, Image, and Culture 1770–1930* (Delaware: Oak Knoll Press, 2000), pp. 147–93.
Henn, T.R. *The Lonely Tower: Studies in the Poetry of W.B. Yeats* (London: Methuen, [1950] 1965).
Henry, Françoise. *Art Irlandais* (Dublin: Imprimé pour le Comité des relations culturelles d'Irlande par Colm O Lochlainn, c. 1962).

Hill, Charles A. and Marguerite Helmers (eds). *Defining Visual Rhetorics* (Mahwah, NJ and London: Lawrence Erlbaum Associates, 2004).

Hodnett, Edward. 'The Kelmscott Burne-Jones', in *Image and Text: Studies in the Illustration of English Literature* (London: Scolar Press, 1982), pp. 197–218.

Hunt, John Dixon. *The Pre-Raphaelite Imagination, 1848–1900* (London: Routledge & Kegan Paul, 1968).

———. *Self-Portrait in a Convex Mirror on Poems on Paintings* (An inaugural lecture presented at the Tuke Hall of Bedford College, London, 29 April 1980).

Joyce, James. *Our Exagmination Round His Factification for Incamination of Work in Progress* (London: Faber & Faber, 1929).

Kennedy, Brian. *Irish Art and Modernism 1880–1950* (Belfast: The Institute of Irish Studies at The Queen's University of Belfast, 1991).

Kennedy, Roísín. 'Divorcing Jack From Irish Politics', in Yvonne Scott (ed.), *Jack B. Yeats: Old and New Departures* (Dublin: Four Courts Press, 2008), pp. 47–56.

Kennedy, Seán. 'Beckett Reviewing MacGreevy: A Reconsideration', *Irish University Review*, 35/2 (Autumn/Winter 2005): 273–87.

Keown, Edwina and Carol Taaffe (eds). *Irish Modernism: Origins, Contexts, Publics* (Bern and New York: Peter Lang, 2009).

Kermode, Frank. *Romantic Image* (London: Routledge & Kegan Paul, [1957] 2002).

Knowlson, James. *Light and Darkness in the Theatre of Samuel Beckett. Text of a Public Lecture Delivered at Trinity College Dublin on 7 February 1972* (London: Turret Books, 1972).

———. *Damned to Fame: The Life of Samuel Beckett* (London: Bloomsbury Publishing, 1996).

——— and Elizabeth Knowlson (eds). *Beckett Remembering Beckett: A Centenary Celebration* (New York: Arcade Publishing, 2006).

Kobler, John. 'The Real Samuel Beckett', *The Connoisseur* (July 1990): 57.

Larmour, Paul. *The Arts and Crafts Movement in Ireland* (Belfast: Friar's Press, 1992).

Leerssen, Joep. 'Celticism', in Terence Brown (ed.), *Celticism*. Studia imagologica 8 (Amsterdam: Rodopi, 1996), pp. 1–20.

———. *Remembrance and Imagination: Patterns in the Historical and Literary Representation of Ireland in the Nineteenth Century* (Cork: Cork University Press, 1996).

Lerm Hayes, Christa-Maria. *Joyce in Art: Visual Art Inspired by James Joyce* (Dublin: The Lilliput Press, 2004).

Lessing, Gotthold Ephraim. *Laocoon*. Trans. Sir Robert Phillimore (London and New York: G. Routledge; E.P. Dutton, [1874] 1905).

Levine, Herbert J. 'Yeats's Ruskinian Byzantium', in Richard J. Finneran (ed.), *Yeats Annual*, 2 (1983): 25–34.

Lewis, Gifford. *The Yeats Sisters and the Cuala* (Dublin: Irish Academic Press, 1994).

Little, Roger. *The Shaping of Modern French Poetry: Reflections on Unrhymed Poetic Form, 1840–1990* (Manchester: Carcanet, 1995).

Lloyd, David. *Anomalous States: Irish Writing and the Post-Colonial Movement* (Dublin: The Lilliput Press, 1993).

———. 'Republics of Difference: Yeats, MacGreevy, Beckett', *Field Day Review* (Dublin: Keough Institute for Irish Studies, 2005): 43–69.

Loizeaux, Elizabeth Bergmann. *Yeats and the Visual Arts* (New Brunswick and London: Rutgers University Press, 1986).

Londraville, Janis (ed.). *Prodigal Father Revisited: Artists and Writers in the World of John Butler Yeats* (Cornwall: Locust Hill Press, 2003).

Longley, Edna. *The Living Stream: Literature and Revisionism in Ireland* (Newcastle upon Tyne: Bloodaxe Books, 1994), pp. 227–51.

———. *Poetry and Posterity* (Northumberland: Bloodaxe Books, 2000).
———. '"Modernism", Poetry, and Ireland', in Marianne Thormählen (ed.), *Rethinking Modernism* (Basingstoke: Palgrave Macmillan, 2003), pp. 160–79.
———. 'Not Guilty?', *The Dublin Review*, 16 (Autumn 2004): 17–31.
MacCarvill, Eileen (ed.). *Mainie Jellett, the Artist's Vision: Lectures and Essays on Art* (Dundalk: Dundalgan Press, 1958).
MacGreevy, Thomas. 'Religious Art and Modern Ireland', *The Gaelic Churchman* (April 1922): 128–9.
———. 'The Daemon of French Painting', *The Dublin Magazine* (August 1924): 30–34.
———. 'Dysert', *The Criterion*, 4/1 (January 1926): 94. Reprinted as MacGreevy, 'Homage to Jack Yeats', *The European Caravan* (1931): 496.
———. [under pseudonym of L. St Senan] 'Aodh Ruadh Ó Domhnaill', *The Irish Statesman*, 6/8 (1 May 1926): 204–5.
———. [under pseudonym of L. St Senan] 'Nocturne of the Self-Evident Presence', *The Irish Statesman*, 7/3 (25 September 1926): 57–8.
———. 'el Artista Adolescente (Retrato)', *The Criterion* (January 1927): 158.
———. 'Notes from Paris', *The Connoisseur*, 78/312 (August 1927): 251–2.
———. *Introduction to the Method of Leonardo da Vinci*, by Paul Valéry (London: John Rodker, 1929).
———. 'The Catholic Element in *Work in Progress*', in James Joyce, *Our Exagmination Round His Factification for Incamination of Work in Progress* (London: Faber & Faber, 1929), pp. 117–29.
———. 'Nocturne', published as 'Nocturne, Saint Eloi, 1929', *The Irish Statesman*, 2/4 (28 September 1929): 69.
———. 'Crón Tráth na nDéithe' ("School of …"), *transition* (November 1929): 114–18.
———. 'For an Irish Book, 1929', *transition*, 18 (November 1929): 119.
———. 'Gloria de Carlos V', *transition*, 18 (November 1929): 119.
———. 'Treason of Saint Laurence O'Toole' (For Alexander Andreyevitch Balascheff), *transition*, 21 (March 1932): 178–9.
———. 'Elsa. To Jean Lurçat', *transition*, 21 (March 1932): 180.
———. *Poems* (London: William Heinemann, 1934).
———. 'Three Historical Paintings by Jack B. Yeats', *The Capuchin Annual* (1942): 238–51.
———. 'Some Statues by John Hogan', *Father Mathew Record* (August 1943): 5–6.
———. 'Dublin – City of Art', *Father Mathew Record* (September 1944): 5.
———. 'Michael Healy: Personal Reminiscences', *The Capuchin Annual* (1944): 113–15.
———. 'The Historical Background to Irish Art (Chiefly Architecture)', *The Capuchin Annual* (1944): 241–9.
———. *Jack B. Yeats: An Appreciation and an Interpretation* (Dublin: Victor Waddington and Three Candles Press, 1945).
———. 'The Dublin Municipal Gallery', *Father Mathew Record* (January 1946): 4–5.
———. 'St Brendan's Cathedral, Loughrea 1897–1947', *The Capuchin Annual* (1946–47): 353–73.
———. 'Fifty Years of Irish Painting, 1900–1950', *Capuchin Annual* (1949): 497–512.
———. 'How Does She Stand?', *Father Mathew Record* (September 1949): 3–4.
———. 'Developments in the Arts', *Studies* (December 1951): 475–8.
———. *Concise Catalogue of Oil Paintings* (Dublin: National Gallery of Ireland, 1963).
———. *Some Italian Pictures in the National Gallery of Ireland* (Dublin: The Italian Institute in Dublin, 1963).
Maritain, Jacques. *Art and Scholasticism: With Other Essays* (London: Sheed & Ward, 1947).

Mathews, P.J. (ed.). *New Voices in Irish Criticism* (Dublin: Four Courts Press, 2000).
——. *Revival: The Abbey Theatre, Sinn Féin, the Gaelic League and the Co-operative Movement* (Cork: Cork University Press, 2003).
Mayes, Elizabeth and Paula Murphy (eds). *Images and Insights: Hugh Lane Municipal Gallery of Art* (Dublin: Hugh Lane Municipal Gallery of Modern Art, 1993).
Mays, J.C.C. 'How is MacGreevy a Modernist?', in Patricia Coughlan and Alex Davis (eds), *Modernism and Ireland: The Poetry of the 1930s* (Cork: Cork University Press, 1995), pp. 103–28.
McAlindon, Thomas. 'The Idea of Byzantium in William Morris and W.B. Yeats', *Modern Philology* (May 1967): 307–19.
McGettigan, Darren. *Red Hugh O'Donnell and the Nine Years War* (Dublin: Four Courts Press, 2005).
McGuinness, Nora. *The Literary Universe of Jack B. Yeats* (Washington DC: The Catholic University of America Press, 1992).
McHugh, Roger (ed.). *Jack B. Yeats: A Centenary Gathering*. Tower Series of Anglo-Irish Studies III (Dublin: The Dolmen Press, 1971).
McParland, Edward. *Public Architecture in Ireland 1680–1760* (New Haven and London: Yale University Press, 2001).
Megged, Matti. *Dialogue in the Void: Beckett and Giacometti* (USA: Lumen Books, 1985).
Meir, Colin. *The Ballads and Songs of W.B. Yeats* (London: Macmillan, 1974).
Melchiori, Giorgio. *The Whole Mystery of Art: Pattern into Poetry in the Work of W.B. Yeats* (London: Routledge & Kegan Paul, 1960).
Miles, Peter. 'Vision and Narrative in Jack Yeats's *The Aramanthers*', in Janis Londraville (ed.), *Prodigal Father Revisited: Artists and Writers in the World of John Butler Yeats* (Cornwall: Locust Hill Press, 2003), pp. 149–69.
Miller, Liam. *The Dun Emer Press, Later the Cuala Press with a Preface by Michael B. Yeats* (Dublin: The Dolmen Press, 1973).
Mitchell, Breon and Lois More Overbeck (eds). *Word and Image: Samuel Beckett and the Visual Text* [*Mot et Image: Samuel Beckett et le Texte Visuel*] (Atlanta: Emory University, 1999).
Mitchell, W.J.T. *Iconology: Image, Text, Ideology* (Chicago and London: The University of Chicago Press, 1986).
——. 'Image and Word' and 'Mute Poesy and Blind Painting', in Charles Harrison and Paul Wood (eds), *Art in Theory 1900–1990: An Anthology of Changing Ideas* (Oxford: Blackwell, 1992), pp. 1107–11.
——. 'Interdisciplinarity and Visual Culture', *Art Bulletin*, 70/4 (1995): 540–44.
——. 'Word and Image', in Robert S. Nelson and Richard Shiff (eds), *Critical Terms for Art History* (Chicago and London: The University of Chicago Press, 1996), pp. 47–57.
Murphy, Maureen. 'Creating Cuala: Lily and Lollie Yeats and the Cuala Industries', in Janis Londraville (ed.), *Prodigal Father Revisited: Artists and Writers in the World of John Butler Yeats* (Cornwall: Locust Hill Press, 2003), pp. 123–47.
Murphy, Paula. 'Introduction', in *Artists' Century: Irish Self-Portraits and Selected Works, 1900–2000* (Dublin and Belfast: A Millennium Collaboration by the Royal Hibernian Academy, the Ormeau Baths Gallery and the National Self-Portrait Collection of Ireland, 2000), pp. 8–23.
Murphy, William M. *Prodigal Father: The Life of John Butler Yeats (1839–1922)* (Ithaca and London: Cornell University Press, 1978).
——. *Family Secrets: William Butler Yeats and His Relatives* (Dublin: Gill & Macmillan, 1995).

Nash, Catherine. '"Embodying the Nation": The West of Ireland Landscape and National Identity', in Michael Cronin and Barbara O'Connor (eds), *Tourism in Ireland: A Critical Analysis* (Cork: Cork University Press, 1993), pp. 86–112.
Nelson, Robert S. and Richard Shiff (eds). *Critical Terms for Art History* (Chicago and London: University of Chicago Press, 1996).
Noon, William T. *Joyce and Aquinas* (USA: Archon Books, 1970).
O'Brien, Jacqueline and Desmond Guinness. *Dublin: A Grand Tour* (London: George Weidenfeld and Nicholson, 1994).
O'Doherty, Brian. 'Jack B. Yeats: Promise and Regret', in Roger McHugh (ed.), *Jack B. Yeats: A Centenary Gathering* (Dublin: Dolmen Press, 1971), pp. 77–91.
———. 'The Literary Tradition and the Visual Response', in *The Irish Imagination 1959–1971* (Catalogue of an Exhibition at the Municipal Gallery of Modern Art, Dublin, 23 October to 31 December 1971), pp. 24–5.
O'Malley, Ernie. 'The Paintings of Jack B. Yeats', in Roger McHugh (ed.), *Jack B. Yeats: A Centenary Gathering* (Dublin: Dolmen Press, 1971), pp. 64–70.
Oppenheim, Lois. *The Painted Word: Samuel Beckett's Dialogue with Art* (Ann Arbor: University of Michigan Press, 2000).
Panofsky, Erwin. *Problems in Titian Mostly Iconographic* (London: Phaidon, 1969).
Parry, Linda. *Textiles of the Arts and Crafts Movement* (London: Thames & Hudson, [1988] 2005).
Pearce, Lynne. *Woman/Image/Text: Readings in Pre-Raphaelite Art and Literature* (Hemel Hempstead: Harvester Wheatsheaf, 1991).
Peters Corbett, David. '"Collaborative Resistance": Charles Ricketts as Illustrator of Oscar Wilde', *Word & Image*, 10/1 (January–March 1994): 22–37.
———. 'Visuality and Unmediation in Burne-Jones's *Laus Veneris*', *Art History*, 24/1 (February 2001): 83–102.
Pilling, John. *Samuel Beckett* (London and Boston: Routledge & Kegan Paul, 1976).
Purser, John W. *The Literary Works of Jack B. Yeats* (Gerrards Cross: Colin Smythe Limited, 1991).
Pyle, Hilary. *Jack B. Yeats: A Biography* (London: Routledge & Kegan Paul, 1970).
———. *Jack B. Yeats and His Family*. An Exhibition of the Works of Jack B. Yeats and his Family at the Sligo County Library and Museum, Sligo (29 October–29 December 1971).
———. '"Men of Destiny": Jack B. Yeats and W.B. Yeats', *Studies* (Summer/Autumn 1977): 188–213.
———. *A Catalogue Raisonné of the Oil Paintings* (London: Deutsch, 1992).
———. *The Different Worlds of Jack B. Yeats: His Cartoons and Illustrations* (Dublin: Irish Academic Press, 1994).
———. *Yeats: Portrait of an Artistic Family* (Dublin and London: National Gallery of Ireland in Association with Merrell Holberton, 1997).
———. 'To Be Loved as a Cupboard: The Yeats Archive in the National Gallery of Ireland', *Éire-Ireland* (Fall/Winter 2001): 212–25.
——— (ed.). *Deborah Brown: Painting to Sculpture* (Dublin: Four Courts Press, 2005).
——— and Zoë Reid. 'From the Archive at the Yeats Museum', *Millennium Mini Exhibition Two* (Dublin, 14 September–9 November 2000).
Richter, Irma A. *Paragone: A Comparison of the Arts: With an Introduction and English Translation* (London, New York, Toronto: Oxford University Press, 1949), pp. 49–71.
Rothenstein, John. 'Visits to Jack Yeats', *New English Review* (July 1946): 43.
Russell, George. *Imaginations and Reveries* (London: Maunsel & Roberts, [1915] 1921).
Ryan, Michael (ed.). *Treasures of Ireland: Irish Art 3000 B.C.–1500 A.D.* (Dublin: Royal Irish Academy, 1983).

Sarraute, Nathalie. *Tropismes* (Paris: Denoël, 1939).
Schoell-Glass, Charlotte. 'Introduction', in Claus Clüver, Véronique Plesch and Leo Hoek (eds), *Orientations: Space/Time/Image/Word* (Amsterdam and New York: Rodopi, 2005), pp. xi–xvi.
Schreibman, Susan (ed.). *Collected Poems of Thomas MacGreevy: An Annotated Edition* (Dublin: Anna Livia Press; Washington DC: The Catholic University of America Press, 1991).
—— (ed.). *The Thomas MacGreevy Archive*. 2007. Last accessed 30 November 2009 <http://www.macgreevy.org>.
Scott, David. *Pictorialist Poetics: Poetry and the Visual Arts in Nineteenth-Century France* (Cambridge: Cambridge University Press, 1988).
——. 'Pictorialist Poetics: The Nineteenth-century French Re-reading of "ut pictura poesis"', *Word & Image*, 4/1 (January–March 1988): 364–71.
——. 'The Problem of Illustratability: The Case of *Sonnets et eaux-fortes*', *Word & Image*, 6/3 (July–September 1990): 241–5.
Scott, Yvonne. 'Jack B. Yeats in Context', in *Jack B. Yeats Amongst Friends: Catalogue for an Exhibition Held in Trinity College, Dublin* (9 September–14 October 2004), pp. 19–25.
—— (ed.). *Jack B. Yeats: Old and New Departures* (Dublin: Four Courts Press, 2008).
Sheehy, Edward. 'Jack B. Yeats', *Dublin Magazine*, 10/3 (July–September 1945): 38–41.
Sheehy, Jeanne. *The Rediscovery of Ireland's Past: The Celtic Revival 1830–1930* (London: Thames and Hudson, 1980).
Sheringham, George and R. Boyd Morrison (eds). *The Robes of Thespis* (London: Benn, 1928).
Skelton, Robin (ed.). *The Collected Plays of Jack B. Yeats* (London: Secker & Warburg, 1971).
——. *The Selected Writings of Jack B. Yeats* (London: André Deutsch, 1991).
—— and Ann Saddlemyer (eds). *The World of W.B. Yeats: Essays in Perspective* (Dublin: Dolmen Press, 1965).
Snoddy, Theo. *Dictionary of Irish Artists: Twentieth Century* (Dublin: Wolfhound Press, 1996).
Steward, James Christian (ed.). *When Time Began to Rant and Rage: Figurative Painting from Twentieth-Century Ireland* (London: Merrell Holberton, 1999).
Symons, Arthur. *The Symbolist Movement in Literature* (London: Heinemann, 1899).
Synge, J.M. *The Aran Islands*. With Drawings by Jack B. Yeats (Dublin: Maunsel, 1906).
——. *In Wicklow, West Kerry and Connemara by J.M. Synge*. With Essays by George Gmelch and Ann Saddlemyer (Dublin: O'Brien Press, 1980).
Taylor FitzSimon, Betsey and James H. Murphy (eds). *The Irish Revival Reappraised* (Dublin: Four Courts Press, 2004).
Thiessen, Gesa Elsbeth. *Theology and Modern Irish Art* (Dublin: The Columba Press, 1999).
Todorov, Tzvetan. *Mikhail Bakhtin: The Dialogical Principle* (Manchester: Manchester University Press, 1984).
Vinci, Leonardo da. 'Paragone: Of Poetry and Painting', in his *Treatise On Painting: [Codex urbinas latinus 1270]*. Trans. and annotated by A. Philip McMahon (Princeton, NJ: Princeton University Press, 1956).
Wade, Allan. *A Bibliography of the Writings of W.B. Yeats* (London: Rupert Hart-Davis, 1958).
Walker, Dorothy. 'Paul Henry: An Alternative View', *Irish Arts Review*, 20/1 (Spring 2003): 61.

Weitzmann, Kurt, William C. Loerke, Ernst Kitzinger and Hugo Buchthal. *The Place of Book Illumination in Byzantine Art* (Princeton, NJ: Princeton University Press, 1975).
Wendorf, Richard (ed.). *Articulate Images: The Sister Arts from Hogarth to Tennyson* (Minnesota: University of Minnesota Press, 1983).
White, Terence de Vere. *A Fretful Midge* (London: Routledge & Kegan Paul, 1957).
Winnett, Steven (ed.). *The Only Jealousy of Emer and the Fighting of the Waves: Manuscript Materials by W.B. Yeats* (Ithaca and London: Cornell University Press, 2004).
Wright, Barbara. *Eugène Fromentin: A Life in Art and Letters* (Bern and New York: Peter Lang, 2000).
Yeats, Jack B. *Modern Aspects of Irish Art*. Series F. 8 (Dublin: Cumann Léigheacht an Phobail, 1922).
——. *Sligo* (London: Wishart & Company, 1930).
——. *Sailing, Sailing Swiftly* (London: Putnam, 1933).
——. *The Aramanthers* (London and Toronto: William Heinemann Ltd, 1936).
——. 'Indigo Height', *New Statesman and Nation*, 5 December 1936: 899.
——. *The Careless Flower* (London: The Pilot Press, 1947).
——. 'Irish Authors: 36', *Eason's Bulletin*, 5 October 1948.
——. *In Sand. A Play with The Green Wave. A One Act Conversation Piece. Edited and With a Preface by Jack MacGowran and With a Drawing by the Author* (Dublin: The Dolmen Press, [1943] 1964).
——. 'My Miniature Theatre', in Robin Skelton (ed.), *The Collected Plays of Jack B. Yeats* (London: Secker & Warburg, 1971), pp. 17–19.
——. *The Charmed Life* (London: Routledge & Kegan Paul, [1938] 1974).
——. *Ah Well* (London: Routledge and Kegan Paul, [1942] 1974).
——. *And To You Also* (London: Routledge & Kegan Paul, [1944] 1974).
——. *The Selected Writings of Jack B. Yeats*. Ed. John Skelton (London: André Deutsch, 1991).
—— and Thomas MacGreevy. BBC Interview. Recorded 6 November 1947, broadcast 17 May 1948 (NGI, YDisc).
Yeats, W.B. *Irish Fairy Tales* (London: Fisher Unwin, 1892).
——. *Poems*. Cover by H.G. Fell (London: T. Fisher Unwin, 1895).
——. 'The Binding of the Hair', *The Savoy*, 1 (January 1896): 83; 135–8.
——. 'Rosa Alchemica', *The Savoy*, 2 (April 1896): 56–94.
——. 'William Blake and his Illustrations to the *Divine Comedy* I. His Opinions Upon Art', *The Savoy* (July 1896): 41–57.
——. 'William Blake and his Illustrations to the *Divine Comedy* II. His Opinions on Dante', *The Savoy* (August 1896): 25–41.
——. *The Secret Rose. With Illustrations by J.B. Yeats* (New York: Dodd, Mead; London: Lawrence & Bullen, 1897).
——. 'A Symbolic Artist and the Coming of Symbolic Art', *The Dome*, 1/3 (December 1898): 233–7.
——. *The Wind Among the Reeds* (London: Elkin Mathews, 1899).
——. *Poems*. Cover by Althea Gyles (London: T. Fisher Unwin, 1901).
——. *The Land of Heart's Desire* (Portland, ME: Thomas B. Mosher, 1903).
——. *Deirdre. Being Volume Five of Plays for an Irish Theatre* (London: A.H. Bullen; Dublin: Maunsel & Co., 1907).
——. *A Vision* (London: T. Werner Laurie, 1925).
——. *The Stories of Red Hanrahan and the Secret Rose*. Illustrated and decorated by Norah McGuinness (London: Macmillan, 1927).
——. *The Collected Poems of W.B. Yeats* (New York: Macmillan, 1933).

———. *The Oxford Book of Modern Verse 1892–1935* (Oxford: Clarendon Press, 1935).
———. *On The Boiler* (Dublin: The Cuala Press, 1938).
———. *The Letters of W.B. Yeats*. Ed. Allan Wade (London: Rupert Hart-Davis, 1954).
———. *Autobiographies* (Dublin: Gill and Macmillan, 1955).
———. *Mythologies* (London: The Macmillan Press, [1925] 1959).
———. 'Art and Ideas' (1913), in *Essays and Introductions* (New York: The Macmillan Company, 1961), pp. 346–55.
———. *Essays and Introductions* (New York: Macmillan, 1961).
———. *The Collected Letters of W.B. Yeats*. Gen. ed. John Kelly, 4 volumes (Oxford: Clarendon Press, 1986).
———. *The Variorum Edition of the Poems of W.B. Yeats*. Eds Peter Allt and Russell K. Alspach (London: Macmillan, [1903] 1989).
Y.O. [George Russell (AE)]. 'The Hibernian Academy', *The Irish Statesman*, 2 (19 April 1924): 166.

Index

Page numbers in *italics* refer to illustrations.

Page numbers in **bold** refer to the chapter that deals mainly with the subject.

Abbey Theatre, Dublin 22, 31, 33, 63, 64, 76, 144, 156–7
Alpine Club Gallery, London 132
America (North) 23, 29, 38, 40, 50, 60n76, 97, 135, 152, 156
An Claidheamh Soluis (newspaper) 33, 34, 42
Aquinas, St Thomas 109, 111, 112
Argentina 40
Ariel (magazine) 13
Aristotle 109, 112
Arnold, Bruce 50, 106, 109, 117, 130, 131, 132, 133, 135, 138, 158
Arp, Hans 115
Arts and Crafts movement 3, 4, 5, 63, 71, 105; Dun Emer & Cuala Industries and 29–30, 31, 32, 34, 38, 40, 51, 55; W.B. Yeats and 9, 13, 14, 16, 17, 19, 22, 23
Asbourne, Lord 34
Atelier Ludovici 29

Balzac, Honoré de 134
Bank of Ireland building, Dublin 100, 144
Barry, Kevin 99

Barthes, Roland 139
Baudelaire, Charles 10, 89, 125n72, 126n104, 134
Baudelaire, Charles 'Correspondances' 89
Bean na hÉireann 40
Beardsley, Aubrey 15, 19, 26n55, 65, 81
Beckett, Samuel (1906–89) 1, 6, 82;
 Jack Yeats and 130, 133, 134, 135, 136, 137, 138, 139–40, 142–3, 144, 146; MacGreevy, Jack Yeats and 97–8, 101, 103, 107, 108, 113, 115, 116–21; 'Two Travellers' theme 147, 148–9, 155–6, 157, 159
 ✦ Work: 'Hommage á Jack B. Yeats' 159; 'Humanistic Quietism' 116; 'An Imaginative Work' 119, 142–3; 'MacGreevy on Yeats' 118–19, 142, 159; *Molloy* 156; *Murphy* 134, 143; 'Recent Irish Poetry' 6, 80, 90, 93, 97, 98, 116, 117, 142; *Waiting for Godot* 156, 157
Bedient, Calvin 148
Belfast 45
Berlin 46

Bhreathnach-Lynch, Síghle 131
Blaikie-Murdoch, W.G. 43–4, 130
Blake, William 12, 14, 17–18, 42
Book of Kells 68, 79
bookplates 46
Bosch, Hieronymus 102. *See also under* MacGreevy, Thomas
Bowe, Nicola Gordon 29
Brancusi, Constantin 99
Braque, Georges 65, 77, 81, 119
Bremen 46
Bristol 46
Broad Sheet, A 60n76, 135, 144, 147
Broadside, A 47, 48–50, 51, 61n106, 135, 144, 147, 149–50
Broadside (New Series), A 54, 82, 157
Brown, Deborah 124n52
Brown, Terence 80, 90–91, 107
Brown, Victor 61n106
Burke, Edmund 2
Burne-Jones, Sir Edward *14*, 41
Byzantine art 12, 31, 67–9, 71, 72, 73, 75, 76, 79, 81–2, 111; 'Byzantine modernism' 76, 91

Cadbury family 46
Canada 40, 94
Cassidy, Beatrice 51, 61n98
Celtic Irish culture 16, 17, 19, 20, 21, 22, 31, 55; art and design 32, 33, 35, 37, 68, 71–2, 111
Celtic Revival 30, 34, 90, 121, 159. *See also* Irish Cultural Revival
Celtic Twilight 21, 54, 68, 73, 76, 91, 96
Cézanne, Paul 65, 77, 81, 134
Chagall, Marc 159
Chelsea Polytechnic 65, 77, 81
Chesterton, G.K. 42, 46
Chiswick Press 41
Christian art 26n55, 32, 108, 111, 164n89
Churchtown, Co. Dublin (Cuala) 30, 38

Clark, Kenneth 158
Clarke, Austin 90, 97, 118
Clarke, Harry 65, 81
Claudel, Paul 107
Clausen's Gallery, New York 23
Cobden-Sanderson, Thomas 25n28
Coffey, Brian 82, 90, 91, 97, 117, 164n89
Coffey, George 40
'collaborative resistance' 15, 22, 65, 73
Colum, Eileen 51, 57n26
Constable, John 91
Cooley, Thomas 104
Co-operative movement 31, 50
Corbière, Tristan 118
Corinth, Lovis 86n49
Cork 46, 58n47
Crane, Walter 13
Criterion, The 94, 113
Crookshank, Anne 77
Cuala Industries 5, 23, **29–62**, 63, 81, 84n6, 118, 133, 149, 156
Cubism 4, 5, 79, 80, 82, 157, 158
Cullen, Fintan 22
Cunard, Lady 64
Custom House, Dublin 104

Daily Sketch 30
Dalton, O.M. 68
Dante Alighieri 17, 113
Davis, Alex 91
Davis, Thomas 48
decorative arts 5, 13, 23, 29, 30–41, 63, 64, 65, 71, 77, 82, 90, 130
Degas, Edgar 98, 99
Delacroix, Eugène 87n73, 89
Devlin, Denis 82, 90, 91, 97, 117
Dial, The 113
Dome, The 15, 19
Donaghy, John Lyle 55, 118
Donegal 32–3
Doves Press 25n28, 41

Dublin (city) 12, 23, 29, 46, 53, 77, 79, 106, 116–17, 120, 142, 144, 152, 155; in MacGreevy's work 99, 100–1, 103–4, 107
Dublin (county) 12, 41, 42, 134
Dublin Dramatic Society 63
Dublin Hermetic Society 12
Dublin Magazine, The 12, 119
Dublin Theosophists 19
Dulac, Edmund 63, 64, 73
Dun Emer Industries 5, 13, 23, **29–62**, 63, 71, 105, 118, 130, 133
Dundrum, Co. Dublin (Dun Emer) 29
Dysert Castle, Co. Limerick 95

École Normale Supérieure, Paris 79, 113, 116
Eliot, T.S. 6, 82, 90, 97, 100, 104, 118, 133; *Waste Land, The* 98, 103, 116
Ellis, Edwin John 9
Ellmann, Richard 72
embroidery 13, 29, 30, 31, 32, 35, 40, 41, 45, 47, 53, 82
Emer, Lady (wife of Cúchulainn) 30, 44
English Arts and Crafts Society 40
Ensor, James 134, 159
Expressionism 145, 155, 157, 158, 165n99

Fenollosa, Ernest 51
Field, Michael (pseud.) 15–16
Fitzpatrick, Nora 30
Fletcher, Ian 15, 69
Flower, Robin 44
Formes (journal) 113
Foster, R.F. (Roy) 17, 19, 22, 33, 53, 68, 71
Four Courts, Dublin 104, 105
France 10, 17, 40, 81, 82, 89, 90, 94, 107, 108, 115–16, 118
fraternité des arts tradition 5, 9–27, 42, 56, 80, 121, 159
Froebel Institute 13

Gaelic League 5, 29, 31, 33–4, 40
Gandon, James 104
Garratt, Robert 87n79, 104–5
Geddes, Wilhelmina 83n3, 87n66, 107–8
gender issues 30, 63–4, 77–83. *See also* women artists
Giacometti, Alberto 97, 98
Gibbon, Monk 97
Gibbons, Luke 48
Gill, Mairie 51
Gill, T.P. 33
Gillis, Alan 91, 117, 120, 121n12, 164n89
Glasgow Herald 55
Gleeson, Evelyn (1855–1944) 5, 23, 29, **30–41**, 39, 47, 48, 52, 96, 130; 'Fragment of an Essay for the Irish Literary Society' 31, 33; McGuinness and 63, 64, 68, 82
Gleizes, Albert 79, 158
Gombrich, Ernst 2, 158
Gonne, Maud 52
Goodman, Nelson 2, 158
Gordon, D.J. 15, 69
Goya 105, 106
Gregory, Lady Augusta 4, 22, 32, 38, 44, 68, 69, 72, 74, 138, 148, 166n123; *Book of Saints of Wonders, A* 44
Gregory, Robert 42
Grünewald, Isaak 92, 102–3
Guardian, The 54
Gyles, Althea *18*, 19, 42, 55, 71, 72, 74

Hagstrum, Jean 2
Hardwick, Joan 46
Hart, Alice 32
Heatherley's School of Art 9
Helland, Janice 63
Henn, T.R. 12, 68
Henry, Dr Augustine 30, 34
Henry, Paul 96

Higgins, F.R. 97
Hone, Evie 64, 77, 79, 80, 81, 82, 109, 111, 157–8
Hone, Nathaniel 23, 122n15
Hugh Lane, The (Dublin City Gallery) 145, 148
Hunt, John Dixon 15
Huysmans, Joris-Karl 17
Hyde, Douglas 22, 32, 33

Impressionism 65, 77, 81, 91
Ireland To-Day 116
Irish Civil War 91, 103, 104, 105, 120
Irish Cultural Revival 1, 4, 5, 22, 29–62, 63, 82, 96, 100, 118, 120, 130, 148
Irish Free State 90, 91, 96, 97, 103, 104, 131
Irish Language movement 4, 32, 33, 52
Irish Literary Society 5, 27n65, 29, 31, 33, 68
Irish National Dramatic Society 23
Irish Race Congress, Paris 94
Irish Republican Army 104
Irish Revivalists movement. *See* Irish Cultural Revival
Irish Statesman, The 79, 113
Irish Times, The 77, 80, 118
Italy, influence of 9, 32, 57n17, 68, 111
Ito, Michio 64

Jellett, Mainie 5–6, 64, 77–9, 80, 81–2, 158; 'Art as a Spiritual Force' 111; *Decoration* 77, 78, 79, 81, 82, 111; discussed by MacGreevy 100, 109, 111, 112; 'Importance of Rhythm in Modern Painting, The' 111; 'Modern Art and the Dual Ideal of Form' 80; 'Rouault and Tradition' 109; *Ninth Hour, The* 111
John O'London's Weekly 152
Jolas, Eugène 99, 113, 115

Joyce, James 1, 6, 82; *Dead, The* 60n79; Jack Yeats and 133–4, 136, 138, 139, 156, 160; MacGreevy and 92, 103, 112–13, 117; *Portrait of the Artist as a Young Man* 112; *Ulysses* 103, 104, 133, 138, 139; *Work in Progress* 92, 113, 142

Kafka, Franz 156
Kandinsky, Wassily 119, 123n44
Kant, Immanuel 109
Keating, Seán 96
Keats, John 26n42, 109
'Kelmscott Chaucer' 14, 22, 41
Kelmscott House 13
Kelmscott Press 14, 41, 43
Kennedy, Brian 158, 159
Kermode, Frank 12
Klaxon, The (journal) 80
Klee, Paul 119
Knowlson, James 154, 156
Kokoschka, Oscar 155, 159

Laforgue, Jules 118
'Lament for Eoghan Ruadh' (Davis) 48, 92
Leeds 46
Leonardo da Vinci 7n5, 57n14, 113; *Mona Lisa* (*La Gioconda*) 114, 115
Lerm Hayes, Christa-Maria 1, 3
Lessing, Georg 2, 26n46
Listener, The 55
Little Review, The 133
Lloyd, David 48, 93, 119, 131
Loizeaux, Elizabeth Bergmann 1, 2–3, 12, 15, 17, 22, 84n22
London 6–7, 9, 10, 12–13, 15, 16, 22, 29, 30, 31, 43, 46, 77, 81, 90, 92, 94, 97, 116, 153, 158
London, National Gallery of 99
Longley, Edna 2, 4, 12, 16, 121n12, 123n47
Lurçat, Jean 115

MacCormack, Katherine 33, 34
MacDonagh, Thomas 34
MacGreevy, Thomas (1893–1967) 6, **89–128**; advocacy of Modernism 77, 79–82, 83; Jack Yeats and 129, 130, 131, 133–4, 136, 137, 138, 142, 144, 146, 155, 158–9. *See also under* Beckett
✦ Work: 'Aodh Ruadh Ó Domhnaill' 82, 91, 92; 'Apropos of the National Gallery' 89; 'Catholic Element in *Work in Progress*, The' 92, 113; 'Contemporary Art in Ireland' 91; 'Crón Tráth na nDéithe' 87n79, 92, 101, 103–5, 106, 107, 113, 134; 'De Civitate Hominum' 105; 'Developments in the Arts' 104; 'Dysert' 92, 94–5, 97, 99, 115, 133; 'Elsa' 113–14, 115; 'Fifty Years of Irish Painting' 27n66, 80; 'For and Irish Book, 1929' 112; 'Gloria de Carlos V' 92, 101–2; 'Historical Background to Irish Art (Chiefly Architecture)' 104; 'Homage to Hieronymus Bosch' 92, 99, 100, 101, 102, 106, 113, 144; 'How Does She Stand?' 100; *Jack B. Yeats* 116, 118, 120; 'Nocturne of the Self-Evident Presence' 82, 91, 101; 'Nocturne' 96, 98; 'Note on Work in Progress, A' 112; 'Picasso, Mamie Jellett and Dublin Criticism' 79, 80, 81; *Pictures in the National Gallery* 116; *Poems* 90, 100, 101, 113, 115, 116, 142; 'Religious Art and Modern Ireland' 107; *Richard Aldington: An Englishman* (1931) 113; 'Seventh Gift of the Holy Ghost' 101; 'Six Who Were Hanged, The' 107; *T.S. Eliot: A Study* (1931) 113
McGuinness, Nora (critic) 93, 131, 132
McGuinness, Norah (1901–80) 5, 55, **63–87**, 66, 67, 91, 111, 130; 'Crucifixion of the Outcast, The' 73–4, 74, 75
MacKenna, Stephen 48, 92
Macmillan & Co. (publishers) 5, 55, 65, 72, 74
Macmillan, Sir Frederick 65, 67, 69
McParland, Edward 104
Mallarmé, Stéphane 17, 22, 98, 99
Manchester Guardian 48
Marichalar, Señor 112
Maritain, Jacques 109
Markievicz, Constance 77
Martyn, Edward 22
Masefield, John 147
Meir, Colin 72, 73
Melchiori, Giorgio 12
Metropolitan School of Art, Dublin 12, 64
Michelangelo 12, 134
Millais, John Everett 9, 10
Miller, Alexander 29
Mitchell, Susan L. 46, 51–2
Mitchell, W.J.T. 1, 2–3, 4, 5, 6, 10, 12, 23, 40, 158, 159; 'family of images' 2, 10
Modernism 1–2, 4, 5–6, 7; Jack Yeats and 133, 137, 142, 144, 159; MacGreevy and 89, 90–91, 96, 100, 111, 113, 117, 121; McGuinness, W.B. Yeats and 64, 76, 77–83. *See also under* Byzantine art
Monsell, Elinor 44
Mooney, Ria 156, 157
Moore, Marianne 113
Moore, Thomas Sturge 42, 47
'Morris Bed, The' 13, 34
Morris, May 13

Morris, William 13, 14, 20, 31, 40, 41, 43, 57n12, 57n22, 59n58, 71, 85n29
Municipal Gallery of Art. *See* Hugh Lane
mythology: Classical 103, 113; Irish 103

Nash, Catherine 96
National Gallery of Ireland, Dublin 146
National Gallery, London 99, 116, 158
National Library of Ireland, Dublin 5, 70
National Literary Society 31
National Museum, Dublin 32, 68
Nationalism 6, 30, 31, 33, 38, 40, 47, 90, 92, 119, 130, 131, 132, 133, 144; cultural 29, 48, 50, 96, 97, 113, 116
Nettleship, John T. 9
New Statesman and Nation 145
New York 23, 34, 46, 117, 133, 136; Armory exhibition 159
New Zealand 40
Noh drama 27n64, 63, 64, 84n6

O'Connor, Frank 54–5, 64, 118
O'Faolain, Seán 55, 64
O'Malley, Ernie 106, 131
Oppenheim, Lois 1, 2–3
Order of the Golden Dawn 17, 19

Pageant, The (periodical) 15
Paley, William 134
Paris 81, 90, 92, 94, 97, 113, 114, 115, 116, 133, 138
Pearse, Pádraig 33
Peters Corbett, David 16, 65
Phibbs, Geoffrey (NMcG's husband) 65, 117
Picasso, Pablo 92, 102–3
Plato 109
Plotinus 109
Plunkett, Sir Horace 22, 33

Pollexfen, William and Elizabeth 12, 147
Pound, Ezra 51, 55, 82, 90, 97, 113, 118, 134
Prado Museum, Madrid 98, 99, 101
Pre-Raphaelitism 4, 9, 10, 12–13, 15, 16, 19, 20, 21, 30, 107; Pre-Raphaelite Brotherhood 24n2
primitivism 151
Proust, Marcel 134, 163n72
Punch 129, 134, 149
Purser, John W. 131, 132, 143, 146
Purser, Sarah 23, 107
Pyle, Hilary 93, 132, 133, 148, 158

Queen Dectira 20, 21, 32
Quinn, John 23, 34, 42, 43, 47, 50–51, 52, 94, 129, 133

Reavey, George 95
Reid, F.W. 156
Reid, Nano 79–80, 86n63
'relationship-in-difference' 4, 6, 160
Rembrandt 91, 105
Renan, Ernest 17
Renoir, Pierre-Auguste 134
Republicanism 52, 92, 94, 106, 130, 160n9
Rhys, Ernest 13, 25n33
Ricketts, Charles 15, 16, 19, 43–4, 55, 71
Rimbaud, Arthur 118
Rivers, Elizabeth 80
Robbe-Grillet, Alain 139
Robinson, Lennox 133, 156
Romanticism 4, 16, 111
Rose, Marilyn Gaddis 139
Rosicrucianism 17
Rossetti, Dante Gabriel 10, 13, 14, 17, 42, 43; *Mary Magdalene* 9; *Mary of Galilee* 9
Rothenstein, Sir John 93, 106
Rouault, Georges 109–11, 112, 119, 159; *Christ and the Soldier* 109, *110*

Royal Hibernian Academy 6, 12, 77, 80
Ruskin, John 13, 40,
Russell, George (AE) 4, 12, 20, 22, 34, 79, 96, 97, 118, 151; *Nuts of Knowledge* 42
Ryan, Esther 51

St Augustine 109
Sarraute, Nathalie 139
Sartre, Jean-Paul 156
Savoy, The 15, 19, 21
Schreibman, Susan 91, 95, 99, 103–4
Scott, David 10, 17, 26n46, 89
'Seagull Portière' 34, 35
Shannon, Charles 15
Sharp, William (pseud. of Fiona MacLeod) 22
Shaw, George Bernard 13
Sheehy, Edward 94, 131
Shelley, Percy Bysshe 14, 42
Sickert, Walter 152–3
Sinclair, Cissie 117
Sinn Féin 33, 94
Skelton, Robin 132–3, 137
Sligo 12, 100–1, 136, 140, 147, 148, 149, 151, 155, 158
Smyth, Edward 104
Society of Dublin Painters 77, 86n63
South Africa 40, 94
South Kensington School of Art 25n22, 29
Spectator, The 55, 76
stained glass 108, 112
Standard, The 135
Stephens, James 97
Stevens, Wallace 100, 107
Steward, James Christian 96
Studio, The 116
Sullivan, Sir Edward 40
Sunday Times, The 141
Surrealism 156
Swanzy, Mary 79, 83n4, 87n66

Symbolism 4, 15, 16–17, 19, 20, 21, 74, 75
Symons, Arthur 15, 17, 43, 147
Synge, J.M. (1871–1909) 6, 48, 50, 55, 147–9, 151, 155, 166n123; *Aran Islands, The* 48, 149, 151; *In Wicklow, West Kerry and Connemara* 153; *Poems and Translations* 43

tapestry 17, 29, 31, 32, 41, 45
Teniers, David 105
Times, The 76
Titian, *La Gloria* 101, 102
Todhunter, John 10, 27n65
transition (journal) 99, 103, 112, 113, 114, 115, 133
Trinity College Dublin 77, 99, 100
Tuohy, Patrick 113
Turrloch, G.H. 53
Twentieth Century Club 38
Tynan, Katherine 44, 46

Vale Press 25n28, 43, 44
Valéry, Paul 113, 114
Van Gogh, Vincent 65, 77, 81, 159
vegetable dye 32–3
Vegetarian, The (magazine) 13, 134
Velazquez 98, 105
Victor Waddington Galleries, Dublin 115, 118
Virgil 113

Wade, Alan 73
Wagner, Richard 22, 124n62, 125n85
Walker, Emery 13, 30, 41, 43
Watteau, Antoine 94, 105, 155, 165n101
Wendorf, Richard 2
West Indies 40
Westminster Art School 13
Whistler, James 19, 122n21, 134
White, Terence de Vere 106

Wilde, Oscar 15–16; *Importance of Being Earnest, The* 76; *Salomé* 26n55; *Sphinx, The* 16
Wilson, George J. 9
women artists 5, 6, 56, 63–4, 77, 79–80
Women's Printing Association, London 30
Wright, Ellen 13

Yeats, Elizabeth Corbet ('Lolly') (1868–1940) 13, 35, 41, 43, 47, 63; in collaboration with her sister Lily 5, 23, 29, 30, 34, 38, 40, 44, 46, 50, 51, 53, 54, 82, 130
Yeats, George (WBY's wife) 47, 53, 64
Yeats, Jack (1871–1957) 6, 12, 13, 23, 81, 82, **129–68**; in collaboration with family 40, 43, 47, 48, 50, 51, 53, 54; MacGreevy, Beckett and 89, 91–6, 98, 99, 100–1, 103, 105–7, 108, 109, 111, 112, 116–17, 118–21
✦ Work: *Above the Fair* 146; *And To You Also* 137; *Aramanthers, The* 6, 119, 135–47, 152, 156; *Bachelor's Walk in Memory* 131, 159; *Ballad Singer, The* 48–50, 49; *California* 120; *Careless Flower, The* 140, 151, 164n89; *Charmed Life, The* 140, 141, 147, 151–2, 153, 154, 155, 156; *Communicating With Prisoners* 82, *83*; *Crossing the Metal Bridge* 106, 129; *Death for Only One* 155; *Draughts* 93, 95, 106; 'Fairy Greyhound, The' 13; 'Finish, The' 51; *Funeral of Harry Boland, The* 93, 106, 131; *Green Wave, The* 151, 156, 157; *Grief* 141, 146; *Halt* 155; *Harlequin's Positions* 156; *Harvest Moon* 155; *In Sand* 144, 157; 'Indigo Height' 145; *La La Noo* 156–7; *Low Tide* 144, 145, 146; *Memory Harbour* 55, 151; *Modern Aspects of Irish Art* 129–30, 137, 152; *Morning, A* 145, 146, 147; *Old Sea Road, The* 151, 156; *Race in Hy Brasil, A* 159; *Red Hanrahan's Vision* 26n56; *Riverside (Long Ago)* 93, 96; *Sailing, Sailing Swiftly* 151, 152; 'Sketches of Life in the West of Ireland' (exhibition) 23, 50; *Sligo* 132, 135–47, 151; 'Start of the Race, The' 51; *Storm/Gaillshion* 145, 147, 152; *Tinker's Encampment* 109, 112, 141, 159; *Tramps* 149, *150*; *Two Men Walking* 155; *Two Travellers, The* 155; 'Village, The' 51; 'Wren Boys, The' 51; 'Young Piper, The' 13
Yeats, John B. (1839–1922) 4, 9, 10, 13, 20, 22, 23, *38*, 74, 75, 76, 140, 153; 'Crucifixion of the Outcast, The' 26n56, 75; *Pippa Passes* 10, *11*
Yeats, Mary Cottenham ('Cottie'; Jack's wife) 34, 50, 129, 131
Yeats, Michael B. 40
Yeats, Susan Mary ('Lily') (1866–1949) 13, *36*, 47, 52, 63, 122n29; collaboration with her sister Elizabeth 5, 23, 29, 30, 34, 38, 40, 44, 46, 50, 51, 53, 54, 82, 130
Yeats, W.B. (1865–1939) 1, 4, 5, 6, 7, **9–27**; collaboration with Norah McGuinness 63, 64, 65, 81, 82; involvement in Dun Emer and Cuala Industries 30, 31, 32, 33, 35, 38, 40, 41–56; Jack Yeats and 130, 131, 133, 134, 135, 136–7, 138, 140, 143, 147–9, 151, 152, 153, 159, 160; MacGreevy and 89, 90, 91, 97, 102, 107, 109, 117, 118

✦ Work: 'Art and Ideas' 9, 16, 41; *At the Hawk's Well* 64; 'Binding of the Hair, The' 15, 20; 'Byzantium' 68, 71, 72; *Collected Poems* 12; *Countess Cathleen, The* 22; 'Curse of the Fires and of the Shadow, The' 26n56, 75; *Deirdre* 64, 76; 'Embroidered Cloths of Heaven, The' 47; 'Fisherman, The' 149; 'Four Years 1887–1891' 12; 'Had I the Heaven's Embroidered Cloths' 47; 'Heart of the Spring, The' 26n56, 74; *In the Seven Woods* 41–2; *Irish Fairy Tales* 13; *King's Threshold, The* 35, 37; 'Lake Isle of Innisfree, The' 47; *Land of Heart's Desire, The* 35; 'Lapis Lazuli' 12; 'Legend, A' 13; 'Municipal Gallery Revisited, The' 148; *Mythologies* 72; *Only Jealousy of Emer, The* 63, 64; 'Out of the Rose' 26n56, 75; *Poems* (1899) 71; *Poems* (1901) 19; *Reveries Over Childhood and Youth* 55, 136, 139, 153; 'Rosa Alchemica' 15; 'Rose of the Shadow, The' 26n56, 75; 'Sailing to Byzantium' 12, 68, 69, 85n40; *Secret Rose, The* 15, 17, *18*, 19, 20, 22, 32, 55, 67, 71, 72, 74, 75, 76; 'Shadowy Horses, The' 15; *Shadowy Waters, The* 22; 'Song of the Happy Shepherd, The' 12, 121n11; *Stories of Red Hanrahan* 42, 56, 72; *Stories of Red Hanrahan and the Secret Rose, The* 5, 55, 65–77, *66*, *67*, *74*, *81*, *111*; 'Symbolic Artist and the Coming of Symbolic Art, A' 19, 72; 'Symbolism in Painting' 16–17; 'Symbolism of Poetry' 16–17; 'Statues, The' 19; 'Travail of Passion, The' 15; 'Twisting of the Rope, The' 26n56, 72, 75, 76; *Vision, A* 12, 64, 84n20, 84n22; *Wild Swans at Coole, The* 149; *Wind Among the Reeds, The* 19

Yellow Book, The 15

For Product Safety Concerns and Information please contact our EU
representative GPSR@taylorandfrancis.com
Taylor & Francis Verlag GmbH, Kaufingerstraße 24, 80331 München, Germany

www.ingramcontent.com/pod-product-compliance
Lightning Source LLC
Chambersburg PA
CBHW070435180526

45158CB00018B/1385